INDIANS

AND A CHANGING FRONTIER

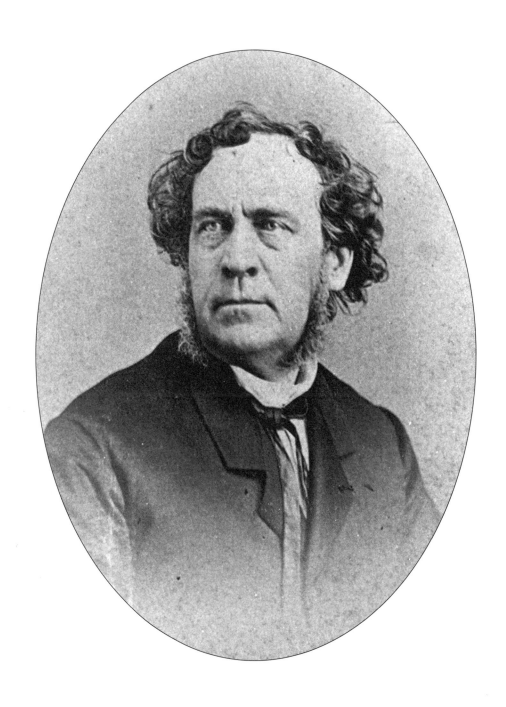

GEORGE WINTER

1809–1876

INDIANS

AND A CHANGING FRONTIER

THE ART OF GEORGE WINTER

Catalog of the George Winter Collection Located at the
Tippecanoe County Historical Association, Lafayette, Indiana, Compiled by

SARAH E. COOKE

and

RACHEL B. RAMADHYANI

Essays by

CHRISTIAN F. FEEST

and

R. DAVID EDMUNDS

Published by the Indiana Historical Society in Cooperation with the Tippecanoe County Historical Association

Indianapolis 1993

The paper in this publication meets the minimum requirements of American National Standard for Information Sciences—Permanence of Paper for Printed Library Materials, ANSI Z39.48-1984. ∞

Library of Congress Cataloging-in-Publication Data

Feest, Christian F.

Indians and a changing frontier: the art of George Winter/ essays by Christian F. Feest and R. David Edmunds; compiled by Sarah E. Cooke and Rachel B. Ramadhyani.

p. cm.

"Catalog of the George Winter Collection Located at the Tippecanoe County Historical Association, Lafayette, Indiana."

Includes index.

ISBN 0-87195-097-9: $49.95

1. Winter, George, 1809–1876—Catalogs. 2. Indians of North America—Pictorial works—Catalogs. 3. West (U.S.) in art—Catalogs. 4. Art—Indiana—Lafayette—Catalogs. 5. Tippecanoe County Historical Association—Catalogs. I. Winter, George, 1809–1876. II. Edmunds, R. David (Russell David), 1939– . III. Cooke, Sarah E. IV. Ramadhyani, Rachel B. V. Indiana Historical Society. VI. Tippecanoe County Historical Association. VII. Title.

N6537. W558A4 1993

759. 13—dc20

92-43041

CIP

CONTENTS

LIST OF COLOR PLATES

PREFACE

In November 1986 the Tippecanoe County Historical Association (TCHA) in Lafayette, Indiana, received a collection of major significance to ethnographers, art historians, and students of nineteenth-century Indiana culture. The George Winter Collection of watercolor paintings and working sketches, letters, manuscripts, and journals was a gift of Evelyn Osterman Ball, widow of Cable Gordon Ball, the artist's great-grandson. The designation of the local county historical museum as recipient of this important collection was in compliance with Cable Ball's wish that the Winter materials remain in the community that had been the artist's home from 1850 until his death in 1876.

Growing up in Lafayette, Cable Ball was aware of his ancestor's accomplishments as a local artist. Oil portraits and landscapes lined the hallways of the stately family home built in Lafayette in the late 1860s by Judge Cyrus Ball. Judge Ball's son Cyrus Gordon had married George Winter's daughter Annette. The family was also custodian of a collection of watercolor paintings accompanied by handwritten narratives, compiled by the artist in his later years from early notes and sketches, which he had hoped to publish. Winter titled these compilations "Journal of a Visit to Lake Kee-wau-nay and Crooked Creek, 1837" and "Journal of a Visit to Deaf Man's Village, 1839."

Until recently, Winter's occupation as an early Wabash Valley artist and his unique documentation of a transitional period in American history have received relatively little treatment by historians. According to George S. Cottman in an article published in the *Indiana Magazine of History* in 1905, the artist's name, though "well known in northern Indiana for nearly forty years," had by 1905 "sunk in oblivion."

In the mid-1930s a remarkable discovery by Evelyn Ball brought renewed local attention to the artist's work. A Lafayette warehouse owned by the Balls had fallen into disuse and was scheduled for demolition. Prior to razing the two-story brick structure, workmen were hired to clear out the building's contents. Mrs. Ball happened to drive by the building and observed a workman, leaning from a second-story opening, knock a painted canvas out of its ornate gilt frame into a waiting dump truck. Horrified, she ordered the workers to stop. Climbing the steep staircase to the cavernous second-floor storeroom, she found the walls lined with sealed camelback trunks and wooden boxes covered with decades of dust and soot. Inside were personal effects from George and Mary Winter, including clothing, correspondence, notes, and hundreds of the artist's working sketches. These were transported to the Ball home where Cable Ball spent months reading and sorting the papers and sketches, developing in the process a deep affection and respect for his great-grandfather.

During the succeeding fifty years of family custodianship, careful management of Winter's works by Cable and Evelyn Ball ensured preservation of the collection as an intact body of materials, its historical value undiminished.

In the 1940s the illustrated journals compiled by Winter and the newly discovered manuscripts were loaned to the Indiana Historical Society (IHS) for the preparation of *The Journals and Indian Paintings of George Winter, 1837–1839* (1948). Major exhibitions of his paintings have been held at the John Herron Art Museum, Indianapolis, 1939; the Ball State University Art Gallery, Muncie, 1976; the Indiana State Museum, Indianapolis, 1980–81; and the Greater Lafayette Museum of Art, 1984.

In 1987, upon arriving at his new position as director of publications at the IHS, Thomas A. Mason received a letter from Francis Levier, the tribal administrator of the Citizen Band Potawatomi Indians of Oklahoma, requesting a reprint of the now out-of-print 1948 book. It was this request that prompted a dialogue between the IHS and the TCHA regarding a joint publication project. During discussions with John Harris, then TCHA director, and later with Patrick Daily, his successor, it was agreed that a catalog to all the works of art on paper in the TCHA's collection, accompanied by excerpts from the artist's writings, would best serve the demands of a growing academic and popular interest in Winter's work. Christian F. Feest and R. David Edmunds were enlisted to contribute essays illuminating the artist's life and work.

The collection required organization and processing for research use and as a preliminary step to the preparation of this book. In 1988 a grant from the Gannett Foundation provided the means to catalog the 760 drawings and watercolors and to produce an indexed calendar to the manuscript materials. An Indiana Heritage Research Grant funded photoduplication for publication and research use of the sketches.

The purpose of the catalog is to provide, for the first time, a comprehensive view of the full spectrum of Winter's artistic interests, accompanied by a selection of his written reflections on the many persons and scenes observed during his long and fruitful life.

ACKNOWLEDGMENTS

To begin, an expression of heartfelt appreciation must be extended to TCHA's former caretakers and curators of the George Winter Collection, including Bird Pollack, Alameda McCollough, and Millie Paarlberg. With their conscientious care, under direction from the Ball family, the collection was preserved and may now be shared with a broader audience through the vehicle of this catalog. The publication was initiated and facilitated by former TCHA administrators John Harris and Carol Waddell, working with Thomas A. Mason, director of publications at the IHS. Administrative aspects of the project have continued with TCHA's present director Patrick Daily, who has enthusiastically supported the project.

To Rachel B. Ramadhyani, my special assistant during several years of processing the collection and compiling the catalog, I extend my deepest gratitude. Much appreciation is due the contributing essayists R. David Edmunds and Christian F. Feest, who shared their invaluable advice and direction. Also generously sharing their expertise were Kathleen A. Foster, curator of nineteenth- and twentieth-century art for the Indiana University Museum of Art; Martin F. Krause, Jr., curator of prints and drawings at the Indianapolis Museum of Art; and Jay Miller, former assistant director of the D'Arcy McNickle Center, Newberry Library, Chicago. Without funding from the Gannett Foundation and an Indiana Heritage Research Grant, several phases of the collection preparation may not have been possible. The opportunity to study the rich collection of Winter oils and the Biddle's Island watercolor series owned by the Cass County Historical Society in Logansport under the guidance of Constance P. Whittington, former curator, was much appreciated.

A very special thanks to all the TCHA staff for their support and patience throughout the project. Particular credit goes to Richard A. Stringfellow, curator of collections, and William Dichtl, curator of exhibits, who willingly offered thoughtful constructive criticism; and to Nancy Weirich, librarian, who kept the project files supplied with printed references to Winter and his work as they surfaced in old newspapers. Kim Ferrill, IHS photographer, and Lafayette photographers Ellen Fischer and Larry Erickson executed with great care the bulk of the photographic work for the catalog. Persons and institutions who gave permission to reproduce images of works in their collections are: Mrs. Cable G. (Evelyn) Ball, Lafayette; the Glenn A. Black Laboratory of Archaeology, Indiana University, Bloomington; the Gerald Peters Gallery, Santa Fe, New Mexico; and Conner Prairie, Fishers, Indiana.

I am indebted to Paula Corpuz, senior editor, Ruth Dorrel and Shirley McCord, editors, and Kathleen Breen and Megan McKee, editorial assistants, IHS, for their work as copy editors, proofreaders, and indexers and for seeing the volume through production. Finally, it would be difficult to express the depth of appreciation due Evelyn Ball for her unwavering faith, interest, and encouragement.

SARAH E. COOKE

Editorial Notes

As reflected in the catalog, much of the value of the Winter Collection lies in its diverse subject matter, often supported by extensive written documentation. In order to highlight this richness and to arrange thematically the 760 works of art on paper, the catalog has been organized into the following broad subject categories: Indiana Potawatomis and Miamis; landscapes; animals and sports; portraits; and historical, romantic, and whimsical studies. Within a subject area, images are generally arranged chronologically by date of observation, followed by undated sketches.

Catalog entries may include, if applicable: the catalog number, image title, attributed observation and execution dates, media statement, dimensions, inscriptions, manuscript quotations, reference to the plate number when previously reproduced in *The Journals and Indian Paintings of George Winter, 1837–1839,* and the TCHA collection number.

Titles of works are taken from inscriptions on the sketches and may include brief subject, location of view, and date, if given. Assigned titles are in brackets. Punctuation from inscriptions used as titles has been standardized. The following abbreviations denote location of inscriptions on the sheet: u.l., upper left; u.c., upper center; u.r., upper right; l.l., lower left; l.c., lower center; l.r., lower right.

When not indicated by Winter's inscriptions, presumed dates of observation were determined by the compilers from manuscript sources in the Winter Collection. Many sketches presented here were executed at a time other than that of initial observation. The watercolor paintings compiled by Winter for publication under the titles "Journal of a Visit to Lake Kee-wau-nay and Crooked Creek, 1837" and "Journal of a Visit to Deaf Man's Village, 1839" were executed circa 1863 to 1871 based on earlier sketches, as documented in manuscript references. These images are noted in the catalog as "Intended for inclusion in G.W.'s Indian journals."

Although common in the ink and watercolor sketches, the presence of graphite (pencil) undersketching is not included in the media statement. Media listed are those clearly intended by Winter as integral to the final rendering. The color of ink is black, unless otherwise noted. The term "wash" is used to indicate either diluted ink or transparent watercolors. The paper for the majority of sketches is light or medium weight drawing stock, cream or buff colored (often darkened with age), unless otherwise noted. Watermarks, when present, are briefly described.

Full sheet dimensions are given first in inches, then in centimeters (in parentheses), with height preceding width. Most works are rectangular; exceptions are noted. If an image area is clearly defined, a second set of dimensions is given for the composition.

Entries are frequently accompanied by relevant excerpts from Winter's manuscripts, which include copy letters, letters received, and extensive notes. Quotes from printed distribution notices describing finished oils are used with preliminary sketches of similar themes. When possible, quotations were drawn from his earliest writings, rather than from subsequent and sometimes revised versions. In these quotations, Winter's spelling, grammar, and punctuation were retained as close to the original as possible; occasionally editorial license was taken for the sake of comprehension and readability. Parentheses used in the quotations are Winter's; bracketed material has been supplied by the compilers. The location of sources for George Winter Collection manuscripts quoted in the catalog is indicated by GWMSS (#). The last line of each catalog entry, generally a letter followed by a number, indicates the collection catalog number of the artwork.

Catalog entries printed in black ink correspond to images reproduced in the catalog; those described in brown ink are not reproduced. To highlight details of ethnographic interest, some images shown in the catalog have been slightly cropped.

Sixty-one images in the essays and catalog are also reproduced as color plates. If an image is reproduced in color a reference is given to its plate number. The use of Cat. # throughout the work refers to catalog entry numbers.

CHRONOLOGY

10 June 1809	George Winter is born in Portsea, England
1826	Takes up residence in London
1830	Sails from England to America
1831–33	Studies at the National Academy of Design in New York
1835	Opens studio in Cincinnati, Ohio
Spring 1837	Moves to Logansport, Indiana
Summer 1837	Sketches Potawatomis attending Logansport court convened to investigate annuity payments
July 1837	Attends the Council at Keewaunay (Bruce Lake, Fulton County, Indiana)
August 1837	Sketches Potawatomis camped at Crooked Creek, Cass County, Indiana
November 1837	Attends annuity payment at Demoss' Tavern on the Michigan Road
September 1838	Observes the last Mass conducted for the departing Potawatomis by Bishop Simon Bruté
September 1838	Sketches the forced emigration of the Potawatomis as they pass through the Logansport area
September 1839	Paints the portrait of white captive Frances Slocum at her home on the Mississinewa River near Peru, Indiana
September 1839	Travels to Lake Manitou near Rochester, Indiana
ca. 1839–43	Sketches Miamis in the Peru area
5 August 1840	Marries Mary Squier of Dayton, Ohio, setting up housekeeping in Logansport
October 1840	Visits site of 1811 Battle of Tippecanoe near Lafayette
22 June 1841	George Winter, Jr., is born
July 1841	Applies for United States citizenship
6 January 1844	Daughter Annette is born
ca. 1844–45	With family, lives in New Carlisle and Dayton, Ohio, during a period of financial difficulties
1844	Travels to Cedar Lake, revisiting Lake Keewaunay
1848, 1854, 1856	Travels to Fort Wayne; Winamac; Lake Maxinkuckee; Maumee River; Berlin, Wisconsin; Burlington, Iowa
1850	Opens studio in Lafayette
25 February 1851	First art exhibition incorporating raffle of Winter's paintings is held in Lafayette
November 1851	Winter's exhibition of "elydoric" paintings and "dissolving views" opens at the Tippecanoe County Courthouse
ca. 1863–71	Compiles two sets of watercolor paintings with accompanying narratives based on earlier sketches and notes about Potawatomis and Miamis
21 September 1865	Marriage of Annette Winter to Cyrus Gordon Ball
1869; 1873	Revisits Tippecanoe Battleground and records his observations
1872	Commissioned by Horace Biddle to produce bound volume of watercolors of Biddle's Island, Logansport
1874	Travels to California to settle his brother's estate
1875	After a brief sojourn in Indiana, Winter returns with Mary to Oakland, California, for extended stay
26 February 1876	Dies of apoplexy while attending a Lafayette meeting

G. WINTER
ARTIST

CHRISTIAN F. FEEST

"Thank heaven!" exclaimed the artist's companion as the two travelers approached the small city, "the remembrances of the Maumee country are somewhat superceded by the cheerful aspect of the scene around us." The young Englishman thus addressed was similarly delighted by what he saw: "Nature truly, has scattered around this devoted spot, with a generous hand, all the elements which are the basis of that pyramid of prosperity which active enterprise will erect." The year was 1837. The place was Logansport on the Wabash ("a fine river for a new country"), whose rapidly increasing population of more than one thousand inhabitants had been attracted by the promise of economic growth following the completion of the Wabash and Erie Canal and the improvement of the Michigan Road to Indianapolis; within a few years nine bridges and one aqueduct spanned the Wabash and Eel rivers. The artist's name was George Winter.[1]

Winter, the youngest of twelve children, was born on 10 June 1809 in the seaport town of Portsea, today part of Portsmouth, on the English Channel.[2] When his father and five of his siblings decided to emigrate to the United States, George and his sister Jane remained in England with their mother. Although the father and one of the brothers came home again after a year, they finally returned to America with most of the family ten years later. George was one of three Winter broth-

ARTIST'S STUDIO SIGN

ers who stayed behind. He had decided to become an artist and wanted to pursue his studies in London.

Even in Portsea there had been enough local draughtsmen and painters willing to take the aspiring colleague under their wings and to introduce him to the basics of their profession. At leisure George could study and copy the paintings existing in the Winter home and in other private homes nearby. Charles Ambrose, a portrait painter of some renown in London, offered to teach the young man, but £700 for a three-year course was more than his father could afford. Left to his own devices, George moved to London in 1826, where he spent the next four years visiting the National Gallery, the Dulwich Gallery, and the annual shows of the Royal Academy at Somerset House, copying paintings and consorting with artists, art dealers, picture cleaners, and other figures of the metropolitan art world. He earned encouragement from these professionals for his copies of J. P. Loutherbourg's *Battle of Ascalon* (depicting the defeat of the Egyptian army by the crusaders under Godfrey of Bouillon in 1099) and was offered free advice on how to cope with the hardships of being an artist. However, he never received any formal training as a painter, although

he tried to be admitted as a student at the Royal Academy. This plan, however, never reached fruition, because when his brother John, with whom he was staying in London, decided to join the family in New York, George accompanied him across the Atlantic in June 1830.

Winter introduced himself to the New York art scene in October 1830 by exhibiting one of his copies of *Battle of Ascalon* at the American Institute of the City of New York, an organization devoted to "the interests of agriculture, commerce, manufacturing, and the arts."[3] Whatever the reaction, if any, might have been, the twenty-one-year-old artist finally decided to become a student at the National Academy of Design. This rather conservative competitor of the American Academy of Fine Arts, founded in 1825 by Samuel F. B. Morse and others, trained its students by letting them draw from plaster casts of classical sculpture. Three certificates of 1 January 1831, 1832, and 1833, signed by the academy's respective vice presidents Henry Inman, William Dunlap, and Samuel Morse, attest that he was enrolled as a student in "1st grade." In 1832, 1834, and 1835 Winter entered portrait paintings in the annual exhibition of his school.[4]

Little else is known about George Winter's activities in his New York years. By 1835 he had followed his parents, his sister Jane, and his brother Charles to Ohio and opened a studio in Cincinnati, where he engaged "in por-

traits and fancy illustrations."[5] In the spring of 1837 he closed his studio again, was living in Middletown, Ohio, and was expected to return to New York before too long.[6] While in Middletown he must have heard about the impending removal of the Potawatomi Indians from their Wabash valley reservations. Guided by "the enthusiasm of adventure and love of the romantic" he decided to visit the Logansport area "for the purpose (before I should return East) of seeing and learning something of the Indians and exercising the pencil in this direction."[7]

This was to be Winter's first face-to-face encounter with American Indians, although members of Native American groups had often come to England or to New York either on political errands or to be exhibited to those unwilling to venture out west. His notions of "the Indian" were based on novels by James Fenimore Cooper or others he may have read, and conformed to the still prevalent "Woodlands" stereotype of "shaved head and scalp lock towering from the center of the cranium," as seen in Benjamin West's paintings of the 1770s.[8] The new image of the Plains Indian, which came to dominate the public's perception of Native Americans for the rest of the nineteenth century, was only just about to emerge. The works of Karl Bodmer, George Catlin, and other artists, which were to bring about this change, were generally unavailable to the public. Catlin had exhibited some of his early work in Cincinnati two years before Winter had moved there, and his work was shown in New York[9] not long after Winter had come to Logansport and taken up lodging at Capt. Cyrus Vigus's Washington Hall hotel.

It was in the "long room" of this hotel that Judge J. W. Edmonds opened his hearings "on the claims of creditors of the Potawatamie Indians of the Wabash" on 13 July 1837.[10] Winter was "in daily attendance" to observe the Indians at close range,[11] but he was also beginning to learn about their complex relationship with their white neighbors:[12] with the federal government determined to remove them west of the Mississippi in accordance with the Indian Removal Act of 1830 and with the wishes of most of the local farmers; with Indian traders, such as Col. George W. Ewing,[13] who were interested in raking in the Indians' annuity payments and thus not in favor of their emigration; and with the Catholic missionaries, who supported the Potawatomis' resistance for reasons of their own.[14]

PAGE FROM GEORGE WINTER'S FIELD JOURNALS

The artist also set up a temporary studio in a building adjacent to the Ewing and Walker trading post, where Iowa, the Potawatomis' speaker at the Edmonds hearings, became his first sitter for a portrait commissioned by Judge Edmonds. Other prominent men also took an interest in the young Englishman and facilitated his work in many ways: Gen. John Tipton, a veteran of the War of 1812, former treaty commissioner, and now United States senator;[15] Col. Abel C. Pepper, removal agent for the Potawatomis and negotiator of the 1836 treaties with the Potawatomis of northern Indiana; Pepper's assistants Lewis H. Sands and George H. Proffit; and John B. Duret, the clerk of the Cass County court.

On 17 July 1837, Sands, Proffit, and their Potawatomi guide Notawkah took Winter to the council ground at Lake Keewaunay (now Bruce Lake), where the government officials hoped to convince the Potawatomis to emigrate to Kansas instantly. For almost two weeks the artist was able to observe and make sketches of the formal proceedings as well as the day-by-day life in the Potawatomi camp. Although some of the Potawatomis were initially reluctant to be sketched for fear that the maker of their images would gain some control over their fates, they soon gained confidence in "Pe-pone" (the Potawatomi word for "winter") and would jokingly greet him by imitating with their hands his motions in sketching them.[16]

Three weeks later the artist made an excursion to another Potawatomi camp at Crooked Creek, where he spent an evening with Joseph Barron. An old interpreter, Barron was married to the daughter of Naswawkay and became one of Winter's major informants on local history. In November Winter witnessed the final annuity payment to the Potawatomis at Demoss' Tavern. All of these occasions provided further opportunities not only to sketch, but also to record his observations in writing.[17]

The diaries which Winter kept on his field trips formed the basis for a series of articles he published in November and December of 1837 in the *Logansport Telegraph*, whose editor John B. Dillon shared Winter's interests in history and Indians.[18] Winter's journalistic efforts, which he continued over the next few years, may have helped him supplement whatever

income he derived from portrait painting. Judge Horace P. Biddle and James Lasselle were other residents of Logansport who supported the English artist whenever possible. Winter quickly became so integrated into the local community that he abandoned all plans to return to New York. His brother William, who was doing well there, paid a debt of two hundred dollars George had left behind.

In September 1838 Winter was present and deeply moved when Bishop Simon Bruté of Vincennes came to say Mass to the Potawatomis prior to their final removal from northern Indiana.[19] Winter also played an active role in investigating the "monster of Lake Manitou" (now Devil's Lake near Rochester). The Potawatomi belief in powerful underwater beings inhabiting lakes had been transformed into a local legend revolving around a sixty-foot-long snake with a three-foot-wide head. After the Potawatomi removal, the citizens of Logansport discussed the means of getting rid of the monster as well.[20]

After the Potawatomis had left and Winter had decided to stay in Logansport; he tried to eke out a living by painting portraits of local people, dead or alive, including that of the late General Tipton, who had passed away on 5 April 1839.[21] Winter's obvious zeal to raise the level of cultural sophistication in the community led him to volunteer as a set painter for the Logansport Thespian Society, a relationship that was severed after the followers of the "histrionic arts" failed to reimburse him for his expenses, but before they were obliged to sell their theatrical property under a court order to pay their rent.[22]

As George Winter turned thirty, two women came to shape his personal life and to contribute to his fame, respectively: his future wife and the "Lost Sister of Wyoming."

In the autumn of 1778 a Delaware war party attacked the home of Jonathan Slocum in the valley of Wyoming near Wilkes-Barre Fort in Pennsylvania and took Slocum's five-year-old daughter Frances captive.[23] Over the following years and decades, the Slocum family tried in vain to trace the lost child and redeem her. Fifty-seven years later, Col. George Ewing, the Indian trader, spent a night in the Miami village known as "Deaf Man's Village" on the Mississinewa River southeast of Peru, Indiana, and accidentally discovered that Maconaqua, the "venerable and respectable looking Indian woman" who had hospitably granted him shelter, was in fact a white

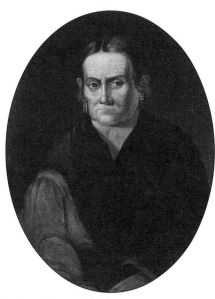

FRANCES SLOCUM *(see Plate 1)*

woman by birth. Fears that she might be taken forcibly from her Miami family had made her keep this secret for so long; now that she was an old woman, she was ready to unburden her soul.

By a series of unusual coincidences, the information that Ewing had obtained on this occasion reached the Slocum family in the summer of 1837, and two of Frances's brothers and one sister traveled to the Mississinewa River to find out whether this Miami woman could really be their long-lost sister. Having identified her beyond a reasonable doubt, they were ready to

take her home, but had to recognize that Frances had become a Miami and wanted to live and die among her people rather than among strangers, however closely related by blood. After a second visit to the Deaf Man's Village in September 1839, Joseph Slocum wanted at least to take his sister's likeness back to Pennsylvania, and he commissioned George Winter, whose name had been mentioned to him in Peru, to paint her portrait.

For Winter this was more than just another assignment. It was an unexpected return to the particular interest that had brought him to Indiana. His drawings of the Miamis of the Mississinewa quickly filled another portfolio. Regardless of the noticeable reluctance shown by Frances Slocum and most of her family to let the artist proceed with his work, Winter felt that he was "on classic ground," and that drawing the features of the woman "whose history was fraught with such intense interest" and "full of painful yet romantic incidents" would result in "the most valued of my aboriginal sketches of the aboriginal people of the Wabash Valley."[24] He was not mistaken. None of his works was reproduced more often during his lifetime or after his death. And even at times when few people remembered George Winter, his name was kept alive in connection with the "Lost Sister of Wyoming."

From the viewpoint of personal happiness, of course, the encounter with his future wife was even more important. Mary Squier was the daughter of the proprietor of various stagecoach lines from Dayton, Ohio, to the north and west. It is likely that the two had first met when George was living in Ohio, but by July 1839 she is referred to as his "bride."[25] Obviously, Timothy Squier had second thoughts about giving his daughter in marriage to an artist, who had not shown that he would be able to feed a family, and who

was an Englishman, to boot. Armed with letters of recommendation written by his friends in Logansport on his behalf, and addressed to Gov. David Wallace and other impressive names, Winter finally must have convinced his prospective father-in-law of his merits. In August 1840 the couple was married in Miamisburg, Ohio, and set up a household in Logansport. Almost a year later Winter renounced his allegiance to Queen Victoria and became an American citizen.[26]

Timothy Squier may not have been altogether mistaken. George and Mary struggled bravely to make a living, but dinner was "often confined to a cold collation."[27] The birth of their son, George, Jr., in June 1841 added another mouth to be fed by the efforts of his father's pencil. At the time their daughter Annette was born in January 1844, the situation had become desperate and the family had moved in with Timothy Squier, who had retired to his farm near New Carlisle, Ohio. In Winter's absence, his possessions in Logansport—buggy, paintings, and all—were seized to cover some of his debts. It took Winter several years to overcome the worst of his dire straits, but he was finally able to return to Logansport in 1845.[28]

Winter tried very hard to succeed. Quite characteristic of his ingenuity in attracting people's attention to his art was his attempt to reap some benefit from the 1840 presidential campaign of William Henry Harrison, in which the candidate's renown as the hero of the Battle of Tippecanoe of 1811 figured prominently. In October the artist spent a week on and around the site (which had been donated to the state of Indiana by General Tipton), looking for the best viewpoints, picking up relics and information, and making sketches under changing but equally difficult weather conditions.[29]

Six huge canvases based on those sketches were finished by the end of the year, and Winter would have loved to show them in Cincinnati before, in Washington at, and in New York or elsewhere after Harrison's inauguration. However, money needed to get this project off the ground was never raised, and before the pictures could be put to good use, the president had died within a month of taking office.

Apart from selling an occasional portrait and giving art instruction to would-be artists of either sex in Logansport, success in Cincinnati—

then probably the largest art market west of the Appalachians—seemed crucial for Winter's survival as an artist. In 1841 he exhibited two pieces at the Cincinnati Academy, including a Battle Scene (yet another copy of the *Battle of Ascalon*).[30] Later he was represented in less prestigious exhibitions (such as at the Firemen's Fair of 1845) and gained some exposure, but made few sales. In Louisville, Kentucky, he sold pictures through dealers.[31]

Winter's situation was, of course, far from unique. The lack of discerning buyers made it next to impossible for many artists, especially in rural areas, to live by their art. He may have recalled the words of William Dunlap, who in 1831 had told the students at the National Academy of Design in New York: "The artist is uniformly in higher estimation where society is of the highest grade." And: "In that country where artists must be patronized, the arts are unknown, mind is uncultivated, and (unless the benevolent desire of ameliorating society should detain them) from that country artists ought to fly."[32]

Art unions were organized, first in New York and later elsewhere, to support the artists and to improve the tastes of the general public. Every year certificates were sold that entitled their owners to receive an engraving of some distinguished work of art. Part of the revenues were used, on the other hand, to buy paintings, which then would be raffled among the membership. Thus, for a fee of five dollars members stood a chance of winning a valuable picture.[33]

When the Western Art Union was organized in Cincinnati in 1847, Winter joined it and was made one of its honorary secretaries. One of his paintings was purchased and distributed in 1848, and three paintings were offered for sale in 1849. A second distribution was to take place in 1853, but by that

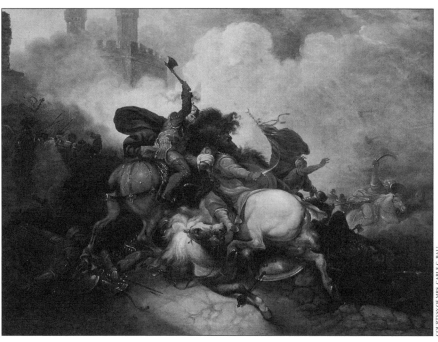

BATTLE SCENE *(see Plate 2)*

time the Western Art Union was clearly not doing well, and Winter could do without it. He was not successful in his attempt to sell a picture to the American Art Union in New York in 1848. His association with the Indianapolis chapter of the American Art Union, founded in 1850, was brief and did not result in sales; there is no evidence that he joined the Indianapolis Art Society (established in 1856), which was organized on similar principles.[34]

Not everyone seemed to like the idea of combining the elevated idea of art and the dubious practice of gambling. "Rome did not rattle the dice, and throw for the works of her Angelo . . . nor America for those of West or Allston," complained the *Photographic Art Journal* in 1851. In the following year, a court found this peculiar mode of disposing of pictures contrary to New York state laws and put an end to the practice.[35]

Indications for the growing appreciation of Winter's work came in 1849, when one of his Tippecanoe Battleground paintings was bought by the state of Indiana at the suggestion of his friend John Dillon, now of the Indiana State Library. A few months later the editor of the Cincinnati *Ladies Repository*, the Reverend B. F. Tefft, met Winter (hyperbolically referred to as "the celebrated 'Indian Painter'") and "emptied [his] pockets" to purchase four of his paintings (only one of which included some Indians). The paintings were engraved and published as frontispieces in the *Repository* in 1850 and 1851.[36] Early in 1853 Winter offered another set to Tefft's successor, the Reverend D. W. Clarke, including Frances Slocum's portrait and various Battleground scenes. Unfortunately, Clarke was out of town when Winter visited Cincinnati in May, but Clarke's assistant bought two pictures, one of which (the idyllic *Fording the Wabash*, rather than any subject of historical signifi-

cance) was published in November 1853.[37]

In the meantime, the artist had moved from Logansport to Lafayette, a relocation that had been discouraged in 1846 by a correspondent because the prospects for patronage did not seem favorable there.[38] However, the prospects must have been better than in Logansport, and in 1850 Winter opened a studio in Lafayette. His family remained in Logansport (where his second daughter died in 1850 at the age of seventeen months) until he had rented a house on Main Street in 1852—another indication of a gradual improvement of his fortunes. As in Logansport, Winter's amiable personality quickly won him many new friends.

Never short of ideas, Winter next tried his hand at a combination of art and show business. Even if people were unwilling to buy paintings, they might be induced to look at them, especially if they were spectacular enough. Serious painters, like Thomas Cole, had made small fortunes by exhibiting large-scale paintings; on a less sophisticated level, huge panoramas were unrolled by itinerant artists in front of an expectant audience, often to the accompaniment of recitals of text or music. Winter's nephew Robert had come to Indiana in 1850 with his "chemical dioramas," a series of magic lantern images of ancient and faraway places, and Winter clearly thought that the new medium might prove beneficial to his art as well.

The result was a mixed-media event called "Elydoric Paintings and Dissolving Views," which opened in Lafayette in November 1851. The four "elydoric" paintings were sizable canvases (14-by-10 feet) with classical and modern European views, executed "with oil and water so as to add the freshness of watercolor to the mellowness of oil painting."[39] Far more atten-

tion was paid, however, to the "dissolving views," in which a "gas apparatus with kaleidoscopic additions" projected images from slides onto a screen behind an opening in the crimson facing of the exhibition hall. To the sound of music, the raptured viewers could see little Cupids emerging from rosebuds, a Venus rising from the sea, or a winter storm blanketing a landscape with large snowflakes.[40]

The show traveled to Indianapolis, Crawfordsville, Madison, and perhaps other Indiana communities, but in October 1852 Winter complained about problems with a Dr. Curtis, who made money with the "panorama" and was making life difficult for the artist.[41] Sobered by his experiences as a showman, Winter returned to painting and to selling his art.

Since the art lotteries of the Western Art Union had been too few in number, the enterprising artist decided to take matters into his own hands.[42] In April 1852 he held his first art distribution in Lafayette, in which ten oil paintings of a total value of $318 were offered as an inducement to buy tickets at $2 each.[43] Winter used his extensive network of family and friends to sell tickets not only throughout Indiana, but also in Ohio, New York, and elsewhere. Despite his good marketing, sales usually fell far short of the values to be distributed; but because many tickets remained unsold, part of the offering reverted to the artist and could be used as prizes in subsequent distributions.

Between 1853 and 1858 Winter also held distributions in Evansville and La Porte, Indiana; Toledo, Ohio; and Burlington, Iowa, but the major event continued to be "Geo. Winter's Annual Distribution of Paintings" in Lafayette. The Lafayette distribution was as much a social occasion as it was a marketing device. Held in some appropriately dignified location, such as the

Melodeon Hall, Snyder's Opera House, or the Corinthian Hall, old friends like Horace Biddle would deliver lectures on topics ranging from "A Discourse on Art" to "Literature of Russia" in order to heighten the anticipation for the final drawing. After some initial experiments with higher prices, tickets remained at two dollars until the last distribution in 1873. Winter would often claim that these drawings were mostly continued at the request of his friends, and that—given the costs for framing and advertising—he was actually losing money. This is hardly believable since the number of paintings disposed of in this manner must have far exceeded the number sold under different circumstances.[44]

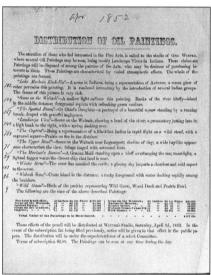

DISTRIBUTION NOTICE FOR APRIL 1852

The approximately five hundred pictures thus distributed in the course of twenty-two years represent a fair cross section of Winter's work during this period.[45] While his own Wabash River valley views and other landscapes make up the largest single group, many of the entries were copies (rarely identified as such) made after prints. His favorite *Battle of Ascalon* appeared next to Sir Joshua Reynolds's *Holy Family* or Thomas Gainsborough's *Market Cart*. There were genre scenes such as *The Lover Too Early*, "representing a mistake of an elderly lover, who causes dismay

and confusion by being 'ahead of time.'"[46] Portraits of people he never met (from Columbus to Patrick Henry) were featured as prominently as places he never visited (from Italy to the Garden of the Gods in Colorado).

Large paintings (like a 40-by-50-inch *Genial Summer*) were the exception. At the other extreme, there were Winter's "Gems," "Little Gems," or "Gems d'Enfants," pictures in the 6-by-8 to 10-by-12-inch range, "thrown off by the pencil under the influence of feeling, giving, necessarily, the spirit awakened on the incipiency of the subjects."[47] As a personalized service, Winter also offered oil portraits "of the persons who may draw them. A landscape will be executed in exchange if desired of equal value." The less fortunate winners would receive their photograph in oil, "executed immediately after the distribution."[48]

Despite the obvious emphasis on reworking older material (including some of his Indian paintings), Winter continued to sketch in the field and produce new work. In 1856 he visited Wisconsin and opened a studio in Burlington, Iowa. Some of the resultant drawings were almost immediately developed into paintings.[49] He returned to the Tippecanoe Battleground in 1869 and 1873 and found the landscape now "domestically tame."[50]

Approaching his fiftieth birthday, however, it is understandable that the artist would have begun to look back and try to make use of his earlier work, whose historical value was becoming more apparent every day. Others shared this feeling. Lyman C. Draper, secretary of the Wisconsin State Historical Society, must have been alerted to Winter's work on the Tippecanoe Battleground and made the artist an honorary member of the society in 1857. Although Winter's Indian paintings may have interested Draper, another

English painter, Samuel Marsden Brookes, was commissioned in the next year to paint portraits of several Menominee leaders.[51]

Benson J. Lossing, a New York artist and historian, had seen Winter's *Frances Slocum* in her brother's house and in 1850 had included his copy of it in his *Pictorial Field-Book of the Revolution*. Lossing visited Winter in Lafayette in 1860 and later received Winter's portrait of Joseph Barron. At the artist's request, Lossing even promised to find a publisher for Winter, but nothing came of it. In 1871, after Winter had published a brief story on Slocum in the *Philadelphia Press*, Lossing wrote again to request further pictures for an article of his on the "Lost Sister of Wyoming."[52]

Sometime in the early 1860s James Walker, an Englishman living in Rhode Island, commissioned George Winter to produce a volume on the Potawatomi chiefs mentioned in the treaties. Although Walker unexpectedly died in 1862, Winter systematically began to collect additional historical information to incorporate into his planned volume.[53] In 1864 he started to fill a notebook with excerpts from his correspondence, his interviews, and his readings on Indians, including Samuel Drake's popular *Book of the Indians*,[54] Edwin James's *Account* of Stephen Long's 1819–20 expedition to the Rocky Mountains, the writings of Indian agent and writer Henry Rowe Schoolcraft, and the Wisconsin Historical Collections.[55] By 1871 his revised and illustrated journals of the Keewaunay Council (a present for John Dillon) and of his trip to Deaf Man's Village were complete. In 1872 he finished his *Views of Biddle's Island* album commissioned by Horace Biddle.[56]

In 1871 William Blackmore, an English entrepreneur and collector of American Indian material who had

already acquired material from George Catlin, and who seemed eager to look at Winter's sketches, contacted Winter. The artist, who felt that his work in the area had been so far "unrequited," was hoping that Blackmore could find a publisher for him in England. Blackmore was unable to visit Logansport, and there the matter ended.[57]

When his brother Charles died in San Francisco in 1874, Winter went to California to settle the estate and to meet his own son, who had moved to the West in 1859. Winter's share in the inheritance turned out to be larger than he expected and included his brother's house. Winter must have realized that he had missed something in not seeing other parts of the world. California seemed like a different country, and he liked the "freedom from restrictions and independence of mind" that he saw there. People appeared to be much more supportive of the arts. Although he was unable to sell any of the pictures that he had brought along, he felt that he could easily compete with the local painters. He returned to Lafayette for Mary, and they traveled to East Oakland for a stay that lasted for more than a year.[58]

Exposure to the new scenery resulted in a series of sketches of California landscapes. Winter also joined the San Francisco Art Association and exhibited ten pictures, both Indiana and California scenes, in its 1875 show. But, in the end, he found that the art market was smaller than previously expected.[59]

On 26 January 1876 George and Mary Winter returned to Lafayette after a trip delayed by snow in the Sierras, in which an engineer and a fireman had been killed. On 1 February George Winter was attending a railroad stockholders' meeting at the Opera House, when he suddenly died of apoplexy at the age of sixty-six.[60]

"Mr. Winter was an English gentle-man of a higher type than those who merely repose on the virtues of their ancestors," Horace Biddle later remembered him. "As a man, he possessed a nice sense of honor and integrity, and made these principles practical throughout his life. Socially he stood very high with all who knew him. He was a gentleman under all circumstances, with a ready and agreeable wit, a genial and engaging humor, and an equable and chastened temper."[61]

RECOGNITION AND ASSESSMENT

While Winter's death was lamented by his family and friends, his work had not received the recognition he clearly had hoped for. Although hundreds of his pictures were hanging in private homes in Indiana and elsewhere, few were signed.[62] The art world at large had not taken note of him. If he was remembered at all, it was for his portraits of Frances Slocum. John F. Meginness' biography of the Lost Sister, published fifteen years after Winter's death, contained an appendix on "George Winter, the Artist," a specimen of his writing, and reproductions of three of his portrait paintings owned by the Slocum family.[63]

When George Cottman gained access to Winter's papers and drawings in his daughter's possession, it was a true rediscovery. They were hailed as unequalled descriptions of the Wabash valley Indians and as "historical relics the state should own." Cottman's interest led to the discovery of one of Winter's smaller Battleground pictures and his portrait of William Digby, the founder of Lafayette, which was rescued from a secondhand store in Lafayette. Both paintings may have been the first to enter public collections after the artist's death.[64]

Apart from another brief note by Cottman, the first treatment of Winter as an artist came in 1921 with Mary Burnet's pioneering work on Indiana art, already based on a somewhat better knowledge of his painted oeuvre, yet still mostly concerned with biographical facts. The emphasis on the pictures' accuracy and historicity ("like Remington, his art is authoritative") can even be detected in evaluations of his style: "His manner of painting was smooth and delicate, yet vividly colored if in water-color and full of the finest detail."[65]

A 1939 show at the John Herron Art Museum in Indianapolis was the "first comprehensive presentation of [Winter's] work which has been attempted." In the accompanying catalog and in later publications the show's organizer, Wilbur Peat, was the first to assess critically George Winter as an artist. According to Peat, Winter had been "modestly equipped as a painter, according to the technical standards of the day," but then most of the early painters of Indiana "had less natural aptitude and technical skill than Winter; on the other hand, some were his equal and others his superior in workmanship if not in accomplishment. Yet, when compared to them, he seems to loom up in greater stature." And, "all things considered, he may well be regarded as the most significant of Indiana's pioneer painters."[66]

As far as Winter's place in Indiana art is concerned, there has been little disagreement with Peat's verdict. In her 1977 survey, Marilyn Holscher calls him "the principal landscape painter of the period." Paul Richard introduces him in the catalog to the second major Winter exhibition in 1980 as "Indiana's most important early painter," and William Gerdts agrees that he was "probably the most noted Indiana artist in the first half of the nineteenth century."[67]

Outside Indiana, however, George Winter has not fared as well. Most accounts of nineteenth-century Ameri-

can art take no notice of him at all, or, if they do, it is with serious reservations. Oliver Larkin, for example, refers to the "rather dry fruits of George Winter's years among the redmen of the Wabash." And E. P. Richardson, after briefly describing Winter's work, qualifies Seth Eastman as "a somewhat better painter than either Catlin or Winter."[68]

Three different perspectives, then, need to be applied in any assessment of George Winter as an artist. Although it is unlikely that Winter exerted much influence on other painters in Indiana, either as a teacher[69] or by his example, his importance as one of the first professional artists to live and work in Indiana is unquestioned. But whereas he was only a minor figure on the national level, his work, nevertheless, must be seen in the wider context of nineteenth-century American art. And finally, we must look at his achievements as a documentarist, particularly of the Native Americans of his state—a question that cannot be totally separated from his merits as a painter.

PORTRAITS

If there was anything that the residents of Indiana expected from a painter at the time George Winter came to Logansport, it was to paint portraits. Some people wanted to be remembered by posterity, others desired a visual memento of their loved ones. Portraiture was one step beyond sign painting—equally useful, if slightly more demanding. Winter's training and past work in New York certainly qualified him for such a task, although it is hard to disagree with Wilbur Peat's listing of Winter's shortcomings in this respect: "Timidity in the handling of paint, sparing use of color, and minor anatomical inaccuracies."[70] With little or no competition in Logansport, however, he soon gained as many commissions for por-

traits from his new friends and acquaintances as could reasonably be expected.

Some of his early portraits were apparently done from sketches, which he would finish in the absence of his sitters. This is certainly true of his portrait of Lewis Sands, the deathbed image of General Tipton, and the portrait of D. W. Dunn, who wrote to Winter in 1840 that the artist might have to complete the painting from memory.[71] Most of the commissions were executed in oil on canvas, but Horace Biddle also specifically requested a miniature in 1843, perhaps realizing that Winter was somewhat better in his drawings and in smaller formats.[72] In 1839 Winter charged Sands forty dollars for a full portrait ("much under my regular price") or twenty-five dollars for a head portrait.

With the spread of daguerreotypes

in the United States in the 1840s, and especially with the arrival of wet-plate negative technology in the mid-1850s, portrait painters had to face increasing competition from the new medium. In 1850 Winter had his own daguerrean likeness taken in Logansport by Mr. Hawkins, an itinerant photographer from Cincinnati, and like many other painters of his day, he tried to take a positive approach to photography.[73] Photographs could, for example, be used instead of sketches in the preparation of oil portraits, as Jacob Hegler had done around 1850 in Lafayette, and probably also the famous Thomas Worthington Whittredge, who had come to Indianapolis in 1842 as a daguerreotypist before turning to painting.[74] There are indications that Winter also followed this practice, and he later even accepted "mail orders" for portraits on the basis of pho-

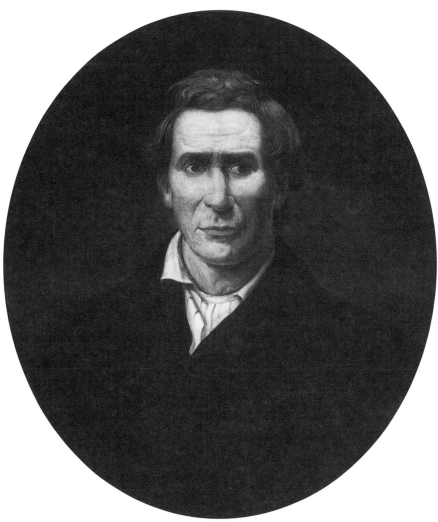

WILLIAM DIGBY *(see Plate 3)*

tographs submitted with detailed instructions as to the color of the subjects' hair, eyes, and dress.[75] Another common practice for painters was to color photographs. Between 1856 and 1860 Winter offered "Photographs in Oil" in his distributions, which were oil-tinted photographic prints.[76]

In 1948 Wilbur Peat counted and identified about fifty portraits by Winter, as compared to about one hundred landscapes.[77] Given the higher percentage of portraits likely to be preserved, these figures offer an indication for the relatively minor importance of this sector of his art, which is also supported by information to be drawn from his distribution lists.[78] Of the surviving examples, the likeness of William Digby, a subject of local history rather than a commissioned portrait, stands out as Winter's most ambitious portrait.[79] But very few attempt to go beyond an almost mechanical transfer of the sitters' features onto the canvas, where they are generally placed against a stark background.[80] "There is something stolid and honest about these compositions," observed Peat, "which we like to associate with the people who are portrayed."[81]

LANDSCAPES

Whatever training as an artist Winter had received, it certainly had not included landscape painting. In fact, there is no evidence that he had taken a serious interest in this field before his arrival in Logansport, when in addition to his Indian drawings he began to fill his portfolio with sketches of picturesque Wabash River scenes.[82] Some of these were used later as backdrops for his Indian paintings, and perhaps that is what they were intended for in the first place.

Oddly, the same is true of his 1840 Tippecanoe Battleground series, which superficially might appear to be his earliest attempt to focus on pure repre-

sentation of nature. Closer inspection reveals, however, that in these paintings Winter was not primarily interested in geological formations, vegetation, or the meteorological phenomena of the sky, but in the historic event, however invisible to the viewer. His painstaking investigations on the site clearly document his concern for the actors in the military drama, their positions, movements, and ultimate fates. His canvases were designed to provide a stage set for the theater of a war that had been revived in the public awareness, and which could be filled with heroic action supplied by the imagination of the audience: "It is to the informed mind that the painter has to address the efforts of the pencil."[83]

The Tippecanoe Battleground series was history painting without visible protagonists. The views conveyed "an idea of the ground and surrounding romantic scenery." They showed "the point near Barnet's Creek where the subtle savage tomahawked the sentinel, . . . the whole surface upon which the gallant army encamped," and the point of land where "the wily Prophet sat during the conflict of battle chanting and propitiating the power of the Great Spirit."[84]

In her analysis of nineteenth-century American landscape painting, Barbara Novak[85] has interpreted "the connection between history painting, landscape art, and the popular panorama" as the transfer of monumental nobility to the representation of landscapes serving as a substitute for a missing national tradition, which fed on the same public taste for the spectacular that made moving panoramas an American craze of the mid-nineteenth century. Winter's Tippecanoe set of six pictures—"two of them measure 152 square feet each, and the other four comprehend an equal surface"[86] —is an early, and somewhat deviant example of this trend. It is pos-

sible that Winter had seen some of the pathbreaking work of Thomas Cole, but even if so, he did not share his compatriot's tremendous success.

Obviously intended as public art, it was the fate of the Battleground pictures never to reach a wider audience. Although seized by his creditors in 1844, at least one of them must have remained in or returned to his possession and was purchased in 1849 for one hundred dollars for the Indiana State Library. In 1852, during Winter's badly attended "Elydoric Paintings and Dissolving Views" exhibition in Indianapolis, it was "displayed under better circumstances than it is usually found in at the State Library."[87] It was later "stowed obscurely away in a little room off the Supreme Court chamber, in the old State House, . . . unframed, with canvas broken and lopped over,"[88] before being discarded.

Later versions were more modest in size: *Bluffs of Prophet's Town* (1853) measured 32-by-20 inches, *Prophet's Town* (1852) 32-by-49, and *Tippecanoe Battle Ground* (1852) 10-by-32, while other versions of a *Tippecanoe Battle Ground Scene* (noted in 1856 and 1873),[89] *Scene on Burnetts Creek* (1870), and *The Old Oaks of Tippecanoe* (1873) were sized 25-by-30 inches.[90] Public art had turned private, the operatic grandeur had given way to modest reminiscence.

The numerous sketches of the Wabash River valley and other landscapes made in the course of more than thirty years exhibit a fairly simple compositional pattern that did not change much over time. Trees provide the structure of the pictorial space, usually by framing it on both sides, sometimes also by dividing it into two unequal parts. The shapes of their trunks and limbs, often gnarled, and the contrast between their dark forms ("foreground broken and varied") and the light ("warm glow") on the body of

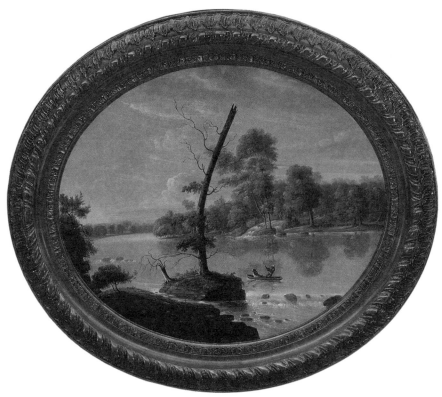

SCENE ON EEL RIVER *(see Plate 4)*

water or opening in the background ("gentle receding distance") define their quiet and picturesque ("placid and pleasing") quality.[91] Variations of the theme were supplied by the different lights of the seasons and times of the day in paintings like *Parting of Summer, Moonlight,* or—most appropriately—*Winter Scene* ("A good subject to gaze at during the hot days of summer").[92]

Winter's growing preference for views of nature is indicated by the fact that they make up about half of the paintings found on his distribution lists. Regardless of whether one agrees with Peat that Winter's "direct, unsophisticated reporting of the local scene" is so accurate, "that the exact locations could be found again without difficulty,"[93] the artist's landscapes were guided at least as much by idealist conceptions as by his concern for facts. On the regional level of Indiana art, they represent a local variant of the compromise between realism and idealism that was characteristic of the Hudson River valley painters. What critic James Jackson Jarves wrote in

1864 of Albert Bierstadt and Frederick Edwin Church also applies to Winter: "Each composes his pictures from actual sketches, with the desire to render the general truths and spirit of the localities of their landscapes, though often departing from the literal features of the view. . . . Though the details of the scenery are substantially correct, the scene as a whole is often false."[94]

INDIAN SKETCHES AND PAINTINGS

Winter's earliest effort to synthesize the productions of his pencil into a major painting was *Kee-waw-nay Village July 21st 1837,* which he hoped the "Indian Department"[95] might be interested in. On 10 April 1838 Winter sent a "hasty sketch" of the planned painting to Colonel Pepper. "I am now," he wrote, "in possession of all studies necessary, after much labour, to enable me to paint a large picture of the council scene."[96] Despite his apparent eagerness to go to work at once, a "vicious disease" prevented him from proceeding as planned. On 17 December he informed Pepper that until that day

"the painting of the Indian Council had remained unfinished through the continuance of my indisposition." The artist must then have worked almost continually for the next three weeks on the picture that "has proven a work of longer duration than I had anticipated." But on 7 January 1839 Winter reported to Pepper that he was about to ship the painting, whose composition he described in some detail.[97]

The pencil-and-ink drawing (Cat. # 37), dated 21 July 1837, must have resembled the "hasty sketch" sent to Pepper in April 1838. It shows in the left of the picture Naswawkay addressing the government officials seated at a table to the right and is clearly a composite image of several individual drawings, the "studies necessary" mentioned by the artist. The background resembles (but is not identical to) the drawing of "Kee-wau-nee village July 26th 1837" (Cat. # 30). In the group of Potawatomis to the left of Naswawkay, we recognize Wewissa (Cat. # 120, 121, 122), Iowa (Cat. # 26, with his arms folded over his chest), and Pashpoho (Cat. # 44, 45, with turban added). According to Winter, the person on the far right is M'joquis, whose individual portrait has not survived. Standing behind this group are Ogamaus ("O-kah-maus") (Cat. # 62) and Chemokomon (Cat. # 94), and seated in front of the group is Neebosh ("Nee-boash") (Cat. # 52), wearing a turban instead of a top hat).

No sketch of Naswawkay survives among Winter's drawings, although one or more must have existed since the artist sent a copy of the speaker's portrait to Pepper in April 1838.[98] However, another portrait must have formed the basis for his appearance in the composite painting *Three Pottawatamies.* Between the orator and the officials we find Mesquabuck (Cat. # 43), Keewaunay ("Ke-waw-nay") (Cat. # 91), and an unnamed individual pictured elsewhere together with

Chaukkoina (Cat. # 53). Kawkawkay is unrecognizable in the council scene drawing on the basis of his individual portrait. Weesaw (for whom no such portrait exists) and Ashkum, both of whom are mentioned by Winter in connection with the council, are also unrecognizable.

Winter identifies the two persons standing behind the officials as the interpreters Joseph Barron and Joseph Napoleon Bourassa, but while Barron is recognizable (though different from the surviving sketches), the other person resembles Naoquet or Luther Rice ("Noah-quet") (Cat. # 23) rather than Bourassa (Cat. # 41). Of the officials, Winter identifies the person on the far right as Col. J. B. Duret,[99] and Colonel Pepper to his left. Lewis Sands and George H. Proffit must be the individuals seated to the left of Pepper.[100]

The sketches on which the finished drawing of the council scene was based both predate and postdate the event: Iowa sat for Winter at his Logansport studio earlier in 1837; Pashpoho was drawn on 22 July and Keewaunay at Crooked Creek on 22 August. Clearly then, the date on the drawing refers to the council rather than to the execution of the sketch. The fact that all of the prominent Potawatomis seem to be depicted on the basis of individual portraits allows the assumption that similar sketches did exist for Naswawkay and others. It is noteworthy that Winter included individual portraits in his composition, which he did not detail in his descriptive account for Pepper. His statement that "many others I have attempted to paint from memory"[101] appears somewhat misleading in the light of the evidence supplied by his drawings.

A look at the painting reveals the changes made by Winter in the process of painting. As Winter noted in his own description, "principal light" has been thrown upon Naswawkay and the

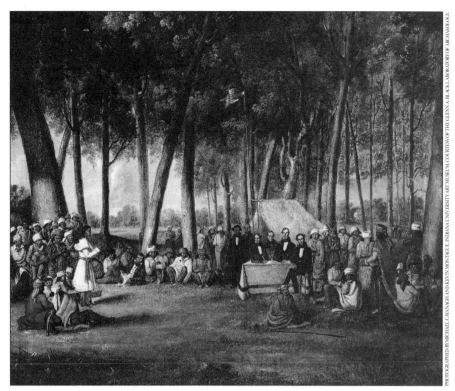

COUNCIL OF KEEWAUNAY *(see Plate 5)*

PHOTOGRAPHED BY MICHAEL CAVANAGH AND KEVIN MONTAGUE, INDIANA UNIVERSITY ART MUSEUM. COURTESY OF THE GLENN A. BLACK LABORATORY OF ARCHAEOLOGY.

group of Potawatomis behind him, whereas the officials are placed in "half-light." This was partly achieved by opening up the left background in order to bring in light between the trees. A few other details were also changed: Barron (now closer to drawing Cat. # 39) and Rice ("Bourassa") have switched places; the chair in front of them has been removed; the Indian sitting rather than kneeling in front of the officials is now more reminiscent of Kawkawkay (Cat. # 97, 98, 99), but he has put down his cane in front of himself; Wewissa, Pashpoho, and M'joquis are dressed more fancifully with sashes or blankets; Naswawkay's coat has a patterned lower border; and the tablecloth has a dark stripe near its edge.

The artist's ambition clearly reflected in *Kee-waw-nay Village* was to produce a true history painting, transcending the narrative level into the field of political allegory.[102] Having studied in his youth the grand-style history paintings in the galleries of London, Winter now had ventured as far into the wilderness as necessary to witness the struggle between Indian and white America. However insignificant

the specific meeting between Colonel Pepper and the Potawatomis might have been in a global perspective, the message it embodied for Winter went far beyond the occasion. The orator's futile plea cannot move the government's messengers of doom, tightly crowded around their paperwork, whose looks are directed at the outside public rather than at the speaker. The Potawatomis' mixed show of defiance, "indolence," and apparent lack of interest indicates at least their ultimate lack of determination. Perhaps they know that their destiny is sealed.

Winter was, of course, not the only artist to perceive the symbolic nature of the image provided by "the council," where, indeed, the future of a whole continent was to be decided. It was here, rather than on the warpath, that the Indian's stereotypically perceived nobility, his primeval wisdom, and his remarkable oratorical skills were manifest, although tragically in vain. There is no evidence that Winter had ever seen Benjamin West's *William Penn's Treaty with the Indians*, painted in 1771, whose "panoramic" composition is certainly not unlike that of *Kee-waw-nay*

Village, and which contrasts with West's earlier "dramatic" rendering of *The Indians Giving a Talk to Colonel Bouquet.*[103] Yet it is obvious that—despite Winter's technical shortcomings—the influence of West and other major artists' history painting on Winter elevated his first major work above other nineteenth-century council scenes such as Samuel Seymour's *Pawnee Indian Council* and *Oto Council of 1819,*[104] James Otto Lewis's *View of the Great Treaty Held at Prairie du Chien September 1825,*[105] or Gustavus Sohon's *Council of the Flathead Indians Signing First Treaty with the United States.*[106] Rudolph Friedrich Kurz's *Cree Indian Council with Trader Denig of 1852*[107] or John Mix Stanley's intertribal *Indian Council of 1843,*[108] while artistically superior, address somewhat different themes.

Kee-waw-nay Village, of small size (20-by-25 inches) and priced at one hundred dollars, arrived in Washington by 23 January 1839 and was submitted by Pepper to an inspection by the Indian Department. Winter hoped that this submission would earn a commission for a larger version. In February Sands promised to use his influence at the department in favor of Winter. By August Col. James Henry Hook, the commissary of subsistence in Washington and Sands's uncle, had looked at it and reported that it had created a favorable impression among the bureaucrats.[109]

In 1858 and again in 1872 Winter recounted the history of the painting in letters to Judge W. Pettit, Lyman C. Draper, and William Blackmore, regretting the fact that Congress had not appropriated the money for his painting—or for an "Indian museum" —despite support from Commissioner of Indian Affairs Hartley T. Crawford, General Tipton, and Colonel Hook.[110] After all efforts on the artist's behalf failed, Pepper, who upon receipt of

Kee-waw-nay Village in January 1839 had sent Winter $30—less than a third of the picture's price—kept the painting for himself.

Given the obvious importance Winter attached to his *Kee-waw-nay Village,* it is a little surprising that he never attempted to produce the larger version, which would have been more appropriate to the dimension of the historic struggle implied in the subject matter. Winter likewise never produced painted versions of either the *Emigration Scene* (Cat. # 114) or *Bishop Brute Preaching to a Concourse of Connected Pottawattamie Indians* (Cat. # 112), which he regarded as "the most to be valued" of his historical images. These three paintings may have been conceived by the artist as a set. Following the encounter with the unrelenting government, the bishop's "last sermon to the Pottawattamie nation" focuses their hopes on spiritual redemption, before the assembled crowd uncoils into an endless line fading into the horizon of oblivion.[111]

Perhaps Winter's frustration over the lack of interest shown by the people in Washington, combined with the amount of work he had to invest even in the small version of the council scene, kept him from finishing his grand design. A look at his oeuvre shows that as time progressed, the artist more and more concentrated on less complex compositions, which could be priced to make a sale.

By early January 1839, shortly after finishing *Kee-waw-nay Village,* Winter had begun to paint a larger picture, measuring 40-by-50 inches, of *Indians Playing Moccasin.*[112] Winter must have later made several copies of this painting, which is mentioned in his papers on several occasions.[113] By 1865 one copy of *The Game of Moccasin* was owned by J. D. Defrees, then superintendent of printing in Washington.[114] Several copies were placed on Winter's

distribution lists: *Playing Moccasin* (40-by-34 inches) was estimated at $150 when raffled at Lafayette in March 1854;[115] *Moccasin* (14 1/2-by-18 inches) was listed at only $20 six years later. No dimensions or value are given for perhaps yet another version of *Pottawa[ta]mie Indians Playing Moccasin* that Winter entered into the seventh exhibition of the San Francisco Art Association in 1875.[116]

The two versions of the painting that are presently known may also be looked at in terms of their relationship to Winter's drawings. The larger and earlier *Indians Playing Moccasin* is similarly ambitious in terms of its composition as the council scene. As in *Kee-waw-nay Village,* the background is based on a separate sketch of a *Distant View of Lake Kee-waw-knay. Indiana July 25 1837* (Cat. # 55), which includes the bark-covered house and brush shade on the right. In the painting, the view onto the lake is widened by placing the smaller, central trees at a greater distance. As in the council scene, one of the functions of this change is to focus the light on the central group of players. (In the later version, *Playing Moccasin,* the central trees are removed, and the trees on the right are cut back to open the view and bring in more light.)

The foreground of the larger version of the painting is derived from the undated compositional sketch *Pottawattimie Indians playing Moccasin* (Cat. # 69), which in turn incorporates material from a number of different field sketches. On the right of the compositional sketch, the two women playing cards are taken from a group of four cardplayers sketched at *Kee-waw-nay village. Indiana. July 28th 1837* (Cat. # 70); standing behind and watching them is Chemokomon, copied from sketch Cat. # 94. In the painting, Chemokomon is sitting in order to reduce attention to the cardplayers and

help focus on the players of the moccasin game. (In another, probably earlier, compositional sketch Cat. # 192, Winter used the four cardplayers as the focal group; in this instance, Chemokomon made compositional sense, while in Cat. # 69 he must be regarded as a leftover from the earlier composition.)

Sketch Cat. # 72 is closest to a model for the moccasin players; however, the object of the game is not revealed. In sketch Cat. # 69, on the other hand, the view opened onto the mat on which the moccasins are placed, and the enlarged group of seated players is surrounded by a huge assembly of pedestrian and equestrian spectators, some of whom resemble certain individuals portrayed elsewhere by Winter (such as, on the far right, Kawkawkay, Cat. # 97–99). The seated and prostrate spectators on the left are based on drawing Cat. # 54 ("Sketched—July 25th 1837 At the village of Kee-waw-nay"), where the bark-covered house in the background may indicate that the picture was indeed taken on the same spot, though on a different date.

Whereas the larger *Moccasin* painting follows the compositional sketch fairly closely, it strengthens the focus on the central group by opening the gap between the players and the man approaching with his horse from the right. In the smaller version, the crowded scene has been considerably thinned out. The cardplayers on the right have been replaced by a reclining man and child, most of the spectators (including one on horseback) are gone, and those remaining seem to take less interest in the game. Rather than a depiction of bustling life in a Potawatomi village, *Playing Moccasin* becomes a very tranquil and bucolic scene. This development heralds Winter's gradual shift from a preoccupation with events (and history painting)

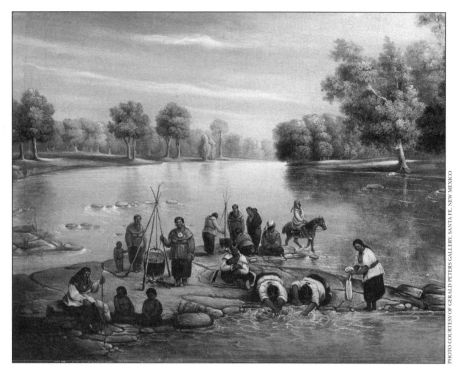

SCENE ON THE WABASH *(see Plate 6)*

<div style="writing-mode: vertical">PHOTO COURTESY OF GERALD PETERS GALLERY, SANTA FE, NEW MEXICO</div>

to Indian genre painting,[117] and, ultimately to depictions of aboriginal man as part of romantic landscapes.

Indians Playing Moccasin may be related to a similar interest in Indian gambling and playfulness shown by other artists of the period: *Winnebagos Playing Checkers* (1842) by Charles Deas; *Chippewa Indians Playing Checkers* and *Indian Women Playing the Game of Plum Stone* by Seth Eastman (1848); John Mix Stanley's two paintings, *Game of Chance* (ca. 1853) and *Gambling for the Buck* (1867); or Arthur Schott's card-playing *Co-co-pas* (1855).[118] Even though most of the images cited are sympathetic to their subjects, in looking at these pictures one is nonetheless reminded of Euroamerican criticism of the native peoples' lack of (Protestant) work ethic and the government's attempt to curb gambling on reservations as part of the process of civilization.

Indians Washing was Winter's entry for the 1849 Western Art Union Sale in Cincinnati, where it was for sale from at least May 1849 to October of the same year. It may possibly have been the same picture that was advertised in January 1851, as an addition to the

artist's first distribution of paintings in Lafayette, as *Female Indians Washing on the Wabash*, and again as *Scene on the Wabash (Squaws Washing)* in February.[119] Since no dimensions are given for any of these pictures, it is impossible to decide with certainty which, if any, of these is the painting that in 1983 was rediscovered in California[120] and that is now in the Peters Collection.[121] It is signed and dated on the reverse: "Scene on the Wabash, Vicinity of Logansport, Indiana, George Winter, 1848."

The background of *Indians Washing* represents the *Eastern View of Biddle's Island* as rendered in Winter's much later Biddle's Island volume of watercolors and in another oil painting.[122] All of them are probably based on a posited intermediary version for which sketch Cat. # 236 had provided the basis. No obvious sources exist among the sketches for the women and children populating the left foreground. There is a drawing showing the standing woman on the far right and her seated companion in the center of the group (Cat. # 87); but this may be a preliminary sketch for the painting rather than a field sketch. The same is true of

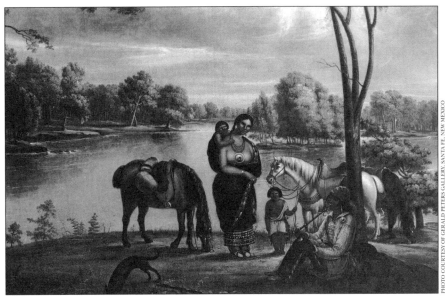

SCENE ALONG THE WABASH RIVER NEAR LOGANSPORT *(see Plate 7)*

drawing Cat. # 85, which shows women and a child around a tripod from which a cooking pot is suspended. The latter sketch is particularly suspect as a document. It is the only drawing illustrating such a tripod, whereas Winter's verbal and visual records clearly refer to kettles being suspended from horizontal sticks placed on forked uprights.[123]

In the watercolor version of *Eastern View of Biddle's Island*, all of the Potawatomis have left, except two women looking upriver and turning their backs on the viewer. In the oil painting of the same scene, a lonely Indian on horseback about to cross the river takes the women's places.

Another *Scene along the Wabash River Near Logansport, Indiana, 1848,* also in the Peters Collection,[124] uses the *Echo Point View* of Biddle's Island[125] as its background. Only the central tree is somewhat more picturesque than in the other versions. Leaning against this tree is the man shown in drawing Cat. # 95; no similarly obvious sources can be cited for the other figures, although women carrying children, prostrate men, and horses occur elsewhere among the drawings. Most suspect is the little boy holding the bow: not only is there not the least discernible source for this figure among the sketches, but

also both the bow and the boy's garments look decidedly suspicious as realistic representations of artifacts.

Further scenes set on the Wabash and Eel rivers painted by Winter as early as the late 1840s exhibit the same tendency to reduce the human element in the romantic scenery, just as the second version of *Playing Moccasin* had done. The Potawatomis, already departed from northern Indiana, now seemed to be gradually vanishing from Winter's landscapes as well. A group of Potawatomis resting underneath a towering elm tree, with the landscape across the river fading in the haze, form little more than a vignette,[126] especially when compared to earlier watercolors of similar subject matter (e.g., Cat. # 12, 14). A solitary tent with a woman preparing a meal for two companions gazing at the Wabash is overshadowed by a tree dangerously inclining over it.[127] Increasingly, cattle began to take the Potawatomis' place in the Wabash River scenes.[128]

Winter's focus on history and genre painting versus portraiture is obvious from the almost complete lack of Indian portraits in oil, although the majority of his Indian sketches and watercolors was made up of portraits. The major exception is his series of *Frances Slocum* paintings, in which the

historical importance of the subject outweighed a merely generic interest in Indians. At least one half-portrait version was produced for Winter's distributions, in addition to the two commissioned by her family.[129] One of the two known watercolor portraits of the Lost Sister is a composite showing her with her two daughters and illustrates the unwillingness of her younger daughter Osonwapakshinqua to be captured by the white painter's magic.[130]

Other composite portraits of Indians by Winter lack this narrative element. In *Three Pottawatamies*, for example, Naswawkay, the Potawatomis' speaker at the Keewaunay council, is placed in the central position, with Iowa and Mesquabuck looking over his shoulders. Winter describes the painting on his March 1854 distribution list as showing "Knas-waw-key, an Indian Orator of eminence. Mus-qua-buck, a distinguished War Chief. And I-o-waw, an influential and brave man. These portraits painted from life—an authentic record of the red men." Iowa and Mesquabuck closely follow the watercolor of the one (Cat. # 26) and the pencil sketch of the other (Cat. # 43); Naswawkay is shown in greater detail than in the council picture, but his "white counterpane coat with cape" and red sash are clearly those shown and described there.[131] Four similar

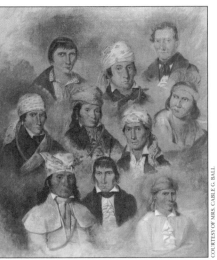

COMPOSITE OF POTAWATOMI CHIEFS *(see Plate 8)*

composite portraits of Potawatomis and Miamis remained in the artist's possession and are now part of Mrs. Cable G. Ball's private collection.

The combination of individual Indian portraits, even of different tribes, into composite groups was a widespread practice, especially in book illustrations of the period.[132] Late in his life George Catlin likewise produced several sets of his earlier portraits rearranged into groups.[133] Such compositions of heads or figures can hardly be seen as possessing any specific artistic merit; they were primarily space-saving devices, and at best could be used to illustrate similarities and variations within and across native populations.

The increasingly romanticized view of individual "aborigines of the Wabash" is also indicated by the 1860 title *Forest Flower* for a portrait of the daughter of Sinisqua[134] (whose image as drawn by Winter shows her to be a fairly acculturated woman; Cat. # 34), *The Captive Sister* for a portrait of Frances Slocum, and *The Old Chief*.[135]

While this development may not have been a direct result of Winter's failure to succeed commercially on the provincial art market, it probably did not hurt his sales. In March 1849 his friend W. Hubbell had advised Winter to cater more to public taste in his Indian paintings and worry less about artistic purity.[136] Similarly, the *Lafayette Daily Courier* of 7 January 1852, while lamenting the lack of patronage given to Winter's work by the Indianapolis public, suggested that a "negro dance, . . . a pow-wow of drunken Indians, or a portrait of the girl that ran away with the Fakir of Siva would have more attraction for the crowd."[137]

By the time this well-meant advice was dispensed, Winter was already compromising the purity of his vocation and had begun to produce paintings after successful, if artistic-

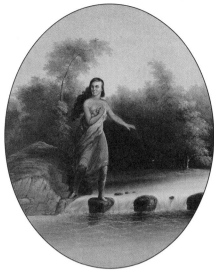

SPOTTED FAWN *(see Plate 9)*
PHOTO COURTESY OF CONNER PRAIRIE, FISHERS, INDIANA

ally inferior, prints. Two of the three engravings Winter most often copied in oil were grossly stereotypical American Indian subjects far removed from his documentary record of Potawatomi and Miami life.

The Chief's Daughter by John Gadsby Chapman (1808–1889), one of the most widely known American artists of his day and the painter of *Pocahontas* (another chief's daughter) in the United States Capitol, depicts a teasingly dressed Indian girl attempting to step across the swift current of a river. This print, which survives among the Winter papers, was the source for Winter's painting *Spotted Fawn, or Chief's Daughter*, which is described in 1856 as "an Indian girl standing near a cascade, draped in graceful negligence, waiting the coming of her lover. A soft, bluish, warm color is diffused over the Painting."[138] The *Spotted Fawn* is first mentioned in a letter from Jane Winter to her brother in June 1847; in 1848 there were at least two of Winter's copies of it for sale in Louisville, Kentucky, and in the same year two or three copies were sold by Winter.[139] Copies appeared again, as a 12-by-14-inch and as a 25-by-30-inch painting, on the lists of Winter's distributions in Lafayette (1852 and 1855), Burlington, Iowa (1856), and La Porte (1858).[140] The appeal of the print at the time

is also shown by its use as an illustration in Henry Rowe Schoolcraft's respectable *The American Indian*,[141] despite its glaring lack of ethnographic value.

Equally successful must have been Winter's version of *The Indian Captive*, based on a print derived from a drawing by Felix Octavius Carr Darley (1822–1888), best known as an illustrator of the works of James Fenimore Cooper and Washington Irving. Like the *Chief's Daughter*, the young Indian female is depicted as desirable in *The Indian Captive*, a desirability contrasting starkly with the savageness of her Indian captor, whose horse is about to cross a river, while a prairie fire rages on the horizon. "This is an effective painting," Winter said of it in 1856.[142] In 1848 one copy was on display at the Artist's Emporium in Louisville, Kentucky, but was returned in September of that year, because Winter had found a buyer for it. Another copy was sent in 1850 to William Hubbell, who wanted either to sell it or buy it himself.[143] It appears on the distribution lists of 1852 (Lafayette), 1856 (Lafayette and Burlington, Iowa), and both 1865 and 1872 (Lafayette). The smaller 14-by-12-inch version was priced at $18, while the 25-by-30-inch version ranged from $70 to $100.[144] Several copies of this painting that have survived[145] show that Winter kept very close to his model.[146]

GEORGE WINTER'S INDIAN DRAWINGS AS ETHNOGRAPHIC DOCUMENTS

Much of the appreciation for the work of George Winter rests on his depiction of the Potawatomis and Miamis he observed in the Wabash River valley in the late 1830s and early 1840s. Even art historians who try to judge Winter's work on purely aesthetic grounds have not been able to overlook the discrepancy between the

limitations of formal excellence and the documentary value of their contents. Wilbur Peat, for example, noted that "at heart he was an artist, not an ethnologist"; and yet it was his drawings' "accuracy of costume and customs, their vividness of characterization, and beauty of technique and coloring [that] make them unusually fascinating." His Indian drawings "lack the free and broad washes that make so many water colors of that day . . . so distinguished; but they were made from the standpoint of ethnological accuracy rather than delightful artistry."[147]

Statements such as these place Winter in a rather unenviable position. Given the sometimes serious doubts about the accuracy of George Catlin's ethnographic record,[148] George Cottman's designation of Winter as "the Catlin of Indiana"[149] cannot necessarily be understood as a compliment. One is also reminded of the severe criticism of Catlin's paintings expressed by Winter's respected teacher William Dunlap, who thought that the "utterly incompetent" artist was merely trying to save himself from rebuke by choosing a subject matter in which he would have no competitor.[150] From a purely ethnographic point of view, the question needs to be raised whether the praise bestowed upon the artist for his Indian drawings is really valid— something art historians should hardly be made to judge. It will also be useful to attempt, however briefly, to place Winter within the field of "pictorial historians of the Indian," most of whom shared his predicament.

George Winter differs from most other painters of the mid-nineteenth century whose work focused on American Indians. For simple reasons of geography, he can hardly be considered an artist of the American West. Much as his Potawatomis and Miamis did not fit the image of the featherbonneted equestrian warriors of the plains,

the quiet gentleness of the Wabash valley did not provide the unconquered horizon of wide open spaces and grand views offered by the trans-Mississippi West. While other artists ventured out into the unknown for limited periods of time, thereafter to return to their urban studios and markets, Winter's minimal western excursion unintentionally landed him in limbo. His sojourn among the Indians was brief because he stayed on after they had left; his market was limited because few of the locals were overly enthusiastic about being reminded of their removed native neighbors. His only commission for an "Indian portrait" was received when Frances Slocum's relatives learned that their long-lost sister had decided not to return to her white family.[151]

Winter's Indian paintings show that their documentary contents, while generally based on original sketches, were subjected to certain modifications caused by compositional needs. This is likewise partly true of the watercolors, especially the scenic compositions. As there is no clear proof for the existence of watercolor field sketches, not too much reliance should perhaps be placed on the documentary nature of the colors shown, e.g., in the dresses depicted, although their overall appearance seems to be largely appropriate.[152] Whereas there appear to be only minor differences between earlier versions of the watercolors and those made for Winter's watercolor sets of the 1860s and early 1870s, the accompanying texts are obviously somewhat more influenced by information obtained by the artist in the meantime.

A common practice among those who painted American Indians in the nineteenth century was the use of Indian artifacts as studio props.[153] An artifact surviving from Winter's collection,[154] a quirt studded with brass tags, appears in his portrait of Pelmawme

("Pel-waw-me") (Cat. # 19). Whether the quirt was obtained after the sitting or later added to the portrait cannot be safely determined.

With other artists who focused on Indian subject matter, Winter shared the notion that he had been destined to produce a lasting record of a vanishing race. If he succeeded in this quest as far as the Potawatomis and Miamis were concerned, it was partly because he faced little serious competition.

As far as the Miamis are concerned, there are not many other visual images that can be compared to or used to supplement the information supplied by Winter. The earliest known portrait of a Miami seems to be an etching of Paccane made in the 1790s by Elizabeth Simcoe, an amateur artist and wife of John G. Simcoe, a British lieutenant governor of Canada.[155] A portrait of the famous Miami chief Little Turtle, said to have been executed in 1797 in Philadelphia by Gilbert Stuart, no longer exists; it is thus difficult to assess the reliability of a print supposedly derived from it.[156] Two oil paintings depict Chief Jean Baptiste Richardville; both are undated and show Richardville in white man's dress.[157]

The only substantial body of Miami portraits was produced in the 1820s by James Otto Lewis (1799–1858), who had been commissioned by Gov. Lewis Cass of the Michigan Territory to paint portraits of Indian chiefs present at various treaty councils in northern Indiana, Michigan, and Wisconsin. Unfortunately, none of the Indian portraits among Lewis's reportedly more than 250 drawings has so far been located.[158] All that survive of his Miami images, made in 1826 at the Treaty of Mississinewa, are eleven lithographs, some of them in slightly variant versions, produced for the artist's *Aboriginal Port-Folio*, first published in 1835–36.[159] The prints include full-

length portraits of Francis Godfroy and "The Son," as well as half-length views of Richardville, Miaqua, Caataake-mungga ("Speckled Loon"), Mowanza ("The Little Wolf"), Pennowweta, Nashemungga, a "Miami chief," a "young Miami chief," and Brewett (whose Anglicized name hardly betrays his identity with Jean Baptiste Brouillette).[160]

If these lithographs may be taken as an indication of Lewis's ability as an artist, George Winter's work does not suffer by comparison. A direct comparison between Lewis's prints and Winter's watercolors of Francis Godfroy and Jean Baptiste Brouillette shows them to be sufficiently similar to be regarded as realistic representations.

An anonymous daguerreotype of Mrs. Skiah, dating from ca. 1850, appears to be the only early depiction of a Miami woman other than in Winter's drawings.[161]

The Potawatomi pictorial record of the same period is slightly more diverse. This is true not only of the artists represented, but also of the places where the pictures were taken, as Potawatomis were then living widely scattered throughout northern Indiana and Illinois, southwestern Ontario, southern Michigan, Wisconsin, as well as in their new homes in Kansas.

Samuel Seymour (1796–1823), who had already accompanied Maj. Stephen H. Long on his 1819 expedition to the Rocky Mountains, also served as the artist of Long's 1823 expedition to the sources of the St. Peter's River. When, passing through the Wabash valley, the party stopped to interview the Potawatomi chief Metea (with Joseph Barron serving as the interpreter), Seymour "took a likeness of him, which was considered a very striking one, by all who knew Metea." The bust-length profile sketch served as the basis for a lithograph published in London in 1825, in which Metea is

depicted together with a Chippewa and a Sauk.[162]

A colored lithograph was produced some years later from the same sketch for Thomas L. McKenney and James Hall's *History of the Indian Tribes of North America*.[163] Most of the native notables illustrated in these three volumes, however, were based on paintings by Charles Bird King (1785–1862) of Indian dignitaries visiting their Great White Father in Washington. King's only known Potawatomi portrait was that of Wabaunsee. Whereas the original painting made for McKenney's Indian Office gallery was destroyed in the Smithsonian fire of 1865, a copy made by King has survived, but it differs markedly from the published lithograph made from another copy produced by Henry Inman.[164]

Although thirty of James Otto Lewis's watercolors were also copied for the Indian Gallery, none of his Miami or Potawatomi portraits were included and thus were not published in the *History of the Indian Tribes of North America*. Eleven Potawatomis portrayed by Lewis on the occasion of their Mississinewa treaty of 1826, however, are depicted in the lithographs of the *Aboriginal Port-Folio*. Magazee, Menoquet, Nahshawagaa ("The White Dog's Son"), Pachepo, Pecheco, Chacoto, Chatonissee, Comnosaqua, Keeotuck-kee, Namaniscut, and Sunaget ("Hard Times") are dressed and painted (though not necessarily portrayed) to their best advantage; all of them are shown in bust-length.[165] The first five or six of these names are recognizable among the signatures on the 1826 treaty.[166] Surprisingly, none of them reappears in Winter's drawings.

The oeuvre of George Catlin (1796–1872) includes three oil portraits of Potawatomis, all of them apparently made in 1830 at Fort Leavenworth, Kansas. Onsawkie ("The Sac"), who is shown holding a wooden

prayer stick, and Napowsa ("Bear Traveling in the Night") were also illustrated as engravings in Catlin's *Letters and Notes*; Kéese, a woman dressed in a tightly fitting cotton blouse, was probably considered by Catlin as not exotic enough to be featured in his book.[167] About twenty years later, in 1848 and 1851, the Swiss artist Rudolph Friedrich Kurz (1818–1871), who spent several years among the Iowa of the St. Joseph and the Upper Missouri, also made sketches of Kansas Potawatomis. They show men and women on horseback and a mixed group artfully draped around a rock.[168]

In 1845 Paul Kane (1810–1871), a Canadian painter inspired by Catlin's work to create a visual record of the Canadian Indians, made drawings and an oil sketch on paper of Potawatomis he met on Mackinac Island and on the Fox River in Wisconsin, one of whom is identified as Coecoosh ("The Hog"). The sketches may have formed the basis for an oil painting on canvas often misidentified as showing Coecoosh.[169] Three Wisconsin Potawatomis are probably likewise shown in a ca. 1850–51 drawing by Balduin Möllhausen (1825–1905), a German artist and writer.[170] Like Catlin's Potawatomis, those by Möllhausen are among his earliest and poorest attempts to depict Indians.

Finally, mention must be made of a series of daguerreotypes and ambrotypes depicting Shabbona, an Ottawa who had married a Potawatomi woman, his wife Canoku, and his grandson Little Snake, all dating from the mid-1850s.[171]

As this brief survey shows, almost all of the images discussed are simple portraits, mostly of men dressed for a special occasion. Winter's drawings are exceptional in their depiction of women, social and ceremonial activities (games, dancing, funeral rites), and certain features of material culture,

such as dwellings. In some cases the drawings even supply evidence for cultural practices not otherwise recorded.

Among the games illustrated by Winter, for example, only the moccasin game (Cat. # 69) is well attested in the ethnographic literature on the Potawatomis.[172] The omission of card-playing (Cat. # 49, 69, 70) in most ethnographic reports can be explained by the general neglect of obvious features of acculturation in accounts of traditional cultures. The absence of any reference to "Yuh-youh-tche-chick" or quoits (Cat. # 68) and the "game of wink" (Cat. # 71) is more puzzling. As far as quoits (or throwing stones at a mark) are concerned, published evidence is only available for tribes of northern and western North America.[173] Judging from Winter's drawing, "wink" appears to have involved two competitors trying to stare one another down. No artifacts are involved, and no description of a comparable game is found in the literature.

Contrary to the focus on ceremonial smoking in ethnographic accounts,[174] Winter illustrates the Potawatomis' use of tobacco in purely social contexts. The smoking apparatus illustrated includes short clay pipes (Cat. # 3, 52, 96), a long-stemmed pipe with a stone head (Cat. # 39), and a tomahawk pipe with inlaid stem (shown several times, most prominently in Cat. # 94 and 95).[175]

Further analysis of the ethnographic contents of Winter's drawings shows that, with a few exceptions,[176] they represent a reliable visual record of selected aspects of the lifeways of the Potawatomis and the Miamis of northern Indiana. His technical abilities, although far from superior, were still in the middle range of those of his colleagues who also contributed to the visual record of the Potawatomi and Miami cultures. Apart from the unquestioned authenticity of his work,

Winter's honesty as an artist greatly contributed to the ethnographic reliability of the pictorial documents he produced. The fortunate survival of an extensive body of his sketches together with a substantial amount of written documentation makes George Winter's Indian work an important primary source for the still largely unwritten historical ethnography of the Potawatomis and Miamis.

The author would like to express his deep gratitude to the staff of the Tippecanoe County Historical Association, especially Sarah E. Cooke and Rachel Ramadhyani, for their tremendous support of his work on Winter.

1. George Winter, "Sketches of Logansport, No. 1," and "Sketches of Logansport, No. 2," *Logansport Telegraph*, 2 October 1841; 9 October 1841 (typed transcript in George Winter Manuscripts, box 1, folder 7, item 6 [hereafter cited as GWMSS] 1–7 [6], Tippecanoe County Historical Association, Lafayette, Indiana); and his manuscript journal of 1837, GWMSS 1–2.

2. The sketch of Winter's years in England is based on his own autobiographical fragment "Our Duties and the Pledges," printed from GWMSS in *The Journals and Indian Paintings of George Winter, 1837–1839* (Indianapolis: Indiana Historical Society, 1948), 17–37. His later life is summarized in Gayle Thornbrough, "Biographical Sketch," ibid., 17–90.

3. James L. Yarnall and William H. Gerdts, comps., *The National Museum of American Art's Index to American Art Exhibition Catalogs: From the Beginning through the 1876 Centennial Year*, 6 vols. (Boston: G. K. Hall, 1986), vol. 5, *Artist Index, S–Z*, 3963.

4. Wilbur Peat, "Winter, the Artist," in *Journals and Indian Paintings of George Winter*, 3–13; GWMSS 1-1 [3]; Mary Bartlett Cowdrey, *The National Academy of Design Exhibition Record, 1826–1860*, John Watts DePeyster Publication Fund Series 74–75 (New York: New York Historical Society, 1943); Eliot Clark, *History of the National Academy of Design, 1825–1953* (New York: Columbia University Press, 1954); and William Dunlap, *History of the Rise and Progress of the Arts of Design in the United States*, 3 vols. (New York: B. Blom, 1965), originally published in 1834, who mentions Winter.

5. GWMSS 1-1 [7, 8, 10].

6. GWMSS 1-1 [9, 10].

7. GWMSS 1-15 [15]; Thornbrough, "Biographical Sketch," 39.

8. Thornbrough, "Biographical Sketch," 44; J. C. H. King, "A Century of Indian Shows: Canadian and United States Exhibitions in London 1825–1925," *European Review of Native American Studies* 5, no. 1 (1991): 35–42.

9. William H. Truettner, *The Natural Man Observed: A Study of George Catlin's Indian Gallery* (Washington, D.C.: Smithsonian Institution Press, 1979), 26, 36.

10. J. W. Edmonds, *Report of J. W. Edmonds, United States' Commissioner, on the Claims of Creditors of the Potawatamie Indians of the Wabash: Presented under the Treaties Made with Them in 1836 and '37* (New York: Scatcherd and Adams, 1837).

11. Thornbrough, "Biographical Sketch," 43–45; Nos. 1–29 in catalog.

12. James A. Clifton, *The Prairie People: Continuity and Change in Potawatomi Indian Culture, 1665–1965* (Lawrence, Kans.: Regents Press, 1977), esp. 279–346; R. David Edmunds, *The Potawatomis: Keepers of the Fire*, vol. 145 of *The Civilization of the American Indian Series* (Norman: University of Oklahoma Press, 1978), esp. 240–72.

13. Robert A. Trennert, Jr., *Indian Traders on the Middle Border: The House of Ewing, 1827–1854* (Lincoln/London: University of Nebraska Press, 1981).

14. Irving McKee, *The Trail of Death: Letters of Benjamin Marie Petit*, Indiana Historical Society *Publications*, vol. 14, no. 1 (Indianapolis: Indiana Historical Society, 1941); John Dolan, "The Plight of the Potawatomi," *Neue Zeitschrift für Missionswissenschaft* 16 (1960): 275–80.

15. Winter preserved among his papers a copy of the *Speech of the Hon. John Tipton, of Indiana, on the Bill for the Protection of the Aborigines* (Washington, D.C.: Printed at the Globe Office, 1838), which may have contributed to his own views of the "Indian problem."

16. George Winter, "Journal of a Visit to Lake Kee-wau-nay and Crooked Creek, 1837," a composite account of various of his writings, was published in *Journals and Indian Paintings of George Winter*, 95–147; Nos. 30–77 in catalog.

17. Nos. 78–104 in catalog.

18. John B. Dillon is perhaps best known for his *History of Indiana* (Indianapolis: Wm. Sheets and Co. for J. B. Dillon & Stanislaus Lasselle, 1843); his 1848 lecture on "The National Decline of the Miami Indians" was posthumously published in Indiana Historical Society *Publications*, vol. 1, no. 4 (Indianapolis: The Bowen-Merrill Co., 1897), 121–43.

19. Thornbrough, "Biographical Sketch," 48–49; McKee, *Trail of Death*, 92–93, 97; Nos. 105–123 in catalog.

20. Thornbrough, "Biographical Sketch," 49–51; Nos. 150–158 in catalog.

21. GWMSS 1-4 [16]; Nos. 631 and 632 in catalog. For another deathbed sketch by Winter see GWMSS 1-9 [10]. For deathbed sketches in early Indiana see Marilyn Reed Holscher, "The First Hundred Years of Indiana Art," in *Mirages of Memory: Two Hundred Years of Indiana Art* (South Bend, Ind.: University of Notre Dame, 1977), 15–61, esp. 27–29, 33; and Wilbur D. Peat, *Pioneer Painters of Indiana* (Indianapolis: Art Association of Indiana, 1954), 124.

22. Thornbrough, "Biographical Sketch," 55–56.

23. See, for example, John F. Meginness, *Biography of Frances Slocum, the Lost Sister of Wyoming* (Williamsport, Pa.: Heller Bros.' Print House, 1891; reprinted in vol. 58 of *The Garland Library of Narratives of North American Indian Captivities*, New York and London: Garland Publishing, 1975); Jacob Piatt Dunn, *True Indian Stories* (Indianapolis: Sentinel Printing Co., 1909), 213–33;

Otho Winger, *The Lost Sister among the Miamis* (Elgin, Ill.: Elgin Press, 1936).

24. George Winter, "Journal of a Visit to Deaf Man's Village, 1839," GWMSS, was written in 1871 and dedicated to Horace P. Biddle. It was published in *Journals and Indian Paintings of George Winter*, 151–96; Nos. 124–149 in catalog.

25. GWMSS 1-4 [16].

26. Thornbrough, "Biographical Sketch," 59–60, 67.

27. Ibid., 61.

28. Ibid., 64, 68, 69.

29. Winter's field journal in GWMSS 2-29 [1]; Thornbrough, "Biographical Sketch," 64–67; Nos. 301–310 in catalog.

30. Yarnall and Gerdts, *Index to American Art Exhibition Catalogs*, 3962–63.

31. GWMSS 1-10 [10-14, 17], 1-11 [9]; Yarnall and Gerdts, *Index to American Art Exhibition Catalogs*, 3969; Thornbrough, "Biographical Sketch," 69–70, 72.

32. William Dunlap, *Address to the Students of the National Academy of Design: At the Delivery of the Premiums, Monday, the 18th of April, 1831* (New York: Clayton & Van Norden, 1831), 6, 8. Winter faithfully kept a copy of this lecture among his papers.

33. Charles E. Baker, "The American Art Union," in *American Academy of Fine Arts and American Art-Union, 1816–1852*, ed. Mary Bartlett Cowdrey, 2 vols. (New York: New York Historical Society, 1953), 1: 95–240, on distributions, esp. 219–32.

34. George Winter, "Western Art Union," *Logansport Telegraph*, 9 October 1847; GWMSS 1-10 [8, 15], 1-11 [8, 9, 11], 1-12 [11, 17], 1-14 [3]; Thornbrough, "Biographical Sketch," 70–72; Yarnall and Gerdts, *Index to American Art Exhibition Catalogs*, 3962; Peat, *Pioneer Painters of Indiana*, 169.

35. Baker, "American Art Union," 229. Similar fears were expressed in 1851 in connection with the Western Art Union. GWMSS 1-13 [16].

36. GWMSS 1-12 [13, 14]; Thornbrough, "Biographical Sketch," 73–74; *Ladies Repository* 10 (October, November, December 1850); 11 (March, December 1851).

37. George Winter to Rev. D. W. Clarke, 24 January and 17 May 1853, Harlow Lindley Papers (M 186), folder 22, Indiana Historical Society Library, Indianapolis.

38. GWMSS 1-9 [14].

39. Paul K. Richard, *Productions of My Pencil: The Art of George Winter* (Indianapolis: Indiana State Museum, 1980), 15.

40. Thornbrough, "Biographical Sketch," 77–80; GWMSS 1-13 [22–28].

41. GWMSS 1-14 [6].

42. Winter may have been the first, but not the only artist in Indiana to use the lottery system to dispose of his paintings. In 1868 John D. Forgy also held "semi-annual distributions of pictures." Peat, "Winter, the Artist," 11; Peat, *Pioneer Painters of Indiana*, 118. In Baltimore, Francis Guy had initiated such raffles of his own works as early as 1803. William H. Gerdts, *Art Across America: Two Centuries of Regional Painting in America,* *1710–1920*, 3 vols. (New York: Abbeville Press, 1990), 1:322, 2:255–56.

43. Thornbrough, "Biographical Sketch," 82. An earlier distribution in January 1851 had not been exclusively of Winter's works. Ibid., 77.

44. GWMSS 2-1, 2-2, 2-3; Thornbrough, "Biographical Sketch," 81–87.

45. A fairly complete listing of these works together with pertinent information on subject matter, size, and value taken from the distribution lists and other sources may be found in Yarnall and Gerdts, *Index to American Art Exhibition Catalogs*, 3960–82.

46. Ibid., 3971.

47. Richard, *Productions of My Pencil*, 14.

48. Yarnall and Gerdts, *Index to American Art Exhibition Catalogs*, 3973, 3974.

49. Nos. 383–394 in catalog; Yarnall and Gerdts, *Index to American Art Exhibition Catalogs*, 3963, 3965, 3969, 3971, 3972, 3977.

50. GWMSS 2-29 [7-21]; Nos. 306–310 in catalog.

51. GWMSS 1-15 [14, 15]; Meginness, *Biography of Frances Slocum*, 231n; Sylvia S. Kasprycki, "Image and Imagination: Menominee Portraits, 1825–1860," *Archiv für Völkerkunde* 44 (1990): 65–131, esp. 106–9.

52. Benson J. Lossing, *The Pictorial Field-Book of the Revolution*, 2 vols. (New York: Harper & Bros., 1850–52), 1:369; GWMSS 1-16 [4, 8, 9], 1-23 [15, 18]. Winter's distribution list of March 1854 already makes reference to the appearance of this portrait in Lossing's book. Yarnall and Gerdts, *Index to American Art Exhibition Catalogs*, 3971.

53. GWMSS 1-16 [19], 1-17 [38c], 1-19 [2]. George Winter to Charles B. Lasselle, 26 June 1863, Lasselle Family Papers (L 127), box 13, folder "Charles B. Lasselle, Sept. 1862–Dec. 1863," Indiana Division, Indiana State Library, Indianapolis.

54. Samuel G. Drake, *The Book of the Indians of North America* (Boston: Published by Josiah Drake, 1833).

55. GWMSS 1-18 [10].

56. Ibid., 1-22 [27], 1-23 [4], 1-24 [6, 17].

57. Ibid., 1-23 [3, 4, 11, 12], 1-24 [4, 17]; Colin Taylor, "'Ho, for the Great West!' Indians and Buffalo, Exploration and George Catlin: The West of William Blackmore," in *"Ho, for the Great West!": And Other Papers to Mark the Twenty-fifth Anniversary of the English Westerners' Society*, ed. Barry C. Johnson, English Westerners' Special Publication 6 (London: Eatome Ltd. for the English Westerners' Society, 1980), 9–49; Taylor, "William Blackmore: A Nineteenth Century Englishman's Contribution to American Indian Ethnology," in *Indians and Europe: An Interdisciplinary Collection of Essays*, ed. Christian F. Feest (Aachen, West Germany: Rader Verlag, 1987), 321–35.

58. GWMSS 1-26 [10-26], 1-27, 1-28, 1-29.

59. Nos. 420–425 in catalog; Yarnall and Gerdts, *Index to American Art Exhibition Catalogs*, 3962; GWMSS 1-29 [32].

60. GWMSS 1-29 [38, 40].

61. Meginness, *Biography of Frances Slocum*, 230.

62. Wilbur Peat, *George Winter, Pioneer Artist of Indiana* (Indianapolis: Herron Art Museum, 1939), [4], notes that "no paintings have been found bearing his signature, although some of his portraits and an occasional landscape has an inscription by his hand on the back of the canvas."

63. Meginness, *Biography of Frances Slocum*, 229–34, frontispiece and plates facing 142 and 164.

64. George S. Cottman, "George Winter, Artist: The Catlin of Indiana," *Indiana Magazine of History* 1 (1905): 114n; Cottman, "Historical Relics the State Should Own," ibid., 132–34.

65. George S. Cottman, "Forerunners of Indiana Art," *Indiana Magazine of History* 15 (1919): 16; Mary Q. Burnet, *Art and Artists of Indiana* (New York: Century, 1921), 38–50, esp. 38, 43.

66. Peat, *George Winter, Pioneer Artist*, [5]; Peat, "Winter, the Artist," 3, 12–13; Peat, *Pioneer Painters of Indiana*, 117.

67. Holscher, "The First Hundred Years," 38; Richard, *Productions of My Pencil*, 1; Gerdts, *Art Across America*, 2:255–56.

68. Oliver W. Larkin, *Art and Life in America* (New York: Rinehart, 1964), 209; E. P. Richardson, *Painting in America, from 1502 to the Present* (New York: Crowell, 1965), 176, 178.

69. Of the notable exceptions were George Adams in Logansport, a sign painter who later returned to sign painting, and Orrin Pentzer in Logansport. Peat, *Pioneer Painters of Indiana*, 117, 81; GWMSS 1-7 [14].

70. Peat, "Winter, the Artist," 8.

71. GWMSS 1-4 [12, 13], 1-5 [9]; for deathbed images, see note 21. See also Winter's description of his sketching of Frances Slocum in "Journal of a Visit to Deaf Man's Village," 177–78; Peat, "Winter, the Artist," 8, for the assumption that they were painted on canvas directly from life.

72. GWMSS 1-7 [17]. The portrait is located at the Cass County Historical Society, Logansport, Ind.; Nos. 616–655 in catalog.

73. GWMSS 1-12 [24].

74. Peat, *Pioneer Painters of Indiana*, 123, 159–60. The same is true of many painters of Indian subject matter, such as Seth Eastman, John Mix Stanley, or Edward Kern. Herman J. Viola, H. B. Crothers, and Maureen Hannan, "The American Indian Genre Paintings of Catlin, Stanley, Wimar, Eastman, and Miller," in *American Frontier Life: Early Western Painting and Prints*, ed. Ron Tyler et al. (New York: Abbeville Press, 1987), 140, 151; Robert V. Hine, *In the Shadow of Frémont: Edward Kern and the Art of Exploration, 1845–1860*, 2d ed. (Norman: University of Oklahoma Press, 1981), 94n, 104–5.

75. GWMSS 1-17 [19, 27]; Richard, *Productions of My Pencil*, 15.

76. Yarnall and Gerdts, *Index to American Art Exhibition Catalogs*, 3873.

77. Peat, "Winter, the Artist," 7, 10.

78. Nos. 616–660 in catalog.

79. Peat, *Pioneer Painters of Indiana*, frontispiece, 123. Two versions of this portrait were placed on Winter's distribution lists in 1856 and 1866. Yarnall and Gerdts, *Index to American Art Exhibition Catalogs*, 3975.

80. This is even true of most versions of Winter's portrait of Frances Slocum, although a surviving composi-

tional sketch (Cat. # 136) suggests that he had planned to place her in front of an interior view of her home.

81. Peat, *George Winter, Pioneer Artist*, [4].

82. Nos. 234–293 in catalog.

83. GWMSS 1-4 [21].

84. George Winter to E. [i.e., Andrew] Campbell, 1 January 1841, quoted in Meginness, *Biography of Frances Slocum*, 231.

85. Barbara Novak, *Nature and Culture: American Landscape and Painting, 1825–1875* (New York: Oxford University Press, 1980), 19–24.

86. Meginness, *Biography of Frances Slocum*, 231. That Winter was experimenting with rather big canvases is also seen from his reference in November 1839 to the "portrait of Gen.l Tipton and a favorite horse — 8 1/2 feet by 6" (GWMSS 1-4 [21]).

87. GWMSS 2-1 [3].

88. Cottman, "George Winter, Artist: The Catlin of Indiana," 111–22, esp. 111.

89. This may be the copy in the Indiana State Museum, Indianapolis, No. 71.981.20.19; Cottman, "George Winter, Artist: The Catlin of Indiana," 114n; Peat, *George Winter, Pioneer Artist*, No. 14.

90. Yarnall and Gerdts, *Index to American Art Exhibition Catalogs*, 3964, 3974, 3976, 3977, 3979.

91. Quotes are from Winter's own distribution lists. Ibid., 3977, 3979, 3981.

92. Ibid., 3971–72, 3973, 3982. For *Nocturnal Landscape*, see Holscher, "The First Hundred Years," 38.

93. Peat, *George Winter, Pioneer Artist*, [4].

94. Barbara Novak, *American Painting of the Nineteenth Century: Realism, Idealism, and the American Experience*, 2d ed. (New York: Harper & Row, 1979), esp. 81–82.

95. In 1824 Thomas L. McKenney became the first head of the War Department's newly organized Bureau of Indian Affairs (sometimes known as the "Indian Office") and developed his older idea of an "Archives of the American Indian" into an "Indian Gallery," which featured ethnographic objects in addition to portraits of famous or notable American Indians. After McKenney's removal from office in 1830, active collecting gradually slowed down. Herman J. Viola, *The Indian Legacy of Charles Bird King* (Washington, D.C.: Smithsonian Institution Press, 1976).

96. GWMSS 1-4 [4].

97. Another description of the picture is contained in Winter's letter of 30 January 1839 to Lewis H. Sands, GWMSS 1-4 [8, 12].

98. Ibid., 1-4 [4].

99. Winter's portrait of Duret is in the Indiana State Museum, No. 71.986.237.1.

100. GWMSS 1-3.

101. Ibid., 1-4 [8].

102. Ann Uhry Abrams, *The Valiant Hero: Benjamin West and Grand-Style History Painting* (Washington, D.C.: Smithsonian Institution Press, 1985), 8.

103. Ibid., 177, 179, 192–93, figs. 109, 122, plate VII.

104. John C. Ewers, *Artists of the Old West* (Garden City, N.Y.: Doubleday, 1965), 28; Edwin James, comp., *Account of an Expedition from Pittsburgh to the Rocky Mountains*, 2 vols. and atlas (Philadelphia: H. C. Carey & I. Lea, 1822–23), atlas.

105. James Otto Lewis, *The American Indian Portfolio: An Eyewitness History, 1823–28*, introduction by Philip R. St. Clair (Kent, Ohio: Volair Limited, 1980), 39.

106. Ewers, *Artists of the Old West*, 170.

107. Ibid., 145.

108. Alvin M. Josephy, ed., *The American Heritage Book of Indians* (New York: Bonanza Books, 1961), 234–35.

109. GWMSS 1-4 [11, 12, 13, 17, 20].

110. Ibid., 1-15 [13, 15], 1-24 [5].

111. Ibid., 1-15 [15].

112. Ibid., 1-4 [12]; this first version is probably the one in the Mrs. Cable G. Ball Collection, Lafayette.

113. Letter to W. Pettit, 8 January 1858; letter by O. W. Pentzer, 8 February 1873, GWMSS 1-15 [13], 1-25 [2].

114. Ibid., 1-19 [2].

115. This may be the copy owned by the Indiana State Museum, No. 71.981.20.19; Holscher, "The First Hundred Years of Indiana Art," 15–88, esp. 61, Nos. 50, 83; Richard, *Productions of My Pencil*, title page; Joseph D. Ketner II, *Pioneer Hoosier Painting* (Fort Wayne, Ind.: Fort Wayne Museum of Art, 1982), No. 45.

116. Yarnall and Gerdts, *Index to American Art Exhibition Catalogs*, 3962, 3971, 3974.

117. Viola, Crothers, and Hannan, "American Indian Genre Paintings," 131–65.

118. Carol Clark, "Charles Deas," in *American Frontier Life*, ed. Tyler et al., 51–77, esp. 58; Viola, Crothers, and Hannan, "American Indian Genre Paintings," 141, 142 (Stanley), 155 (Eastman); Henry Rowe Schoolcraft, *Historical and Statistical Information Respecting the History, Condition, and Prospects of the Indian Tribes of the United States: Collected and Prepared under the Direction of the Bureau of Indian Affairs Per Act of Congress of March 3rd, 1847*, 6 vols. (Philadelphia: Lippincott, Grambo, 1851–57), 2:plate 18; earlier published under a different title in Mary Eastman, *Dacotah; or, Life and Legends of the Sioux Around Fort Snelling* (New York: J. Wiley, 1849), frontispiece (Eastman); William H. Emory, *Report on the United States and Mexican Boundary Survey: Made under the Direction of the Secretary of the Interior*, 34th Cong., 1st sess., H. Exec. Doc. No. 135, 2 vols. (Washington, D.C.: Cornelius Wendell, Printer, 1857), 1:facing 111 (Schott).

119. GWMSS 2-1 [1a, 2].

120. Steve Mannheimer, "Rare Painting by Hoosier Is Discovered," *Indianapolis Star*, 23 October 1983, p. 10E.

121. Julie Schimmel, "The Land of the Free," in *The West Explored: The Gerald Peters Collection of Western American Art* (Santa Fe, N.Mex.: Gerald Peters Gallery, 1988), 13–83, esp. 89, plate 15.

122. George Winter, "Views of Biddle's Island" (manuscript in the collection of the Cass County Historical Society, Logansport, Ind.), 4; *Eastern View of Biddle's Island*, oil on canvas, Cass County Historical Society.

123. GWMSS 1-3.

124. Schimmel, "The Land of the Free," 88–89, plate 14.

125. Winter, "Views of Biddle's Island," 5; No. 234 in catalog.

126. Peat, *George Winter, Pioneer Artist*, No. 17; Nos. 183, 197, and 267 in catalog; Yarnall and Gerdts, *Index to American Art Exhibition Catalogs*, 3962, 3968.

127. Peat, *George Winter, Pioneer Artist*, No. 18; No. 241 in catalog.

128. Yarnall and Gerdts, *Index to American Art Exhibition Catalogs*, 3965–66, 3976–77, 3981.

129. Ibid., 3971. This may be the painting in the collections of the Tippecanoe County Historical Association. Peat, *George Winter, Pioneer Artist*, No. 3.

130. No. 137 in catalog. The individual watercolor portrait is in the Mrs. Cable G. Ball Collection.

131. The early collection history of this painting is recounted by Thornbrough, "Biographical Sketch," 86; it was later obtained by Edward P. Hamilton, a Wisconsin pioneer collector of archaeological material, who donated it in 1956 to the Wisconsin Historical Society (No. 1956.5000).

132. For example, Samuel Seymour in William H. Keating, *Narrative of an Expedition to the Source of St. Peter's River*, 2 vols. (London: Geo. B. Whittaker, 1825), plate 3; Ewers, *Artists of the Old West*, 39; Karl Bodmer in Maximilian Prinz zu Wied, *Reise in das Innere Nordamerika in den Jahren 1832 bis 1834*, 2 vols. and atlas (Coblenz, West Germany: J. Hoelschen, 1839–41), atlas:plates 3, 7, 12, 20, 33, 45, 46.

133. Truettner, *Natural Man Observed*, 56; Horst Hartmann, *George Catlin und Balduin Möllhausen: Zwei Interpreten der Indianer und des Alten Westens* (Berlin: D. Reimer, 1984).

134. Yarnall and Gerdts, *Index to American Art Exhibition Catalogs*, 3967.

135. Ibid., 3971, 3972.

136. GWMSS 1-12 [8].

137. Ibid., 2-1 [3].

138. Yarnall and Gerdts, *Index to American Art Exhibition Catalogs*, 3978.

139. GWMSS 1-10 [3, 10, 11, 14, 17, 21], 1-11 [10].

140. Yarnall and Gerdts, *Index to American Art Exhibition Catalogs*, 3961, 3978.

141. Henry Rowe Schoolcraft, *The American Indians: Their History, Condition and Prospects, from Original Notes and Manuscripts* (Buffalo, N.Y.: George H. Derby & Co., 1851), facing 96.

142. Yarnall and Gerdts, *Index to American Art Exhibition Catalogs*, 3964.

143. GWMSS 1-10 [11], 1-11 [9], 1-12 [9].

144. Yarnall and Gerdts, *Index to American Art Exhibition Catalogs*, 3964; GWMSS 2-1 [3], 2-1 [56].

145. For example, Cass County Historical Society, Logansport; Mrs. Cable G. Ball Collection, Lafayette; Bancroft Library, Berkeley, Cal. (Rick Stewart, Joseph D. Ketner II, and Angela L. Miller, *Carl Wimar: Chronicler of the Missouri River Frontier* [Fort Worth, Tex.: Amon Carter Museum, 1991], 56, fig. 37).

146. Similar prints served Winter as models for his paintings: *Mariner's Beacon*, Yarnall and Gerdts, *Index to American Art Exhibition Catalogs*, 3961; collection of the

Indiana State Museum, No. 71.975.34.1; Burnet, *Art and Artists of Indiana*, facing 48; Richard, *Productions of My Pencil*, 11; GWMSS 1-13 [29, 30], 2-1 [3, 6, 7]; *Falls of Trysberger*, Yarnall and Gerdts, *Index to American Art Exhibition Catalogs*, 3967, *Dungeon Gill*, ibid., 3966, and probably others.

147. Peat, *George Winter, Pioneer Artist*, [3]; Peat, "Winter, the Artist," 6.

148. Thomas P. Myers, "Catlin and the Conibo: A Cautionary Tale," *Archiv für Völkerkunde* 44 (1990): 153–62.

149. Cottman, "George Winter, Artist: The Catlin of Indiana," 111.

150. Dunlap, *History of the Rise and Progress*, 3:172; Viola, Crothers, and Hannan, "American Indian Genre Paintings," 131–32.

151. In 1850 a fraternal lodge offered Winter a commission to paint a fictional portrait of the Miami chief Little Turtle, but nothing ever came of it. GWMSS 1-12 [16].

152. George Ewing's orders of trade cloth for the Indian trade reflect the highly specific demands of his Native American customers as far as colors and patterns are concerned. See Charles E. Hanson, Jr., "Printed Calicos for Indians," *The Museum of the Fur Trade Quarterly* 24, no. 3 (Fall 1988): 1–11. A detailed comparison of these fashion trends with Winter's watercolors would allow a final judgment of the authenticity of the colors in Winter's work.

153. See, for example, Stewart, *Carl Wimar*, 112–13.

154. Now in the collections of the Tippecanoe County Historical Association. An Indian flute once owned by Winter was lost in 1842, when he lent it to Joseph Barron, who never returned it. Thornbrough, "Biographical Sketch," 68.

155. Charles Callender, "Miami," in *Northeast*, vol. 15 of the *Handbook of North American Indians*, Bruce G. Trigger, ed., W. C. Sturtevant, gen. ed. (Washington, D.C.: Smithsonian Institution, 1978), 681–89.

156. Frederick Webb Hodge, ed., *Handbook of American Indians North of Mexico*, Smithsonian Institution, Bureau of American Ethnology, Bulletin 30, 2 vols. (Washington, D.C.: U.S. Government Printing Office, 1907–10), 1:771. The Polish national hero and veteran of the American Revolution, Tadeusz Kosciuszko, is also reported to have made a portrait of Little Turtle on the same occasion, which is likewise lost. It is impossible to decide whether this was Kosciuszko's own work or a copy of the Stuart painting. Izabella Rusinowa, "Indians in the Reports of Polish Travelers of the Second Half of the Nineteenth Century," in *Indians and Europe*, ed. Feest, 297–306, esp. 298.

157. One, preserved at the Fort Wayne Historical Museum, Fort Wayne, Ind., is attributed to Horace Rockwell (1811–1877); the present location of the other portrait, made by an anonymous painter, is unknown (a photograph, however, exists in the collections of the Chicago Historical Society).

158. The Joslyn Art Museum, Omaha, Neb., owns an 1826 genre painting in oil illustrating a war dance of an unidentified midwestern tribe. Mildred Goosman, *Artists of the Western Frontier* (Omaha, Neb., 1976), 22, 44. Copies by Fielding Lucas of some Lewis watercolors are held by the American Philosophical Society, Philadelphia.

159. Lewis, *American Indian Portfolio*; Kasprycki, "Image and Imagination," 66–68.

160. Only Richardville, Godfroy, and "Little Wolf" are clearly identifiable as signers of the 1826 treaty. "Ca-ta-ke-mon-gua" is identified in the Miami treaty of 1834 as the daughter of Godfroy and Angelique. Charles J. Kappler, *Indian Affairs: Laws and Treaties*, 5 vols. (Washington, D.C.: U.S. Government Printing Office, 1904–41), 2:280, 427, 428.

161. Collection of the Wabash County Historical Society, Wabash, Ind. Among the George Winter manuscripts is a photograph bearing the puzzling inscription "Francis Lafontain died at the Lafayette House Apr. 13, 1847 age 39. La Fontain last Chief of the Miamis. Me-shine-go-ma-shua" and, perhaps in a different hand, "Picture found with Mr. Winter's papers."

162. Keating, *Narrative of an Expedition*, 90, plate 3.

163. Thomas L. McKenney and James Hall, *History of the Indian Tribes of North America: With Biographical Sketches and Anecdotes of the Principal Chiefs*, 3 vols. (Philadelphia: F. W. Greenough, 1838–44), 2:facing 113; James D. Horan, *The McKenney-Hall Portrait Gallery of American Indians* (New York: Crown Publishers, 1972), 326–27.

164. Viola, *Indian Legacy of Charles Bird King*, 96; Andrew J. Cosentino, *The Paintings of Charles Bird King (1785–1862)* (Washington, D.C.: Smithsonian Institution Press, 1977), 184; McKenney and Hall, *History of the Indian Tribes*, 2:facing 107; Horan, *McKenney-Hall Portrait Gallery*, 328–29.

165. Lewis, *American Indian Portfolio*.

166. Kappler, *Indian Affairs*, 2:275–76.

167. Truettner, *Natural Man Observed*, 207–8; George Catlin, *Letters and Notes on the Manners, Customs, and Condition of the North American Indians*, 2 vols. (London: Published by the author, 1841), 2:98, 99–100.

168. J. N. B. Hewitt, ed., *Journal of Rudolph Friedrich Kurz*, Smithsonian Institution, Bureau of American Ethnology, Bulletin 115 (Washington, D.C.: U.S. Government Printing Office, 1937), plate 21; Ernst J. Kläy and Hans Läng, *Das romantische Leben der Indianer malerisch darzustellen . . . Leben und Werk von Rudolf Friedrich Kurz (1818–1871)* (Solothurn, Switzerland, 1984), 46, 112.

169. J. Russell Harper, ed., *Paul Kane's Frontier: Including Wanderings of an Artist among the Indians of North America by Paul Kane* (Austin and London: University of Texas Press, 1971), 59, 276–77, 278, plate IX; Clifton, *The Prairie People*, 310.

170. Hartmann, *Catlin und Möllhausen*, 99, 120.

171. Three ambrotypes and a photograph of Shabbona (one by H. B. Field), two photographs after daguerreotypes of Little Snake, and one photograph after an ambrotype of Shabbona's wife are in the collections of the Chicago Historical Society. Compare, for example, Edmunds, *The Potawatomis*, 72; Clifton, *The Prairie People*, 274.

172. Stewart Culin, *Games of the North American Indians*, Twenty-fourth Annual Report of the Bureau of American Ethnology to the Smithsonian Institution (Washington, D.C.: U.S. Government Printing Office, 1907; reprinted New York: Dover, 1975), 344; Alanson Skinner, *The Mascoutens or Prairie Potawatomi Indians: Social Life and Ceremonies*, Bulletin of the Public Museum of the City of Milwaukee 6, no.1 (Milwaukee, Wis.: Published by the Board of Trustees, 1924; reprinted Westport, Conn., 1970), 43–44; Robert E. Ritzenthaler, *The Potawatomi Indians of Wisconsin*, Bulletin of the Public Museum of the City of Milwaukee 19, no. 3 (Milwaukee, Wis.: Published by the Trustees, 1953), 167.

173. Culin, *Games of the North American Indians*, 722–28.

174. Publius V. Lawson, "The Potawatomi," *The Wisconsin Archeologist* 19 (April 1920): 69–74, esp. 70; Skinner, *Mascoutens or Prairie Potawatomi*, 20, 224–25.

175. One of Möllhausen's Potawatomis carries his clay pipe in his hair (compare Kasprycki, "Image and Imagination," 118, for the identical practice among the Menominee). Both tomahawk pipe and stone pipe with wooden stem are also illustrated by Lewis in his portraits of Me-no-quot and Chat-o-nis-see.

176. See, for example, Winter's depiction of a tripod kettle hanger in *Indians Washing*, already noted.

GEORGE WINTER:
MIRROR OF ACCULTURATION

R. DAVID EDMUNDS

In 1837, when George Winter first arrived in the central Wabash valley, he encountered an environment of change. The young and boisterous state of Indiana, which had just celebrated its twentieth birthday, housed a rapidly growing population eager to exploit the region's rich natural resources which the fledgling *Logansport Telegraph* described as "the basis of that pyramid of prosperity which active enterprise will erect." Indeed, although much of the Hoosier State still was covered by virgin forests or prairies, its frontier period was rapidly coming to a close, and booming communities such as Logansport, Peru, and Lafayette looked forward to a prosperous future when Indiana would take its place as one of the more settled and prosperous states of the Union.[1]

There were other inhabitants of Indiana who did not share in this enthusiasm. The northern half of the state still contained large numbers of Potawatomi, Miami, and some Delaware people, and these Indian residents were less sanguine in their appraisals of the state's future. Although all of these tribes previously had relinquished their claims to most of their lands north of the Wabash, they still occupied numerous small individual or village reservations, and many held a deep emotional attachment to

the region. Both the Miamis and Potawatomis had occupied the region since early in the eighteenth century, and although state and federal officials recently had attempted to remove them west of the Mississippi, the Potawatomis and Miamis clung tenaciously to their homeland, steadfastly refusing both the threats and the promises of the government.[2]

Most Hoosiers considered the Indians to be a nuisance. Like many other settlers throughout the Middle West, white residents of the Wabash valley argued that the Indians remained a barbaric, backward people who refused to accept American "civilization." Although Indians had adopted some of the technological advantages of European culture (firearms, metal utensils, clothing, etc.) and had fallen victim to some of its vices (alcohol), federal officials such as Indian Agent Abel C. Pepper and Sen. John Tipton argued that Potawatomi and Miami culture remained in a static state; they were incapable of meaningful change. As long as they remained in Indiana their condition would continue to deteriorate. Indeed, according to Superintendent of Indian Affairs Thomas McKenney, the Potawatomis, Miamis, and other tribal people "pretend to [do] nothing more than to maintain all the characteristic traits of their race. They catch fish, and plant patches of

corn; dance, paint, hunt, get drunk, when they can get liquor, fight, and often starve."[3]

Yet McKenney's and Tipton's assertion that the Potawatomis and Miamis were culturally stagnant reflected the ignorance and ethnocentricism of these officials and many other Americans. As George Winter's paintings and other evidence from this period amply illustrate, both the Potawatomis and Miamis had made significant cultural changes during the seventeenth and eighteenth centuries. Far from existing in a static, cultural limbo, these Indians had proven remarkably adaptive and had combined traditional tribal values with many new ideas offered to them by Europeans. But to understand this transition, it is necessary first to examine the traditional Potawatomi and Miami life-styles, and then to investigate the Europeans with whom they had the most contact.

Both the Potawatomis and Miamis were Algonquian-speaking people, linguistically related to a broad spectrum of tribes which occupied much of the Northeast, the Great Lakes region, and part of the northern plains. Although the Potawatomi language closely resembles Ottawa or Chippewa, while Miami is more similar to Illinois, both tribes could (with a minimum of difficulty) understand each other. Their socioeconomic systems were almost

identical. When first encountered by the French, both tribes combined hunting, fishing, and gathering with horticulture, assembling together in large tribal villages during the spring, and remaining in these settlements until their crops of corn, squash, and pumpkins were harvested during the following autumn. Following the harvest, both the Potawatomis and Miamis scattered into small winter hunting camps occupied by extended families. While in their larger summer villages, both tribes participated in a series of religious ceremonies and religious and social activities at which friendships and family ties were renewed and strengthened. During the winter, however, families remained more isolated, and individuals spent the cold, dreary months sitting by their lodge fires crafting, sewing, or repairing the utensils or clothes which were used by their members. During the winter months, grandparents and other elders huddled around the fire and shared their rich knowledge of tribal stories or traditions with their grandchildren.[4]

Both the Miamis and Potawatomis believed that their world was influenced by a myriad of supernatural entities. In addition to one great power in the universe, they believed that the forests, prairies, and streams hosted numerous other spirits who held considerable hegemony over their daily lives. Both tribes asserted that they had a special relationship with a cultural hero or "trickster" (the Potawatomis called him Wiské) who had provided their people with many of the lessons and necessities of life. Individuals or family members maintained their contacts with particular manitous or spirits through their use and possession of sacred bundles, while members of both tribes regularly consulted with shamans or medicine people, tribal members who possessed particularly effective skills in dealing with the manitous.[5]

While Miami and Potawatomi children sat by the fire listening to their elders tell them of tribal traditions and manitous, their mothers and aunts prepared and sewed the deer and elk skins which both sexes used for clothing. Women wore a simple, sleeveless, deerskin dress, and in the winter they added deer or elkskin leggings. Men wore a breechcloth, held in place by a leather belt, and in cooler weather they also wore leggings. Both sexes wore moccasins, and in the winter they wrapped themselves in bearskin or buffalo-hide robes. Most of their everyday clothing was unadorned, or decorated only by painted symbols, but their ceremonial dress was embellished with shell and copper ornaments and trimmed with dyed porcupine quills, usually arranged in a floral pattern. Women always wore their dark hair long, although men often shaved their heads except for a traditional scalp lock.[6]

Everyday life followed a strict division of the sexes. Men hunted, fished, trapped, and made war. Women planted, cultivated, and harvested the crops. Women also prepared food, manufactured clothing, and cared for the children. Both sexes cooperated to build the frame and bark houses which were utilized in the summer, or the more compact, frame and mat-covered wigwams used during the winter months.[7]

A communal people, the Potawatomis and Miamis originally took their identity as members of extended families or clans. Individual initiative or welfare was sublimated for the benefit of one's family, and primary allegiance was to one's father's (patrilineal) clan. A Potawatomi or Miami warrior gained prestige through his generosity, and those individuals who provided or shared the most were the most honored. Moreover, many possessions also were owned communally, each individual using a canoe or utensil when he or she needed it. In 1700 it would have been unconscionable for any Potawatomi or Miami to hoard any material possession if such an item was needed by another member of his family, clan, or tribe.

Potawatomi and Miami clan systems also shaped the political structures of both tribes. Since individuals' loyalties were focused primarily upon their clan or kinship group, both tribes originally lacked any centralized political structure, and tribal unity (if such a concept existed) was maintained by a common language, religious ceremonies, and kinship ties. Summer villages usually were led by village chiefs, highly respected older warriors who served as mediators in intravillage, or intratribal disputes; but they served only because other members of the village believed they possessed the common sense and accumulated wisdom to provide sound judgments. They often were assisted by a village council of other seasoned warriors, but neither the chief nor the councilors possessed any coercive power, and if individuals within the village became disenchanted with their leadership, they were free to leave. Unquestionably, prior to the late eighteenth century, no single village chief or even group of chiefs claimed to speak for or govern either the Miami or the Potawatomi tribe.[8]

By the early nineteenth century, both tribes were undergoing significant change. Like many other Indian people in the Great Lakes and Ohio valley region, the Miamis and Potawatomis of northern Indiana had been considerably influenced by those Europeans with whom they had had the most contact: the Creole French. French officials, priests, and coureurs de bois had first settled in Indiana during the early eighteenth century. Posts

were established near South Bend (Fort Saint Joseph), at Fort Wayne (Fort Saint Philippe, later Fort Miamis), Lafayette (Fort Ouiatenon), and Vincennes, and these settlements became the nucleus for the French penetration of the Wabash valley and northern Indiana. By 1776 the vast majority of Europeans who lived in Indiana, Illinois, Michigan, or Wisconsin were of French descent and their Creole dialects had become the lingua franca of the region. As late as the War of 1812, frontier settlements such as Vincennes, Fort Wayne, and Detroit held predominantly French-speaking populations, and in 1816 territorial governor Lewis Cass estimated that "four fifths" of the white population of Michigan Territory were of "that class of population."[9]

Many of these French settlers exercised considerable influence within the Potawatomi and Miami villages. Active in the fur trade, Creole merchants carried their wares to the Indian villages, bartering their merchandise for beaver, muskrat, or otter pelts taken along the Eel, the Tippecanoe, or the Kankakee rivers. Since these traders bargained directly with the tribespeople, many of the Creoles learned the Miami and Potawatomi languages, and during the eighteenth century they also adopted other facets of Miami or Potawatomi culture. Before the American Revolution most Creoles traveled in pirogues, or birchbark canoes, and they attired themselves in a combination of native and European costume. Most wore moccasins, deerskin leggings, and winter clothing made of traditional hides or fur, but they also wore cloth shirts and caps, and wrapped themselves in trade blankets. The Creole traders not only dined on venison, fish, maize, and other Indian fare, but they also brought their own brandy, and after establishing permanent posts along the Wabash

or the Illinois, they attempted to grow wheat and mill flour for bread. Unlike the British settlers on the eastern seaboard, the Creole French of Indiana, Illinois, or Michigan did not insist that their Indian neighbors relinquish their traditional way of life and embrace a foreign, European culture. Indeed, rather than forcing the Miamis and Potawatomis to become Frenchmen, the Creoles initially adopted much of the Indian culture, readily utilizing those aspects of Potawatomi or Miami life which proved to their advantage.[10]

The Jesuits facilitated this acculturation. Some of the French priests who first ventured into the Potawatomi and Miami villages demanded that these tribespeople embrace the totality of Roman Catholicism, but by the late eighteenth century the Jesuits had learned that the Indians were much more receptive to a faith that combined Catholicism with traditional tribal values, and the priests wrapped a Roman Catholic veneer around traditional Potawatomi or Miami ceremonies. The Jesuits maintained a mission on the St. Joseph River from the 1690s through 1773 (when Pope Clement XIV dissolved their order), but in the decades following the American Revolution, the mission had been abandoned. Still, priests from Vincennes and Detroit periodically visited northern Indiana, holding Mass, baptizing converts, and keeping the Creoles and the Indians Catholic in form, if not always in substance.[11]

The Jesuits also officiated at some of the many marriages that occurred between Creole traders and Potawatomi and Miami women. By the early nineteenth century such unions had produced a growing number of mixed-blood or métis people who resided in both the Creole and Indian communities. Indeed, American observers venturing into Illinois, Michigan, or

Indiana frequently commented upon the large numbers of mixed-blood people who inhabited the frontier settlements. In Illinois, militia captain Roger Craig complained that the settlement at Lake Peoria was full of such "damned rascals," while at Detroit, Cass reported that "many of the traders and a great many of the agents and clerks employed by the companies have Indian or half-breed wives and the mixed offspring they produce have become extremely numerous." At Fort Wayne, William Keating complained that "the inhabitants are chiefly of Canadian [French] origin, all more or less imbued with Indian blood . . . it is almost impossible to fancy ourselves still within the same territorial limits" of the United States.[12]

In contrast to the settlers who were pouring into the southern part of the state, the mixed-bloods showed little interest in agriculture. Emulating their French forefathers, the mixed-blood Miamis and Potawatomis remained active in the fur trade, which still held many attractions. Traders were men of wealth who enjoyed considerable economic and political influence, but they were not tied down to small farms and the drudgery required to maintain them. The mixed-bloods' kinship ties within the Miami and Potawatomi tribes provided them with access to these communities and facilitated their commerce; and as cultural brokers the mixed-bloods spoke the tribal languages and always were welcome in the scattered Indian camps. Moreover, because many of these mixed-blood Potawatomis and Miamis possessed the rudiments of a frontier education, they understood the vagaries of frontier bookkeeping. Some were so adept that British or American firms attempted to hire them as agents. Most, however, remained self-employed. Many were quite successful. Of particular note was Miami mixed-blood Jean Baptiste

Richardville, who maintained a trading post at Fort Wayne. In 1816, when Indiana entered the Union, Richardville was reputed to have been the wealthiest man in Indiana.[13]

Yet neither their wealth, education, nor business acumen endeared them to the Americans. Ethnocentric in their perspective, Hoosiers and other Anglo-Americans considered both the mixed-bloods and their more traditional kinsmen to be "uncivilized" and incapable of assuming any meaningful role in the new state of Indiana. Although many Miami or Potawatomi mixed-bloods spoke French, in addition to several Indian languages, and maintained extensive trading ventures, the Americans described them as "ignorant" because they spoke no English. At Fort Wayne, the site of considerable Miami and Potawatomi trading activity, William Keating complained that his contacts with the mixed-bloods produced "a surprising, and to say the least, an unpleasant effect; . . . the traveller fancies himself in a real Babel."[14]

Many Hoosiers also disliked the mixed-bloods' continued adherence to other aspects of Native American culture. Some Americans were critical of Potawatomi or Miami clothing, commenting that their costumes, which combined both traditional Indian attire with American or European clothing, were "something which partakes of the ridiculous, as well as of the disgusting." At Vincennes, Adam Walker, a member of the Fourth Regiment of the United States Army, described mixed-bloods employed by the army as a rabble whose "appearance caused us to doubt whether we had not actually landed among the savages themselves." Although some observers admitted that many of the Indians dressed well, "good blankets—leggings winged with expensive ribbons—moccasins of shewy kind—handsome turbans—good wide black ribbons attached to their cue (hair)," others carped that the Potawatomis and Miamis continued to utilize only skins and expensive trade cloth. Unlike the sturdy American settlers, they refused to dress in plain homespun or wool garments.[15]

Other Americans argued that the mixed-bloods would never be accepted on the frontier because they were of "mongrel" descent, the products of mixed marriages. Francis Parkman, one of the most widely read American authors of the nineteenth century, claimed mixed-bloods were "a race of rather extraordinary composition, being . . . half Indian, half white man, and half devil." At Fort Wayne, William Keating charged that the settlement "contains a mixed and apparently very worthless population . . . all more or less imbued with Indian blood," while at Detroit, Cass complained that the Potawatomi mixed-bloods who inhabited southern Michigan and northern Indiana possessed the vices of both races while failing to inherit any of the virtues. Unquestionably, most Americans subscribed to the popular stereotype that "half-breeds," at best, were a shifty lot, a people caught between two cultures. According to Baptist missionary and Indian Agent Isaac McCoy, the Potawatomi mixed-bloods near South Bend were lazy, possessed an exalted and "mistaken sense of honor," and posed a "formidable obstacle" to the "improvement" of the other Indians.[16]

Indeed, it was this "obstacle to improvement" that most vexed the Americans; for the mixed-bloods and their kinsmen among the Miamis and Potawatomis refused to become farmers. To the settlers flocking into Indiana from Kentucky and southern Ohio, this lack of interest in small yeoman agriculture was the worst sacrilege imaginable. Eager to open the remaining Miami and Potawatomi lands to white settlement, American officials charged that the Indians allowed most of their lands to lie uncultivated, and the small gardens they tended "shew the extreme defect of agricultural knowledge." They were interested only in "limited husbandry." Consequently, agricultural products formed "only a small proportion" of the Indians' "subsistence," and they spent "half the year in labor, want, and exposure, the other half in indolence and amusements." From the Hoosier perspective, if the mixed-bloods and their full-blooded kinsmen were not farming the land, they were wasting it.[17]

But if the mixed-bloods and the Indians were "lazy" and spent half the year in "want and exposure," how could they spend the remaining months in "indolence and amusements"? How could a people who many frontiersmen characterized as "destitute" support themselves? Moreover, if the Indians were so short of material resources that the government decided to remove them beyond the Mississippi to "save" them, why did white travelers venturing among the tribes so rarely mention food shortages among the Potawatomis and Miamis during this period? Surely, neither the mixed-bloods nor their full-blooded relatives regularly feasted upon sumptuous banquets, but by all accounts they dined as well as most white frontiersmen in the Wabash valley; indeed their fare was very similar. In addition, Hoosier descriptions of Indian clothing sewn from expensive trade cloth; brightly colored shawls, ribbons, and turbans; and Indian women bedecked in trade silver suggest a level of prosperity which many whites did not enjoy. And by all accounts, most of the Indians' horses were fine animals, much admired by the settlers, who also commented that the animals often were equipped with "all the accouterments of an Arab potentate."[18]

Why then did American settlers

and officials from state and federal governments describe these Indians as "savages" and urge their immediate removal to the West? The answer, of course, lies in the Americans' ethnocentric appraisal of the Potawatomi and Miami way of life, and in the tribespeople's continued occupation of potentially valuable farmland in the upper Wabash valley. Envisioning a land of small yeoman farmers, Hoosiers found no place for a people who refused to till the soil or to function as tradesmen within the established white communities. Although many of the Indians obviously remained self-sufficient, their continued residency in northern Indiana constituted a potential threat to the development of the region. How could Hoosier land speculators and businessmen attract new settlers into the Wabash, Tippecanoe, and Eel valleys if these areas were "plagued" by small communities of Indians? Obviously, neither the Miamis nor the Potawatomis posed any military threat, but many whites compared them to "gypsies," a people who maintained semipermanent residences, but who also wandered about the countryside forming temporary campsites as they continued their hunting, trapping, or trading activities.

The mixed-bloods posed a potentially more dangerous problem. They were more sedentary than their less-acculturated kinspeople, but they also were more prosperous. Described as "wily," "manipulative," or "renegades" by federal officials, they actually were far better equipped than the less-sophisticated full-bloods to represent the tribes' interests in negotiating with the federal government. Relatively well educated, they understood the machinations of frontier land policy and often intervened during treaty proceedings to acquire individual reservations for themselves and other Indians.

But since these small individual reservations then formed a haven for those communities of Indians who remained in Indiana, such intervention ran counter to federal Indian policies.[19]

The prosperous and successful mixed-bloods also posed another threat to the government's plans for Indian removal. They continued to provide a very viable role model for their less-acculturated kinsmen. Although some of the full-bloods had grown dependent upon government annuity payments (goods or money provided to the tribespeople as payment for land cessions), most of the mixed-bloods remained entirely self-sufficient, actively trading throughout the Indian and Creole communities. Some officials feared that if the full-bloods emulated their kinsmen, and also became more self-sufficient, they would be much more difficult to remove from Indiana. Consequently, both federal and state officials brought considerable pressure upon the Potawatomis and Miamis to remove as soon as possible.

George Winter's paintings and correspondence provide some unique insights into these events. His paintings and sketches illustrate that most of the Potawatomis and Miamis whom he encountered were not a destitute people. On the contrary, his paintings indicate that they were well dressed, arrayed in clothing that both illustrated their wealth and indicated their degree of acculturation. Most of the Potawatomi and Miami men portrayed in Winter's paintings are dressed in frock coats similar to those worn by prosperous white settlers on the Indiana frontier. The coats are well tailored, with wide, fashionable lapels and natural, unpadded shoulders. Most are sewn from wool or broadcloth and fashioned in black, gray, or other conservative colors, although Miami mixed-blood Jean Baptiste Brouillette,

and Wewissa, a Potawatomi chief, are attired in lighter hues. Almost all of the men are wearing ornate, ruffled shirts, and two mixed-bloods, Brouillette and Francis Godfroy, are wearing vests or waistcoats. In a similar subscription to European or American fashion, most of the Potawatomi and Miami men featured in Winter's portraits are garbed in European or American neckwear.

Yet other parts of the men's clothing indicate the ties to their Indian heritage. Although the ornate, ruffled shirts were probably admired by most white Hoosiers, the Potawatomis and Miamis wore them loose and very long. They were not tucked into trousers. Indeed, almost all of the Indians still wore the traditional breechcloth, held

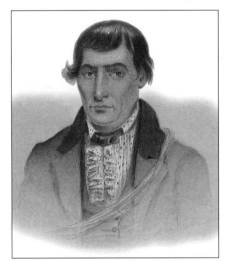

SUN-GO-WAW *(see Plate 10 and Cat. #111)*

in place by a belt, and worn under the long shirt. The shirt and coat were augmented by leggings. As Winter's paintings illustrate, the leggings, at least upon special or ceremonial occasions, were quite ornate and were decorated with fringe, multicolored embroidery, or expensive ribbons. Forgoing the rough leather shoes and boots crafted by frontier cobblers, all the men wore more comfortable and highly decorated moccasins.

Other parts of the men's clothing reflect varying degrees of acculturation. Some of the men, such as Sungowaw, Benache, and Wewissa are wearing colorful woven sashes, draped

BEN-ACHE *(see Plate 11 and Cat. #47)*

over one shoulder and passing under the opposite arm. Benache and We-wissa also wear such sashes around their waists. Some of the Potawatomis and Miamis have cut their hair to resemble the styles worn by white frontiersmen, while others, Swago, Pashpoho, and Wewissa, have kept theirs longer, in the styles used by the Shawnees and Wyandots. In an interesting combination of both Indian and white hairstyles, mixed-blood Francis Godfroy wore his hair short except for one long braid or "cue," which he tied with a black ribbon and which Winter portrays as draped over his left shoulder.

Head coverings also indicate a broad range of acculturation. Many of the Potawatomis and Miamis wore brightly colored scarves wrapped around their heads to form turbans. Turbans were common among the Ohio and Indiana tribes and were widely utilized by the Creeks, Cherokees, and some of the other southern Indians. In the decades prior to the War of 1812, and shortly after, many of the warriors adorned the turbans with feathers, including highly valued ostrich plumes that were acquired from British traders. After the War of 1812 most of the northern tribesmen wore feathers only on ceremonial occasions. Among Winter's subjects,

only older Potawatomi men such as Kawkawkay, Mesquabuck, and one unidentified man still wore "a bunch of feathers on the crown of their head." Others, such as Sackhum, a Miami, and Francis Godfroy seemed to prefer top hats purchased from frontier merchants.[20]

Although Winter commented that some of the Potawatomi men and women "were painted very curiously" in red and black, only Notawkah and old Kawkawkay are portrayed wearing such a traditional decoration. In a similar break with tradition, all but Mesquabuck and Peewawpay, a Miami, had relinquished wearing a silver ring through the septum of their noses, although such an ornament had been worn widely prior to 1815. Many of the men continued to wear earrings, and these adornments remained in fashion among both the full-bloods and mixed-bloods after their removal to Kansas.[21]

Winter's portrayal of Miami and Potawatomi women also reflects their wealth and acculturation. Winter was very impressed with the women's colorful, beautifully ribboned garments which "could not fail to arrest the eye of a common observer, much less an artist's . . . who must ever be ready to drink in what ever is lovely, attractive, and beautiful." In describing Joseph Barron's wife, Winter declared that "her wardrobe is very splendid and costly, . . . handsomely checkered by various colored ribbons, etc., and with a handsome shawl, moccasins, and a hundred rows of beads around her neck, she has a singular and picturesque appearance." Indeed, most of the Miami and Potawatomi women painted by Winter wore dark, full, broadcloth skirts that fell almost to their ankles, loose-fitting, brightly colored blouses (often sewn of "the finest silk"), and an embroidered or highly decorated shawl which also could serve as a head covering. Their leggings, or

"nether garments" as Winter so modestly described them, were "also made of cloth, handsomely bordered with many colored ribbons, shaped into singular forms—and wrapped so tightly around them, that they waddle rather than walk." On their feet the women wore moccasins, often decorated with beads, ribbons, or porcupine quills.[22]

Mirroring their husbands' financial status, many of the women bedecked their clothing and themselves with trade silver. All wore heavy silver earrings, and many carried "red and black blankets, as their rich mantles are called, which are made of superfine broad cloth decorated with colored ribbons, and silver ornaments, very costly, and are worn over the head and covering the body very gracefully." Winter joked that many of these "capes" were so covered with silver rings that they "had the appearance of armor." He estimated that because of the silver ornaments attached to them, some of these garments "were estimated as being worth $200." Winter's portraits of two Potawatomi women, Massaw and D'mouchekeekeeawh, illustrate his subjects' wealth and status. Married to Creole trader Andrew Goslin (Gosslieu), Massaw's wealth is displayed in the heavy silver ornamentation on her cape and in her expensive blue crepe shawl with orange figures. D'mouchekeekeeawh was married to half-blood Abram Burnett and

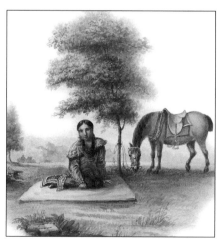

MIAMI INDIAN GIRL *(see Plate 12 and Cat. #161)*

also ornamented her shawl with a cape of trade silver.[23]

Descriptions and paintings of Potawatomi and Miami housing also indicate that both tribes were using residential structures modeled after the Europeans. Some tribespeople continued to live in the mat-covered wigwams and pole and bark summer houses used by their forefathers, but by the 1830s most of the Potawatomis and Miamis in northern Indiana lived in log cabins similar to those utilized by both the Creole French and the Anglo-Americans. As Winter's paintings of Osage Village and Deaf Man's Village indicate, most of these cabins were modest dwellings, usually surrounded by split rail fences and a few outbuildings. Winter described Deaf Man's Village, a Miami settlement on the Mississinewa, as "one bark hut resting on the ground, resembling a gable roof. The double log [cabin] in which the Captive [Frances Slocum] lived—two or three cabins of lesser pretensions were attached to it—making a formal line parallel to the river. . . . A good-size log stable stood farther back diagonally from the main building; and a tall corncrib stood farther back to the left, separated by some fifty yards distance." After spending the night at the Slocum cabin, Winter recorded that the Indians slept on wooden "bunks, . . . such as are commonly used by frontier people," hung their clothing upon pegs driven into the walls, kept a rifle standing in the corner, and stored many of their more valuable personal possessions in boxes and containers on the mantle of the fireplace. Although Winter commented that his bedroom contained no chairs and was "rude and aboriginal in nature," the dwelling and its outbuildings so closely resembled cabins utilized by non-Indians that Winter and other travelers could not distinguish that the cabin was occupied by Indians unless they had examined the contents of the interior or met the residents.[24]

Some of the Potawatomi and Miami homes were more substantial. After sketching and spending some time at Massaw's and Andrew Goslin's residence, Winter commented that this "rich and influential squaw, and her husband, a Frenchman" lived in an "uncommonly large wooden mansion," which was "as good a home as the most affluent farmer possessed, or perhaps aspired to." Although the two-story structure was sparsely furnished, it provided shelter for over twenty guests during the Potawatomi removal negotiations in July 1837. Miami mixed-blood Francis Godfroy's home was even more palatial. Built near Peru, on the banks of the Wabash, "Nan-Matches-sin-wa," or "Mount Pleasant," contained a large, two-story frame residence, a "substantial trading house, . . . well stocked with merchandise peculiarly adapted to the Indian purchaser," a storehouse, several log buildings, and a springhouse located adjacent to the river. Winter visited the Miami entrepreneur at that location in 1839, dined at his host's "generous table," and spent the night in a bed that "was excellent in all its appointments," including "clean sheets that indicated the impress of civilization and comfort." After eating a hearty breakfast, Winter made a preliminary sketch of the estate, but the painting evidently never was completed.[25]

In addition to material objects, Winter recorded a series of activities which illustrate the Indians' blending of European and Native American cultures. For example, both the Miamis and Potawatomis continued to practice many of their traditional dances. In July and August 1837 Winter attended the council proceedings at Keewaunay's village (located on Bruce Lake in western Fulton County), where he observed the Potawatomis participating in an impromptu dance to celebrate the occasion. After a large bonfire was kindled, the tribespeople assembled in a large circle, and accompanied by a drum and "the wild gutteral strains of a child of the forest" about forty Potawatomi men danced around the interior of the assemblage. After considerable "yelling, whooping, and laughing," they were joined by about a dozen "superbly dressed" women whose "manner of dancing was of an entirely distinct character from the men. They merely shuffle or scuffle along—scarcely raising their moccasins from the ground." Yet other Potawatomis, particularly the mixed-bloods, also enjoyed European or American music, and Winter remarked that "I found many among them who were good fiddlers, and to their good offices, the Indians were enlivened in their wigwams, . . . and the early settlers in around the settlements." Among these musicians was Miami mixed-blood Bill the Fiddler (William Brouillette), whom Winter included in a group portrait.[26]

Winter's paintings and descriptions of Potawatomi and Miami games and amusements not only offer some valuable insights into how these people passed their leisure time but also illustrate the tribespeople's acculturation. Winter was particularly interested in the more traditional games played by these Indians, and he sketched or painted the Potawatomis playing "Wink," "Moccasin," and "Yuh-Youh-Tche-Chick." "Wink" was a contest between two individuals who stood face-to-face and stared at each other. The first individual to blink, or "wink," lost the contest. As Winter's sketch illustrates, such staring matches attracted the attention of other Indians and were surrounded with much good-natured joking and teasing. "Moccasin" could be played by individuals or teams and involved the concealment of

several small objects under a series of upturned moccasins. One individual or team hid the objects, while the other individual or team tried to guess their location. "Yuh-Youh-Tche-Chick" was a game usually played by men and involved the casting of small, flat, stone discs. The object of the contest was to cast the discs as close to a predetermined target as possible. All of these amusements often were associated with considerable wagering or gambling, as were card games, played by both sexes, but particularly popular with Potawatomi and Miami women. Although Winter commented that he was unable fully to understand some of the Indian card games, they were played with European or American playing cards. Both tribes also played American card games popular on the Indiana frontier, and Massaw, the Potawatomi wife of Andrew Goslin, was a "gambler of no ordinary ability . . . she played euchre very well," and was highly skilled at poker, often "raking men of experience who attended her receptions in the second story of the cabin."[27]

Winter also records a widespread and more negative aspect of Potawatomi and Miami acculturation: a growing addiction to alcohol. The French had first introduced brandy among the western tribes, and, like other Indian people, the Potawatomis and Miamis had developed a fondness for "Onontio's milk." After the American Revolution, frontier traders plied the tribes with whiskey, and the fiery liquid became the "dram of darkness" for many of the Indians. Winter's correspondence and journals indicate that many frontier Hoosiers, like their Indian neighbors, used the "vile beverage" to excess, but he believed that whiskey was "an article of fearful destructive influence upon the aboriginal race." In August 1837, when Winter arrived at the Potawatomi removal

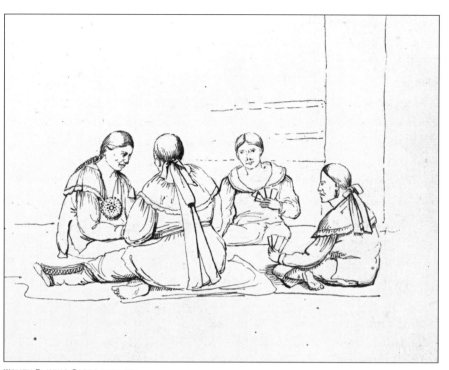

WOMEN PLAYING CARDS *(see Cat. #70)*

camp at Crooked Creek (about nine miles west of Logansport), he found that Keewaunay, one of the principal Potawatomi chiefs, was inebriated, and that "a great number of the Indians have left the camp for Logansport to indulge in intoxication." While in the camp he encountered Swago, who also had been drinking, and Naswawkay, so drunk that he had threatened the lives of Indian Agent George H. Proffit and several of his Potawatomi kinsmen. In his notes and correspondence Winter indicates that Potawatomi leaders such as Ogamaus, Benache, and Aubbeenaubbee all were plagued by alcoholism, and Winter's painting of Swago, painted near the mouth of the Eel River in 1837, pictures the intoxicated subject sitting near a stump, his finger stuck in the mouth of a whiskey flask. Ironically, Winter's painting of Pashpoho also portrays him in a similar condition. Although Pashpoho was described as "a perfect Indian Dandy" and usually took great pride in his appearance, he previously had refused to allow Winter to paint his portrait. Following the 1837 council at Keewaunay's village, Pashpoho became drunk and despondent and asked Winter to

paint him sitting in the forest.[28]

Pashpoho's reluctance to have his portrait painted illustrates that many of the Potawatomis and Miamis still retained at least part of their traditional value system. Subscribing to a widely held Native American belief that if an artist created an accurate likeness of an individual, the artist would gain supernatural power over that individual, or capture his or her soul, several Potawatomis and many Miamis refused to allow Winter to paint their portraits. Weesaw, an elderly Potawatomi chief, refused to sit for Winter, and the artist could only sketch Mesquabuck surreptitiously, from a distance. Many Miamis were even more reluctant to have their likenesses captured, and after Francis Godfroy continued to refuse Winter's requests, the artist painted him from memory. In a similar manner, Frances Slocum and her daughters also were wary of Winter's requests. The daughters refused to cooperate, but Frances reluctantly agreed to pose only after Winter emphasized that the painting had been commissioned by her white brother. Their uneasiness is mirrored in the finished painting. Both Frances and her oldest daughter Kickkesequa

(the wife of Jean Baptiste Brouillette) are portrayed facing the artist, but Winter painted Kickkesequa from memory. Slocum's younger daughter Osonwapakshinqua is portrayed with her back turned.[29]

Winter's journals and correspondence illustrate that some Potawatomis and Miamis continued to adhere to other traditional beliefs regarding spirits and "medicine." Although many of the Potawatomis had been converted to Roman Catholicism, others still followed their tribal religious beliefs, and both Potawatomi and Miami shamans continued to practice within the tribes. Indeed, even some of the ostensibly Christian Indians resorted to these medicine people for a broad spectrum of reasons, and many of the Miamis kept medicine bags and powders for "spells and incantations." Winter reported that in 1837 the "squaw of M-Jo-Quiss," a relatively acculturated woman, suffered from a "neuralgia attack" and resorted to a Potawatomi medicine man at Potawatomi Mills, at the outlet of Lake Manitou, at present Rochester, Indiana. The shaman was a "chasgied," a diviner and juggler, who after singing the appropriate chants, lanced the woman's scalp with a piece of flint, "placed his mouth upon her head, and affected to suck from the cranium small bones, the cause of her disease." He then "spit the bones into his hand, exhibiting (the objects) to the friends and relatives of the patient, who had submitted to the painful ordeal, . . . with the utmost placidity." According to Winter, "the cure was complete."[30]

By the late 1830s Catholic priests active among the Potawatomis were preaching against such medicine men. After the Saint Joseph mission had closed in 1773, priests from Detroit and Vincennes periodically visited the Potawatomi and Miami villages, holding Mass, baptizing infants, and providing the church's sanction to marriages taking place in the region. In 1820, however, Baptist Isaac McCoy had opened a mission school among the Miamis and Potawatomis at Fort Wayne, and two years later, after interceding with federal officials, he was able to acquire a section of land on the Saint Joseph River, near Niles, Michigan, just north of the Indiana-Michigan border. Evidence suggests that the Potawatomis would have preferred a Catholic mission, but McCoy was able to gain access to the government's annual appropriation of one thousand dollars for the mission, and in late December 1822, he moved his school from Fort Wayne to the new site.[31]

Carey Mission, named after William Carey, a Baptist missionary to India, temporarily prospered. By 1825 forty-two male and twenty-eight female students were enrolled in the school and over 270 acres of crops were under cultivation, but McCoy's insistence that his students learn to become small yeoman farmers, and his denunciation of the Roman Catholic faith, earned him the opposition of the Potawatomi mixed-bloods. After 1826 the mission declined, and six years later McCoy abandoned the site and moved his mission to Kansas.[32]

As the Baptists' fortunes declined, the Catholics renewed their efforts. In 1830 Father Stephen T. Badin, a priest from Detroit, established a new mission at a Potawatomi village located near modern Niles, Michigan. He was assisted in his efforts by Pokagon, the village chief, and by Joseph Bertrand, a Potawatomi mixed-blood trader active in the region. Within six months Badin had baptized over three hundred converts, and using his new mission as a base he visited other Potawatomi villages throughout northern Indiana. In 1832 Badin was joined by Ghisler Boheme, who was training for the priesthood, and by Father Louis Deseille, a Belgian priest who had just arrived in the United States. Although the mixed-bloods had become alienated from McCoy, they supported the Catholic efforts, and in turn, the priests championed the mixed-bloods as role models, urging the other Potawatomis to combine some limited farming with hunting, trading, and a variety of economic endeavors. Meanwhile, the priests used their French identity to their advantage. Indeed, in addressing the Indians Badin often referred to himself as their "affectionate father, the *French* Priest," and he was careful to disassociate himself from any identification with federal agents or the Indian

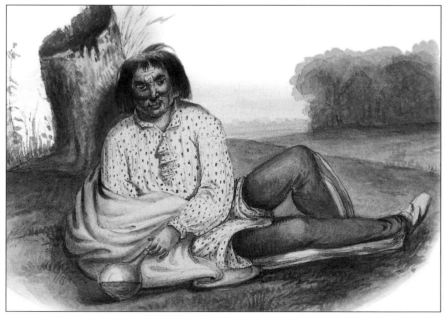

SWAW-GO *(see Plate 13 and Cat. #21)*

policy of the United States.[33]

The Catholic missionary efforts were envisioned as a threat by American Indian agents. During the early 1830s, federal officials purchased the last large tracts of Potawatomi land in Indiana, Illinois, and Michigan. Conducted at a series of treaties held at Camp Tippecanoe, Indiana (1832), and at Chicago (1833), the treaties provided the Indians with over $640,000 in cash, annuity payments, and trade goods, but the agreements ceding lands in Indiana scarcely mentioned removal, only stating that the government would assist the Indians to go west, "if they shall at any time hereafter wish to change their residence." Moreover, as in some previous treaties, federal officials had been forced to allow the Potawatomis to set aside more than 120 small individual or village reservations within the ceded lands before tribal leaders agreed to the large land cession. Obviously, those Potawatomis who wished to remain in Indiana still retained a large, if scattered, land base.[34]

In retrospect, federal officials realized their mistake, and between 1834 and 1836, just prior to Winter's arrival in Logansport, they attempted to purchase the small individual or village reservations. Ironically, they found that many of the mixed-bloods already had sold most of their individual reservations, at a handsome profit, to white settlers. In contrast, the village chiefs still retained those small tracts of land that contained and surrounded their villages, and these village reservations now served as sanctuaries for those Potawatomis who refused to remove to the West. Utilizing both threats and bribery, federal officials then negotiated with the village chiefs and purchased most of the remaining village reservations in northern Indiana.[35]

Menominee, a chief with a village reservation on the Yellow River near modern Plymouth, adamantly rejected federal Indian Removal Agent Abel C. Pepper's offers. A Catholic convert, Menominee sought support from the priests and set aside land within his reservation for a chapel and a parochial school. Badin returned to the East in 1833, but Father Deseille continued his mission. Although Father Deseille assured Pepper that he was interested only in the Potawatomis' "spiritual concerns . . . I am for nothing in all the temporal concerns of the Indians," Pepper informed his superiors that the Catholic influence "must be put down—defeated, or emigration will be retarded." He also denied Deseille permission to establish a Catholic school at Menominee's village.[36]

Deseille's protestation of disinterest in Indian policy was not quite true. Although his primary focus remained the spiritual concerns of his converts, both he and Bishop Simon G. Bruté, at Vincennes, championed a series of self-sustaining Catholic Indian communities on the remaining village reservations in northern Indiana. Indeed, both clerics believed that if the Potawatomis settled down on their lands and adopted "the best moral habits of the civilized life," were economically independent, and subscribed to "temperance, decency, and reverence [for] the laws of the country," the federal government eventually would allow them to remain and become "regular and good citizens" of the United States. Accordingly, Deseille encouraged Menominee and several of his followers to visit Washington, where the Potawatomis met with federal officials and obtained a written promise that they could remain in Indiana as long as they owned their reservation.[37]

Officials in Washington evidently believed that Pepper still could convince Menominee to relinquish his reservation; but they were wrong.

Throughout the summer the agent made repeated offers for the tract, but Menominee refused. Finally, frustrated by Menominee's intransigence, on 5 August 1836 Pepper purchased the tract from Notawkah, Pepinawah, and Mackahtahmoah, three other residents of the reservation. Then, one month later, he purchased several small village reservations which the Camp Tippecanoe treaties had awarded to Ashkum, Checawkose, Kinkash, and Weesionas. But since these chiefs also had refused to sell, Pepper bought the tracts from other Potawatomis whom he designated as "the chiefs, warriors and headmen of the Potawattamies of the Wabash." These "chiefs," Iowa, Pashpoho, Wewissa, Keewaunay, and Pepinawah, were heavily in debt to Ewing and Walker, a trading firm located at Logansport, and did not live on the ceded reservations.[38]

These fraudulent treaties sent a shock wave of anti-American sentiment among the Potawatomi villages along the Tippecanoe River. They also created an intratribal dispute of major proportions. Menominee, Ashkum, Checawkose, and other Potawatomis denounced those tribesmen who had sold their reservations, and Ashkum and Checawkose threatened to kill Iowa, Pashpoho, and the other "chiefs" of the "Pattawatamies of the Wabash." Since both sides attended a major Potawatomi annuity payment shortly after the treaties had been signed, the proceedings erupted in violence, and government officials were forced to suspend the payments. In response, federal agents appointed Judge John W. Edmonds to investigate the charges of fraud and to ascertain just which Indians were to receive the funds. Edmonds also was instructed to investigate the validity of the many financial claims made against the tribe, by both mixed-blood and American traders.[39]

George Winter arrived at Logansport in May 1837 during the midst of this political maelstrom. Many of the individuals whom he encountered were much involved in these events. Judge Edmonds began his investigation of the circumstances surrounding the canceled annuity payments on 13 June 1837, and the proceedings were conducted in the "long room" at Washington Hall, a frontier inn at Logansport. Winter "was in daily attendance in Judge Edmonds' court, watching with great interest the dusky sons of the forest who were examined upon each section of the document which was read and interpreted to them by Rice, the half-breed, who was an educated and intelligent man." Because Winter became so closely associated with the Indian agents and their activities, many of the Indians whom he sketched or painted were members of the faction led by Iowa, Pashpoho, and the other "chiefs of the Pattawatamies of the Wabash." This group of younger Potawatomi leaders had allied themselves with Indian agents Abel C. Pepper, Lewis Sands, and George Proffit, and because their lives had been threatened by some of their kinsmen, they remained close to Logansport.[40]

Foremost among this group was Iowa. Although Winter referred to him as "a young and prominent chief," there is little evidence to suggest that other Potawatomis envisioned him as a leader prior to his elevation by Pepper, and his illegal sale of reservations along the Wabash. Judge Edmonds also "took a fancy to him," and the relatively young Potawatomi leader played a major role in the testimony at Logansport during the summer of 1837. Winter admitted that Iowa, assisted by his brother M'joquis and "others of his clique, by small hidden strategy assumed influence over and above older men . . . this may have resulted from their more favorable view of the

U.S. government, whose representatives passed over the older chiefs." Following the 1836 payment disturbances, Iowa at first feared for his life and requested to remove to the West as soon as possible, but by 1837 he evidently believed that federal officials would protect him, and that if he remained in the East he still would share in the distribution of payments and annuities. Although Pepper paid Iowa and some of his friends $750 for their supposed support of the 1838 removal, Iowa continued to oppose the trek, and when Indian Agent George Ewing spoke in favor of the removal, Iowa denounced him as a liar, stating that each pockmark on Ewing's face (the trader recently had recovered from smallpox) was indicative of a falsehood Ewing had told the Indians. In response, Pepper "threatened to break him of his chieftainship," and Iowa finally agreed to go west. He and his comrades remained frightened of retribution for the illegal sale of the Tippecanoe reservations, however, and feared that their enemies would attack them after they removed to Kansas. Partly in response, federal officials established a new reservation for the Wabash Potawatomis at the Osage River Subagency in Kansas. Ironically, Iowa, Ashkum, and Menominee were all removed to Kansas in the fall of 1838. Winter's journals and notes provide valuable information about Iowa, and Winter's paintings of the young chief are the only known portaits of the man.[41]

Closely allied with Iowa was Pashpoho, another young chief whom Pepper included as a "chief of the Pattawatamies of the Wabash." Considered "the best dressed man of his tribe," Pashpoho allowed Winter to paint him only after he had been drinking, and the resulting portrait features a rather disheveled figure, sitting on a log in the forest. An earlier

portrait by James Otto Lewis (circa 1828), however, pictures Pashpoho in a frock coat, ruffled shirt, turban, and necktie, with a dagger stuck in a sash tied around his waist. Following the fraudulent Tippecanoe treaties, Pashpoho also feared for his life, and during the winter of 1836–37 he remained near Logansport. Like Iowa, he opposed removal but went west in 1838. Ironically, within six months he returned to Indiana where he assumed the leadership of a small village on the Yellow River. Although he again agreed to remove, in October 1839 government funds to finance the removal, which had been deposited in a bank at Delphi, were lost when the bank failed. As a consequence, local officials at Rochester arrested Pashpoho for failure to pay certain debts owed by the Indians in his village to nearby merchants. Indian Agent Samuel Milroy secured his release, and one year later Pashpoho was reunited with Iowa in Kansas.[42]

Naswawkay, an uncle of Iowa and M'joquis, played an important role in these circumstances. Painted by Winter in a group portrait of the Potawatomi chiefs who met with Pepper and other Indian agents at Keewaunay's village, Naswawkay was also featured as the Indian speaker in Winter's painting of the "Kee-Wau-Nay Council." A Catholic convert, Naswawkay was a prominent leader whose village lay near the eastern shore of Lake Maxinkuckee, and although he cooperated with Pepper in the sale of lands and in the removal process, he was respected by most of the factions within the tribe. He served as the principal orator at the councils held at Keewaunay's village, and following the meetings he confidentially warned Indian agents that Iowa was using his influence to prevent the 1837 removal. When agents betrayed his confidence, he became intoxicated and threatened

Indian Agent George H. Proffit's life, but later cooperated in the removal and accompanied Proffit to Kansas in the fall of 1837. Winter indicated that Naswawkay was an intelligent man, with a very good knowledge of the treaties that the Potawatomis previously had signed with the United States. According to Winter, Naswawkay was "dignified in his manner; tall in stature; he has no turban, but his long and flowing hair fell with much grace upon his shoulders. He is far from being handsome, yet he is a remarkable looking Indian."[43]

Keewaunay was an older man who had fought with Tecumseh and the British during the War of 1812. Like many other Potawatomis whom Winter encountered, Keewaunay was heavily in debt to the trading house of Ewing and Walker and had conspired to sell Ashkum's and Pepinawah's villages. He also signed the fraudulent treaty in which Menominee's reservation was illegally sold to the United States. Although he agreed to removal, he obviously was reluctant to leave his homeland, and Winter indicated that he "drowned his sadness" during the weeks just prior to his departure. He eventually accompanied Naswawkay to Kansas during the autumn of 1837.[44]

Several other Potawatomis who were much involved in either the investigations surrounding the 1836 claims payment or the abortive removal of 1837 also were painted by Winter. Ashkum, one of the chiefs whose reservation was illegally sold at the Tippecanoe treaties, was clandestinely sketched by Winter at the subsequent investigations in Logansport. Ashkum was so incensed over the sale that he publicly threatened the lives of Iowa, Pashpoho, and the other "Wabash chiefs," causing the latter to spend much of the winter of 1836–37 in Logansport. A traditional leader of about fifty years of age, Ashkum previ-

ously had served as a major spokesman for the tribe, but Pepper was annoyed by his intransigence and prolonged oratory. In response, Pepper promoted first Aubbeenaubbee, then Naswawkay to the post.[45]

Winter also painted Benache, Notawkah, Wewissa, and Naoquet. Benache was half French, about sixty years old, and from a village located on the Tippecanoe, in the southeast corner of modern Marshall County. During the War of 1812 he reputedly participated in the attack upon the Fort Dearborn garrison. Winter described him as "genial" and of "superior talent," but commented that he was "wild when drunk." A Catholic, Benache avoided removal and died near modern South Bend sometime after 1840. Notawkah, who also participated in the sale of Menominee's reservation, was subsequently employed by Pepper as a guide and messenger. During the summer of 1837 he escorted Winter and a small party of Indian agents from Logansport to Keewaunay's village, generously offering Winter his horse when the author had difficulty with the mount he had hired for the journey. Wewissa, a younger chief also allied with Iowa, participated in the questionable sale of the Tippecanoe reservations and in the subsequent disturbances at the 1836 annuities payment. He attended the council at Keewaunay's village in 1837 but was hesitant about removing to the West. Although he initially agreed to remove in 1837, he withdrew from the removal camp, then again changed his mind and accompanied George Proffit to Kansas. Also participating in these events was Naoquet, or Luther Rice, a mixed-blood who previously had attended McCoy's school at Carey Mission, and the Choctaw Academy at Great Crossings, Kentucky. A bright young man with an excellent command of both Potawatomi and English, Rice

served the government as an interpreter throughout the removal period. During the autumn of 1837 he accompanied another removal party of Potawatomis from the South Bend region that was conducted to the West by Lewis Sands. Rice served as the government interpreter at the Osage River Subagency in Kansas until his untimely death on 21 May 1843.[46]

During the summer of 1837 Winter also encountered Joseph Barron, a French Creole long associated with Indian affairs in Indiana. Born at Malden, Ontario, in 1773, he settled at Vincennes in 1790. Fluent in several tribal languages, Barron was employed by Gov. William Henry Harrison and subsequent officials as an interpreter during the first third of the nineteenth century. He was married to several Indian women, but many of the Indians distrusted him. In 1810 he visited Prophet's Town, where his life was threatened by the Shawnee Prophet, but Tecumseh intervened to guarantee his safety. In 1821 he moved to Fort Wayne, and six years later he relocated at Logansport. Winter first met and sketched Barron during Edmonds's investigation of the 1836 Potawatomi claims disturbances, but in August 1837, while visiting the Potawatomi removal camp at Crooked Creek, Winter met with the old interpreter in his tent, which was elaborately furnished with rugs, blankets, pillows, and a "large black trunk studded with brass nails . . . and a small red one with trinkets . . . rolls of ribbon, and numerous things carelessly, but picturesquely distributed." Barron had recently married the daughter of Naswawkay, a woman forty-five years his junior, but she "manifested by action a good deal of love for the old fellow," and Barron furnished her with a "very splendid and costly wardrobe." According to Winter, Barron, "a man upwards of sixty, . . . possesses considerable activ-

ity, dances well, can wrestle and throw men of nearly twice his weight, can speak seventeen languages, fourteen of which . . . are Indian." Barron accompanied Proffit and the small party of Potawatomis who left Crooked Creek on 23 August 1837. They arrived on the Osage River in Kansas on 27 September. Barron returned to Logansport, where he resided until his death on 12 December 1843. Winter's painting is the only known portrait of this famous frontier personality.[47]

Although most of the Potawatomis mentioned above had ceded their lands, they remained reluctant to leave Indiana. In response, during July 1837 Pepper and several other officials met with many of the "chiefs and headmen of the Pottawattamies of the Wabash" at Keewaunay's village. Winter attended these proceedings, and his journals and paintings provide valuable information about the meeting. Pepper warned the Potawatomis that they could no longer remain east of the Mississippi, for they had "not a handful of land left . . . your fire has gone out. Your wigwams are cold. . . . You cannot live in a country where white men multiply as rapidly as black birds, and as numerous as pigeons." If they would emigrate to the West, the federal government would provide them with land, sawmills, gristmills, rifles, blankets, farm implements, and numerous other articles. Moreover, in the near future, federal officials planned to pay all tribal annuities to those Potawatomis who had removed beyond the Mississippi.[48]

Naswawkay spoke for the Potawatomis and informed Pepper that the Indians did not wish to go west. He reminded Pepper that federal officials had assured them that they would not be removed forcibly, and he chided Pepper that: "We have been promised often that we all should have great riches if we would only sell our lands.

We have been promised rifles and everything that we should want. These young chiefs have not received these things. We stand in wonder and amazement. We have ceded our lands. We see no promises performed."

If the president was really their Great Father, and if the Indians were his children, why should they leave? Would a father send his children into exile? According to Naswawkay, "You call us your children from your mouth, why not treat us as your white children?"[49]

But Pepper persisted, and by early August almost three hundred Indians had assembled at the removal camp on Crooked Creek. Their number soon diminished. Many of these tribespeople were heavily in debt to traders in Logansport, and the merchants feared that if the Potawatomis removed and tribal annuities were paid to the Indians in the West, the Potawatomis would never pay the debts they owed in Indiana. In consequence these merchants spread rumors that Kansas was an inhospitable land, and that once the Indians were deposited in the West, the government would pay them no more annuities. Potawatomis from the removal camp on Crooked Creek were lured to Logansport, where the traders plied them with liquor and informed them that they would have no protection beyond the Mississippi, and that in the West, those Indians still bitter over the sale of the Tippecanoe treaty lands would assassinate them. Frightened by the rumors, Potawatomis began to leave the removal camp, and although both Pepper and Proffit sought to stop the defections, they were unsuccessful. In mid-August Wewissa and his followers withdrew from the camp, and fearful that the removal would completely disintegrate, on 23 August 1837 Proffit led the remaining Potawatomis off toward Kansas.[50]

The removal party contained only

fifty-two Indians. As they passed through Illinois they contracted cholera and encountered heavy rainfall that flooded several rivers in their path. They crossed the Mississippi at St. Louis and arrived in Kansas in October. By the following summer, most of these Potawatomis had returned to Indiana.[51]

Winter's painting of the council at Keewaunay's village provides a visual image of the leading figures in these events. In the painting, Pepper is seated at the right end of the table. To his right is Lewis Sands, a removal agent, whose arm rests on the table, and George Proffit is standing behind Sands. Col. John B. Duret, who served as the secretary for the proceedings, is seated in front of the flagpole, at the opposite end of the table, holding a pen. Behind Duret, standing next to the flagpole, is mixed-blood Joseph N. Bourassa, a government interpreter. To Bourassa's right stands Joseph Barron. On the far left, Naswawkay stands facing the agents with his hands placed before him. Behind Naswawkay is Wewissa, and to his right is Iowa, whose arms are crossed across his chest. To Iowa's right sits Pashpoho, his arms embracing his knees, and M'joquis. Behind M'joquis stands Ogamaus, or "Little Chief." Neebosh is portrayed with a pipe in his mouth, sitting directly below Iowa's right elbow. Keewaunay is reclining against a tree, directly in front of Naswawkay, his legs extended upon the ground. The elderly Kawkawkay, dressed in a flowered tunic, sits on the blanket below Pepper's feet.[52]

Although Pepper acknowledged that the removal had failed because of the traders, he also blamed the Catholics. Both Menominee and Father Louis Deseille had protested against the illegal sale of Menominee's reservation, and in response Pepper charged that the priest was a "nefarious influ-

ence" and a "Catholick and a foreigner working against the United States." During the spring of 1837 Lewis Sands, Pepper's assistant, investigated Deseille's activity among the Potawatomis along the Yellow River and reported that the priest "was using his influence in opposition to the views of the government." In response, on 13 May 1837 Pepper ordered Deseille to leave the reservation and to "cease holding any talks or councils with the Potawatomies."[53]

Ironically, Pepper's denunciation of Deseille only pushed more Potawatomis into the Catholic camp. From the Indians' perspective, the government's disfavor increased the Catholics' credibility, and although Deseille did not openly campaign against the 1837 removal, many Potawatomis opposed to the emigration now flocked to Menominee's small reservation. In September 1837 Deseille contracted cholera and died, but he was replaced by Father Benjamin Marie Petit, a priest newly arrived from France. Petit arrived on the Yellow River in October, where he immediately was embraced by the mixed-bloods for whom he had "nothing but the highest praise." He spent the winter of 1837–38 not only gaining more converts, but also encouraging the Indians to petition the government to allow them to remain in Indiana.[54]

The petitions failed. The other chiefs who had sold Menominee's reservation had agreed to remove to the West on 6 August 1838, and on 27 July Pepper met with the Potawatomis and instructed them to assemble for removal at a camp near modern Plymouth. Menominee and his followers refused to assemble, so Pepper dispatched a message demanding that the old chief and his followers evacuate their village and come to the camp. Meanwhile, as news of the removal spread along the Indiana frontier,

white squatters moved onto Menominee's reservation, attempting to preempt farmland. Menominee's followers destroyed a squatter's cabin, and in response other settlers burned about a dozen Indian houses.[55]

Fearing bloodshed, Pepper then invited Menominee and his counselors to another conference at the Catholic Mission at Twin Lakes, near modern Plymouth, and on 29 August 1838, after the Indians had assembled, Sen. John Tipton and 100 armed volunteers surrounded and captured the Indians. During the next five days Pepper, Tipton, and other federal agents assembled additional Potawatomis at Menominee's village, and on 4 September 1838, about 850 Indians were marched off toward the West. Menominee and several of his advisors were forced west at gunpoint.[56]

Although Winter did not participate in the capture of Menominee and his followers, he did visit the removal when the Indians and their captors passed near Logansport. On the evening of Saturday, 8 September 1838, he journeyed to their encampment on Mud Creek, and he obviously was moved by their suffering. Many of the Potawatomis had contracted an "intermittent [typhoid] fever," and over three hundred Indians were debilitated. According to Winter, Menominee and several other leaders were closely guarded ("truly a saddening sight, as they lay surrounded by a vigilant citizen soldiery"), and the entire camp was surrounded by a picket line of sentinels. On Sunday, 9 September, Father Petit, who had been given permission to accompany the removal, and Bishop Simon Bruté visited the encampment, and in the afternoon Bruté held Mass and ministered to the sick and dying. Winter was present during the Mass and sketched Bruté delivering a sermon, which he described as "a grand and imposing scene; truly an

historic event." Sungowaw, whom Winter also sketched at the removal camp, served as Petit's and Bruté's interpreter on this occasion.[57]

Winter was sympathetic to the Indians' plight. Like most other Hoosiers, he believed that the Potawatomis' removal was inevitable, but he argued that Menominee and his followers had been captured by a "high handed act, . . . a deceptive and cunning, cruel plan," and suggested that an apology was due to the Indians. He pointed out that some of the volunteers who had served in the removal had been much saddened by their duties, but others were "vagabonds and pillagers of the lowest order as humanity would recognize," and he wondered how a "Christian people" could justify such actions. Unlike Pepper, Winter described the Catholic clerics in favorable terms, indicating that Petit had "done good work for the Indians Blessed be his converts—and hallowed his memory in heaven and on earth."[58]

Winter also was present on the morning of 10 September 1838, when the removal party departed from the camp at Horney's Mill en route to the West. According to the artist, Menominee and the "captive chiefs" were placed in a wagon at the head of the procession and, escorted by the armed volunteers, the Potawatomis "were seen moving down the hillsides, along the banks of Eel River, on the way to their westward home—to the land of the sunset—but to them all clouded in black."[59]

The emigration, now celebrated as the "Trail of Death," was a disaster. Rations issued to the removal party were of such poor quality that those whites who accompanied the emigration refused to eat them. So many Potawatomis became ill and fell behind that a separate and smaller removal formed and followed in the wake of the original party. They crossed the Missis-

sippi River near Quincy, Illinois, and finally straggled into the Osage River Subagency in early November. Approximately 750 Potawatomis arrived in Kansas. Forty-two Indians died en route, and another sixty deserted the removal and returned to Indiana. Father Petit also contracted typhoid fever, and although he survived to Kansas, he died at St. Louis on 10 February 1839.[60]

In retrospect, George Winter's paintings, sketches, and journals provide a valuable chronicle of these Indian people and their activities. Winter was an excellent observer. Although he was not trained as an ethnologist, he possessed a natural curiosity about the Indian people who inhabited the Wabash and Tippecanoe valleys, and since he was born and raised in Great Britain, he was not burdened with the widespread prejudice against Indian people that so characterized many of the residents of the American frontier. Unquestionably Winter shared the commonly held American assumptions about the benefits of agriculture and "progress," but he also recognized and recorded the intrinsic values and qualities of Potawatomi and Miami life. For George Winter, the Indians were not just a nuisance who had to be removed before northern Indiana could prosper, they were an "interesting and strange people," but a people "bound by the noble impulses and feelings of the heart—a people whom we Christian men might contemplate and draw therefrom the teachings of living and vital charity." Indeed, Winter was fascinated by his subjects, and later in his life, after most of the Indians had been removed beyond the Mississippi, he often commented that he wished he had spent more time in their villages.[61]

Most historians would agree. Winter's sketches and paintings are the best visual record of Native American life

in Indiana during this period, and indeed, his depictions of Indian costumes and daily life are unsurpassed for the Potawatomis and Miamis. Other painters portrayed some of these people during this decade, but these artists worked in studios or painted the Indians after they had been removed to the West. Some of Winter's subjects (Pashpoho, Sawagut) were painted by James Otto Lewis, but Lewis lacked Winter's artistic talent, and his subjects are stiffly posed within a studio. Charles Bird King also painted Potawatomis from the Midwest, but they were posed in a studio in Washington, D.C., and his work contains no depictions of Potawatomi and Miami camp life. George Catlin painted Potawatomi and Miami emigrants in the West, but they already had been removed beyond the Mississippi. Paul Kane's paintings provide insight into Potawatomi life in Wisconsin, but these more northerly members of the tribe differed considerably from the Indiana Potawatomis in their cultural patterns. Only Winter furnishes a visual image of these people in their Indiana homeland, and combined with his notes and journals, his sketches and paintings provide a perceptive mirror image of the Potawatomi and Miami people.[62]

That mirror also reflects their acculturation. By the 1830s both the Potawatomis and the Miamis were a people in transition, a people who had combined their traditional aboriginal ways with the cultural patterns of the French Creoles to create a society that was well adapted to the fur trade economy of the Old Northwest. Many of these mixed-blood entrepreneurs had prospered and were engaged in trading networks that stretched from Detroit, Fort Wayne, and Vincennes to St. Louis, Prairie du Chien, and beyond the Mississippi, and as they prospered they provided role models for their less-acculturated, more tradi-

tional kinsmen. Indeed, Indians and Creole Frenchmen had intermeshed so completely in the Wabash valley that the onrushing Hoosiers had difficulty in ascertaining the racial and cultural borders, if any truly existed, between the two. But to the Hoosiers, these boundaries, or the lack of them, were ultimately unimportant, since neither the French nor the Indians were willing to subscribe to the model of male-centered, yeoman agriculture championed by a rapidly expanding nation. And so the Potawatomis and Miamis, mixed-bloods and full-bloods, acculturated and traditional, and many Creole Frenchmen as well were forced beyond the Mississippi. But we know about their acculturation because a British-born emigrant, trained as a miniaturist, took delight in painting their costumes, camps, and way of life. And his paintings, journals, and correspondence provide the ethnographic details that mirror their acculturation.

The author wishes to express his appreciation for the cooperation and assistance of Patrick Daily and Sarah E. Cooke of the Tippecanoe County Historical Society in providing materials used in this essay. Cooke was particularly helpful in facilitating the research for this project.

1. *Logansport Telegraph*, 9 October 1841, quoted in Wilbur D. Peat, "Winter, the Artist," in *The Journals and Indian Paintings of George Winter, 1837–1839* (Indianapolis: Indiana Historical Society, 1948), 9.

2. The treaties can be found in Charles J. Kappler, ed., *Indian Treaties, 1778–1883* (New York: Interland Publishing Co., 1973). Also see R. David Edmunds, *The Potawatomis: Keepers of the Fire* (Norman: University of Oklahoma Press, 1978), 218–72 passim.

3. John Tipton to Thomas L. McKenney, 31 January 1830, in Nellie Armstrong Robertson and Dorothy Riker, eds., *The John Tipton Papers*, 3 vols. (Indianapolis: Indiana Historical Bureau, 1942), 2:243–44; Abel C. Pepper to George Gibson, 24 October 1834, Records of the Bureau of Indian Affairs, Letters Received, Commissary General of Subsistence, Potawatomi Emigration, Record Group 75, National Archives; Report by Thomas McKenney, 22 March 1830, U. S. Congress, Senate, 21st Cong., 1st sess., Senate Document 110, 2–3.

4. Edmunds, *The Potawatomis*, 3–23; Bert Anson, *The Miami Indians* (Norman: University of Oklahoma Press, 1970), 3–40; Charles Callender, "Miami," in Bruce G. Trigger, ed., *Northeast*, vol. 15 of the *Handbook of North American Indians*, ed. William C. Sturtevant, 20

vols. (Washington, D.C.: Smithsonian Institution, 1978), 681–89.

5. Edmunds, *The Potawatomis*, 20–21; Callender, "Miami," 685–86.

6. Edmunds, *The Potawatomis*, 16–18; Callender, "Miami," 682–84.

7. Edmunds, *The Potawatomis*, 16–18; Callender, "Miami," 682–83.

8. Edmunds, *The Potawatomis*, 21–22; Callender, "Miami," 684–85.

9. Petition to Congress by Inhabitants of Michigan Territory, 23 January 1809, in Clarence E. Carter, comp. and ed., *The Territorial Papers of the United States*, 27 vols. (Washington, D.C.: Government Printing Office, 1934–), 10:266–68; Memorial to Congress by the Inhabitants of Peoria, 20 December 1813, ibid., 16:379–83; Isaac Darneille to John Breckinridge, 22 October 1803, ibid., 7:133–34; William H. Keating, *Narrative of an Expedition to the Source of St. Peter's River*, 2 vols. (London: George B. Whittaker, 1825), 1:79; Cass to the Secretary of War, 31 May 1816, Carter, *Territorial Papers*, 10:642–45.

10. Terrance J. Martin, "Modified Animal Remains, Subsistence, and Cultural Interaction at French Colonial Sites in the Midwestern United States," Illinois State Museum *Scientific Papers* 23 (1991): 409–19; R. David Edmunds, "'Unacquainted with the Laws of the Civilized World': American Attitudes toward the Métis Communities in the Old Northwest," in Jacqueline Peterson and Jennifer S. H. Brown, eds., *The New Peoples: Being and Becoming Métis in North America* ([Manitoba]: University of Manitoba Press, 1985), 185–94.

11. Letter by Claude Allouez, 1672, in Reuben G. Thwaites, ed., *The Jesuit Relations and Allied Documents*, 73 vols. (Cleveland: Burrows Bros., 1896–1901), 58:37–41; "Perrot Memoir," in Emma Helen Blair, ed., *The Indian Tribes of the Upper Mississippi Valley and Region of the Great Lakes*, 2 vols. (Cleveland: Arthur H. Clark Co., 1911–12), 1:188–89; Hjalmar R. Holand, "The Sign of the Cross," *Wisconsin Magazine of History* 17 (December 1933): 155–64; George Paré, "The St. Joseph Mission," *Mississippi Valley Historical Review* 17 (June 1930): 24–54.

12. Roger Craig to Ninian Edwards, 10 December 1812, in E. B. Washburne, ed., *The Edwards Papers* (Chicago: Fergus Printing Co., 1884), 86–90; Memorial to Congress from the Inhabitants of Peoria, 20 December 1813, in Carter, *Territorial Papers*, 16:379–83; "Extracts from Franklin's Narrative," Lewis Cass Papers, William L. Clements Library, University of Michigan, Ann Arbor; Keating, *Expedition*, 1:79.

13. Cass to William Crawford, 31 May 1816, Letters Received by the Secretary of War, Main Series, Record Group 107, M221, Roll 68, 1376–80, National Archives; William Henry Harrison to Henry Dearborn, 3 March 1803, in Logan Esarey, ed., *Messages and Letters of William Henry Harrison*, 2 vols. (Indianapolis: Indiana Historical Commission, 1922), 1:76–84; Cass to Noah Noble, 5 January 1826, Office of Indian Affairs, Letters Received, Record Group 75, M234, Roll 300, 28–29, National Archives. Also see Anson, *The Miami Indians*, 188–90; Edmunds, *The Potawatomis*, 226–27; and Wallace A. Brice, *History of Fort Wayne* (Fort Wayne, Ind.: D. W. Jones & Son, 1868), 293–94.

14. Keating, *Expedition*, 1:79; "On the Prophet," Winter's Notes, George Winter Manuscripts, box 2, folder 21, items 2-3 (hereinafter cited as GWMSS 2-21 [2-3]), Tippecanoe County Historical Association, Lafayette, Indiana. This particular item, which focuses upon the Shawnee Prophet, is composed primarily of secondary sources collected by Winter.

15. Keating, *Expedition*, 1:79–80; Adam Walker, "A Journal of Two Campaigns of the Fourth Regiment of U.S. Infantry," in Esarey, *Messages and Letters of William Henry Harrison*, 1:697; "Mendicant Indians," Winter's Notes, GWMSS 2-34 [11]; Cass to the Secretary of War, 31 May 1816, Records of the Secretary of War Relating to Indian Affairs, Letters Received, Record Group 75, M271, Roll 1, 1275–85, National Archives.

16. Francis Parkman, *The Oregon Trail* (New York: New American Library, 1950), 62, 121; Keating, *Expedition*, 1:79–80; Cass to the Secretary of War, 31 May 1816, Record Group 107, M221, Roll 68, 1376–80; Isaac McCoy, *History of Baptist Indian Missions* (New York: Johnson Reprint Corp., 1970), 111. For an excellent discussion of mixed-bloods in America, see William J. Scheick, *The Half-Blood: A Cultural Symbol in 19th-Century American Fiction* (Lexington: University Press of Kentucky, 1979).

17. "Extracts from Franklin's Narrative," Cass Papers, Clements Library; "Journal of a Visit to Deaf Man's Village, 1839," *The Journals and Indian Paintings of George Winter*, 165.

18. *Logansport Telegraph*, 25 November 1837, GWMSS 1-4 [2]; Winter's Journal, 21 July 1836, and Winter to his sister, 19 August 1837, ibid., 1-3 [1]. This letter by Winter to his sister has been included with the 1836 Journal. Also see Isaac McCoy to William Hendricks, 23 December 1826, Isaac McCoy Papers, Kansas State Historical Society, Topeka, and "Journal of a Visit to Deaf Man's Village, 1839," *The Journals and Indian Paintings of George Winter*, 169, 182.

19. R. David Edmunds, "'Designing Men, Seeking a Fortune': Indian Traders and the Potawatomi Claims Payment of 1836," *Indiana Magazine of History* 77 (June 1981): 109–10.

20. "Kaw-Kaw-Kay," Winter's Notes, GWMSS 2-13 [1-2]. George Catlin painted many Shawnees, Delawares, Creeks, and Cherokees wearing turbans. See Royal B. Hassrick, *The George Catlin Book of American Indians* (New York: Watson-Guptill Publications, 1977).

21. Entry for 21 July 1836 in Winter's Journal, GWMSS 1-3 [1]. Many Indians, including Pontiac, Tecumseh, and Joseph Brant wore rings through the septums of their noses. The practice seems to have declined markedly in the decades following the War of 1812.

22. Winter's Journal, 1836, ibid.; Winter to his sister, 19 August 1837, ibid.; *Logansport Telegraph*, 25 November 1837, ibid., 1-4 [2]; James Bryant to Winter, 6 February 1858, ibid., 1-15 [17]; "Indian Memorandum," 1861, ibid., 1-16 [19].

23. Entry for 21 July 1836 in Winter's Journal, ibid., 1-3 [1]; Winter to his sister, 19 August 1837, ibid.; and Winter's Notes, ibid.

24. Winter, "Journal of a Visit to Deaf Man's Village," *The Journals and Indian Paintings of George Winter*, 166–73; Winter to J. W. Forney, November 1871, GWMSS 1-23 [13].

25. Entry for 21 July 1836 in Winter's Journal, GWMSS 1-3 [1]; "Journal of a Visit to Deaf Man's Village," *The Journals and Indian Paintings of George Winter*, 183–89.

26. *Logansport Telegraph*, 25 November 1837, GWMSS 1-4 [2]; Winter's Journal, 1837, ibid., 1-1 [1].

27. Winter to A. Arnold, 29 May 1865, ibid., 1-19 [2]; Winter's Journal, July 1836, ibid., 1-3 [1]; Winter to his sister, 19 August 1837, ibid.; "Mas-saw. Chieftess of the Pottawattami Nation," Winter's Notes, ibid., 2-15 [1-2].

28. James Bryant to Winter, 6 February 1858, ibid., 1-15 [17]; Winter to Horace Biddle, 27 June 1863, ibid., 1-17 [38]; Winter's Journal, 1837, ibid., 1-2 [1]; Winter to his sister, 9 August 1837, ibid., 1-3 [1]; entries for "Aub-Bee-Nau-Bee," "Ben-Ache," "Swa-Go," and "Pash-Po-Ho," in Winter's Notes, ibid., 2-7 [1-4], 2-8 [3-8], 2-19 [1-3], 2-24 [3-4].

29. Winter to J. B. Lossing, 16 December 1871, ibid., 1-23 [18]; "Indian Memorandum," ibid., 1-16 [19]; Winter's Journal, 1837, ibid., 1-2 [1]; "Mis-Quaw-Buck, War Chief," Winter's Notes, ibid., 2-16 [3-5]; Winter to his sister, 19 August 1837, ibid., 1-3 [1]; Winter, "Journal of a Visit to Deaf Man's Village, 1839," *The Journals and Indian Paintings of George Winter*, 169–80, plate XXVIII.

30. Edmunds, *The Potawatomis*, 20; "The Medicine Men," GWMSS 2-35 [1]; "Indian Memorandum," ibid., 1-16 [19].

31. Isaac McCoy to Unknown, 18 July 1821, Isaac McCoy Papers, Kansas State Historical Society; McCoy, *History of Baptist Indian Missions*, 174–77, 179; "Articles of a Treaty Made and Concluded at Chicago . . . on 29 August 1821," in Kappler, *Indian Treaties*, 198–201.

32. McCoy to Cass, 2 July 1825, Records of the Bureau of Indian Affairs, Michigan Superintendency, Record Group 75, M1, Roll 12, 256–57, National Archives; McCoy to Rev. Francis Wayland, 23 May 1825, McCoy Papers, Kansas State Historical Society; McCoy, *History of Baptist Indian Missions*, 133, 247–48, 403–4.

33. "Father Baden, Missionary among the Pottawattamie Indians; Relating Also to Father Petit," Winter's Notes, GWMSS 2-20 [2]; Robert Edwards to Cass, 27 August 1830, Records of the Bureau of Indian Affairs, Michigan Superintendency, Record Group 75, M1, Roll 27, 257–60, National Archives; Edwards to Cass, 4 September 1830, ibid., 83–85; J. Herman Schauinger, *Stephen T. Badin: Priest in the Wilderness* (Milwaukee: Bruce Publishing Co., 1956), 223–43; Badin to the Potawatomis, 29 June 1832, ibid., 234–35; Thomas T. McAvoy, *The Catholic Church in Indiana, 1789–1834* (New York: Columbia University Press, 1940), 175–76; "Remarks on Statement C," in Potawatomi File, Great Lakes-Ohio Valley Indian Archives, Glenn A. Black Laboratory of Archaeology, Bloomington, Indiana.

34. These treaties can be found in Kappler, *Indian Treaties*, 353–55, 367–76, 403–15.

35. William Marshall to Cass, 1 January 1835, Records of the Bureau of Indian Affairs, Letters Received by the Office of Indian Affairs, Record Group 75, M234, Roll 355, 203–5, National Archives; "Abstract of the Lands Bought of the Potowotomy Indians in 1834," Documents Relative to the Negotiations of Treaties, Record Group 75, T494, Roll 3, 179, National Archives. The treaties can be found in Kappler, *Indian Treaties*, 428–31, 450–63.

36. Irving McKee, ed., *The Trail of Death: Letters of Benjamin Marie Petit* (Indianapolis: Indiana Historical Society, 1941), 15–16; Deseille to Pepper, 10 October 1835, National Archives, Records of the Bureau of Indian Affairs, Records of the Commissary General of Subsistence, Potawatomi Emigration File, Record Group 75, National Archives; Pepper to Cass, 16 October 1835, ibid.; Deseille to Pepper, 21 March 1836, ibid., T494, Roll 3, 393; Pepper to Deseille, 18 April 1836, ibid., M234, Roll 361, 85.

37. Pepper to Deseille, 16 May 1837, in "Documents: Correspondence on Indian Removal, Indiana, 1835–1838," *Mid-America* 15 (January 1933): 185–86; Deseille to George Gibson, 28 December 1835, ibid., 179–80; Bruté to Carey Harris, 25 June 1838, ibid., 190–91; Herring to Pepper, 11 May 1836, Record Group 75, M21, Roll 18, 402-403, National Archives.

38. "Articles of a Treaty Made and Concluded at a Camp on Yellow River, August 5, 1836," in Kappler, *Indian Treaties*, 462–63; Lewis Sands to Pepper, 29 May 1837, "Documents," 186–87; John W. Edmonds, *Report on the Disturbance at the Potawatamie Payment, September, 1836* (New York: Scatcherd & Adams, 1837), 8. The treaties ceding Askum's, Kinkash's, Checawkose's, and Weesionas's reservations can be found in Kappler, *Indian Treaties*, 470–72.

39. Pepper to Cass, October 1836, M234, Roll 355, 678–86, National Archives; Potawatomi chiefs to Andrew Jackson, 18 October 1836, ibid., 691–706; Ward, Polke, Berthelet, and Stevenson to the Secretary of War, 27 October 1836, ibid., 784–85; Alexis Coquillard to Edmonds, 22 June 1837, ibid., 1041–47; Edmonds, *Report on the Disturbance at the Potawatamie Payment*, 4–5, 11–13. A discussion of these events can be found in Edmunds, "'Designing Men, Seeking a Fortune,'" 109–22.

40. Potawatomi chiefs to Jackson, 18 October 1836, M234, Roll 355, 691–706, National Archives; Pepper to Harris, 20 August 1837, ibid., Roll 361, 173–74.

41. "I-O-Wa, Pottawattamie Chief," Winter's Notes, GWMSS 2-12 [1-5]; Winter to his sister, 19 August 1837, ibid., 1-3 [1]; Harris to Pepper, 29 March 1838, M21, Roll 23, 519, National Archives; Harris to Pepper, 11 June 1838, ibid., Roll 24, 331–32; Harris to Pepper, 29 June 1838, ibid., 433–44; Edmunds, *The Potawatomis*, 260. Also see Louise Barry, ed., *The Beginning of the West: Annals of the Kansas Gateway to the American West, 1540–1854* (Topeka: Kansas State Historical Society, 1972), 359.

42. "Pash-Po-Ho, Pottawattamie Chief," Winter's Notes, GWMSS 2-19 [1-3]; Potawatomi chiefs to Jackson, 18 October 1836, M234, Roll 355, 691–706, National Archives; Petition to the President of the United States from the Principal Chiefs of the Pottawatomie Nation, 22 January 1839, Isaac McCoy Papers, Kansas State Historical Society; Samuel Milroy to William Polke, 23 October 1839, in Dwight L. Smith, ed., "Documents: The Attempted Potawatomi Emigration of 1839," *Indiana Magazine of History* 45 (March 1949): 65–66; Polke to [Samuel Milroy?], 28 October 1839, ibid., 68; Milroy to T. Hartley Crawford, 8 November 1839, ibid., 74–76.

43. "Naus-Waw-Kay, Pottawattamie Orator," Winter's Notes, GWMSS 2-17 [1-3]; Winter to his sister, 19 August 1837, ibid., 1-3 [1]; Winter's Journal, 1837, ibid., 1-2 [1].

44. "Kee-Waw-Nay, Pottawattamie War Chief," Winter's Notes, ibid., 3-13 [4-6]; Winter to his sister, 9 August 1837, ibid., 1-3 [1].

45. "Ash-Kum, a Chief," Winter's Notes, ibid., 2-6 [1-6]; Pepper to Cass, October 1836, M234, Roll 355, 678–86, National Archives; Edmonds, *Report on the Disturbance at the Potawatamie Payment*, 4–5.

46. "Ben-Ache, Pottawattamie Headman," Winter's Notes, GWMSS 2-8 [3-9]; Winter to his sister, 19 August 1837, ibid., 1-3 [1]; Winter's Journal, 1837, ibid., 1-2 [1]; Barry, *The Beginning of the West*, 337–38, 363, 502; Edmunds, *The Potawatomis*, 259, 265.

47. "Joseph Barron, Interpreter," Winter's Notes, GWMSS 2-8 [1-2]; "On the Prophet," ibid., 2-21 [2-3]; Winter to his sister, 19 August 1837, ibid., 1-3 [1]; Robertson and Riker, eds., *The John Tipton Papers*, 1:341, n 64; R. David Edmunds, *The Shawnee Prophet* (Lincoln: University of Nebraska Press, 1983), 88–89; Barry, *The Beginning of the West*, 331.

48. Winter's Journal, 1837, GWMSS 1-2 [1].

49. Ibid.

50. Winter to his sister, 19 August 1837, ibid., 1-3 [1]; Pepper to Harris, 12 August 1837, M234, Roll 361, 166–67, National Archives; Indian Agents to Harris, 13 August 1837, ibid., 83–84.

51. Pepper to Harris, 20 August 1837, M234, Roll 361, 173–74, National Archives. Also see George Proffit, "Journal of the Pottawattamie Emigration." This journal can be found interspersed between correspondence in M234, Roll 361, 108–206, National Archives.

52. Winter to Pepper, 7 January 1839, GWMSS 1-4 [8].

53. Potawatomi chiefs to the President, 15 November 1836, M234, Roll 355, 715–17, National Archives; Pepper to Harris, 13 May 1837, ibid., Roll 361, 79; Sands to Pepper, 11 May 1837, "Documents," 183–84; Pepper to Deseille, 16 May 1837, ibid., 185–86. Also see Potawatomis to Cass, 6 April 1837, Potawatomi File, Great Lakes-Ohio Valley Indian Archives, Glenn A. Black Laboratory of Archaeology.

54. Sands to Pepper, 20 May 1837, "Documents," 186–87; McKee, *The Trail of Death*, 25; Petit to Mme. Chauvin Petit, 15 October 1837, ibid., 30–33; Petit to Bruté, 9 December 1837, ibid., 40–47; Petit to Bruté, 26 December 1837, ibid., 47–51; Petit to Célestine de la Hailandière, 25 March 1838, ibid., 58–63. Also see Potawatomi chiefs to Bruté, 30 September 1837, Thomas Timothy McAvoy Papers, Indiana Historical Society Library, Indianapolis, Indiana.

55. Minutes of a council held near Plymouth, Indiana, 27 July 1838, GWMSS 2-31 [1]; Speech by Menominee, 6 August 1838, quoted in Irving McKee, "The Centennial of 'The Trail of Death,'" *Indiana Magazine of History* 35 (March 1939): 36; Tipton to David Wallace, 18 September 1838, Robertson and Riker, eds., *The Tipton Papers*, 3:713–18.

56. Tipton to David Wallace, 31 August 1838, Robertson and Riker, eds., *The Tipton Papers*, 3:682; "Journal of an Emigrating Party of Pottawattomie Indians, 1838," *Indiana Magazine of History* 21 (December 1925): 316–17.

57. "Encampment at Mud Creek," GWMSS 2-32 [4]; Winter to Lyman C. Draper, 6 February 1858, ibid., 1-15 [15]; "Sun-Go-Waw," Winter's Notes, ibid., 2-24 [1-2].

58. Winter to Draper, 6 February 1858, ibid., 1-15 [15]; "Sun-Go-Waw," Winter's Notes, ibid., 2-24 [1-2].

59. Winter to Draper, 6 February 1858, ibid., 1-15 [15].

60. Petit to his family, 14 September 1838, McKee, *The Trail of Death*, 90–93; L. A. Elet to Bruté, 18 February 1839, ibid., 114–16; "Journal of an Emigrating Party," 317–34. Also see William Polke to Carey A. Harris, 19 September 1838, in Dwight L. Smith, ed., "A Continuation of the Journal of an Emigrating Party of Potawatomi Indians, 1838, and Ten William Polke Manuscripts," *Indiana Magazine of History* 44 (December 1948): 403–4; Hull to Polke, 30 October 1838, ibid.; Dwight L. Smith, "Jacob Hull's Detachment of the Potawatomi Emigration of 1838," *Indiana Magazine of History* 45 (September 1949): 285–88.

61. *Logansport Telegraph*, 25 November 1837, GWMSS 1-4 [2]; Winter, "Mendicant Indians," ibid., 2-34 [11]; Winter to Draper, 14 January 1858, ibid., 1-15 [15].

62. See Herman Viola, *The Indian Legacy of George Bird King* (Washington, D.C.: Smithsonian Institution, 1976), 96; George Catlin, *Letters and Notes on the Manners, Customs, and Conditions of North American Indians*, 2 vols. (New York: Dover Publications, 1973), 2:96–97; J. Russell Harper, ed., *Paul Kane's Frontier: Including Wanderings of an Artist among the Indians of North America* (Austin: University of Texas Press, 1971). No edited compilation of James Otto Lewis's works has been published.

Catalog of the George Winter Collection Located at the Tippecanoe County Historical Association, Lafayette, Indiana

Compiled by

Sarah E. Cooke

and

Rachel B. Ramadhyani

IMAGES OF INDIANA
POTAWATOMIS
& MIAMIS
WITH RELATED VIEWS

LOGANSPORT, INDIANA, JUNE–JULY 1837

"IN THE SPRING OF 1837, BEING ON A VISIT FROM NEW YORK CITY, west, I arrived at Logansport, having been allured to the Wabash Valley, purely with a view to see the Indians, and make sketches of them at the Payment and Councils I had heard that would soon take place. Col. A. C. Pepper was then Indian Agent, and . . . Col. Sands was Sub. Agt., George Profit, enroling agent. Judge Edmonds was at the same time appointed United States Commissioner to investigate the Pottawattamie claims, which were shrouded in some difficulties.

The Indian Chiefs were mostly summoned to meet him here. This circumstance afforded me the opportunity of a high gratification of seeing the Indian of reality, rather than the one of *fiction* that I had often read of. . . .

In the summer of 1837 I established a studio in Logansport. The Pottawattamie Indians often visited me there, as they had become familiar with me at the 'Councils', and 'Payments'; and seeing me often with the officers of the Government in charge of the Indian agency, I prevailed upon many who evinced former hesitancy to sit for me.

Ewing & Walker's trading establishment was in Logansport; consequently, the town was often thronged with the red men. In the rear of their store, there was an enclosure or court yard, with a building within which was head quarters for the indians—and a secure place for depositing their 'forest merchandise' and resting of their ponies.

There the Indians often spent their nights in joyous hilarity—and the effects of their deep libations from the o-mo-di (bottle) made night hideous with whooping and yelling and in savage unrestrained revelry. . . .

The indians called me *Pe-pone*, having discovered my name was Winter; and it was a *common salutation* with them, whether they met me in the streets of Logansport, or in the woods—to hold up the left hand, and with the right make motions in an imitative manner as though they were sketching me. Being thus on such familiarity, there were not many obstacles to my obtaining 'sitters'. There were however, *some* who were *tardy*, through a *superstitious conceit*, in being *'imaged'* upon canvas or paper.

Some of the Pottawattamies could not be induced to sit—until a friendship of many months had inspired them with full confidence that there was *'nothing to pay'*, or that *I* would have *no controul of their future destiny*!!!

After sketching I-owa, M'jo-quis, Abraham Burnet, Knas-waw-kee, and other Chiefs and Headmen—*volunteers* came forward. Sketching became to them a source of amusement, and provocative of many a loud and unrestrained laugh.

The indian is quick in his perception, and being without the *civilized* man's *conventionalities* and *affectations*, he was a model of *'good breeding'* in his opinions upon so strange an art as painting. The indian applauded by his signs and gesticulations, the painted resemblance of natural objects though often puzzled over effects of color, and by landscape painting, by the *distance* and nearness of objects as perspectively drawn and painted.

I remember an indian in my studio once, going down upon his knees to examine minutely a painting that was upon my easil—he gazed long upon it grunting out his approbation—he then went *behind* the canvas, under the impression that he could look *through the atmosphere* of the painted scene. Both sides of the canvas he imagined contained the same scene. While it is amusing to *know the son of* the forest was dec[ei]ved by the *'mimic art'*, yet, I have ever regarded the circumstance as one of the highest compliments to the natural effect of art. . . .

Daily opportunities were constant there for the observation of the Indian character and to obtain subjects repleteful of interest for my portfolio. The costumes of the Indians are faithfully followed, and no attempt has been made to make the subjects fanciful or in any way objects of 'poetic fiction'. These are true portraitures of the Indians, and of their own peculiar conceits of dress. . . .

Whatever interest therefore these sketches may afford, they at least might be relied upon as being drawn from the living persons. . . . Fidelity to the subject must give real value to all efforts of the artist, as contributions to the history of this unfortunate race who are rapidly dissappearing from earthly existence." (GWMSS 1-4 [17], 2-5 [10], 1-2)

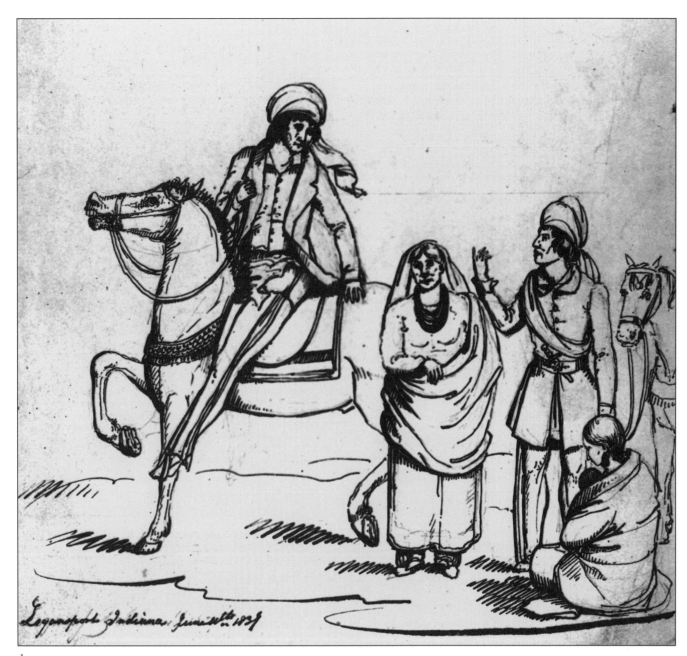

1.
LOGANSPORT INDIANA
JUNE 11TH 1837
Ink on paper; star-shaped watermark
10 1/2 x 7 7/8 (26.5 x 19.7)
OV-340

2.
INDIAN GROUP
Observed 1837; executed ca. 1863–71
Ink on paper
16 1/8 x 11 1/2 (40.8 x 29.0);
comp. 9 3/8 x 7 3/4 (23.6 x 19.7)
Nearly identical to Cat. #1
OV-356

(1) "This group in outline, has no other significance than to represent a picturesque combination of figures of the aborigines.

The figure on the Indian pony would in some degree give an idea of Pash-po-ho's figure and easey mode of riding. . . .

But few may discover the artistic merits of an outline work—*The profession*, know how great a *test* it is—to produce a subject in outline. The line is *the 'picture'. There is not* dependence upon the auxilliary effect of light, and shade or the fascination of color. The subject to be conveyed depends wholly on the flowing line for its . . . successful result." (GWMSS 2-5 [11])

3.
POTTAWATTAMIE INDIANS
Executed ca. 1863–71
Blue and black ink on paper
16 x 11 3/8 (40.4 x 28.8)
OV-356a

4.
SOLOMON'S SEAL 1846
Graphite and ink on paper
10 x 7 7/8 (25.4 x 19.9)
Inscribed, l.r.: "George W"
Detail used in Cat. #3
F-317

5.
GRAVE YARD LOGANSPORT
JUN 24TH 1847
Graphite and ink on paper
8 1/4 x 12 3/8 (21.0 x 31.3)
Inscribed, l.l.: "Poke weed. Phytolacca."
l.c.: "Verbascum blattaria. (Mullein)"
Includes details used in Cat. #3
F-318

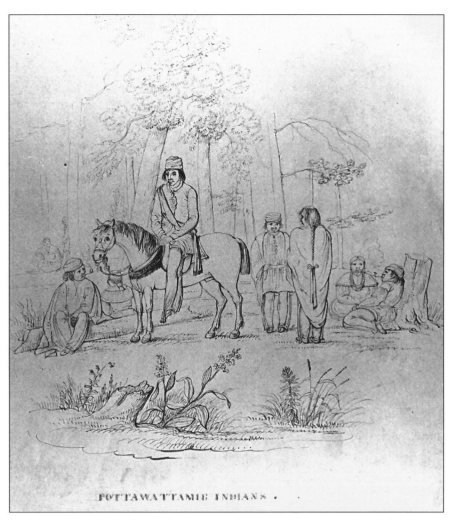

POTTAWATTAMIE INDIANS .

6. *(see Plate 14)*
ABORIGINAL EQUESTRIANS
POTTAWATTAMIES
LOGANSPORT INA
JUNE 1837
Watercolor and ink on paper
7 7/8 x 9 3/4 (19.7 x 24.6)
K-3

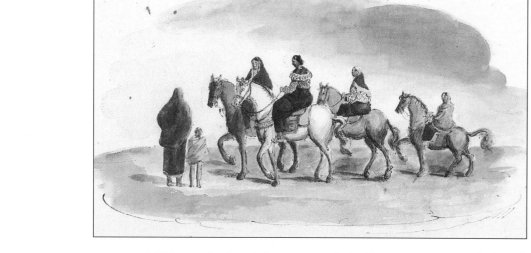

(6) "The arrival and departure of the Pottawattamies at Ewing & Walker's trading establishment were constant—and the ever varying picturesque groupings were attractive and inviting to the pencil.

The indians were always visible on the streets—sometimes riding upon their ponies—(bobbed tailed) always in 'indian file'. They not only presented picturesque appearances but we might add, very grotesque ones." (GWMSS 1-2)

7. *(see Plate 15)*
LOGANSPORT INDIANA
JUNE 1837
Watercolor and ink on paper
9 3/4 x 7 5/8 (24.8 x 19.3)
Inscribed, l.r.: "GW"
K-9

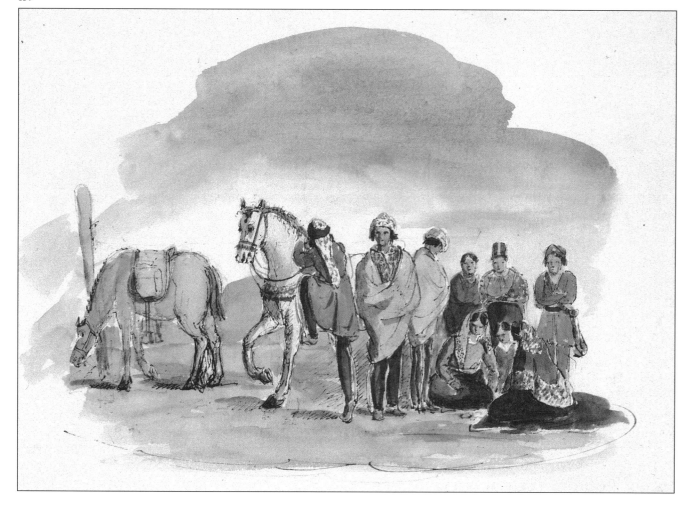

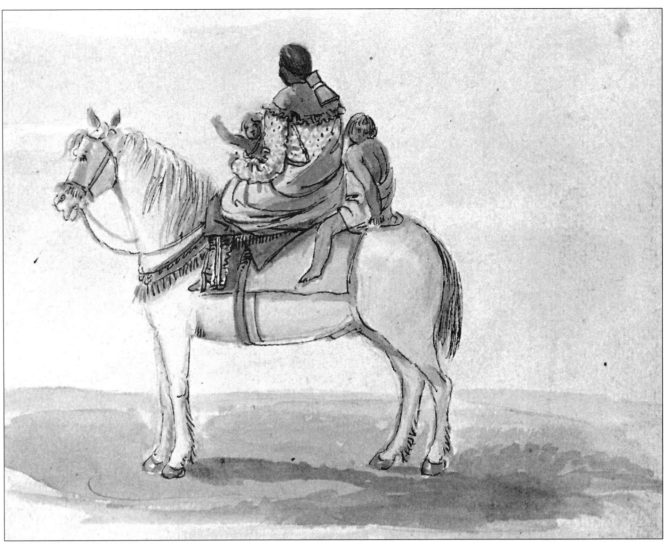

8.
[WOMAN AND TWO CHILDREN ON WHITE HORSE]
Watercolor and ink on paper
5 5/8 x 4 5/8 (14.2 x 11.6)
K-20

9.
[WOMAN AND TWO CHILDREN ON WHITE HORSE]
Executed ca. 1863–71
Watercolor on paper
11 3/4 x 15 3/4 (29.6 x 40.0)
Similar to Cat. #8
M-72

10.
[WOMAN AND TWO CHILDREN ON HORSE]
Graphite on paper
1 5/8 x 2 1/8 (4.0 x 5.3)
Indistinct sketch;
similar to Cat. #8
G-438

11. (see Plate 16)
POTTAWATTAMIE INDIAN LOGANSPORT JUNE 1837
Watercolor and ink on paper; embossed seal
9 3/4 x 7 3/8 (24.7 x 18.7)
Inscribed, l.l.: "GW."
l.r.: "No 29 Geo Winter"
K-4

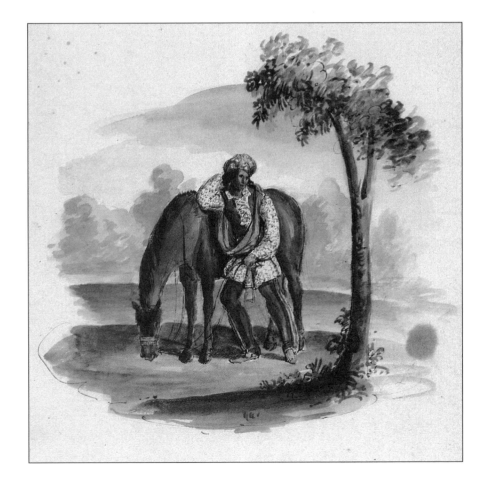

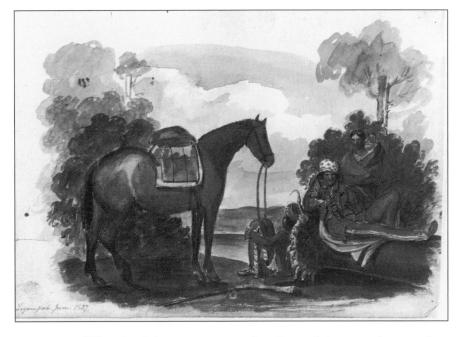

12.
LOGANSPORT JUNE 1837
Watercolor and ink on paper
7 3/4 x 10 3/8 (19.5 x 26.1)
K-10

(12) "The aborigines were a people of great leisure, and seemed to 'take no note of time'. If they came in town from their villages in the morning—it was not a necessary consequence that they return when the sun fell below the horizen. No! they were a people of *extreme leisure* and slow in trading (buying), nor would *the opportunity* be lost in obtaining a *whiskey*, an article of fearful distructive influence upon the aboriginal race." (GWMSS 1-2)

13.
"NO-WASH-MOAN"
Graphite on paper
8 1/8 x 10 1/8 (20.5 x 25.6)
Inscribed, l.r.: "Meaning rest—
Pot-to-wat-ta-mie"
G-433

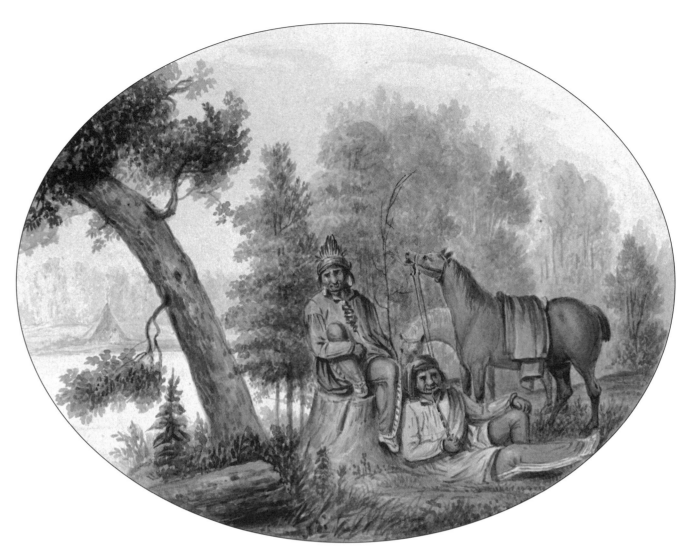

14.
NO-WASH-MOAN
Executed ca. 1863–71
Watercolor on paper
14 3/4 x 11 5/8 (37.5 x 29.6);
comp. 7 x 8 7/8 (oval) (17.6 x 22.4)
Journals and Indian Paintings, *Plate XX*
M-71

15.
POTTAWATTAMI INDIANS INDIANA
Graphite on paper
5 5/8 x 9 (14.2 x 22.8)
Two indistinct studies with resting figures
G-434

16.
LOGANSPORT INDIANA
JULY 8TH 1837
Watercolor and ink on paper
4 1/2 x 7 1/8 (11.4 x 17.9)
K-11

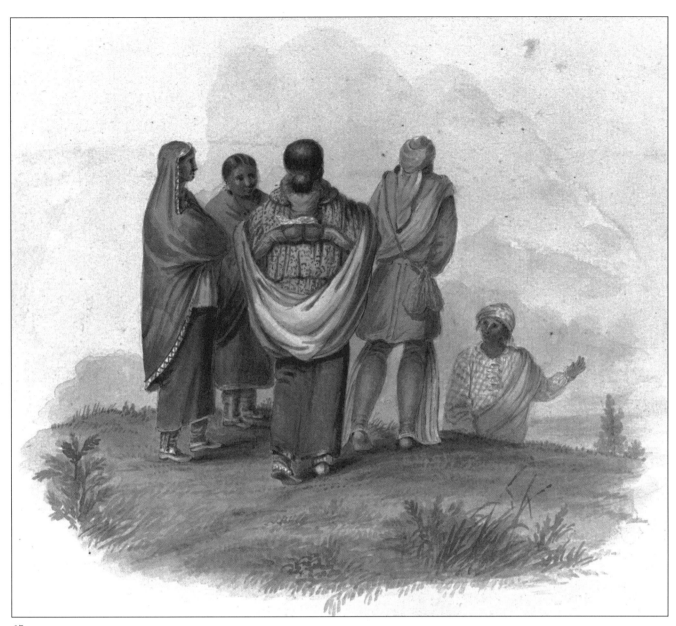

17.
[GROUP ON HILLTOP]
Observed 1837; executed ca. 1863–71
Watercolor and ink on paper;
watermark "J WHATMAN"
11 5/8 x 15 5/8 (29.5 x 39.6)
Journals and Indian Paintings, *Plate XXIX*
L-45

18.
Pottawattamie Indians
Logansport Aug [?] 1837
Watercolor and ink on paper
7 5/8 x 5 1/8 (19.4 x 13.0)
Similar to Cat. #17
K-12

(17) "[The squaws] wore red and black blankets, as their rich mantles are called, which are made of superfine broad cloth decorated with colored ribbons and silver ornaments—are very costly, and are worn over the head and covering the body very gracefully reaching nearly to the ground. Some of these dresses were estimated as being worth $200.

Some of the squaws were encumbered with many rows of beads, that I verily believe would weigh ten pounds—ear rings too of silver, that were so heavy as to elongate the ears to a most frightful extent.

Their nether garments are also made of cloth, handsomely bordered with many colored ribbons, shaped into singular forms and wrapped so tightly around them that they waddle rather than walk." (GWMSS 1-4 [2])

19. (see Plate 17)
PEL-WAW-ME
Watercolor and ink on paper
10 1/2 x 8 3/8 (26.7 x 21.2);
comp. 5 3/4 x 4 1/2 (14.6 x 11.4)
L-39

(19) "The trader rushes in—his peculiar marketable wares adapted to the Indian fancy. The aborigine soon doffs his 'skins' and the ruder costume natural to the primitive condition, when his wants are limited, and he depends upon none of the resources of the civilized man. He seeks to, by a singular falsity, assimilate himself in appearance to the 'Che mok ko mon', or whiteman. He adopts the *frock coat*—red sash—turban or headdress, formed of varied colored shawls of different textures; and the calico 'pes-mo-kin' (shirt) with broad ruffles become objects of the greatest fascination. . . .

The more 'poetic Indian', that is represented always in nudity, with a fine roman nose, shaven head—with the scalp lock decorated with tufts of feathers . . . have never come within my observations." (GWMSS 2-5[10])

20.
SWAW-GO
Observed 1837; executed ca. 1863–71
Watercolor on paper
11 3/4 x 15 3/4 (29.9 x 40.0)
Intended for inclusion in G. W.'s Indian journals
Journals and Indian Paintings, *Plate XI*
OV3-67

21. (see Plate 13)
SWAW-GO
Observed 1837; executed ca. 1863–71
Watercolor on paper
11 1/2 x 16 1/4 (29.2 x 41.2);
comp. 7 1/8 x 9 1/8 (oval) (18.1 x 23.1)
Inscribed, l.l.: "No 38. Geo Winter"
Similar to Cat. #20; intended for inclusion in
G. W.'s Indian journals
Journal-68

22.
[SWAW-GO]
Observed 1837
Graphite on paper
4 1/2 x 3 1/4 (11.3 x 8.2)
Similar to Cat. #20
G-406

(20) "Swago, was an excentric Pottawattamie Indian who was an object of special notice when he came to the trading house of Ewing & Walker & Co, in Logansport. Which was a circumstance of common occurance. But poor Swago knew nothing of the *economic* virtues—and his *'purposes'* of trade were often assumed to cover up the hidden and nefarious object of obtaining whiskey. . . .

Notwithstanding Swa-go's failing in the virtues of temperance and sobriety, yet he was an Indian of marked character.

There are many stories told of Swa-go's reputation in his tribe as a Kee-sheek-win (a rapid runner) and it was often asserted with confirmed confidence in its veracity that he has run a suck-see (or deer) down in his more vigorous manhood. . . .

The likeness of Swa-go, as represented in the illustration that accompanies this brief notice, indicated his wordly (to him) *happy* condition.

He has been *to town* and he has possessed himself of the *big-bellied bottle* of whiskey, which might have been upon fair conjecture, *once filled* He *corks* it with his finger—there will be no *waste.* . . .

The sketch of Swa-go was made in the year 1837, near the confluence of the Wabash and Eel Rivers. Knas-waw-kay (and Swa-go), with some of his band, had come from Lake Mux-in-kuck-kee where Knas-waw-kay lived—and were temporarily encamped near Logansport." (GWMSS 2-24 [3])

23.
NOAH-QUET. KNOWN AS
RICE THE INTERPRETER.
A HALF BREED INDIAN
SKETCHED—1837
Graphite on paper
10 3/8 x 7 3/4 (26.1 x 19.7)
G-373

(23) "I was in daily attendance in Judge Edmond's court—watching with great interest the dusky sons of the forest, who were examined upon each section of *the document*, which was read and interpreted to them by *Rice*, the 'half-breed', who was an educated and intelligent man. . . .

At that time there was a large number of the Pottawattamie indians—assembled by the Honbl. J. W. Edmonds. . . . He was appointed U. States Commissioner to investigate some complications in regard to the Pottawattamies 'claims', growing out of *mysteries* of the *indian trade*. The Pottawattamies had their many grievances, and complaints, as all indians seem to, or do have, who are, or have been in Treaty stipulations with the U. S. Government; and who have been made the victims of the unscrupulous and mercinary Indian trader. A communication, setting forth the troubles, and grievences of these wronged people, had been written under their *supposed sanction,* and forwarded to Washington, D. C. by *their friend* G. W. E. [George Washington Ewing] an indian trader well known to the people of the Wabash valley. But through some reported *interliniations* in the document, *unknown* to the indians, which were implicatory of certain other parties connected with the *'morality'* of indian trade; the affair was deemed of such importance as to call forth on the part of the U. S. Government an investigation of the facts.

Judge Edmonds, therefore in conformity with his special duties organized a *Court* at the Hotel known as 'Washington Hall', then kept by our worthy old friend and host, Capt. C. Vigus.

On this occasion there were summoned from their respective villages—to testify in this investigation, many of the Chiefs and Headmen of the Pottawattomie tribe. (Among them I remember—*Knas-waw-kay*—the principal orator, *I-o-wa, M'-jo-quis* (his brother), *Wee-wis-sa, Kee-waw-knee, Pash-po-ho, We-saw, Me-shak-coose, Knee-bush, Old Jim, Abraham Burnett, Ben-ache—under Black Bird* at the *Massacre* at *Chicago, Ash-kum, No-taw-kah,* and others.)" (GWMSS 1-2)

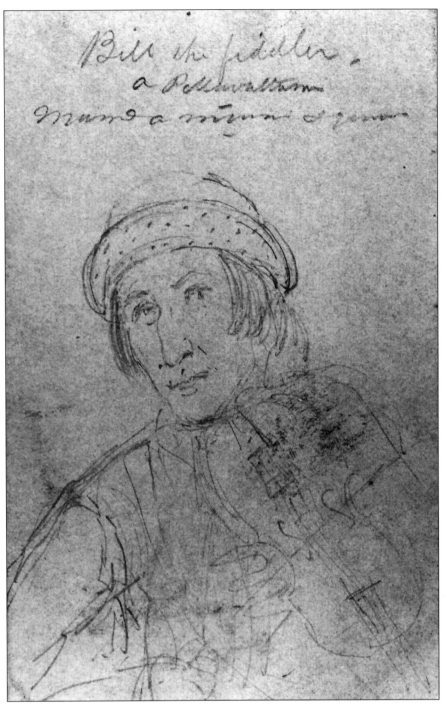

24.
BILL THE FIDDLER
Graphite on blue paper;
lined on verso
4 x 2 1/2 (10.0 x 6.3)
Inscribed, u.c.: "a Pottawattami
married a Miami squaw"
G-419

25.
[PROFILE PORTRAIT OF
BILL THE FIDDLER]
Graphite on blue paper;
lined on verso
4 x 2 1/2 (10.1 x 6.3)
G-420

(24) "The Court was held in the *'long room'* in Washington Hall, a room well remembered by *us*, and many *others yet surviving* the merry old times—full of 'the spirit of bright hours', when the *fiddling* of Bouriette . . . was danced to with great savor by those who constituted at that time the gay and sellect circle. . . .

Whatever opinion may be entertained proverbially—in regard to *the grave* and stoical indian—It is very certain that no civilized races have so facetiously and pleasantly won the affection of the Red races as the French people.

I know the class of people that I have found merge into their tribal relationship—were generally a lively and cheerful people. I found many among them who were good 'fiddlers'—and to their good offices, the Indians were enlivened in their wigwams, and they gave a zest to the life of the indian traders and the early settlers in around the settlements. I have danced to their music with right good heart. (at the time of Councils.)"
(GWMSS 1-2, 2-39 [5])

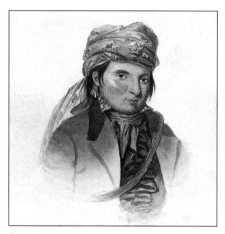

26. (see Plate 18)

**POT-TA-WAT TA-MIE CHIEF.
I-O-WAH**

Observed 1837; executed ca. 1863–71
Watercolor and ink on paper
15 7/8 x 11 7/8 (40.1 x 29.9);
comp. 9 3/8 x 7 3/8 (oval) (23.6 x 18.7)
Intended for inclusion in G. W.'s Indian journals
Journals and Indian Paintings, *Plate XXI*
M-59

(26) "I soon became acquainted after my arrival in Logansport, with Judge Edmonds who on learning that I was an artist interested and seeking information relative to aboriginal life, expressed himself much interested in my purposes in visiting the Wabash valley.

The first aboriginal sketch that I made was one of I-o-wa, by request of the Judge who seemed to take a particular interest in the young Chief.

This opened the way, and *removed* the coyness on the part of the indians in sitting for me. I-o-wa was very much *flattered* when Judge Edmond's request for his likeness was communicated to him. . . .

When I-o-wa came to my studio to sit for his likeness . . . he came prepared, as he no doubt thought—after a careful preparation of his toilet—to appear to the best advantage.

He appeared before me with a new plug hat of *tall proportions*—with a *gold star* in the front as an ornament.

This was a droll conceit—but destroyed too much of the aboriginal character.

Through Barron, the interpreter, I advised him of my desire to paint him with his 'turban'—as he would afford more interest to his 'father'—to possess his resemblance as an Indian Chief in the costume of his tribe.

He retired for a few minutes to Ewing's trading establishment which was near my studio. On his return he came with his head surrounded with a handsome red silk shawl, tied with much picturesque effect. The long ends falling gracefully over his shoulders.

Previous to his sitting I presented him with a cigar—and commenced smoking one myself. This was a courtesy deemed agreeable to indian ideas of friendship.

I-o-wa was no smoker. He however took a few whiffs—and placed the cigar down. The painting then proceeded. . . .

[Iowa's] eminence in the Councils of his tribe was remarkable in one so young. He and his brother Ma-jo-quis, Wee-wis-sa, Wee-saw and others of his clique, by some hidden strategy, assumed influences over and above older men, that excited some interest among the white people.

Nas-wa-kay in his speech at the Council at Kee-waw-kney village alluded to the circumstance. He was then speaking for the tribe. He remarked substantially that the chiefs now were more numerous than the number of the villages—implying that a controuling influence existed in the Councils with the U. S. Government that was not in accordance with the views of the older chiefs.

Col. Pepper perhaps found difficulties in effecting the purposes of their removal *West*, by continuing to treat with the Pottawattamies any longer under the old regimes of the older Chiefs. . . .

I-o-wa was chosen speaker—in reply to Judge Edmonds on closing his court." (GWMSS 1-2, 2-12 [1], 2-12 [3])

27.
MA-JO-QUIS' SQUAW

Ink on paper

8 3/4 x 6 (22.1 x 15.2)

M'jo-quis was the brother of I-o-wa (see Cat. #26)

G-428

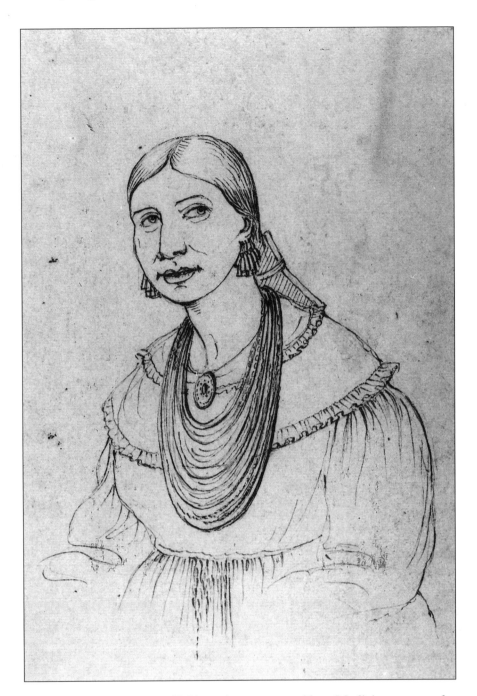

(27) "The squaw of M-jo-quiss was treated by a Medicine man at the Pottawattamie Mills. Her head was affected by disease—perhaps a nuralgia attack. The friends and family assembled to witness the wonderful cure.

Wild and frantic gesticulations were manifested. The head of the woman was excoriated with a sharp flint—bleeding was a necessary consequence and no doubt some relief was effected. But the Charlatan—medicine man placed his mouth upon her head and affected to suck from the cranium small bones—the cause of her disease which he had adroitly concealed in his hand—and at the happy moment—he affected to spit the bones into his hand—exhibiting to the friends and relatives & to the patient, who had submitted to the painful ordeal which she had passed through with the utmost placidity based upon a faith upon the efficacy and results of the magical power of the *medicine* man.

The cure was complete." (GWMSS 2-35 [1])

28. (see Plate 19)
**OLD AUB-BEE-NEW BEE'S—SON
LOGANSPORT—1838 [1837?]**
Watercolor on paper
10 3/8 x 6 5/8 (26.2 x 16.8)
K-15

29.
[AUB-BEE-NAW-BEE'S SON]
Observed 1837
Watercolor on paper
12 1/4 x 15 7/8 (30.9 x 40.2)
Inscribed, l.r.: "No. 8. George Winter"
Similar to Cat. #28
Journals and Indian Paintings, *Plate XXVII*
M-65

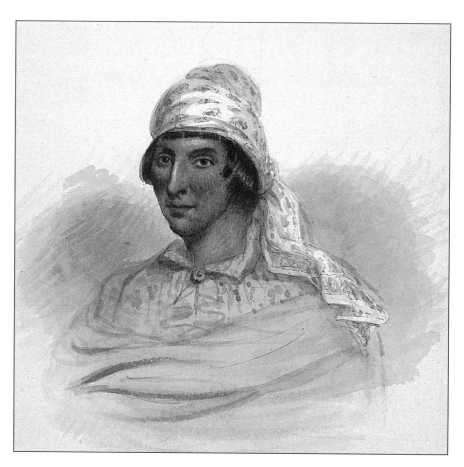

(28) "This young indian was well known to the white people—and was remarkable for his viciousness and a *distinctive* reputation which excited interest.

There are many things told of this young *warrior.* The great event of his life was the killing of his father, the famous orator and Headman, who was conspicuous in bringing about to a successful issue the Treaty of 1832.

Young Aub-be-naw bee was a good looking Indian. His head was of fine oval conformation—his features were of a higher type than that presented by the *Pott-a-wat-ta-mies* generally. His eyebrows were somewhat arched—his mouth well chisled and not so large as the characteristic mouth of his people—and his nose was a fine acquiline. . . .

In 1837, Young Aub-bee-naw-bee could almost daily be seen in Logansport around Ewing & Walker's trading establishment. I knew him well—and sketched him. . . .

At the Treaty of 1832, it is said that [the elder Aub-bee-naw-bee] was watched—a fear being entertained by the Commissioner who was in Council with the Indians—that the younger Aub-bee-naw-bee would carry into execution the threat that he had made of killing his father.

The fact is . . . the father had killed his squaw in some unfortunate drunken broil and the son was seeking revenge for his mother's death.

Not long after the Treaty of 1832 was consumated—the great orator and distinguished red man [Aub-bee-naw-bee] fell a victim to the tomahawk [of his son]—in accordance with the law and justice of the red race." (GWMSS 2-7 [1])

Keewaunay Council, July 1837

"*Kee-wa-knay village* was located on the borders of Lake Kee-wa-knay, situated in the south western corner of Foulton Co. Indiana. It was at this indian village that Cols. A. C. Pepper and Lewis H. Sands held their first Councils with the Pottawattamie in the month of July 1837, relative to the indians yielding the occupancy of their lands, and to the making [of] the preliminary preparations for their departure for their future home west of the Mississippi river.

These Councils soon followed after the investigation of the 'Pottawattamie claims', by Judge Edmonds; and in the month of November of the same year—*the last annual payment east* of the Mississippi was made.

The announcement of Col. Pepper's intention of holding councils in July awakened much interest among the people of the surrounding country, who were *much interested* for the indians' departure; but there was another class of people who *were anxious* for the indians *to remain* in the State. That was composed of those, who were interested in the *indian trade. These councils*, to me—were fruitful of many anticipated pleasures in connection with the augmentation of *aboriginal subjects* for my portfolio. . . .

Until the 21st I had been upon the tip toe of expectation of witnessing what my imagination had surrounded with a halo of romantick interest—that was an Indian Council. I had often read of these scenes which a council necessarily produces. I had often heard and read of Indian eloquence which is so peculiar for a density of thought and forcibleness of expression. . . .

On the afternoon of [20] July 1837, Col. Lewis H. Sands, George Profit, myself and our indian guide *No-ta-quah*, left Logansport for the Council ground, being twenty eight miles distant. Col. A. C. Pepper had

preceded us. The weather was very warm—yet pleasant. We forded the Eel River—thence, struck for the Michigan road north. The noble and gigantic oaks bordered the avenue, throwing out their full foliaged branches, casting their friendly shadows along the road, varied by *level lines*, and *gentle rises*, yet it was characterized by the peculiarity of a primeval condition.

We stopped at *Troutman's* well known cabin—here we refreshed our horses, nor were we *forgetful of ourselves*—we all 'smiled'. We now bade farewell on a sunny afternoon, to the more beaten path for the Village. After remounting our steeds, No-ta-quah, who had ridden by my side until now, spurred his *horse forward* and struck the *indian trail*, running nearly due west. Here we ceased riding two abreast, and from necessity, fell naturally enough into *'indian file'*. . . .

The morning was bright and unclouded. The foliage of the trees—the innumerable wild flowers—the tall grass waving with the gentle breeze—seemed to be *lit* up with more than common brilliancy, and Lake Kee-waw-nay, that beautiful sheet of placid water, contributed to a great degree to give beauty to the wild and uncultivated country around us. . . .

The appearance of the various tents Squaws—with their silver ornaments Sun Glancings—the shadows of the forest Peculiar combination of the Bridles, Saddles, Blankets, packages, and the various aboriginal *furniture*. Forks erected for hanging various articles upon. Fine effect—strange—novel. . . .

. . . I could but feel the delight which every mind susceptible of the influence of pictorial beauties necessarily would under the same happy circumstances that I then existed. From the vague ideas some people have of *artists*, in supposing them *he is only busy when at his easil*, I must have appeared *indolent* amidst such golden advantages before me. . . .

. . . We quartered at a large log [house]. . . .

The door of the room opened from the large hall which is peculiar to all double log cabins.

There were two small windows that let in the light to the room which was rather spacious. Upon the floor I . . . slept with perhaps twenty other white men during the holding of the Councils. It was hard sleeping, having nothing but my saddle bags for my pillow—and a cloth cloak of which I made a pallet to relieve the body from the immediate contact with the floor. This mode of sleeping would have been a hardship, had [it] been imposed upon me, as a penance—but being voluntary, it had the peculiar merits of a romantic character. I was among the Indians, and willingly shared in the ruder modes of life. . . .

The room was destitute of any of the attributes of civilization or comfort, save a bed in the corner of the appartment, which had been specially reserved for the Indian Agent Col. A. C. Pepper.

The other furniture or 'traps' consisted of one split bottom chair, an empty flour barrel which I extemporized into a table with a piece of deal board placed upon the top of the barrel—which answered very well for my purpose of putting my portfolio.

These were days of romance with me and the very limited appliances of convenience gave rather a zest to my situation." (GWMSS 1-2, 1-3, 2-30 [1], 2-28 [1])

30.
**KEE-WAU-NEE VILLAGE
JULY 26TH 1837**
Graphite on paper
10 5/8 x 15 5/8 (26.9 x 39.5)
OV-3

(30) "An indian village does not *always consist* of very many wigwams. . . . Kee-waw-knay village was the home of O-ga-mass, and the Chieftess Mas-sa. . . .

The *locality* possessed many claims too—which made it an inviting one, being but a few rods from Lake Ke waw knay with its 'shady groves' and gentle grassy slopes." (GWMSS 2-30 [2])

31.
LAKE KEE-WAW-NAY—1837
Graphite on paper
8 3/8 x 12 5/8 (21.2 x 31.9)
A-4

32. (see Plate 20)

SIN-IS-QUAW. (PEBBLE) WIFE
OF TOM ROBB. KEE-WAW-NAY
VILLAGE—INDIANA
JULY 20TH 1837
Watercolor and ink on paper
10 3/8 x 6 5/8 (26.2 x 16.8)
K-5

33.

SIN-IS-QUA
Observed 1837; executed ca. 1863–71
Watercolor on paper
12 1/4 x 16 (31.0 x 40.6)
Similar to Cat. #32
Journals and Indian Paintings, *Plate XII*
M-70

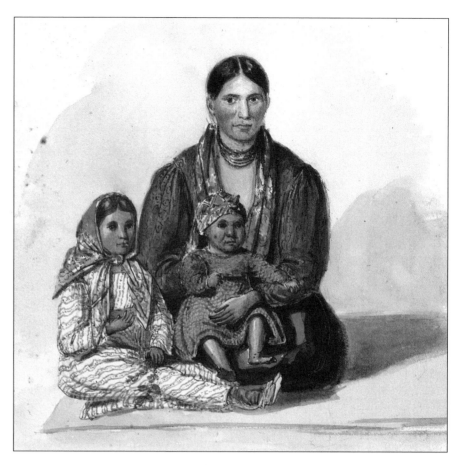

(32) "Sin-is-qua . . . was the first aboriginal woman that I had obtained a sitting from. . . .

The likeness of Sin-is-qua was sketched at the village of *Kee-wa-knay* at the Cabin of Mas-saw, amidst much confusion incidental to so many visiting Col. A. C. Pepper's Headquarters. It was a singularly mixed group of Redmen, squaws, and whitemen who were attracted by curiosity to the camp—as were the hangers on upon the Indian people. *Sin-is-qua* was a ready sitter, and was interested in the *Che makeman's* [white man] singular operations of transcribing the resemblance of herself and children upon paper.

It was a profound mystery, however—and no doubt her mind was much puzzled over the purposes of making the sketch. . . .

She was a most excellent woman, and became a convert to Christianity during Father Petit's missionary labors at the Twin Lakes, near Plymouth Indiana. Tom Robb, her husband, became dissipated—which ultimately led her to separate from him. Tom was a *hanger on*, and lived as many white men do—upon the bounty of the red men. . . .

. . . He was a soldier under Col. Campbell at the battle of the Mississinaway. . . . [He] never cared much to discuss the *merits* of that unfortunate battle. . . .

. . . [Sinisqua] unfortunately fell into domestic affliction by the loss of her younger child, a boy represented in the sketch. She went west of the Mississippi when the great body of the tribe left the state of Indiana—1838. Her husband retired to Cedar Lake, endeavored to sustain himself by hunting & fishing. He died there under peculiar circumstances.

She afterwards returned from the West, and settled with a small colony of indians on Silver Creek Michigan." (GWMSS 2-19 [4], 2-22 [4], 2-22 [5])

34.

**NANCY-ELIZABETH-ROBB.
DAUGHTER OF SIN IS QUAW**

Observed ca. 1844
Watercolor and ink on paper
9 5/8 x 6 3/4 (24.2 x 17.4)
L-38

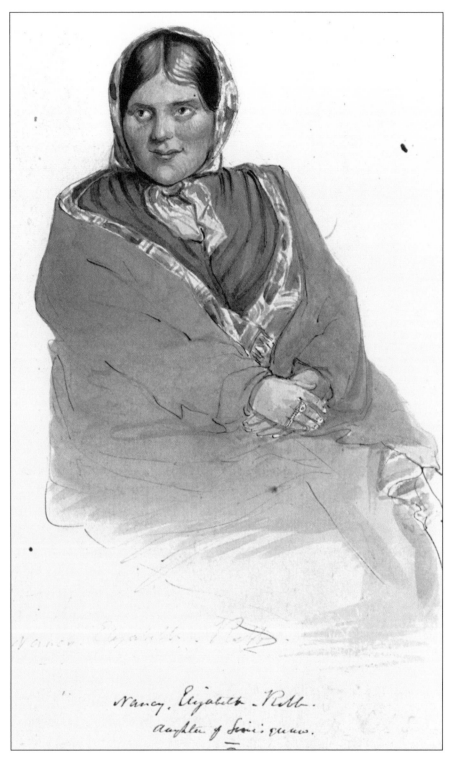

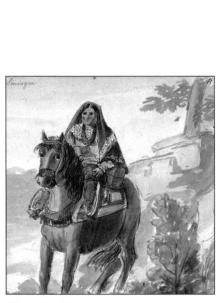

35. (see Plate 21)
SINISQUA
Watercolor and ink on paper
4 5/8 x 5 5/8 (11.7 x 14.0)
K-19

(34) "About seven years after I had made the sketch [of Sin-is-qua and her children in 1837], I was surprised by a visit in Logansport from her, her daughter Nancy, who had grown up to be a young woman, and some other squaws. Their appearance in town was a novel event—the *aboriginal* visitors were followed to my house by a large number of persons from curiosity. I gave them a warm greeting, and they seemed much delighted to meet me again. On showing them some of the paintings of *'Nas-waw-kay'*, *'I-o-wa'*, and others of her tribe, which she had seen many years before, they afforded them much pleasure—they talked to each other about the likenesses with much volubility and earnestness." (GWMSS 2-22 [3])

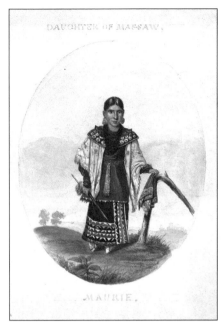

36. (see Plate 22)

DAUGHTER OF MAS-SAW. MAURIE

Observed 1837; executed ca. 1863–71
Watercolor and ink on paper
16 1/8 x 11 5/8 (40.9 x 29.3);
comp. 9 1/4 x 7 3/8 (oval) (23.5 x 18.6)
Inscribed, l.l.: "[N]o 36 [Ge]o Winter"
Intended for inclusion in G. W.'s Indian journals
M-61

(36) "The young Indian girl—whose likeness accompanies this brief memoir—was the daughter of Andrew Goshlieu and the Chieftess Mas-saw.

Maurie was about fourteen summers, attractive in her general demeanor, and was a favorite among the Indians at the village of Kee-waw-nay, where her parents resided. This likeness was sketched at the log cabin of her mother, where Col. A. C. Pepper held his head quarters during the period of his holding Council with the Pottawattamis.

Sinis-qua and her children had submitted to be sketched, and their likenesses excited much interest among the Indians who thronged Mas-saw's Cabin, where I had extemporized a studio amidst much confusion and a mixed crowd of White and Indian people. There being no chairs, or conveniences for a comfortable sitting, my efforts being here in water colors, I adapted myself to circumstances, and consequently took to the bare floor with the grace of *eastern custom*, and Indian habit.

My proposition to sketch Maurie was readily assented to by Maurie's mother, but the young Indian girl betrayed much emotion and fear—the countenance of the girl fell from her usual bright expression to one that betrayed an anxious sadness, and her tears were shed profusely.

Mas-saw however urged her to sit, and it was with reluctance she consented.

The pride of the mother was exhibited in the subject—and especially as she knew that there was nothing to pay—so she directed Maurie to put on her more ornamented Mech-a-ko-teh—her nap-p'kum-wa-gin-ik, and her strings of beads.

Maurie retired to remodel her costume, and in a very short time, she reappeared adorned with the silver ornamentations which are very conducive to the happiness and worldly vanity of an Indian woman. . . .

Maurie, after consenting to sit for her likeness, was disposed to show herself off in the most attractive manner—so in imitation of white people whom she had noticed used parasols, she consequently thought it would be an adornment to have one in her hand, with the addition of a large bandanna pocket-handkerchief. . . .

Maurie . . . was married to a white man, who from his position in the Indian trade, being an employee of the great traders, Ewing-Walker and Co., his facilities were many of seeing Maurie at her village home—and having influence too with Mas-saw her mother who had given the daughter a precedent in marrying Andy Goshlieu.

She therefore became the wife of Yo-ca-top-kone, and whatever honor was entertained by her Indian family in marrying a white man, and whatever happiness the young Indian girl experienced in her marriage relationship we cannot proclaim—it was suddenly brief, for death soon came upon Yo-ca-top-kone—and Maurie afterwards went to the *far off west* with the Pottawatami people A.D. 1838." (GWMSS 2-15 [3], 2-15 [5])

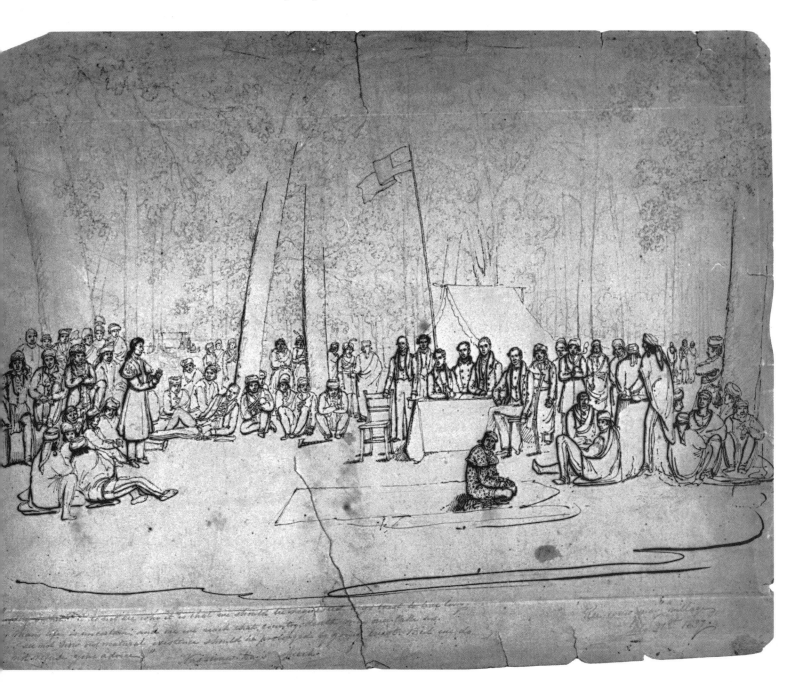

37.

KEE-WAW-NAY VILLAGE
JULY 21ST 1837

Ink and graphite on paper
10 1/2 x 13 1/2 (26.5 x 34.2)
Inscribed, l.l.:"'My Father, I do not see why it is
that we should be requested to go west to live long.
Man's life is uncertain; and ere we reach that
country, death may overtake us. I see not how our
natural existence should be prolonged by going west.
But we do not refuse your advice.' Nas-waw-kay's
speech."
Journals and Indian Paintings, *Plate I*
OV-341

(*37*) "Amidst the troubled days of life there are some that we love to remember. The 21st of July [18]37 is one that memory will ever bring before me, with all its associated pleasures. I had remained in the Indian camp several days . . . to witness what my imagination had surrounded with a scene of romantic interest—an Indian Council. In what I had already witnessed among the Indians, reality had exceeded anticipation; but I had often read and heard of Indian eloquence—of their condensity of thought, and force of expression—and the thought, in regard to the Council, would only revolve—am I to be dissappointed? We knew how frequently the enchantment which distance and description give, dissolve when we near the object, and the unveiled truth presents itself. . . .

The day I have said was bright, clear and unclouded. It was such a day as well suited the deliberations of both the pale faces and the Red children, as they were to be carried on in the woods, near and in sight of our quarters. It is only when the sky is unclouded that the Indians feel happy in their councils. The hour of 10 was the appointed time to commence the

'talk' relative to their immediate Emmigration—which particularly concerned all of them as a Nation. According to their last treaty they had one year more to remain upon their lands—yet as it was the policy of the Government and the interest of the Indians that they should go West, the sooner they did so, the better for both parties—the interests were mutual. The Pottawattamies are poor—they have no lands and they are much in debt. Their resources cut off—scarcely enough game upon the lands to afford common sustenance—and the whites densely settling and hemming them in on all sides. . . . Until the moment of the commencement of the speaking, our time was occupied agreeably enough in regarding the movements, and the various employments of these interesting children of Nature. . . .

. . . Col. P[epper], with the other officers of the Government, were in punctual attendance at the chosen spot, and at the hour appointed. It was in the cool shade of the forest, where the Agents' tent had been pitched; and before it lay a prostrate oak, upon which the Indians could sit and confront their 'father'. A red blanket had been placed upon the table for the Secretary to write on. The blanket was removed at the suggestion of Mr. Barron, one of the Interpreters, it being an emblem of blood. Fearing the superstitious feelings of the Indians might be awakened, a white one immediately substituted.

The officers were in waiting more than an hour before the congregating of the Indians, who seemed destitute of business habits. They are generally tardy in collecting together at their Councils, nor is it a circumstance to excite our surprise—for I believe a history of Indian Councils would not exhibit any 'bargains' in favor of the Aborigines. . . .

. . . at last a great number assembled and seated themselves upon the prostrate tree or on the green sward—displaying a very picturesque wild and splendid group, wherein every imaginable attitude was exhibited. Some of the chiefs were very splendidly attired upon the occasion. . . .

The American Flag is raised at the stand. Iowa, M'joquis, Wee saw, Kee waw-knay, Ash-kum, Wee-wiss-sa and others form an interesting and picturesque group. Other Indians sitting and lying around in their careless and easy manner as listeners. A keg of tobacco is placed for the Indians. They help themselves—every one took as much as he pleased.

Nas-waw-kay—Speaker for the Indians. He is dressed in a white counterpane coat with cape. His figure was erect—though an elderly man. His complexion very dark. Hair longer than the Indians generally wear it. It fell in flowing locks over shoulder. He wore a red belt across one shoulder—to the side, with a number of tassels attach[ed] in the common style of the Indians. A crimson sash around his waist. Red leggings—with wings, as usual. Standing forward from the principal group of Chiefs and Head men. His appearance was very striking & imposing. . . .

It is but natural for those who may see this painting to inquire the name of this and of that Indian. I will mention some. You may be enabled to do so, without my particularizing the characters; you may see resemblances of Indians too whose names are not familiar to me; and permit me to explain my *aim* for effect.

The principal group of Indians is to your left, as you view the painting....

'Nas-waw-kay' stands conspicious in his white counterpane coat and red silken sash. Immediately near his flowing hair sits 'We-wiss-sa'. Following in an oblique line are 'I-o-wa', 'Pash-po', and 'M-jo-quis'; directly in rear of the two last named Chiefs stands 'O-go-mass' (blind Chief). 'Knee-bush's' head only is seen close to the coat of 'I-o-waw'.

'Kee-waw-nay' reclines in indolent ease at the tree inclining to the National Flag; and the aged chief sitting with a stick near him, and in a direct line under [Col. Pepper] and near the feet of Col. Duret is 'Kar-kar-ky'....

Before speaking was commenced, Nas waky and the principal Chiefs left their position, and advanced to Col. P[epper] &c. with a belt or wampum and shook the Officials by the hand. I was honored with the same courtesy, being among them. Returned to their places confronting Col. Pepper &c.

After a brief pause, Col. A. C. Pepper addressed them in a long speech. This speech was previously prepared. After the delivery of it, for the Pottawattamies Nas-waw-kay advanced and delivered extemporaneously his reply.

Every time the speaker made a statement that they whist to be *impressed* upon the Agents' mind, the aboriginal gutteral exclamation was given. Sometimes one of the indians would back up the utterance by exclaiming–'eque in'. (That is so)

The [h]arrangue was interesting. Nas waw kays manner was emphatic. At times very graceful.

His speech was *not favourable* to the wishes of C[ol]. A. Pepper. The Col. assured me that it was truly quite a diplomatic effort. Knas-waw-key was known to be personally favorable to Emigrating that fall. But his remarks were the sentiment of the tribe.

Immediately after the Council was dissolved, Col. Pepper left the ground immediately and abruptly for Logansport. The Indians fear that they have offended their father.

Col. Sands & Profit remain at the village of Kee waw kney." (GWMSS 1-4 [1], 1-3, 2-30 [1], 1-4 [8])

G. W. to W. Blackmore, 5 March 1872:

"Through my valued friend now deceased, Col. A. C. Pepper, who was Indian Agent at Logansport A.D. 1837–38, I was in hopes of obtaining a Commission to paint a large work of *an Indian* Council Scene at the Village of Kee-waw-nay.

Mr. Crawford who was then Indian Commissioner entertained the idea of giving the Commission for the execution of the painting. Though I had the influence of Genl. John Tipton, of the U. S. Senate, and Col. Hook, a prominent gentleman at Washington ... yet to make a success of the Commission it required a *special appropriation* of Congress which was found to be *inexpedient* at that time.

My hopes fell by the deaths of Senator Tipton and Col. Hook and Col. Pepper's retiring from his agency.

Thus will hope often–'Tell a flattering tale'." (GWMSS 1-24 [5])

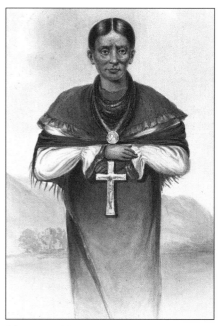

38. (see Plate 23)
MISS EN NAH GO GWAH
Executed ca. 1863–71
Watercolor on paper
16 3/4 x 12 1/2 (42.5 x 31.5)
Intended for inclusion in G. W.'s Indian journals
Journals and Indian Paintings, *Plate XIX*
L-43

39.
JOSEPH BARRON–INTERPRETER
Observed 1837
Ink and graphite on paper
11 1/4 x 8 (28.6 x 20.2)
G-362

40.
JOSEPH BARRON'S CABIN
(INTERPRETER) ON THE BANKS
OF THE WABASH 1837
Graphite on paper
8 1/8 x 11 3/8 (20.5 x 28.8)
Sketch of two-story log house with
gable-ended chimneys
G-453

(38) "We can now show the signs medals and other emblems of friendship then delivered to us, and we hope Father, that you do not consider them as mere bells hanging around our necks." (From Nas-waw-kay's speech at the Council of Kee-waw-nay, 21 July 1837; GWMSS 1-3)

(39) "Joseph Barron was born in Detroit about the year 1765. He was of French descent. . . . Being identified with the history of the great North West, having occupied the office as an Indian Interpreter, he was conspicuous in his confidential relationship with those who were eminent in official positions. . . .

Barron was the principal Interpreter for Genl. Harrison when he was Governor of the Territory of Indiana. . . . Though he could not read or write his vernacular (French) or the English language, yet he was variously employed in which some education would seem necessary. . . .

. . . as a consequence, it is probable that we have not always good interpretations of the speeches delivered by the indians at the various treaties and Councils. No doubt many beautiful and forcible thoughts of the Indians have been shaped into less beautiful forms of speech. . . .

Baron, personally was an interesting man–he was slender in form above the middle height. Black eyes–sallow complexion–large roman nose–small mouth–wore a que *a la aborigine*–with a large bow of black ribons dangling on his back. . . .

. . . He [was] a man upwards of 60 . . . a well formed forehead, bald pate, gray hair, heavy eye brows *naturally* but he has the habit of singeing them. . . .

He possesses considerable activity–dances well, can wrestle and throw men of nearly twice his weight–can speak seventeen languages, fourteen of which I believe are Indian. . . .

My personal acquaintance with Joseph Barron was first formed in 1837 A.D. at Logansport. He was then Interpreter to Col. A. C. Pepper, who was U. States Indian Agent. . . .

I met him often at the Indian encampments. He was at Col. Pepper's Councils with the Indians at Kee-waw-nay Village. He did not at that time Interpret, but in a partial way. Bourrassa Interpreted the speeches of Knas-waw-kay. . . .

. . . My portrait of him was the only portrait he ever sat for. He was a very remarkable subject for the pencil, and the result was a good likeness. . . .

He went west with a band of Pottawattamie Indians in the fall of 1838. . . .

. . . Barron returned from West of the Mississippi. . . .

In the year 1840, he was on the Tippecanoe Battle Ground at the great Harrison Convention. . . .

He accompanied many of us from Logansport to see Mr. Clay on his visit to the Capital of our State in 1842. . . .

. . . [he] died at the residence of his son 'Joe's'. He was perhaps 80 years old. . . . He was at the Battle of Tippecanoe, but I believe took no particular position as a soldier, but doubtless was useful to his general in suggesting the movements of the enemy as indicated by the battle song–or those peculiar commands of the aborigines in their warfare." (GWMSS 2-8 [1], 1-16 [8], 1-3)

41.
BOURASSA. INDIAN INTERPRETER 1837
Graphite and ink on paper
7 1/4 x 5 3/4 (18.3 x 14.4)
G-358

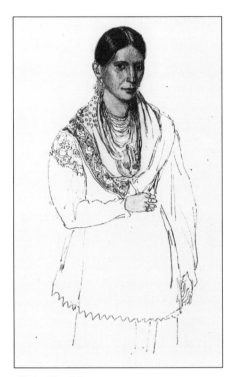

42. (see Plate 24)
QUEH-MEE SKETCHED AT KEE WAW-NAY VILLAGE 1837
Watercolor and ink on paper
10 1/8 x 6 3/8 (25.6 x 16.2)
K-7

(41) "Rice and Bourassa were Interpreters and *aboriginal men*–intelligent and had a good knowledge of English. They were among the exceptions that came under my own experience. . . .

Bourassa . . . was an Educated half breed." (GWMSS 2-21 [2], 2-30 [1])

(42) "Queh-mee was a paupoose of rather attractive personal appearance whom I often saw in camp, both in the Village of Kee-waw-nay and at the encampment at Crooked Creek. . . .

Queh-mee was selected as a subject for the pencil more particularly as an aboriginal *beauty* than for her being associated by any romantic or startling circumstance in her gay life.

She appeared to be a docile, good and kind girl. She was skillful with the needle and had good taste in the arrangement of the colored ribbands in the ornamentation of the Indian moccasin and leggings. . . .

Queh-mee was fatherless. He had for some years since been laid beneath the skab-a-kin-kit-twen (green grass or sod).

Her mother was a cheerful and sprightly Indian woman, somewhat advanced in life. . . .

She was the squaw of B[ourass]a, the Interpreter.

Queh-mee and her mother left Crooked Creek for the far west with the band of Pottawattamies under the charge of George H. Proffit in the fall of the year 1837." (GWMSS 2-22 [1])

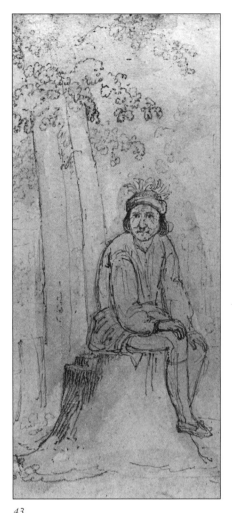

43.

**MIS-QUAW-BUCK–WAR CHIEF
RED IRON (DISTINGUISHED)
JULY 21ST 1837**

*Graphite, ink, and yellow wash on paper
10 3/8 x 6 3/4 (26.2 x 17.0)
G-342*

(43) "Mis-quaw-buck was a war chief and a man of great influence among his tribe. Col. Pepper in making his treaties with the Pottawattamies sought his influence by a private interview with him at his village. . . .

. . . Col. P[epper] . . . with his Interpreter Noah-quet–a half breed known as Rice–went privately to the different villages and secured the concurence of those Chiefs & Head men, such that, when the public Councils were held with the Indians, they were but mere forms to ratify [what] had already been secretly affected.

. . . By offers of goods or horses, Saddles or blankets, or by a certain *reservation*–or reservations of land to this chief, or to that one–The chiefs were now by these means brought to accede to the sale of the lands. . . .

To bravery, Mus-qua-buck was spoken of as a man of some gallantry, and when C[ol]. P[epper] visited him at his wigwam on the treaty business, the old Chief constantly kept the squaws amused by his genial manner. . . .

The Chief made his *mark* with Ash-kum, Kar-kau-kee, and others in the treaties which were duly ratified by the U S Government. . . .

I obtained the likeness of old 'Mis-quaw-buck' at the Village of Kee-waw-nay in the year 1837.

. . . The Indians were fast assembling. . . .

. . . [A]mong them, there sat a figure of great dignity and solemnity of expression. . . . It was 'Mus-qua-buck' . . . whom I had sketched unconsciously to him at the time while sitting on a stump of a tree watching some young Indians playing some game. He was completely disencumbered of all those gaudy trappings which the indians who are immediate neighbors of the Whites indulge in. His dress was simple–wild and well suited to his mode of existing. He had on a hunting shirt of coarse muslin, buck-skin leggings and moccasins, with a blanket strapped around his body and falling gracefully over his nether limbs. His head was surrounded by a small discoloured shawl, and had a bunch of feathers on the crown of his head–his hair was rather long and fell negligently over his ears. He possesses very prominent and striking features–and a silver ring hung flat through his nose (an odd fancy) gave him that singularity of appearance which but few possess." (GWMSS 2-16 [3], 2-16 [4], 1-3)

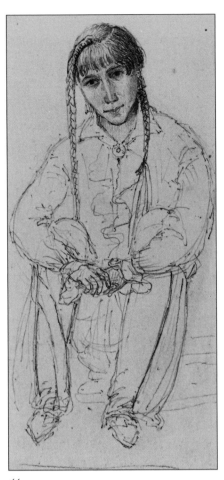

44.
**PASH-PO-HO. KEE-WAW-NAY
VILLAGE JULY 22ND 1837**
Graphite and yellow wash on paper;
star-shaped watermark
10 5/8 x 6 3/4 (26.8 x 17.1)
Inscribed, l.c.: "In the Treaty of 1836"
G-343

45. *(see Plate 25)*
PASH-PO-HO
Observed 1837; executed ca. 1863–71
Watercolor and ink on paper
15 3/4 x 11 3/8 (39.9 x 28.9);
comp. 9 1/4 x 7 1/2 (oval) (23.5 x 18.9)
Inscribed, l.l.: "No 37 [G]eo Winter"
Intended for inclusion in G. W.'s Indian journals
M-62

(44) "Pash-po-ho was a prominent man, and though his name stands at the head of the list designated as the Proper Chiefs of the Wabash Pottawattamies in the treaties of Augt. 5th. 1836 and Sept 23 of the same year, yet he was not regarded as the *principal* Pottawattamie chief–as young To-pen en e bay was, '*king*'–or head of all the Pottawattamie nation. To-pen-bay was living in 1838–and went West. He objected to my sketching him, though Joseph Barron the Interpreter tried to influence him to sit to me. . . .

Pash-po-ho was an *aboriginal gentleman*–he was considered the best dressed Pottawattamie Indian in the nation, and was exceeedingly graceful when mounted upon his handsomely equipped pony.

The heavy plated bit–handsome bridle–the nose strap fringed with bright red–the breast strap of great width with numerous tiny bells that jingled as the prancing movement of his steed

. . . the handsome spanish saddle with plated stirrups pendant. The saddle cloth handsomely ornamented, and the girth of many colors interwoven in the web. . . .

How different is the illustration that accompanies this eulogized descriptive account of Pash-po-ho. . . .

How Pash-po-ho consented to let me sketch him may be explained thus: It was at the village of Kee-waw-nay that this sketch was obtained. Pash-po-ho had often been solicited to sit for his likeness–and uniformly objected. He was one of the Chiefs who opposed the emigration, yet he privately told Col. Pepper in my presence, that he was himself anxious to go west immediately. He said–but if I advocate the emigration, I shall be killed.

. . . it was evident that his mind was perplexed, and that he sought that relief to a mind perturbed . . . in drinking deeply of the 'Fire water'.

It was the day after the ajournment of the Council, when the Indians had mostly returned to their respective villages. I remained, and concluded to employ my pencil in sketching the surrounding points that were most attractive to me. I was the only white man there in the village, with the exception of Andrew Gosslieu, Mas-saw's husband. I still quartered at her cabin, and continued to do until the reassembling the Indians, when they were to give their final answer in regard to their emigration west of the Mississippi that fall, 1837.

While I was sketching a scene of the Lake, Pash-po-ho was passing along in front of me in a condition no way doubtful. . . . his 'toute-ensemble', so careless and reckless, so wanting of the usual neat and studied appearance which generally characterized the Chief.

He saluted me with the usual compliment of '*Bou-zho-nic*' of the Indians, and made the significant motion of his hand for me to follow him. . . .

. . . I followed him some quarter of a mile north from the lake, to the shade of a grove. . . .

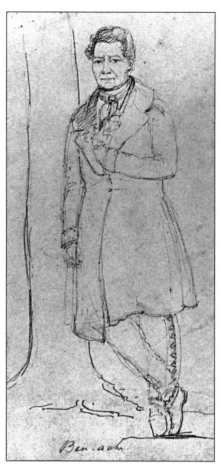

46.
BEN-ACHE
Observed 1837
Graphite and ink on paper
10 3/8 x 6 5/8 (26.2 x 16.6)
G-365

47. (see Plate 11)
BEN-ACHE
Observed 1837; executed ca. 1863–71
Watercolor and ink on paper
16 1/4 x 11 3/8 (41.2 x 28.7);
comp. 7 7/8 x 5 7/8 (oval) (20.0 x 14.9)
Inscribed, l.l.: "No 33 Geo Winter"
Similar to Cat. #46; intended for inclusion
in G. W.'s Indian journals
L-42

Pash-po-ho sat down, made a motion, and grunted an equivalent of *'go ahead'* which I did, literally–and my surprise was equal to my gratification in having the opportunity of getting his likeness, though not under the most attractive circumstances–but as he presented himself so I faithfully sketched him.

In the year 1838, Pash-po-ho went with the Emigration West of the Mississippi." (GWMSS 2-19 [1])

James R. M. Bryant, Bloomington, Indiana, to G. W., 6 February 1858:

"[A]fter a long and dusty days march [Pash-po-ho] would wash off, dress in all his Indian finery, with his magnificent leggins, worked all over with beads, ribbons, and porcupine quills, and after carefully painting his face, would take a seat at the foot of a tree, and gaze with admiring complacency upon himself. He was a perfect Indian Dandy, and truly a fine looking fellow." (GWMSS 1-15 [17])

(46) "'Benache' was a 'headman', having no claims to the honors of Chief. He was one, in point of talents in the Pottawattamie tribe who exerted great influence. . . .

At the village of Kee-waw-nay I became acquainted with Benache. He could speak French–his paternity was of french connection and blood. He was a half breed. . . .

Benache in the year 1837, when I sketched his likeness was nearly sixty years of age. . . .

He was a man of great loquacity, social and genial of manner. Occasionally he would get under the influence of the fire water–he was then boisterous and difficult of controul–on one occasion in the town of Logansport where he often came to trade, he was threatened with a lodgement in jail. The confinement in the old log jail of that place was of terror to the Indian. . . .

Benache died in the vicinity of South Bend Indiana, where he had lived many years. He became a convert to the Catholic faith." (GWMSS 2-8 [3])

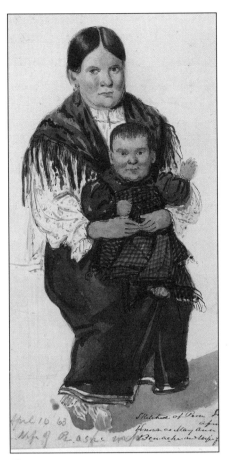

48.
KNOWN AS MARY ANN–DAUGHTER
OF BEN-ACHE AND WIFE OF
PE-ASH-WAH. SKETCHED AT PERU
INDIANA. APRIL 10TH 1842
Watercolor, ink, and graphite on paper
9 x 5 3/4 (22.9 x 14.5)
K-18

49.
KEE-WAU-NEE–VILLAGE–
JULY 23RD 1837
Ink and graphite on paper
6 3/4 x 10 1/2 (17.0 x 26.7)
OV-344

(48) "Mary Ann *Benache* was a fine looking *squaw* when I first saw her in 1837. She had been engaged to a young man named Johnson, who was unfortunately buried on the Prairie. She was afterwards married to Capt. Reed, whom I knew well. . . . Old McCartney married *her* after Reed left her. He was an *elderly* man. They lived but a short time together. She was finally married to the celebrated indian known as *Pee-ash-wah,* whose revenges upon the *Weeahs* was bloody and frequent. . . . Mary Ann Benache was accidentally shot by an indian. She was thereby crippled. I saw her afterwards with her mother in *Peru* in 1843 [1842?]. She had come to Peru for the purpose of having her child baptized by Priest Clarke. . . . I made a sketch of her and child. They delayed return home several hours for me to make the sketch." (GWMSS 2-39 [13])

(49) "A group of interesting figures were here with their handsome and fantastical draperies which gave them a very picturesque appearance sitting in consultation under a shady tree & *there* another group was enjoying the morning repast at a wigwam, and another was seen gambling and sending forth their merry peal of laughter–which would dispel from your mind the idea of the Indian being a grave child. Some were riding and running races, whooping and yelling–others playing a game . . . which is similar to that of Quoits. The squaws too, formed no little interest and picturesque beauty in the much animated and truly novel and extraordinary scene before us. Their occupation principally was making moccasin or leggings– the character of their work, which requires a great quantity of diversified coloured ribbons–and exposed as they were to view in unstudied negligence and combined with the many coloured garments of their own–and many of the capes of which, were covered with large circular ornaments of silver which had the appearance of armour, could not fail to arrest the eye of a common observer–much less an artists, whose eye must ever be ready to drink in what ever is lovely attractive and beautiful–here was the flow of the soul." (GWMSS 1-3)

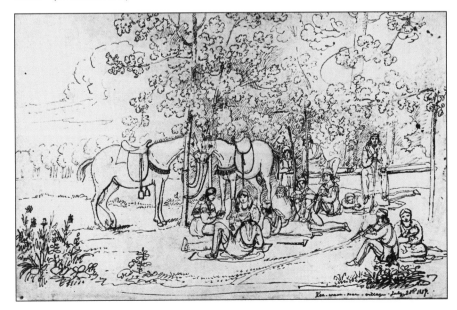

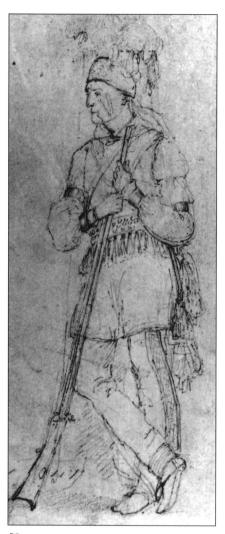

50.

YO-CA-TOP-KONE. KEE-WAW-NAY JULY 24TH 1837

Graphite on paper
9 5/8 x 6 1/8 (24.3 x 15.5)
Journal-345

51. (see Plate 26)

YO-CA-TOP-KONE

Observed 1837; executed ca. 1863–71
Watercolor on paper
16 x 11 1/2 (40.6 x 29.1);
comp. 9 7/8 x 7 1/4 (oval) (25.0 x 18.4)
Inscribed, l.r.: "No. 7. George Winter"
Intended for inclusion in G. W.'s Indian journals
M-76

(50) "Henry Taylor the subject of this sketch was a whiteman who was for several years in the employ of Ewing, Walker & Co–Indian traders before alluded to in the brief memoir of *Maurie*. He was a man who had the confidence of his employers and was well versed in the peculiar pursuit and peculiar modus operandi of the Indian trader, the purpose of which–as demonstrated by experience–is large gains, with an eye to *advantage* of the situation. It does not call for the higher qualities of christian practice. . . .

I remember many clerks in their establishment [Ewing, Walker & Co.], and among them perhaps no one was more faithful to their trust than Taylor. It is a common thing among people in an Indian country, especially those who are intimately associated in business with the red people, to have *their squaws*–or Indian wives. . . .

The drawing, under the title of 'Yo-ca-top-cone' conveys–by feature–position–and costume, a seeming impersonation of a meditative–and well-formed, distinguished Pottawattamie Chief. But it is only our old friend Taylor in masquarade. Knowing my interest in the Indian people, and being at the Village of Kee-wau-nay at the time that I was attending Pepper's councils, Taylor thought he would interest me by a *practical* joke–by secretly conniving with his Indian *'flame'*, and her mother, Mas-saw, by dressing up in Indian costume–and assume the character of an Indian chief.

The deception was complete, for 'the toute ensemble' of an Indian, stood before me.

The *cheat* afforded much amusement to the red people of the village, and Maurie and Mas-saw were exceedingly amused." (GWMSS 2-28 [4], 3)

52.
NEE-BOASH SKETCHED AT THE VILLAGE OF KEE-WAW-NAY– JULY 1837

Graphite on paper
10 5/8 x 6 3/4 (26.8 x 17.1)
Inscribed, l.c.: "One of the chiefs in the Treaty of /36"
G-361

53.
CHAUK-KO-INA. KEE-WAW-NAY VILLAGE 1837

Ink and graphite on paper
10 1/2 x 6 3/4 (26.6 x 17.0)
G-360

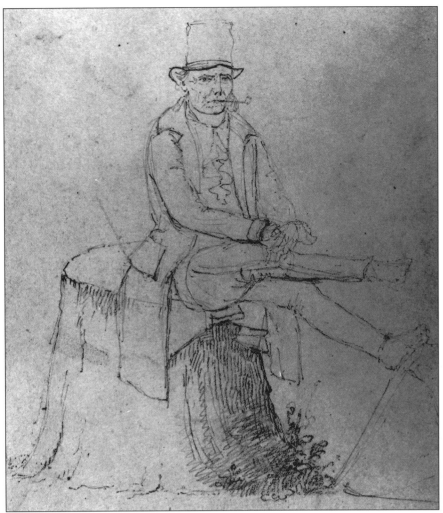

(52) "Nee-boash was a man of more than common reputation as a warrior. He was a man above the medium height and perhaps in 1837, when I sketched him, sixty years of age....

Nee-boash fought in the battle of Tippecanoe with some distinction. It is said that he lost the tip of his nose....

... it is related that when he returned to his village after the battle of Tippecanoe with the fair proportions of his nose curtailed–that his squaw, on meeting him, was so amused at his altered and excentric appearance– that he was excited to unbridled wrath, and in his fit of anger–tipped her nose with his 'ko-man' or knife....

I knew Nee-boash's squaw. She was proverbially known as *'Cut nose'*....

... I made the sketch of the Chief at the Village of Kee-waw-ney in the month of July 1837, and his squaw also. A secured sketch of the Chief I made at 'Crooked Creek', a month later–and on the day that a small band of the Pottawattamies departed West of the Mississippi under the command of George Profit....

... He was sick there. Dr. Jerolaman bled him. He was much pleased with the operation, as he derived much relief. He appeared in his tent quite calm and dignified. He had been scalped in some conflict with some other tribe.... The old man generally wore busk skin leggings with but a narrow sides or wings which were not very much adorned with ribbon facings–so much indulged in among the Indian people." (GWMSS 2-18 [1], 2-18 [4])

54.

SKETCHED—JULY 25TH 1837 AT THE VILLAGE OF KEE-WAW-NAY

Ink and graphite on paper
13 x 10 1/4 (32.9 x 26.0)
G-346

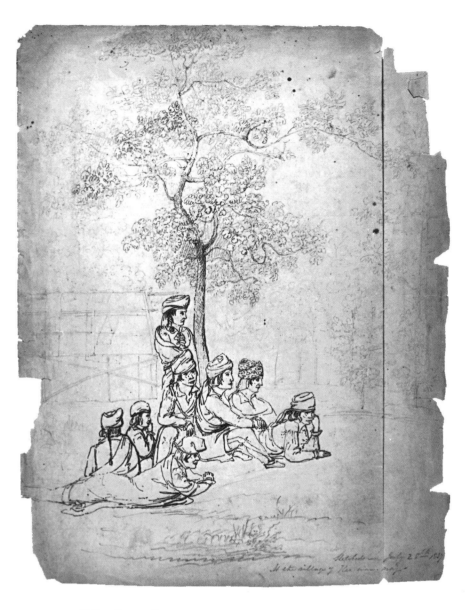

(54) "The Council scene at Kee-waw-nay was a singular combination of Indian men in all the vanity of costumes of varied colors and a difference of fashions—yet as a whole was truly aboriginal in character.

Within this interesting grand group there were many *lesser* picturesque groups. These outlined ones, are to the artist among the most interesting efforts of the several likenesses and scenes that compose this collection of original works....

These outlines—groups—are placed among the other efforts for variety, and they fully illustrate the easy and careless mode of sitting in a council scene of the Children of Forest life." (GWMSS 2-30 [3])

55.

DISTANT VIEW OF LAKE KEE-WAW-KNAY. INDIANA JULY 25TH 1837

Graphite on paper
10 1/2 x 13 1/2 (26.6 x 34.0)
A-2

56.
INDIAN DANCE. LAKE
KEE-WAW-KNAY–INDIA 1837
Graphite on paper
14 1/2 x 19 7/8 (36.6 x 50.4)
OV-355

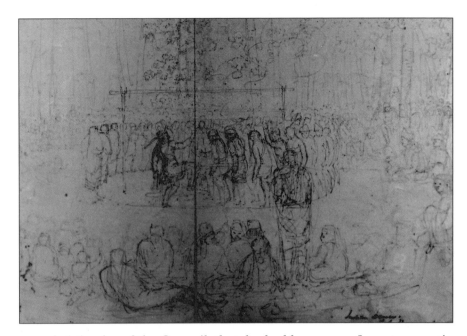

(56) "The night of the Dance succeeded the day of the Council–that day had been one of great romantic excitement–the night was not less so. . . .

Col. Sands orders a beef killed for the Indians–great excitement over the event. The evening–beautiful and clear–moonlight. The Indians have a national dance in reciprocation for Col. Sands liberality. . . .

. . . The preparatory steps to the spectacle were the making of a drum, which was soon effected by knocking the head of a keg, and stretching deer skin over it, purposely prepared. Two poles about eight feet high were then planted in the ground, at the distance of fifteen feet from each other; upon these another was placed horizontally, underneath which a fire was built–and soon spread its red and cheerful light around, illumining the near objects; and partially dispelling the gloom of the dark night.

'The Dance! the Dance!' was at last echoed through the crowd. The Indians had retired from the fire and formed themselves into a large circle–presenting an assemblage of surpassing oddity. Some spread their blankets upon the green sod, and reclined or sat–many seated themselves upon decaying prostrate trees, or on stumps, which afforded great scope for variety of position. Some smoked their tomahawk pipes, with the silver ornaments glittering in the light of the fire–the smoke curling gracefully in the still and undisturbed air. Wee-saw, a chief was called upon to open the Dance; but Wee-saw could not unless he received a dollar fee. This singular request was soon gratified, and he commenced dancing around the stakes and fire to the tapping of the drum, accompanied with the wild gutteral strain of a child of the forest. As he danced around he muttered something in indian, by way of encouragement to others to follow. Several Indians joined in and increased in number, until about forty were moving at a kind of 'dog trot', to use a vulgarism but expressive one. After going around and around repeatedly, some of the 'pale faces', who had dressed themselves a la Indian, joined the dance–and by their awkwardness, afforded much amusement to the Indians and bye standers. A change of step among the dancers was now made, with something more like an effort. It was a species of hopping upon each leg alternately, while the foot was made to strike the ground three times in quick succession, with some force; and which timed in accordance with the wild music. Occasionally some of the Indians would dance backwards, joining hands with others whom they faced. A swing round, with whooping and yelling, produced a good effect. Again the figure of the dance changed by dancing two abreast.

M'-jo-quiss and Wee-wiss-sa, two chiefs danced with admirable grace. Yelling, whooping and laughing, were the constant accompaniments of the festivity.

The Squaws, who had been merely passive spectators to the dance, now joined it. A dozen, very superbly dressed heightened the effects and beauty of the scene. Their manner of dancing was of an entirely distinct character from the men. They merely shuffle or scuffle along–scarcely raising their moccasins from the ground."
(GWMSS 1-4 [2], 2-30 [1])

57. (see Plate 27)
D-MOUCHE-KEE-KEE-AWH
Observed 1837; executed ca. 1863–71
Watercolor on paper
16 1/8 x 11 3/8 (40.9 x 28.8)
Intended for inclusion in G. W.'s Indian journals
Journals and Indian Paintings, *Plate XVIII*
M-77

58.
D-MOUCHE-KEE-KEE-AWH
Observed 1837; executed ca. 1863–71
Watercolor on paper
15 3/8 x 11 1/2 (39.0 x 29.0)
Similar to Cat. #57; intended for inclusion
in G. W.'s Indian journals
M-64

59.
**[WOMAN WEARING CAPE
OF BROOCHES]**
Graphite on paper
7 1/8 x 4 7/8 (17.9 x 12.4)
G-391

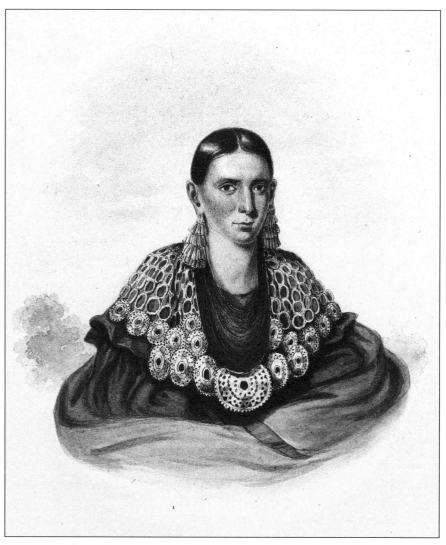

(57) "D-mouche-kee-kee-awh was the squaw or wife of Abram Burnett. She was an Indian woman of much personal attraction. She excited the admiration of whitemen as well as that of the Indians.

D-mouche-kee-kee-awh was a full blood Pottawattamie woman, but was not a representative type of the received idea of indian characteristics, those of low forehead and high cheek bones.

The likeness of this woman is a sketch from life–and I might add that it is not overdrawn in the interest of flattery. . . .

Abram Burnett appeared always proud of his handsome squaw. . . .

Burnett was educated at the Choctaw institution in Kentucky—though a good honest fellow, of fine robust appearance–yet was not particularly of a brilliant type of intellectual capacity.

Burnett and Squaw went to Kansas with general emigration of the Pottawattamies of the Wabash A.D. 1838. . . .

Burnett died at Topeka Kansas 1871, so the local papers of the place announced. They report him as a *Chief* and a man of large farming interest, and who had with age, become a rival of Godfroy and La Fontaine in physical ponderosity, it being stated that he was a man of 350 pounds avoirdupois.

Of D-mouche-kee-kee-awh, it might be truly said that no Pottawattamie squaw equalled her in regard of dress–she was as her likeness indicates–*'plated'* with silver broaches, the very ne plus ultra of an Indian woman's toilette." (GWMSS 2-10 [3])

60. (see Plate 28)

MAS-SA

Observed 1837; executed ca. 1863–71
Watercolor and ink on paper
16 1/4 x 11 1/2 (41.2 x 29.2);
comp. 7 7/8 x 5 7/8 (oval) (20.0 x 14.8)
Inscribed, l.r.: "No. 24 George Winter"
Intended for inclusion in G. W.'s Indian journals
Journals and Indian Paintings, *Plate IX*
M-60

(60) "Mas-saw, the Chieftess. . . .

. . . was the mother of Maurie. . . .

The chieftess' name is attached to the long list of the Indian Chiefs and Headmen, Warriors &c. in the Pottawattamie Treaty of Augt. 5th, 1836. . . .

Mas-saw married a white man known as Andrew Gosselin who was living with her when I first knew her in 1837.

Her rank as Chieftess was inherited, and of course not obtained by her marriage with Gosselin, who was a French Canadian, and was of that class so often found identified by intermarriage with the Indian people. . . .

Mas-saw was a woman of no common mind–ability; and her influence among the Indians was very observable. She resided at Kee-waw-nay village. . . .

Col. Pepper held his head quarters at Mas-saw's cabin when he held his Councils at the Council ground, but a short distance from her cabin. She was not indifferent to the interests of the silver dollar. During the time of the Councils she derived considerable revenue from her accommodations, rude as they were. . . .

. . . The group at the rude table in the cabin was peculiar, yet composed mostly of educated men. Col. A. C. Pepper, Col. L. H. Sands, George Profit, Dr. Jerolaman, Gardiner agent to secure Indian boys for the Choctaw Academy, Kentucky, were the companions of the hour. Our meals were enlivened by much pleasant feeling and conversation. . . .

Mas-saw was much assisted in her culinary operations at her wigwam by Do-ga. . . .

Do-ga sat for her likeness very readily. . . .

She was so much gratified with the likeness that she brought Mas-sa to the studio in full 'regimentals' to sit.

She had her cape covered with circular silver ornaments. . . .

Several strings of small blue beads hung around her neck. She wore a ke-chep-so-win or belt–pendant from it were several steel chains with *watch keys* attached, falling as low as the knee over a mich-a-ko-teh or petticoat handsomely ornamented with silver rings. . . .

. . . her petticoat was handsomely bordered by rows of ribbons of the primitive colors, an occasional row of a secondary color. These ribbons were about two inches wide, cut into points and vandykes–very neatly sewed. . . . Her cloth blanket too was bordered by ribbons and silver rings. . . .

. . . Her blanket and petticoat were of good dark blue broad cloth . . . her moccasins . . . were neatly made and handsomely checkered on the laps with ribbons of the primitive colors. . . .

Red leggings . . . completed the handsome costume. . . .

Mas-saw stood patiently for a very long time. . . .

It was a small full length sketch in oil that I painted. The result astonished both the chieftess and Do-ga.

Mas-saw went west with Emigration of the Pottawattamies in the year 1838." (GWMSS 2-15 [1], 2-18 [2], 2-10 [6], 2-12 [6])

61.
KEE-WAW-NAY–VILLAGE.
MAS-SA'S CABIN AND
WIGWAM OF O-GA-MAUS.
JULY–1837
Graphite and ink on paper
8 1/8 x 11 3/8 (20.4 x 28.8)
G-452

(61) "[O-kah-maus] was permanently fixed at the Village of Kee-waw-nay previous to the Pottawattamie emigration.

His wigwam was no common edifice. The village was the home of Mas-sa also. They were near neighbours–but a few paces distance separated their wigwams. . . .

[Mas-saw's] house was head quarters for Col. P[epper] and *subs* particular friends. It was a double log–substantially built. It consisted of two lower rooms on the ground floor & two rooms above. . . .

. . . a wide hall or passage of 9 feet in width . . . seperated the rooms both on the first and second floor. The kitchen was immediately in the rear. This log house was a place of general rendevous for the Indians who did not bring their camps with them. . . . [Before this] uncommonly large wooden mansion . . . the ground is cleared but partially–it being well studded with stumps of trees. . . .

O-kah-maus wigwam was made of bark and its structural lines conformed very much like to the *dome* of some building that had been blown off from its proper position and in its aerial flight had fallen to its present locality.

It appeared to be based upon an octagon. It was open at the apex which facilitated the smoke from the central fire to escape to the open air. The frame work was built with many stout poles of hickory and was faced with bark–in squares or sections–with diagonal crossings of sticks, which acted as binders and kept the bark from bulging from the action of the atmosphere. It had a patchy appearance, was weather beaten–but it was unique and picturesque." (GWMSS 2-12 [6], 1-3, 2-18 [5])

62.
O-KAH-MAUS (LITTLE CHIEF)
Graphite on paper
10 1/8 x 6 3/4 (25.6 x 17.0)
Inscribed, l.c.: "Known in the Treaty of
Augst. 8th. 1836."
G-368

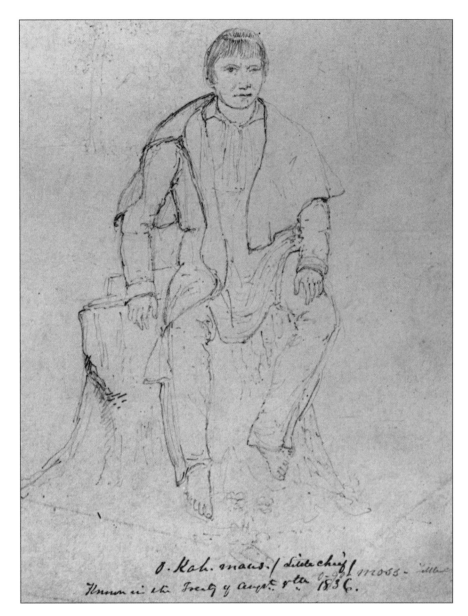

(62) "O-kah-maus was a heriditary chief but not inheriting any great qualities of mind or distinction. He possessed no particular influence in council or in war or in the chase was he expert. Yet O-kah-maus was a chief and his assent to the making of treaties with the Government was as essential as that of Kaw-kawk-kay, Ash-kum, Ne-bosh the Brave, or the more intellectual orator and chief Nas-waw-kay.

O-kah-maus was what the Indians call Po-ke-queh, or one eyed. . . .

In personal appearance the chief was rather repulsive. He had not the personal pride of a Pash-po-ho. . . .

The quiet of O-kah-maus was painfully disturbed by the death of a sister who had been murdered by an Indian–a former lover–under very singular circumstances. . . .

Though the chief was peaceful in disposition and was free from the vice of indulging in the 'fire water'. . . .

. . . he had to suffer from drunkenness in others for he was very severely lacerated in his right cheek by some intoxicated Indian, who in his excitement struck wrongfully 'O-kah-maus'." (GWMSS 2-18 [5])

BURIAL SCENES

"One of the most interesting scenes that came within my observation at the Village of 'Kee-waw-knay' was that of the burial of an aboriginal woman. It occured in July A.D. 1837.

During the time of the Council was being held by Col. A. C. Pepper with the Pottawattamies, application was made to him for the arrest of an Indian, who had maliciously, and in a very *remarkable* manner, caused the death of the sister of Chief O-ga-maus. . . .

After the Council was concluded, [Col. Pepper] left the Council ground immediately for Logansport; the Agents' head quarters. . . .

I determined to remain alone until the reassembling of the Indians, as I could fully employ my time in sketching points of interest . . .

While rambling through the beautiful oak openings the following morning, so prolific of picturesque attractions–a loud reverberating sound in the surrounding woods fell upon my ear.

I knew that a 'giant' of the forest had fallen. The point of interest was soon found. O-ga-maus and other Indians were engaged in contemplating the tree that had fallen before the labors of the axe. . . .

The Indians, with the assistance of a whiteman, A. [Goslin], the husband of Mas-saw, were employed in chopping a six foot log off the prostrate tree. Afterwards they split off boards preparatory to making a 'che-pe-em-kuk', or rude coffin. These were the preparatory labors to the interment of the deceased woman.

These operations were made near the Village, and in close vicinity to the burial ground, bordering upon the margin of the lake, commanding a very pleasant view. . . .

While some of the Indians were preparing the rough boards for the coffin, others were employed in digging a shallow grave–not more than two feet in depth, which was the only grave made *below* the surface in this burial ground.

These rude preparations made for the interment of the deceased aboriginal woman occupied the friends much time; and it was not until the crimson rays of the setting sun fell across the clear surface of the lake, that these Indian people brought their work to a completion.

Through the squaw, Do-ga, who could speak english with some fluency, I learned that the burial would take place on the morrow. . . .

The shades of night had gathered over the Village of Kee-waw-knay. I sat at the cabin door of Mas-saw, which was but a few rods distance from the ponderous pyramidal bark wigwam of O-ga-maus. . . .

Lamentations of the wailing women could be audibly heard as they mourned over the dead woman. The light from the interior of the wigwam stole through the fissures of the bark of the rude structure. It was a dramatic effect." (GWMSS 2-36 [1])

63.
INDIAN BURIAL GROUND. LAKE
KEE-WAW-NEY. INDIANA. 1837

Graphite on paper
6 3/4 x 10 3/4 (17.2 x 27.3)
G-454

(63) "The Indian burial place . . . was *occupied* with no less than twenty tenements of death, over which were placed rude and moss covered logs of small diameter variously placed. Many of the corpses were resting upon the surface of the earth. Through the interstices of one of these piles, curiosity led me to glance into the peaceful chamber of death–and I beheld the shocking and painful sight of a prostrate and decaying corse . . . with the . . . remains enveloped in the discoloured robes of the grave. It was truly a sad sight, which brought the regret that I had yielded to curiousity's promptings. A small area of ground cleared from the green showed that much devotional care and pains had been bestowed in keeping this sacred spot free from the spontaneous weed. . . . A slender pole with a white flag waving gently in the air was planted in the ground which is ever carefully watched, lest the wanton storm should shatter it to pieces.

No Indian burial ground is without this emblem of sacredness and peace. . . .

How many apologies for the Indians' reluctance to leave his native wilds for the strange land destined for him in the 'Far West' presented themselves to the mind as I sat contemplating the hallowed scene before me. . . .

The Red man cherishes the memory of his departed Fathers! See with what devotional care the ground on which the sepulcher in which the remains of his fathers repose in undisturbed peace are tended. And what a combination of mixed feeling must all this degraded and unfortunate race experience . . . when they will have to bid farewell forever to their native forests–and to leave their sacred burial grounds, with a consciousness that *ere long* the *advances* of *civilization* will obliterate them from the face of the earth." (GWMSS 2-36 [5])

64.

INDIAN BURIAL

Observed 1837
Wash on paper
5 1/4 x 6 3/4 (13.3 x 17.0)
Inscribed, verso: "Indian Burial Scene No. 1–
near Lake Kee-waw-nay–Indiana"
Journals and Indian Paintings, *Plate V*
OV-348

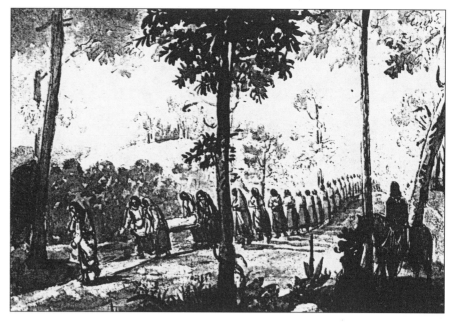

(64) "The morning opened with clear sky, the sun gaining in warmth as we strolled through the shady groves of the white oak openings, so park like and pleasant.

The burial ground was soon gained where already some of the Pottawattami men had assembled.

From my chosen position, the funeral cortege was observable as it emerged from the wigwam of the Chief. It descended a gentle slope and crossed a 'run' immediately fronting the cabin of Mas-saw; it soon reappeared through the sparsely growing trees. . . .

O-ga-maus, the brother of the deceased, preceded the corpse; the friends followed, after the manner of the aborigines, in Indian file.

The body was wrapped in white muslin and laid upon a board; hickory withes were tied around the corpse to secure it in place upon this rude bier.

The ends of the withes were held by six squaws, three on each side, who carried the remains to their final resting place, followed by a large number of squaws who exhibited gravity of demeanor. A large number of Indians had now assembled to witness the interrment; this sudden death of the sister of the Chief had awaked a very sympathetic feeling among the Indians." (GWMSS 2-36 [1])

65.

INDIAN BURIAL

Observed 1837
Wash on paper
5 3/8 x 6 7/8 (13.4 x 17.2)
Inscribed, verso: "Indian Burial Scene No. 3"
Journals and Indian Paintings, *Plate VI*
OV-349

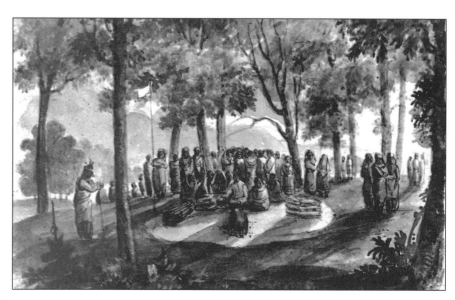

66.

INDIAN FUNERAL
KEE-WAW-NAY–VILLAGE INDIANA.
JULY 27TH 1837

Ink and graphite on paper
10 5/8 x 6 3/4 (26.8 x 17.1)
Inscribed, l.c.: "The burial of the sister of
O-kah-maus whose death was caused by the
shocking brutality of an indian–"
G-347

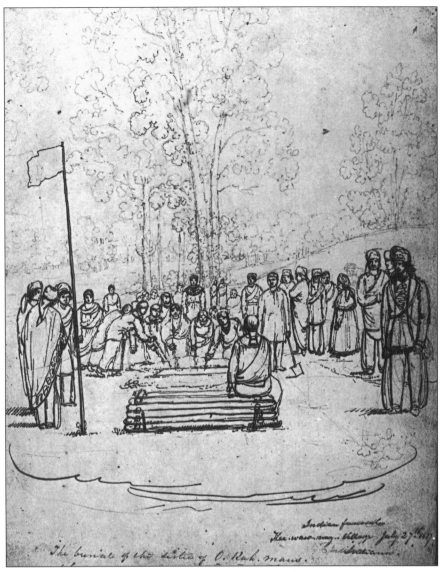

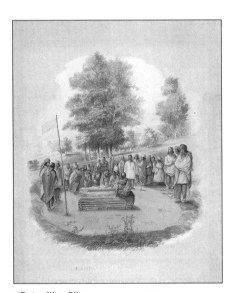

67. (see Plate 29)

INDIAN BURIAL
KEE-WAW-NAY VILLAGE 1837

Executed ca. 1863–71
Watercolor on paper
15 1/2 x 11 3/8 (39.3 x 28.8)
Inscribed, l.c.: "No 20"
Intended for inclusion in G. W.'s Indian journals
Journals and Indian Paintings, *Plate XVI*
M-81

(66) "Temporarily the body was deposited at the grave while the previously prepared rough boards were placed within, making a nailless . . . coffin.

The corpse was then placed with much care within its narrow cell and the lid board put on with precision.

An interesting ceremonial followed. The squaws then in a solemn manner–each gathering up a handful of the freshly turned up soil, and sprinkled it upon the coffin. . . .

O-ga-maus, who had stood a silent spectator of the burial of his sister, now advanced . . . and soon filled up the grave and shaped it above the surface into an oblong mound.

Then the relatives sat down and partook of food, while the friends of the family continued to surround the grave.

Here the scene grew intensely striking. A large number of Indians . . . stood within the shadows of the trees around the burial ground.

A fire had been kindled previous to the interment; the smoke now floated in wavey and arid thinness, diffusing its tint of blue in the foliage of the outspreading branches of the trees, giving a mystical appearance–harmonizing with the wildness of the forest scene." (GWMSS 2-36 [1])

GAMES

68.

YUH-YOUH-TCHE-CHICK
KEE-WAU-NEE–VILLAGE–
INDIANA JULY 28TH 1837
Ink and graphite on paper
6 7/8 x 10 3/8 (17.5 x 26.3)
OV-354

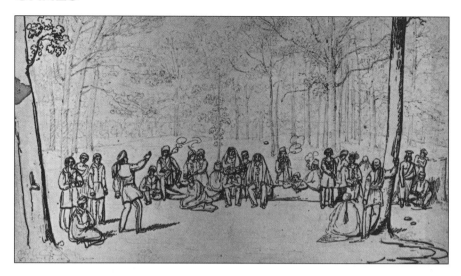

(68) "The hour of ten was appointed to commence the 'talk'. Until that time there was an expansive field of observation to engage the mind. . . .

There were some hundreds of Indians present. . . . They were scattered around in groups of singular looking figures. . . .

Some . . . were amusing themselves by riding–running races–or whooping–yelling–and playing a game called 'yah-yent-tche-chick', which is similar to quoits. . . .

. . . It was after the Council had been ajourned some several days. I was alone [in Mas-saw's cabin] in a room facing north. . . .

I had *extemporized* a table by placing a piece of board accross a flour barrell. This answered my purpose for writing and finishing up my sketches.

One day whilst I was strengthening my sketch (with pen and ink) of the Indians playing the game of *'youh youh-chick-chick'*, the door was opened carefully and *y-och-se* entered. . . ." (GWMSS 1-4 [1], 2-28 [2])

69.

POTTAWATTIMIE INDIANS
PLAYING MOCCASIN
Observed 1837
Ink and graphite on paper
8 x 10 1/4 (20.4 x 26.0)
OV-351

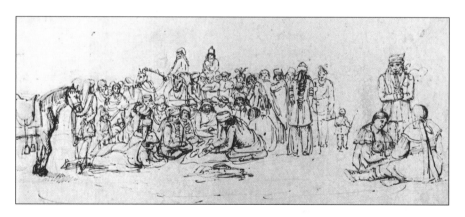

(69) "I have commenced another indian picture, measuring 40/50 inches. It is to represent a group of indians playing moccasin. The scene includes a view of lake Kee-waw-nay." (GWMSS 1-4 [12])

Notice of Winter's Distribution of Paintings, Lafayette, 16 March 1854:

"'Playing Mocasin'–This scene presents a view of the placid waters of Lake Kee-wau-knee. A group of Aborigines are introduced playing the exciting and favorite game of Mocasin. The picturesque costume is faithfully preserved. . . . The original sketch was made on the spot in 1837." (GWMSS 2-1 [12a])

70.
KEE-WAW-NAY-VILLAGE
INDIANA–JULY 28TH 1837
Ink on paper
6 3/4 x 10 1/2 (17.1 x 26.5)
Four women seated on floor playing cards;
similar to card-playing group at right in Cat. #69
OV-352

71.
THE GAME OF WINK
Ink, wash, and graphite on paper
5 1/4 x 6 3/4 (13.4 x 17.2)
OV-350

72.
[GROUP OF MEN, POSSIBLY
PLAYING GAME]
Graphite on paper
4 1/2 x 3 1/4 (11.1 x 8.2)
G-405

(70) "Mas-saw had some civilized qualities of no mean pretensions. She was in fact a gambler of no ordinary ability. She played euchre very well–and those who understand the game of 'Poker' said that she was an adroit expert, often *raking* men of experience who attended her 'receptions' in the *second* story of the cabin." (GWMSS 2-15 [2])

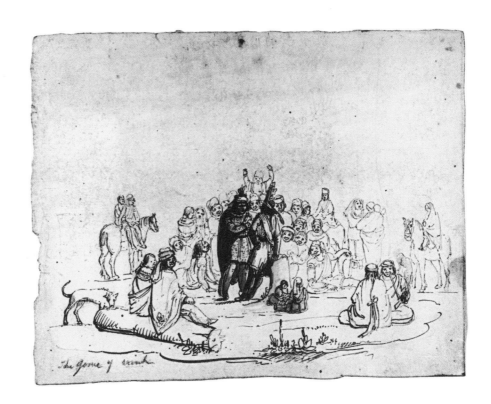

73.
NEAR LINDSAY'S CABIN–1837
Graphite and ink on paper
8 7/8 x 13 (22.5 x 33.0)
Family group with horses; woman holding baby
G-369

74.
INDIAN GROUP
Ink and graphite on paper
6 1/8 x 7 (15.5 x 17.6)
Family group with horses; woman holding baby
G-432

75. (see Plate 30)
NO-TAW-KAH. VILLAGE OF KEE-WAW-NAY–JULY 27TH 1837
Watercolor and ink on paper
10 x 6 5/8 (25.3 x 16.7)
Inscribed, l.c.: "In the Treaty of /36 Our guide to Lake Kee-waw-nay"
K-6

76.
NO-TAW-KAH
Observed 1837; executed ca. 1863–71
Watercolor and ink on paper
15 1/4 x 11 7/8 (38.5 x 30.2)
Inscribed, l.c.: "In the treaty of 1836 Geo Winters Guide to Lake Kee-wau-nay"
"No 10"
Similar to Cat. #75
Journals and Indian Paintings, *Plate XII*
M-78

77.
DESERTED VILLAGE–NEAR LINDSAY'S CABIN 1837
Graphite on paper
3 7/8 x 6 1/2 (9.6 x 16.5)
Pole framework of four tents
G-456

LINDSAY'S CABIN, FOLLOWING COUNCIL

(73) "This morning Col Sands and Profit depart for Logansport to remain untill the expiration of seven days.

Lindsay, formerly blacksmith to the Pottawatamies Invited me to his cabin–some three miles distant to spend my time there until the council met again. He told me than no sooner would the officers would be out of sight of the village–the Indians would be drunk.

I remained to see the frolick–His remarks were verified." (GWMSS 2-30 [1])

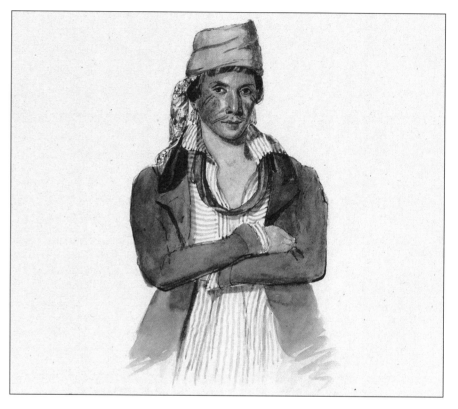

(75) "No-ta-quah extended to me two very marked courtesies: one of them previous to our leaving Vigus' Hotel–the Washington Hall. I had hired a horse to go to [Keewaunay] village; great was my surprise to find awaiting me before the hotel door, a *'two story'* horse–about 17 hands high. As I stood contemplating the Elephantine animal, trying to solve the problem how I could mount–and *surmount* the difficulties, not being *physiologically of tall pretentions*. . . .

No-ta-quah . . . courteously offered me his horse, which was an easy riding animal of smaller mould, the property of Capt. McCartney, which the indian had ridden in from the Camp. I gladly accepted No-ta-quah's offer.

While riding along the 'Michigan Road' with him, and following Col. L. H. Sands and George Profit, I accidentally dropped my whip–(a rawhide) I did not think it important enough to stop to pick it up. The keen eye of the indian discovered my loss. He presented me with *his*–smilingly. . . .

I shall ever remember No-ta-quah's courtesies. He is associated with that novel trip to the village of Kee-wau-knay. . . .

. . . Some [Indians] were painted very curiously–red and black are the only paints that I have seen used among them." (GWMSS 1-2, 1-3)

CROOKED CREEK, AUGUST 1837

"I . . . was once more allured from the hurry and bustle of civilized life–to the beautiful retreats of the unfortunate and expatriated Indian, to witness the very exciting and affecting scene of the departure of the little emigrating band of Pottawattamies from their native and cherished forest homes. . . . The removing agent Mr. P[roffit] who had now the sole charge of the Emigration had pitched his tent and Banner at the great bend of Crooked Creek eleven miles west of the town of Logansport four days succeeding the last council, as the Chiefs, headmen and warriors of the nation were informed he would, for the purpose of assembling those indians who were favourable to an immediate emigration to their new homes–The country allotted to them in the 'Far West' by the U. S. Government.

On the lovely day of Augst. 19th. a small party of four–your humble servt. being one–set out for the Indian Camp in a vehicle though rude in construction yet had the redeeming qualities of being strong–and suited to the country. . . . We crossed the ford at the confluence of the lovely Rivers Eel & Wabash whose banks are beautifully bordered by the rich leaved sycamore and oak, followed the Lafayette Road a short distance and struck in upon some barrens a little northerly, and followed a westerly course on our route. We noticed but a few blurs upon the sublimities of nature's work by the innovations of the white man. . . .

. . . the bells of the Indians horses were indistinctly heard in the distance. . . .

We entered in the Camp ground singing a song with chorus, which was previously agreed upon. . . . We drove up to the agents camp, before which stood the 'American stripes'–a Banner associated deeply with the History of the U. S. it having been in the battle of Tippecanoe and covered the body of Spencer. It has several bullet holes in it. . . . Mr. Profit the removing agent gave us a cordial welcome–we were all well acquainted with him. . . .

While dinner was preparing we took a ramble around the Camp ground, where each of our attentions was engrossed by things which more or less interested us. Most of the indians were to me as old friends as I have sketched most of them at *Kee-waw-nay* village. . . . Nas-waw-kay as usual was pleased to see me. I proceeded from wig-wam to wig-wam, saluting all. The war chief Knee-bush . . . was in his wig-wam in depressed spirits. He told me he was sick. . . .

The Camp ground was a perfect level platform called the *great bend* of Crooked Creek. It is well timbered though not thickly, yet well adapted for an encampment–trails were visible in all direction–intersecting each other–having a *map* like appearance, which the intercourse from one wig-wam to the other had produced. We quartered at a Log-house consisting of one solitary room which was a kitchen, bed room and pa[r]lour. This was the residence of a white settler, who provided us fare of a mean character at the rate of 75 cts per diem. . . .

After dinner we all returned to camp and whiled away our time the best way we could. We watched the process of issuing rations to the Indians. The Commissary blew his horn which was the summons for them to come and recieve them—this was an operation which was brief, there being less than a hundred Indians here. Night came on and we were summoned to supper—This we *attended to with alacrity* and we did ample justice to it . . . like the indians, we found eating drinking coffee and smoking engrossing a good portion of our time. It was quite dark when we left the supper table for the Camp. . . . Through the foliage we could discover the faint glimmering of the various fires at the different wigwams. . . .

. . . A dance was proposed by one of our party which was soon put into execution. . . .

We kept up our festivity until midnight, when all feeling somewhat fatigued and by general consent, concluded to retire . . . shook our blankets . . . then wrapt ourselves up . . . making our *saddle bags* pillows for our precious *heads*. . . .

20 August 1837 Our party arose early this morning. . . . Until the hour for breakfast we huddled around our fire. . . . The Indians had to pass us to get their rations from the Commissary whose camp was immediately before us as we sat. Every passing Indian underwent our greatest scrutiny. . . some would have their flower wrapped up in a shawl that had been used as a *turban*—and others might be seen with a dirty *shirt* acting as a substitute for a bag probably mislaid—others again might be seen with good clean bags, indicating more refinements. The Indians may be considered dirty in their habits—and its true I have witnessed many a dirty scene among them, but I doubt whether the whites under the *same circumstances* would be as clean—*indeed* I have seen *dirtier* white people than I have Indians.

Today we spent pleasantly enough. From wigwam to wigwam we strolled, observing the amusements and occupations of the various families." (GWMSS 2-32 [1], 1-3)

78. *(see Plate 31)*
**INDIANS RESTING NEAR
LOGANSPORT AUGT 10 1837**
Watercolor and ink on paper
6 3/4 x 10 (16.9 x 25.3)
*Inscribed, l.l.: "A Miami [Potawatomi?] Indian
spancelling his horse"*
K-13

79.
INDIAN CAMP
Observed 1837; executed ca. 1863–71
Watercolor on paper
11 1/2 x 16 (29.2 x 40.5)
Inscribed, l.r.: "No. 25. George Winter."
*Similar to Cat. #78; intended for inclusion
in G. W.'s Indian journals*
Journals and Indian Paintings, *Plate XXX*
OV3-74

80.
**[GROUP PREPARING CAMP;
MAN HOBBLING HORSE]**
Observed 1837
Graphite on paper
4 1/2 x 6 5/8 (11.2 x 16.7)
G-401

(78) "The bell of the indian pony is often heard from the far off distance in the forest–and you may be sure it comes from the streams and creeks, and springs, where the Indians make their encampments. . . .

The indians do not, except upon the prairie, attach their ponies to stakes. Their ponies in camp generally are spanceled or hobbled, so that they cannot stray away to any great distance–and having bells attached to a strap around their necks, any movement necessarily causes a tingling of the bell–and each one having some peculiar tune different from another the sound is familiar to each one its possessor; there is but little difficulty in tracing the stray pony that may have wandered off to a distance to browse. . . .

When an indian is about to camp, spanceling the ponies is among the preliminaries of settlement for the night.

The squaws, in the meantime, seek the saplings for the tent poles–and the younger trees for forks to place the cross stick to hang the essential *pot* on, to commence the boiling–the venison or bear meat to generate the savory soup.

. . . a *trunk of a tree* no vestage of greeness or vegetation about it, but stands naked and in bold relief against a clump of lovely young trees–as I gazed at the tree, the thought passed through my mind that it was an emblem of the Pottawattamie nation. Its strength, greatness and glory had passed away–but was now a weak and a fast receding unglorified thing.

The clump of young trees which appeared to *watch this decaying* trunk stood a fain emblem of the *obstructing pale faces*–who are thickly settling the country." (GWMSS 2-38 [1], 2-38 [2], 1-3)

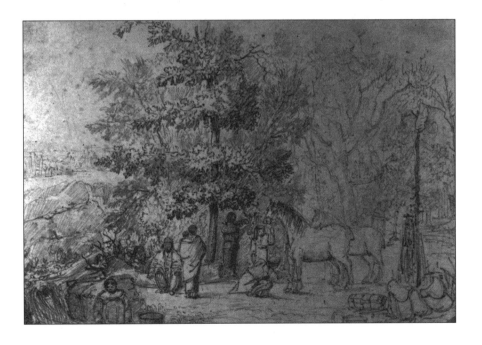

81. (see Plate 32)
POTTAWATTAMIE INDIANS
CROOKED CREEK INDIANA 1837
Watercolor on paper
6 5/8 x 10 1/4 (16.9 x 25.9)
Journals and Indian Paintings, *Plate XVII*
K-14

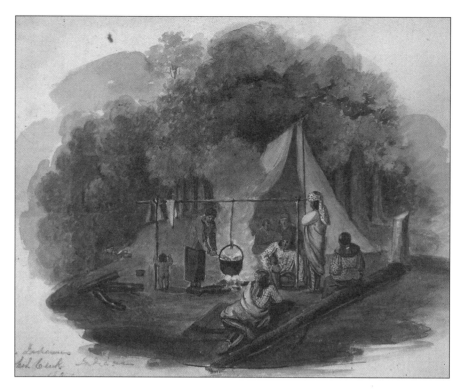

(81) "The squaws seem to have more than their share in the duties necessary to their sustenance and comforts. . . . The squaws perform all the culinary operations–chop wood–fetch water from the spring saddle their horses when setting out to journey–Leaving nothing for the indian to do, but to hunt–and to sleep–and to seek recreation otherwise as feeling and inclination may dictate. . . .

My friends with myself strolled around the Camp ground this evening to take *a few items*–in doing so we did not pass by the wigwam of *Old Barron* . . . before which was a large blazing fire. Mr. Baron and his squaw were at supper. The canvass was thrown open, and the interior of the wigwam had something of the display of an *eastern* canopy. The fire reflected its light upon it, and what with a tallow candle suspended in the centre by a piece of twine, the wigwam became brilliantly illuminated.

The earth was covered with matting. Blankets red and white were used as pillows to recline on–a large black trunk studded with brass nails here and small red one with the little trinkets of the squaw–with various rolls of ribbon there–and numerous things carelessly, but picturesquely distributed about this savage residence." (GWMSS 1-3)

82.
[CAMP SCENE WITH HORSES]
Graphite on paper
7 x 8 1/2 (17.7 x 21.4)
G-400

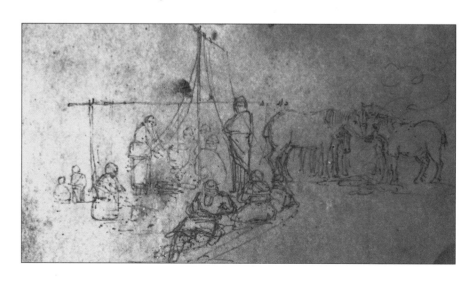

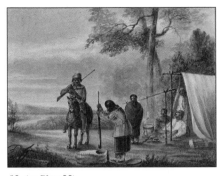

83. (see Plate 33)

[CAMP SCENE WITH WOMAN
POUNDING GRAIN]

Executed ca. 1863–71
Watercolor on paper; watermark "J WHATMAN"
11 5/8 x 14 7/8 (29.7 x 37.6)
Inscribed, l.r.: "No 16"
Journals and Indian Paintings, *Plate XXII*
L-46

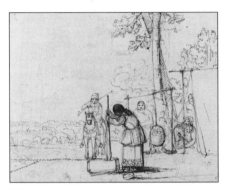

84.

[CAMP SCENE WITH WOMAN
POUNDING GRAIN]

Ink and graphite on paper
4 7/8 x 6 (12.2 x 15.3)
G-372

85.

[CAMP SCENE WITH WOMEN
COOKING]

Ink on lined blue paper
3 1/4 x 5 1/2 (8.0 x 13.8)
G-443

(83) "The Indian camp by some bright stream, overshadowed by friendly trees–the fire blazing and crackling–the pot of venison suspended upon the cross stick–the cool refreshing breeze wafted from the flowing waters–your calumet filled with the genial weed, its fragrance floating on the air–your platter before you, the simmering pot, with its savory contents sending out its assurances under your olefaction. He who has tasted of the freedom of the forest will say that *this scene* is enjoyable to civilized and savage man. . . .

The early settlers of new countries knew full well the method of the indians, which they followed from necessity before the *grist mill* is known [in] the *settlements* in making hominy. The heavy pole used in pulverizing Indian corn in a *hole* in *the end* of a log is familiar in *its* use to the *squaw* in her domesticity." (GWMSS 2-38 [1], 2-19 [2])

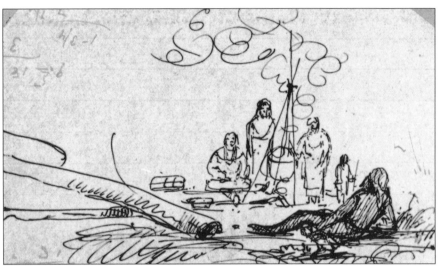

(85) "[A] *pot* which was swinging before us upon a *horizontal stick* placed upon two forks at several feets' seperation–which was placed before every wigwam for the purpose of cooking, and putting meat on . . . was under the scrutinizing eye of the young Indian, in which pot he discovered some boiled potatoes and giving a yell he took possession. . . . The young Indian looked up at me, and said–Eat my friend. I replied in Indian–I would. I dipped my hand into the pot and drew forth a *potatoe* which occupied me several minutes to *devour*, as I was neither hungry nor favourably impressed with the manner in which they had been cooked. To have refused eating with them would have probably offended them–which I would not have done willingly. . . .

I remember well being asked to take soup for the first time among the Indians. Indian corn was an important ingredient but the flavour of it was very disagreeable to me, and it was therefore no common exertion that I made to eat it. I did manage to swallow it, yet it was an extraordinary effort that made me conceal that I was undergoing the process of taking an emetic. . . .

However, when a supply of food is placed before you which is an *over lash* to your yet delicacy, place a piece of tobacco before your trencher–you may consider yourself as having made no breach of politeness, but have shown a high knowledge of etiquette, upon which you may return great 'honors'." (GWMSS 1-3, 2-37 [1])

86.

INDIAN ENCAMPMENT. FIGURES REPRESENTING THE INDIANS EATING WATER MELLONS

Ink on paper; embossed seal
7 7/8 x 9 3/4 (19.8 x 24.8)
Journals and Indian Paintings, *Plate III*
OV-388a

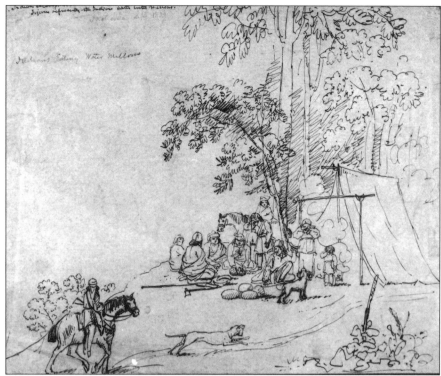

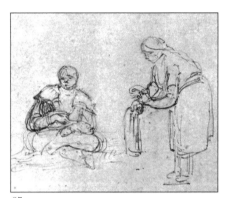

87.

[STUDY OF TWO WOMEN]

Graphite on paper
4 3/4 x 6 5/8 (12.0 x 16.8)
G-417

(87) "The indian father or mother is supposed to have a less tender parental regard for the offspring than the civilized man. The great spirit has given the red man a heart to feel and sympathize as fully and deeply for his offspring as the white man–indeed the playful spirits of youth are equally customary to him. His hopes run high, and his ambition soars, as he contemplates the child that is to be the future chief or head man among his fellows." (GWMSS 2-34 [10])

88.

[CHILDREN AT PLAY]

Graphite on paper
7 5/8 x 6 1/4 (19.4 x 15.7)
G-444

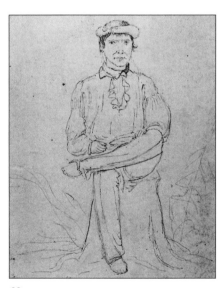

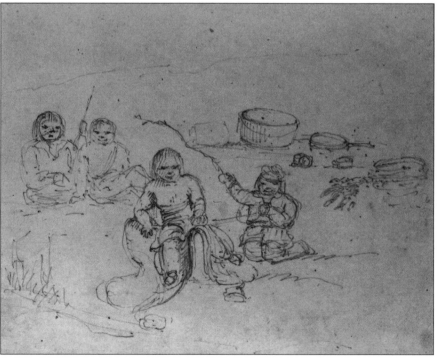

89.

SAW-WAW-GUT. SKETCHED AT CROOKED CREEK 1837

Graphite and ink on paper
6 7/8 x 5 3/8 (17.4 x 13.4)
Inscribed, l.l.: "Capt. McCarty's friend"
u.r.: "one of the chiefs known in the treaty of
Septr. 23rd 1836"
G-364

90.

SAW-WAW-GUT

Observed 1837; executed ca. 1863–71
Watercolor on paper
14 1/4 x 11 3/8 (36.0 x 28.9)
Inscribed, l.c.: "No 32"
Similar to No. 89; intended for inclusion in G. W.'s
Indian journals
M-66

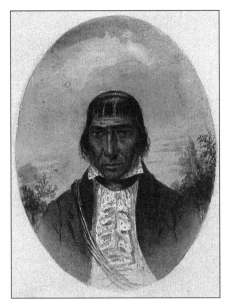

91. (see Plate 34)
KE-WAW-NAY. WAR CHIEF
Observed 1837; executed ca. 1863–71
Watercolor on paper
16 1/4 x 11 5/8 (41.0 x 29.4);
comp. 4 1/2 x 3 1/2 (oval) (11.5 x 8.6)
Inscribed, l.l.: "No. 35 Geo Winter"
Intended for inclusion in G. W.'s Indian journals
Journals and Indian Paintings, *Plate VIII*
L-41

92.
**KE-WAW-NAY. SKETCHED AT
CROOKED CREEK–
AUGST. 22D. 1837**
Graphite on paper; star-shaped watermark
10 1/2 x 6 7/8 (26.6 x 17.3)
*Inscribed, l.c.: "One of the Pottawattamie chiefs that
made the Treaty of Sept. 23. 1836"*
Similar to Cat. #91
G-363

(91) "'Kee-waw-nay' was a war chief–one of the old patriarchs of the Pottawattamies of the Wabash. The village of Kee-waw-nay and the charming lake which was in close vicinity was named after this chief.

He was an old man of consideration among his people, and identified in the treaties made by Col. Pepper in the purchase of the lands which the Pottawattamies held within the state of Indiana north of the Wabash. . . .

. . . *Kee-waw-nay, Nee-boush, Godfroy* (a Miami chief) and some others whom I personally knew, fought at that celebrated battle [Battle of Tippecanoe] *among* the opposers of Harrison's advances upon the Indian country. Kee-waw-nay was found–he, like many other brave Indians had no *chronicles* to make known his prowess or achievements, and it is to [be] regretted that we cannot get easy access to a history of these people in the detail of their lives. . . .

The reports of commanding generals often furnishes us with the particular individual acts of bravery of those who served under them–and are thereby, given an undying fame. But alas! the *brave Indian* who fights for his home and the preservation of his game often looses the oppertunity to live in song–or in history–to perpetuate his daring deeds. . . .

The old man [Kee-waw-nay] seldom indulged in the use of the [firewater], that bane upon the red race. Yet there were times that he would drown his sorrows, growing out of the burdened wrongs of his people and the crowding memories of the land and home from which he was soon to be severed forever. . . .

The old chief left the old hunting grounds for the West with great reluctance. He was one of the band who left for the West in the year 1837, in charge of George H. Proffit, numbering about one hundred only. It was the avant courier of the emigration that followed in the autumn of 1838. I remember well the day of the departure of that little band, when they struck their tents preparatory to forming their line of march. It was early in the morning when Col. Pepper informed me that he had determined upon their moving that day. I went to the old chief's wigwam, and asked him to let me sketch him, as I desired to remember him by his likeness. . . . The old chief and myself were on very friendly terms, but it was not until the *'eleventh hour'* that I could get his consent to sit for me." (GWMSS 2-13 [4], 2-13 [5])

93.

**AFTER THE PAYMENTS–DEMOSS'
TAVERN MICHIGAN ROAD. 1837**

Ink, wash, and graphite on paper
7 x 8 5/8 (17.7 x 21.9)
Inscribed, l.r.: "Pottawattamie Indians carousing"
G-371

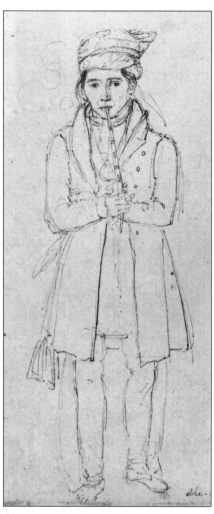

94.

CHE-MOKO-MON

Graphite on paper
9 1/2 x 6 5/8 (24.1 x 16.8)
G-366

DEMOSS' TAVERN PAYMENTS, NOVEMBER 1837

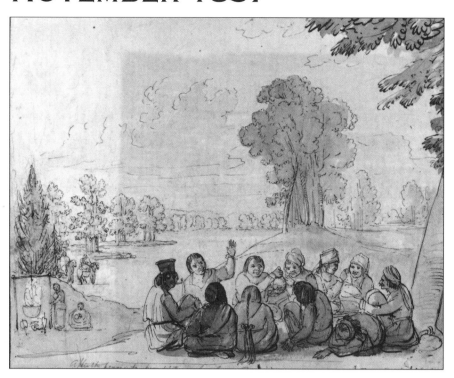

"In the fall of 1837, at the Annual Payment of the Miamis–a large quantity of goods brought upon the Payment Ground and offered by Col. A. C. Pepper (it being an *Indian trading job,* in which somebody in official position no doubt was to realize a *fat profit*). . . . The Indians objected to recieving the goods. By treaty stipulations *their* annuity was to be paid, as *hitherto it had been*–in silver. . . .

The goods were in finality rejected. They were then shipped to Logansport, and offered in part Payment of the Pottawattamies in *Nov. following*. They were accepted by the Pottawattamies after a long *parley*. The sudden change in the weather–it becoming very cold–proved a potent auxilliary in inducing the indians to accept the goods.

Pottawattamie Payments at Demoss' House, Michigan Road–9 miles north of Logansport, took place Nov. 21st. 1837. About one half of the Payments made in goods. . . ." (GWMSS 2-31[1], 2-32 [3])

(94) "Tobaco among the indians is a 'weed' of great importance and significance. It is not only used by them as a medium of recreative pleasure in smoking. But is used also, symbolically–for ceremonial, religious, and votive offerings. . . .

The importance attached to tobacco ceremonially may be illustrated by the following circumstance known to myself. Ash-kum, when summoned to attend the last Pottawattamie payment in 1837, did not appear at the *payment ground*. Col. Pepper did not send him any tobacco, as he was in duty bound to do, in justice and consideration of a Chief–and as the evidence of his 'Father's' continued friendship. Consequently, Ash-kum remained at his village in high dudgeon and contempt for his father's omitting the usual ceremony and 'high consideration'." (GWMSS 2-6 [2])

95.
[SEATED MAN SMOKING PIPE TOMAHAWK]
Graphite on paper
4 3/4 x 6 7/8 (12.0 x 17.4)
G-431

96.
[SEATED MAN SMOKING CLAY PIPE]
Graphite on paper
4 1/4 x 3 5/8 (10.7 x 8.9)
OV-371a

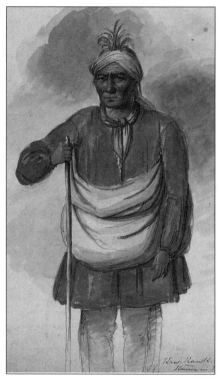

97. *(see Plate 35)*
KAW-KAWK-KAY
Observed 1837
Watercolor and ink on paper
10 3/8 x 7 3/4 (26.2 x 19.6)
Inscribed, l.r.: "Known in the Treaty of Augst. 5th 1836."
Journals and Indian Paintings, Plate X
K-2

98.
KAW-KAWK-KAY. ONE OF THE CHIEFS KNOWN IN THE TREATY OF AUGST 5TH 1836
Observed 1837
Graphite on paper; star-shaped watermark
10 3/8 x 6 3/4 (26.1 x 17.2)
Inscribed, l.c.: "Are you a chief? I once was, but now I am a dog!"
Similar to Cat. #97
G-381

99.
[KAW-KAWK-KAY]
Observed 1837
Graphite on paper
13 1/4 x 10 1/8 (33.7 x 25.7)
Similar to Cat. #97
G-357

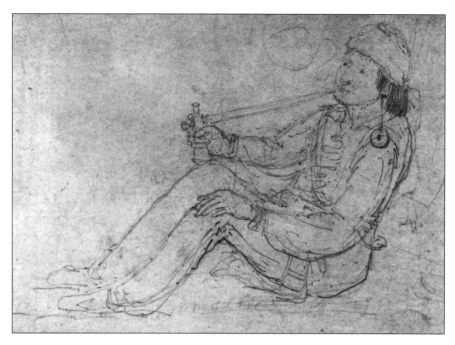

(97) "Kar-kar-kay was a fine old and venerable indian Chief. I first saw him at the last Pottawattamie Payment. The 'Chief's' appearance was particularly attractive, for he looked the truly venerable patriarch. . . .

. . . His costume was free from tawdry pretentions. His Pes-mo-kin [shirt] was red, without any figure or ornamental display. His white heavy blanket was thrown around him in a peculiar manner so that he could carry his venison and quas-kin (bread). His head was adorned with a small shawl, neatly tied fitting close to his cranium, with a tuft of feathers *fan fashioned.* . . .

The old man rested upon his long staff, which was an ever necessary prop to his somewhat enfeebled person.

I am not a Chief–I am a dog! was his reply to Bouriez, an indian trader who acted as interpreter for me when he asked him the question if he were a Chief. . . . The old Chief very readily consented to let me sketch him. . . .

When I sketched the venerable old man, he was standing near a log cabin in vicinity of *Demoss's house*–Head quarters then of Col. Pepper. In the Cabin, the Col. was holding a Council privately among *a few Chiefs* relatively to the Pottawattamies' recieving *a lot of Blankets, Cloth,* and other goods–among them worthless rifles, as a part of their *annual payment,* which was soon to be made. . . . The operation was *one* of *many infamous trading jobs.* . . .

The old Chief was not invited to the honors of council. . . . The chief . . . now by some *strange mysteries* of *policy* is an outcast–no longer a chief, but a dog!

Kar-kar-kay was a man of some peculiarities–one in particular was strikingly observable. Notwithstanding his advanced age . . . he always went *'a pied'.* The 'oldest aboriginal inhabitant' of the forest, never remember his mounting a pony. On his appearing at Demoss's to receive his annuity, he was *afoot*; and on the day of the Emigration setting forth from the grove at *Horney's mill* near Logansport in the fall of 1838, the old patriarchal Chief, leaning upon his staff, was observed making good time with those who were mounted and prepared for the long journey to (Kansas) West of the Mississippi." (GWMSS 2-13 [1])

100. (see Plate 36)
MEE-SHAWK-KOOSE
Observed 1837
Watercolor and ink on paper
10 1/4 x 7 3/4 (25.8 x 19.4)
Inscribed, l.c.: "Treaty of /36"
Intended for inclusion in G. W.'s Indian journals
Journal-2a

101.
MEE-SHAWK-COOSE.
POT-TA-WAT-TA-MIE CHIEF
Observed 1837; executed ca. 1863–71
Watercolor and ink on paper
16 1/4 x 11 1/2 (41.0 x 29.2);
comp. 6 x 6 (circular) (15.3 x 15.3)
Inscribed, l.r.: "No. 1. George Winter"
Similar to Cat. #100; intended for inclusion in
G. W.'s Indian journals
Journal-69

102.
MEE-SHAWK-COOSE
Observed 1837
Graphite on paper
9 1/2 x 6 3/4 (24.2 x 17.0)
Inscribed, l.c.: "A chief known in the
Treaty of Septr. 23rd. 1836."
Similar to Cat. #100
G-380

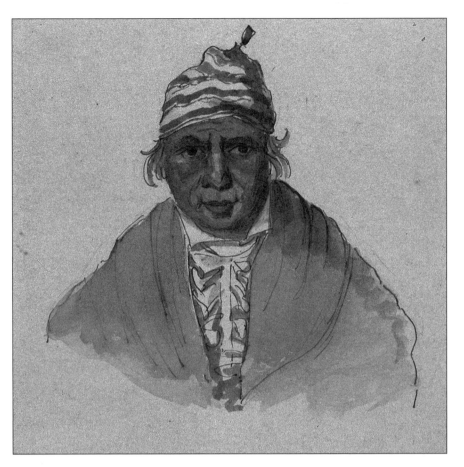

(100) "Me-ch[uck]-coose was a venerable old indian of perhaps some seventy summers. He was a good man of quiet and unobtrusive manners. He was a chief of hereditary claims. . . . His constant reference to his own good qualities was very amusing.

He would often approach his friends (among the whites) by striking his breast with his clinched fist and exclaim–Me-chuck-coose good man me!

He had this misfortune–in what way I could never learn–of receiving an injury of his right arm which seemed to be withered and useless, and which he generally well concealed.

His appearance was very striking and peculiar. He wore a green blanket, and in the place of the usual shawl surrounding of the head–his head was covered with what is 'nowadays' called a *'smoking cap'*, striped with blue and tasseled at the top.

I often solicited him to come into my studio to sit–he declined by remarking, 'Me-chuck-coose–good man me–may be some time!'

At the *last Pottawattamie Payment* at 'De Moss's', on a very cold day, he came to me, and made motion indicative of his willingness to *sit* and redeem his implied promise made some time previously. His extreme homeliness yet characteristic face made him an easy model in securing a striking likeness.

During the time of my sketching him he was surrounded by a large number of indians who were disposed to joke the old man–many a cute and amusing thing must have been thrown out, for there was a constant round of merry laughs during the operations of my pencil.

Me-chuck-coose, however maintained his equanimity, paying no regard to what was said, which much facilitated me in bringing about a quick result." (GWMSS 2-16 [1])

103. (see Plate 37)
PEA-WALK-O
Observed 1837
Watercolor, ink, and graphite on paper
9 7/8 x 6 1/2 (24.9 x 16.2)
Inscribed, l.r.: "Daughter of Sin-is-quaw.
and Tom Robb. and wife of Reed."
l.c.: "No 28"
K-8

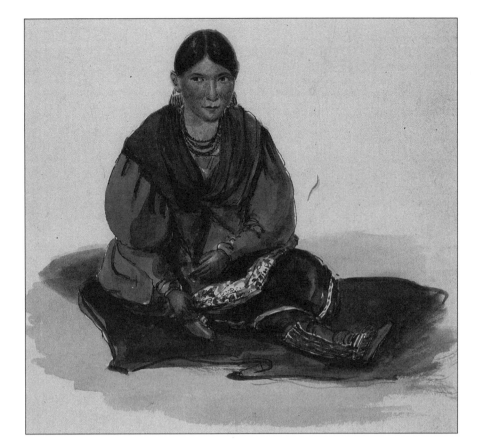

(103) "'Pea-walk-o' the subject of this sketch, was the daughter of 'Sinisqua', a full blood Pottawattamie woman and a well-known white man, Tom Robb.

She was the squaw or wife of Capt. Reed, a man of bland and pleasant manners—a white man. . . .

'Pea-walk-o' readily consented to sit to be sketched. She had no superstitious fears of *evil results* from submitting for the portrayal of her 'image'. . . .

'Pea-walk-o' was sketched at Demosses in the fall of [1837].

There was no vain pretension in 'Pea-walk-o's' nature. Modest in manner & shrinking from the gaze of the rude and unmannerly fellows (white men) who on visiting an Indian encampment treat the Indian people as though they had no feelings of a common humanity. My feelings of indignation have often been aroused in seeing Christian white men standing before the Indian wigwams, gazing upon the Indians in their domesticity as though they were beasts of forest browsing and feeding upon 'skub-a-kin' (grass).

'Pea-walk-o' had no coquettish proclivities. She did not often gaze upon her 'wa-wass-mo-in' (looking glass). Her 'mich-a-ko-teh' (petticoat) was unadorned with silver rings or brooches. No red blue and yellow ribbands gave attractive appearance to it.

She was of the solid sort—a woman, though young, knew how to take care of her lodge cook the venison and made good 'pe-quesh-kin' (bread) to please her noble white lord. . . .

Pea-walk-o like her good mother was a convert to Christianity under the ministrations of the Rev. Father Petit, the successful Missionary in the *Pottawattamie* nation." (GWMSS 2-19 [4])

104. (see Plate 38)

MENDICANT INDIANS

Executed ca. 1863–71

Watercolor on paper

15 7/8 x 11 1/2 (40.3 x 29.0);

comp. 5 7/8 x 7 7/8 (oval) (14.9 x 19.8)

Inscribed, l.l.: "No 40 Geo Winter"

Intended for inclusion in G. W.'s Indian journals

OV3-73

(104) "It was the custom at one time to make the payment to the Chief of the respective bands. This mode of payment was afterwards changed, as sometimes many of the Indians fell short of their prorated per capita allotment of their annuity through the cupidity of the dishonest traders, as it was their policy to get the Indian Chiefs into the greatest indebtedness. By this means the traders always on the alert for the *'grab'*– and having an influence over the Chiefs, they would look to the Chiefs for payment. They to sustain their credit would too often yield to the trader and pay up for their extravagence–and many a poor Indian would receive but a portion of his annuity. The *poor* Indian having no credit at the trading establishment would of course necessarily suffer–this course made a poor class of Indians. . . .

We see an Indian with many horses, good equipment, good wigwams, good blankets, leggings winged with expensive ribbons, moccasins of shewy kind, handsome turbans, good wide black ribbon attached to the cue or seg-a-pin-wan. To which much pride is attached by the aboriginal man.

In contrast to this affluential display, there is the poor and indigent Indian who has no horse or any of the significant displays of pride of 'wealth'. His blanket is worn and discolored. He has no turban or pony–no rifle, but the primitive bow. There is the well to do family and there is the poor one. It is known that there are benevolent institutions in some tribes–such as the 'beggars dance'–to alleviate the needy wants of misfortune. . . .

The group depicted before us represents mendicant Indians, who are not starveling, though poor in rags and wretchedness." (GWMSS 2-12 [2], 2-34 [11])

POTAWATOMI EMIGRATION, 1838

"In 1838, a large emigration of the Pottawattamies took place, under the direction of Genl. John Tipton and Col. A. C. Pepper, and immediately under the superintendence of Genl. Marshall, and his subordinates. Much that is sad and touching relates to their removal westward. . . .

It was only by a *deceptive* (in a moral point of view) and cunning cruel plan, they were coerced to emigrate. . . . By convening a special Council of the principal Chiefs and Head men, at the Catholic Mission at the *Twin lakes*, near Plymouth, under the pretence of a Council of Amity, and good will, [Genl. Tipton] secured them as prisiners. A high handed act, for such it was. For its execution, stern necessity, must be the apology. The policy was as painful, as it was successful.

This was followed up by the detailing parties of volunteers, who had been previously enlisted under authority, to bring in from the differant villages, men, women and children into Camp. . . .

The Camp was now in full organization, but volunteers came crowding in from all parts of the State, in anticipation of the indians resisting, of which at one time, there was a seeming probability. Very varied was the character of this heterogeneous body of men. Some were of the highest respectability in the state, and others, in appearance at least, vagabonds and pillagers of the lowest order, such as humanity would recognize. . . .

. . . the whitemen were gathering thick around them, which was but a sad necessity for their departure. Still they clung to their homes. But the flames of the torch were applied–their villages and wigwams were annihilated. The principal Chiefs were secured by the strong arm of authority, and lead or rather driven Captives out of the land at the point of the bayonet! It was truly a melancholy spectacle, that awoke a deep feeling of sympathy for their unhappy fate." (GWMSS 1-15 [15], 1-12 [13])

105.
**ASH-KUM AT LAKE
KEE-WAW-KN[AY] 1838**
Graphite on paper
10 1/4 x 7 1/8 (26.1 x 18.1);
comp. 7 7/8 x 5 3/4 (oval) (19.9 x 14.5)
Inscribed, l.c.: "Discarded Speaker."
G-376

106.
ASH-KUM
Observed 1838; executed ca. 1863–71
Watercolor on paper
16 1/4 x 11 3/4 (41.1 x 29.6);
comp. 9 3/8 x 7 3/8 (oval) (23.6 x 18.6)
Inscribed, l.r.: "No. 2. George Winter"
Similar to Cat. #105; intended for inclusion in
G. W.'s Indian journals
Journals and Indian Paintings, *Plate XV*
M-57

(105) "Ash-kum was an orator of some consideration and distinction; he however was not continued in such capacity, when I knew him in 1837....

In his speeches he always went into a circumlucutary historical account of his tribe, and the various treaties made with the government he was very minute, tedious and perplexing, although he had perspicuity of thought, and could *clearly* express himself....

It was therefore in consequence of Ash-kum's verbosity and tediousness of detail, that Col. Pepper requested that in his future business with the Pottawattamies, some other speaker should be appointed by the Indians. Knas-wa-kay was chosen–and Became their principal orator....

Ash-kum in person stood above the middle heighth, and some fifty years of age–perhaps *some moons* more.... He could not speak much english, though he could make himself amusingly understood....

Ash-kum was among those old chiefs who retained their prejudices against having themselves portrayed–or from the secret contempt for being remembered among white men through the medium of the pencil. Yet he was amused at others whom I painted, and was ever ready with his spicy joke upon their likenesses.

To me personally he was friendly and ever wore a smile upon his countenance when we met on the council ground in the forest, or at the town of Logansport where he often came to trade at Ewing & Walker & Cos well known trading establishment.

I do not remember seeing him among the large number of converts to Christianity under the missionary labors of father Petit.

He was however free from the vice of drinking.... He was a peaceable man, but opposed the emmigration westward in 1837....

He however fell into ranks, in the fall of 1838, when the strong arm of the U. S. Government coerced the Indians through the active and determined cooperation of Genl. John Tipton with Col A. C. Pepper & Col Lewis H. Sands....

Ashkum was strongly attached to his native forests and lakes–and left Indiana with a deep feeling of regret." (GWMSS 2-6 [1], 2-6 [4])

107.

[CAMP IN FOREST CLEARING]

Graphite on paper
5 1/8 x 6 3/8 (13.0 x 16.1)
G-437

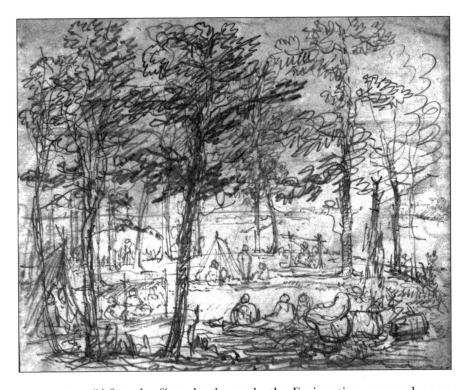

108.

**WISS-SO-GAY. SKETCHED AT THE
ENCAMPMENT–ON THE PRARAIE
NEAR MUD CREEK–INDIANA. 1838**

Graphite on paper
9 x 7 1/4 (22.7 x 18.3)
G-378

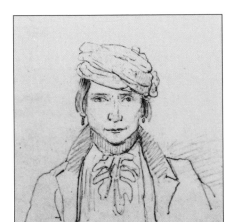

109.

**MAH-TA-WAH-AH. OTCH-CHE-MA.
SKETCHED NEAR EEL RIVER–1838**

Graphite and ink on paper
6 3/4 x 10 1/4 (16.9 x 25.9)
Inscribed, l.l.: "Mah-ta-wa-ah. In the Treaty.
Septr. 20. 1836."
G-379

(107) "After the first days' march, the Emigration camped upon a small prarie near a *run* known by the unpoetical sobroquet of '*Mud Creek*'. . . .

About 18 miles from Logansport Muddy Creek crosses the Michigan road. Creek is called by the sobroquet which it so well deserves–the water as it passes sluggish along has no small quantity of alluvial matter incorporated with it. On a small prarie near this creek on [9] Sept [1838] a thousand Indians of the Pottawattamie tribe encamped after a hard days travel *in sickness*–and in tribulation. . . .

The group of the captive Chiefs was truly a saddening sight, as they lay surrounded by a vigilant citizen soldiery. Nor did their condition fail to reach even the hearts of many a settler, who rejoiced mostly, at the departure of them as a nation. . . .

On the 9th of [Sept.], the emigration moved some 18 miles towards Logansport, and camped near Horney's Mill, in a grove of friendly timber near the vicinity of Eel river. Here they rested on the sabath." (GWMSS 1-15 [15], 2-32 [4])

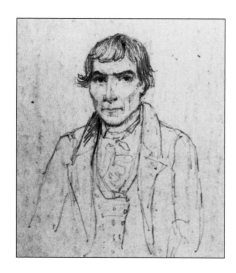

110.
**SUN-GO-WAW. SKETCHED 1838–
NEAR HORNEY'S MILL–
CASS CO.–INDIANA**
Graphite on paper
9 1/2 x 7 3/8 (24.1 x 18.7)
*Inscribed, l.c.: "An eloquent orator–and one of the
brave men who exerted themselves to prevent their
nation emigrating west of Mississippi."*
G-377

111. (see Plate 10)
SUN-GO-WAW
Observed 1838; executed ca. 1863–71
Watercolor on paper
16 1/4 x 11 1/2 (41.3 x 29.0)
Inscribed, l.r.: "No. 5 George Winter"
*Similar to No. 110; intended for inclusion in G. W.'s
Indian journals*
Journals and Indian Paintings, *Plate XIII*
M-58

(110) "[Sun-go-waw] was among the several Warriors, Chiefs, and Headmen who were made prisoners at the Catholic Mission at the *Twin Lakes....*

Sun-go-waw was one of Father Petit's converts, and of great usefulness to the Priest in his godly purposes and work in the Pottawattamie people.

He acted in the capacity of Interpreter to the good father, with marked usefulness and ability....

Sun-go-waw was among the principal men of those who were carried prisoners (in waggons) at the head of the column of the emigration.

About one week after the departure of the Indians, Sun-go-waw was released, and sent back to Logansport, with a despatch to Genl. John Tipton, by Genl. Morgan, in command of the Indians. This *Commission* was a post of honor, which Sun-go-waw greatly appreciated. I remember the day he appeared at Logansport. He enquired of me as I stood at Capt. C. Vigus' Hotel corner, for Genl. Tipton's residence, which was about a mile distant from the bridge, eastward, up the Wabash, which he readily found.

Sun-go-waw faithfully performed the duty (assigned or) confided to him. He received an answer from Genl. Tipton, and on the following day he returned, alone to overtake the emigration, which he had left several days previously. This was the last time that Sun-go-waw was seen on the *'loved Wabash'.*" (GWMSS 2-24 [1])

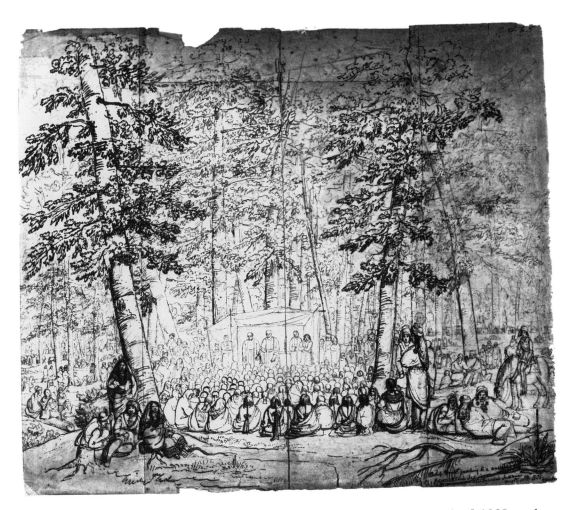

112.
BISHOP BRUTE PREACHING TO A CONCOURSE OF CONNECTED POTTAWATTAMIE INDIANS NEAR LOGANSPORT INDIANA AUGST. [SEPT.] 16TH. 1838.
Ink and graphite on lined paper
12 3/8 x 14 3/4 (31.4 x 37.2)
Journals and Indian Paintings, *Plate II*
OV-383

113.
[BISHOP BRUTÉ PREACHING IN WOODED AREA]
Observed 1838
Graphite on paper
4 7/8 x 6 1/8 (12.1 x 15.4)
Similar to Cat. #112; indistinct sketch
G-382

(112) "It was in the month of [September] 1838, and on a sabbath day, that the Pottawattamie emigration column rested within the shadow of a large grove, near a clear stream of water, in close vicinity of the Eel River. This was a halt after the second day's march to their far off destination, West of the Mississippi.

It was here that the Rt. Rev. Brute, Bishop of Vincennes, preached to the converted Pottawattamies. . . .

Independent of the moral aspect of this group, it was one of beautiful picturesque effect. The singularly draped red people, in bright and startling combinations of color, blending in harmony with the forest trees, tinged with the influences of the decaying year, created a deep impression upon the beholder. . . .

I sketched this imposing and interesting scene, which embraces perhaps nearly 1000 Indians. I have a Cartoon of this subject–and it has always been a subject near my heart." (GWMSS 2-24 [1], 1-15 [13])

Father Benjamin Marie Petit to Bishop Simon Bruté, 13 November 1838:

"While I was awaiting the public stage at the hotel [in Logansport], a traveler came up to me and presented me with a pencil sketch which seemed to me a good one and which represented the confirmation ceremony at the camp, the altar at the foot of the great tree, the linen tapestries, Monseigneur [Bruté], M. Mueller and me, our young interpreter, and all the Indians, with their grave, pious solemn demeanor. I was asked several questions about the Indians' language, habits, and traditions." (Irving McKee, *The Trail of Death: Letters of Benjamin Marie Petit.* Indianapolis: Indiana Historical Society, 1941.)

EMIGRATION IMAGES

"The morning following this eventful and impressive day, the emigrating column was formed, headed by the Captive Chiefs who were conveyed in wagons, guarded by the strictest surveillance. Soon the whole nation were seen moving down the hill sides, along the banks of Eel river, on the way to their westward home. . . .

Ah! Well do I remember that scene, as the Indians left a beautiful grove of oaks where they had encamped a few days previous to their emigration, and descended a gentle declivity, the summit of which commanded an extensive view of a rich and *wide spreading* fertile land–and upon which with many others I stood to view with effect the little band as they passed by us. . . .

. . . they formed with their heavily packed ponies a picturesque scene, which a painter could but have deemed lovely as they followed the serpentine windings of a trail on the lower wild lands. . . . I gazed with many others whom curiosity had brought to the spot, at the little emigrating band until they faded before us in the western horizon. The Indian's is a mournful memory!

Many melancholy and touching thoughts passed through the mind and these questions presented themselves, as the indistinct and fast fading forms of the party were lost to the view. Has the Redman in his entercourse with the White, witnessed the practice of the immutable principles of justice and probity which a holy religion teaches? Has he been taught virtue and divine reverence in example or by precept? . . . To these startling inquiries let the page of history respond. Could the poor and degraded aborigine give his history to the world, it could but speak in emphatic language–the continual series of oppressions of the White man, from the day he first put foot upon the aboriginal soil; and surely would the gilded emblazonary of Freedom's boasted escutcheon be tarnished in the sight of *Philanthrophy* and *Justice*." (GWMSS 1-15 [15], 2-32 [2])

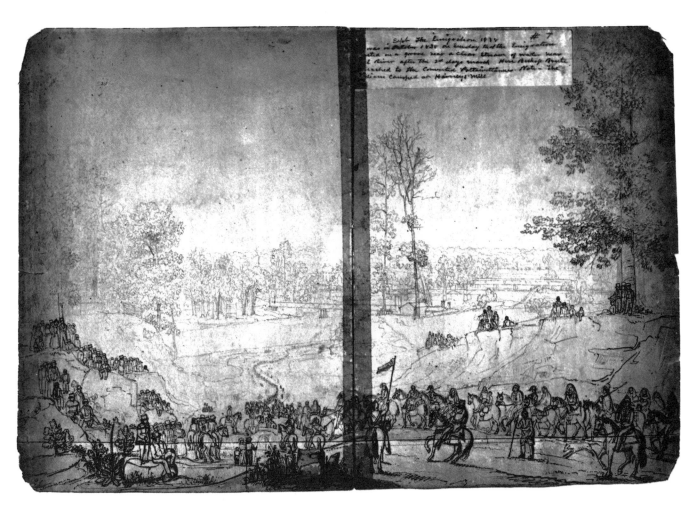

114.
[EMIGRATION SCENE]

Observed 1838
Ink and graphite on paper
12 1/4 x 18 1/8 (31.1 x 45.6)
Inscribed, u.r.: "Sept The Emigration 1838
It was in October [September] 1838 on Sunday that
the Emigration rested in a grove near a clear stream
of water near Eel River after the 2d days march
Here Bishop Brute preached to the converted
Pottawattamies.
Note–The Indians camped at Horneys Mill"
Intended for inclusion in G. W.'s Indian journals
OV-384

115.
POTTAWATTAMIE EMIGRATION

Observed 1838
Graphite on paper; embossed seal
9 3/4 x 7 7/8 (24.8 x 19.8)
G-385

116.

[LINE OF MOUNTED FIGURES]

Ink and graphite on paper

3 1/4 x 4 3/8 (8.2 x 11.1)

OV-387a

117.

[LINE OF FOUR EQUESTRIANS]

Graphite and ink on paper

9 x 12 (22.9 x 30.3)

G-370

118.

[LINE OF MOUNTED FIGURES]

Graphite on paper

2 1/8 x 3 3/8 (5.2 x 8.5)

Indistinct sketch

G-386

119.

[LINE OF MOUNTED FIGURES]

Ink on paper

7 7/8 x 9 3/4 (20.0 x 24.8)

OV-387

120. (see Plate 39)

WEWISSA

Watercolor and ink on paper

10 7/8 x 7 5/8 (27.6 x 19.2)

K-16

121.

WEWISSA

Graphite and ink on paper

9 x 6 7/8 (22.9 x 17.4);

comp. 7 7/8 x 5 3/4 (oval) (19.8 x 14.5)

Similar to Cat. #120

G-359

122.

WEWISSCO

Ink on laid paper;

watermark "PARSONS HOLYOKE"

4 1/2 x 3 7/8 (11.4 x 9.7)

Similar to Cat. #120

G-422

(120) "I remember *We-wis-sa* well. I have a sketch of him. He was a very small man–dressed very extravagantly, and fancifully. . . . [His mother] was a very venerable woman." (GWMSS 1-17 [38b])

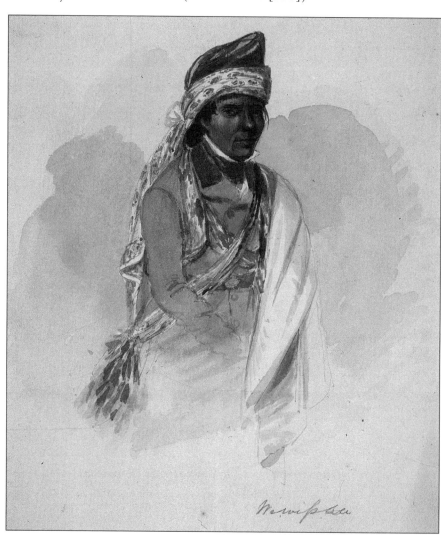

123. (see Plate 40)

THE MOTHER OF WE-WIS-SA

Executed ca. 1863–71
Watercolor and ink on paper
16 x 11 7/8 (40.4 x 30.0);
comp. 7 3/8 x 5 3/4 (18.2 x 14.4)
Inscribed, l.l.: "No 39 Geo Winter"
Journals and Indian Paintings, *Plate XIV*
L-44

(123) "It was reported that during the emigration of the Pot-ta-wat-ta-mies in the fall of 1838, that in consequence of the infirmaties of the Mother of We-wis-sa, she became of great inconvenience to the family in keeping up with the main body of the Indians, and that *they* held a council for the purpose of deciding whether they should dispose of the old woman by the *tomahawk* and there-by relieve themselves of the incumbrance of caring for her.

I never heard this confirmed, and therefore never regarded the circumstance of an authentic character worthy of indorsement." (GWMSS 1-17 [38b])

PERU AND DEAF MAN'S VILLAGE, 1839

"This 'Journal' of a visit to the 'Deaf Man's village', on the Mississinawa river, A.D. 1839, illustrated by my pencil of scenes on that pleasant stream and with likenesses of persons alluded to within these pages, I have revised and put in its present form. . . .

. . . The journal will be illustrated by some views of the village from differant points–also a view of the Osage village and 'Nan-matches-sin-wa', the home of Chief Francis Godfroy, and a likeness of the chief too.

The likenesses of The Captive, her daughter, Kick-ke-se-qua and her husband Capt. Brouillette will naturally be the most interesting illustrations.

This journal, perhaps will never find a place, in the public press during my life time. I am preparing it with much care–with many reminiscences of the Indian people too. It will be left to my family for preservation.

The journal I am copying upon folio paper and will contain nearly one hundred pages. This is distinct from other volumes in preparation. . . .

These chronicles may afford you and others some interest, as they relate to a *white woman*, known as the 'Lost Sister', whose destiny was cast among the aborigines–she having been made captive by the Delaware Indians in the year 1778, in the Wyoming valley at the tender age of five years, and who lived among the Indians sixty years, and whose fate was unknown until her accidental discovery by her surviving relatives, a short time before I made my visit to the 'Deaf Man's Village' to sketch her likeness. . . .

My old friend John Green, received a communication from Peru, where the relatives of Frances [Slocum], and the Captive herself had assembled, making a request of my early presence, as they wished a portrait of the 'Lost Sister'.

Being deeply interested in Indian people, it was no common gratification that I felt in securing so romantic an *object*, to place among my many sketches of the aboriginal people in my possession." (GW DMV Journal, GWMSS 2-23 [26])

124.

**SCENE IN WABASH & ERIE CANAL
1839**

Blue and brown ink on paper
7 3/4 x 9 5/8 (19.6 x 24.3)
Inscribed, l.c: "near Logansport Geo Winter"
A-10

(124) "The town of Peru in the year 1839 was then a small place, situated on the Wabash about eighteen miles east of Logansport. . . .

The *facilities* of getting to Peru from Logansport were then very circumscribed. And it was a slow Hack–and the casual canal boat–that the impatient traveller depended upon for *transit*. . . .

. . . I stepped into the Columbia at 7 o'clock with many regrets, for I left a party of the *'fair creations'* of this earth. . . . From a room glowing with the light of *brilliant eyes* and sunshiny smiles . . . I was caste into the sombre appartments of a freight boat commanded by a civil captain enough. . . . The blast of the Boat horn reached my ears, as the summons of the Boats departure. . . .

I lingered at the rich banquet of beauty, and thereby, to use an *elegant* flight, almost 'lost my bacon'. The boat had *started*, and it was only by the active exercise of my lungs, that I made myself known as 'the expected one'. . . .

It was however a singular transition from the festal throng, to the freight boat, pungent with *ship odors*–I found myself like 'any other man', embarked for a night of 'unrest' within the confines of this peculiar craft.

It was not until the dawn of welcome day, that we had reached our destination–just eighteen miles distance." (GW DMV Journal, GWMSS 1-4 [19])

125.
SCENE ON THE WABASH NEAR PERU. INDIANA. 1839
Graphite on paper
9 1/8 x 11 7/8 (23.1 x 30.0)
A-14

126.
[CAPTAIN BY-GOSH]
Watercolor with ink on blue-lined paper
6 1/2 x 4 7/8 (16.5 x 12.4)
K-17

127.
CAPTAIN BY-GOSH
Executed ca. 1863–71
Watercolor with ink on paper;
watermark "J WHATMAN"
16 x 11 7/8 (40.6 x 30.0)
Similar to Cat. #126; intended for inclusion in
G. W.'s Deaf Man's Village journal
L-49

(125) "The forest trees here are unsurpassed–the beautiful Wabash winding its way through this rich and beautiful section of country–glassing the thick wooded banks in its surface gives an interest what takes captive the poet and the painting gaze." (GWMSS 1-4 [19])

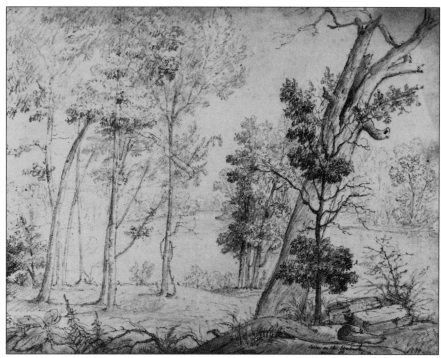

(126) "Amidst the motley group of passengers, some twenty in number, who composed the *living freight*, I recall one who is remembered by the survivors of that time. . . . 'Captn. *Bygosh*', a sobrouquet by which he was proverbially known, and originating in his profuse use of the exclamatory phrase of *'by gosh'*, being a substitute for one of a common profane character.

The old man was a type of the old french voyageur class; he was far advanced in life's journey. He was happily in the enjoyment of a sinecure of $300 pr annum from U. S. Government, as a *sort* of Interpreter, but whose acquaintance with the english language was very limited. He could not read or write the french language. He had been, however a useful man, as a *runner* for the officers of the Government in their official entercourse with the Indians in treaty-making duties.

'Captn. Bygosh' could speak the Pottawattamie and Miami languages in higher degree of perfection than he could his vernacular. . . .

He was a pleasant and amusing companion, and wore away the otherwise tedious hours of the trip upon the 'inland sloop'–or freight boat to Peru.

Incessant smoking was a peculiar enjoyment of his. He loved the 'common plug'–cut and *rubbed it in* his hands with a peculiar gout a-la-Indian.

His old night cap covering his brow to the projecting point of his large acquiline nose, with his short clay pipe between his lips–occasionally puffing out clouds of blue smoke of the genial weed, helped to make a face, deep seated in lines, a picturesque object." (GW DMV Journal)

128.

**CHIEF GODFROY'S CABIN NEAR
PERU IND**

*Graphite on paper;
watermark "J Whatman Turkey Mill 1852"
9 3/8 x 14 1/8 (23.6 x 36.0)*
G-462

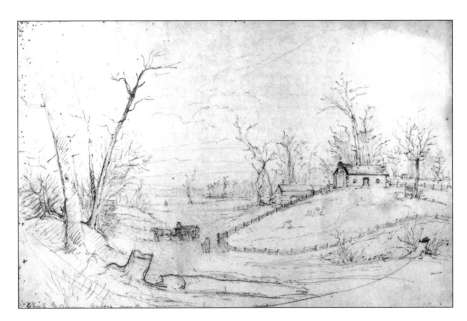

(128) "On my arrival at Peru, where curiosity had been awakened for my presence, to sketch the 'Captive', I found to my great disappointment that the Slocums had departed for Logansport en route for Pennsylvania. They had become impatient for my nonarrival at Peru.

We had passed each other on the canal during the night. . . .

. . . Notwithstanding this predicament, I concluded to venture up to the Deafman's Village and endeavour to accomplish my mission, though I was not very sanguine of success in securing the likeness, being unattended by the relatives . . . as I was aware that the Miamis were exceedingly superstitious in regard to having their likenesses transferred to the canvas. . . .

Peru was in her infancy–and was not then [possessed] of a Livery stable–to borrow a horse was not seemingly a possible event.

I found my old friend G[rove?]r at Peru, who was from Logansport and in the enjoyment of leisure, and who readily accepted my challenge to a trip 'a la pied' to the village some nine miles distance.

We crossed the Wabash near Chief Godfroy's trading house, in a canoe, to the Miami National Reservation. . . .

. . . a densely timbered body of land running southwardly some forty miles, the Wabash making its N. W. boundery extending up nearly to the forks.

The great and fertile body of land known as the 'Miami National Reservation', which included the Mississinawa Country, in the year 1839, was a grand, and almost undisturbed forest.

The sound of the axe there, had been but faintly heard. . . .

My portfolio was my only *baggage*, thus, without any oppressive encumbrance, I had leisure and independence for my preambulations."
(GW DMV Journal, GWMSS 1-23 [18], 2-23 [11])

129. (see Plate 41)
OSAGE VILLAGE 1839
Executed ca. 1863–71
Watercolor on paper
11 5/8 x 12 7/8 (29.3 x 32.7);
comp. 5 3/8 x 8 5/8 (13.7 x 21.8)
Inscribed, l.c.: "No 14"
Intended for inclusion in G. W.'s Deaf Man's
Village journal
Journals and Indian Paintings, *Plate XXV*
OV3-54

130.
OSAGE VILLAGE ON THE
MISSISSINAWA–1839
Graphite on paper
7 x 10 (17.8 x 25.3)
Similar to Cat. #129
G-457

(129) "After leaving Peru, and following the trail a few miles, I arrived at the Osage Village. The route was delightfully shady and the vernal bowers of the trees were now changing to the richer tones of autumn. . . .

. . . The Village then consisted only of a log cabin, and a *bark wigwam.* There was a slender (aboriginal) fence enclosure. Before these rude structures, was spread out, a field of corn in tassel, embracing perhaps some five acres.

The Mississinawa swept by in a curve, in the rear of the village. This village no doubt had been one of some significance, as it was a noticeable fact that four indian trails centered at this point. They crossed at right angles–and diverged to the cardinal points. There were some fine, sturdy oaks and elms, in massive groups standing upon the banks of the river–then very low but very clear. Our approach to the village was announced by *the loud barking* of the dogs.

At this village, I found Bill [Tom?] Smith an eccentric *Wea Indian* whom I had often seen at the town of Logansport. From him I learned the ford, at this juncture, a 'nekabush shah' (horse) would have been a valuable facility to reach the opposite bank. However, I could not under this strait make the kingly offer of a 'Kingdom for a horse'.

After a short rest upon the bank of the Mississinawa and smoking a good 'Havanna', I waded the river." (GWMSS 1-23 [18], 2-23 [10])

131. (see Plate 42)
**NAN-MATCHES-SIN-A-WA. 1839.
CHIEF GODFROY'S HOME**
Executed ca. 1863–71
Watercolor on paper
16 1/4 x 11 1/2 (41.1 x 29.1);
comp. 5 3/8 x 8 5/8 (13.6 x 21.8)
Inscribed, l.r.: "No. 15 George Winter"
Intended for inclusion in G. W.'s Deaf Man's
Village journal
OV3-55

(131) "Here again I followed the trail and soon arrived at Nan-Matches-sin-ewa–the home of the celebrated war chief Francis Godfrey.

I knew the Chief. He visited my studio in Logansport in 1838.

Nan-matches-sin-awa is . . . a pleasant locality. It commands a view of the Wabash. . . . The Deaf Mans Village from that point was but a few miles distant. The trail ran directly to it. I passed but one 'Log' occupied by a white family." (GWMSS 1-23 [18])

132. (see Plate 43)
BOURIETTE-INDIAN INTERPRETER
Observed 1837; executed ca. 1863–71
Watercolor on paper
16 1/8 x 11 5/8 (41.0 x 29.3)
Inscribed, l.r.: "No. 6. George Winter"
Intended for inclusion in G. W.'s Deaf Man's
Village journal
Journals and Indian Paintings, *Plate XXIII*
OV3-80

(132) "About 2 miles from Matches-sin-ewa, I met the famous Capt. Jean Baptist Brouillette who was going to Peru on some special business. He as usual was handsomely dressed.

. . . We 'pow wowed' for some time. He could speak English tolerably well. I made a sketch of Brouillette in 1837 at the last Pottawattamie Payment *east* of the Mississippi. He knew that I was going to the village to sketch his mother in law. He presumed to return in the evening. . . .

. . . I remember very distinctly when I first saw Brouillette. He was on a visit to Logansport in the fall of the year of the 'Payment'. . . .

The 'sketch' [of Brouillette] . . . I made in 1837, when attending the last Pottawattamie payment made east of the Mississippi River . . . at Demoss's House Michigan Road. . . .

. . . He was a 'French half breed' of elegant appearance, very straight and slim. In personal appearance he had a decided commanding mien. In height he stood six feet two inches. His tout en semble was unique, as his aboriginal costume was expensively shewey. He wore around his head a rich figured crimson shawl *a la turban*, with long and flowing ends gracefully falling over the shoulders. Silver ornaments–or clusters of earbobs testified their weight by a partial elongation of the ears. . . .

He wore a fine frock coat of the latest fashion. (When the indian assumes the white man's garb, he always chooses a frock coat. It is an object of beauty to his eye.) His 'pes-mo-kin', or shirt was white, spotted with a small red figure, overhanging very handsome blue leggings, 'winged' with very rich silk ribbons of prismatic hues, exhibiting the squaw's skillful needlework. A handsome red silk sash was thrown gracefully over his left shoulder, and passing over the breast and under the right arm, with clusters of knots, and fringed masses, gave point and style to Brouillette's tall and majestic figure.

133.

BEAU-RI-ETTE–MIAMI INDIAN

Observed 1837

Graphite on paper

10 3/8 x 6 3/4 (26.3 x 17.1)

Inscribed, l.c.: "The son in law of Francis Slocum the Captive"

"Distinguished orator regarded as the finest man in the nation–"

G-367

. . . His mind was clear and strong. He had great comprehension and scope of thought. Brouillette had a great reputation as an orator, possessing great volubility of language. He was a peaceful man, and a great friend to the white men, among whom he claimed many warm friendships. He was also a *'Medicine man'*, (though not a juggler) possessing a knowledge of the healing art. . . .

. . . Capt. Brouillette, for he was proverbially known among the white men by that soubroquet, was the first Miami indian that cultivated corn with the plough. Brouillette has often visited Lafayette. . . .

Brouillette was a half breed; his father was a Frenchman, and was made a captive when a youth. By a remarkable coincidence, Capt. Brouillette wife's mother, [Frances Slocum] was also a Captive. . . .

[He] became a convert to Christianity through the missionary labors of one of the Slocums–a nephew of the 'Captive', who settled among the Miamies after the discovery of his Aunt. Brouillette attached himself to the Baptist denomination. He entered into his religious profession with an earnest goal, so much so, that he became a missionary among the few of the tribe that yet remained in the State of Indiana–along the Mississinewa River, Pipe Creek and other of the old cherished localities of the Miami people.

. . . Capt. Brouillette died at the village [Deaf Man's Village] on 17th ult. [June 1867]." (GWMSS 1-23 [18], 2-9 [1])

(134) "After leaving the Captn., I crossed a well shaded run, where an inviting spring allured me to a refreshing draft. . . .

The sun was now on the decline, and . . . after a warm yet leisure walk of nine miles, I came upon a high bank, at the ford of the Mississinawa, where upon the opposite bank the cabin of 'Ma-con-a-qua', and the 'Deaf-man's Village' presented themselves to my view.

The river at this point was but a few rods in width, and very low, but clear. The village confronted in a parallel line the bank upon which I stood. The river view looking eastwardly, was bounded by a graceful bend presenting a pleasant view–with the few cabins upon the bank, which converged nearly to a point where the bank of the opposite side curved so gracefully. . . .

'The Wigwam' upon the Mississinawa at the Deafman's village where the Captive was discovered by her surviving relatives, was a large double log cabin of comfortable capacity–such as characterize the thrifty farmer's home in the West. A smaller cabin was attached to it in which a very aged squaw lived. There was also a small bark hut, seperated at a distance from the main 'log', of a few rods.

In addition to these structures, were a tall corn crib and stable–and all unitedly constituted the famous Deaf Man's village and home of Mono-con-a-qua, The Lost Sister–Frances Slocum. . . .

134. (see Plate 44)
THE DEAF MAN'S VILLAGE
Observed 1839; executed ca. 1863–71
Watercolor on paper; watermark "J WHATMAN"
10 x 12 7/8 (25.2 x 32.6);
comp. 5 5/8 x 9 (14.3 x 22.7)
Intended for inclusion in G. W.'s Deaf Man's
Village journal
Journals and Indian Paintings, *Plate XXVI*
OV3-52

On arriving at the ford I saluted the Village. The Captive woman appeared in the hallway that was between the two wings of her log cabin. . . .

On my entering the cabin, I was an object of curiosity to the family–and especially to the young paupooses who betrayed more *outward* evidences of wonder than is peculiar to the aborigines. . . .

. . . It was to a Negro that I was under obligation to express my purposes of the visit to the 'Captive'. This man of 'color' had identified himself with the Miamis. He had married a squaw, and spoke fluently the tongue of that people.

He was general mechanic in the settlement. At the time I arrived at the village, he was engaged in rebuilding a lath and plaster chimney for Frances Slocum. . . .

He detailed to the Captive that I was the *expected person* that her brother expected at Peru, to paint her portrait; and the causes that had detained me at Logansport.

The Captive woman remarked, 'that her brother Joseph wished her resemblance, and expected me at Peru. It was for his gratification that she had promised to submit to its being done. She had no *desire* herself to have it done. The Miamis saw no good in it. But she had *promised* her brother, and she would not break her word with him'.

I told the Negro interpreter to say that the sun was now low, and the light nearly gone, and that on the morrow, I would make my sketch of her–that I had met Brouillette on his way to Peru, and that he had promised to return that night, and that I would talk again to her when he returned." (GW DMV Journal; GWMSS 1-23 [13])

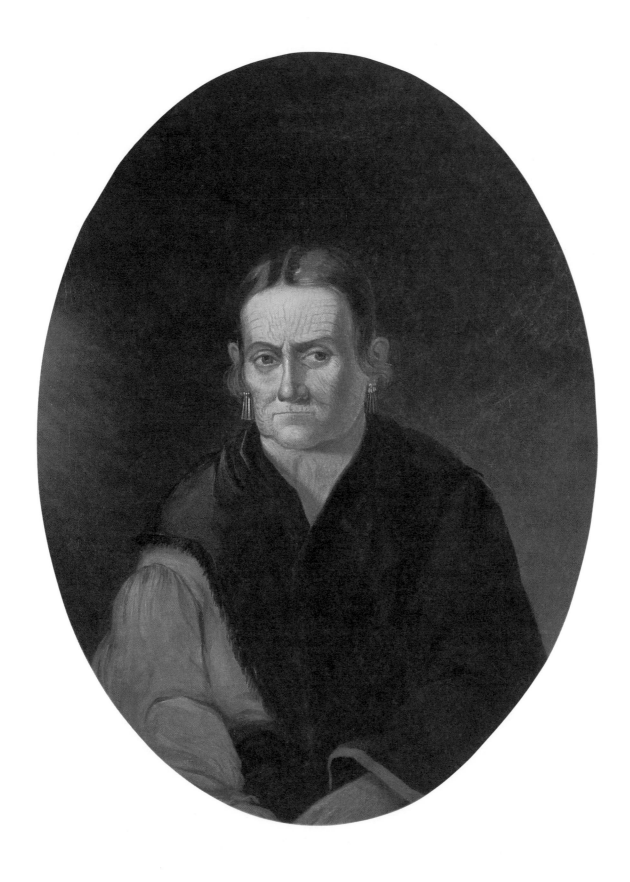

Plate 1. FRANCES SLOCUM

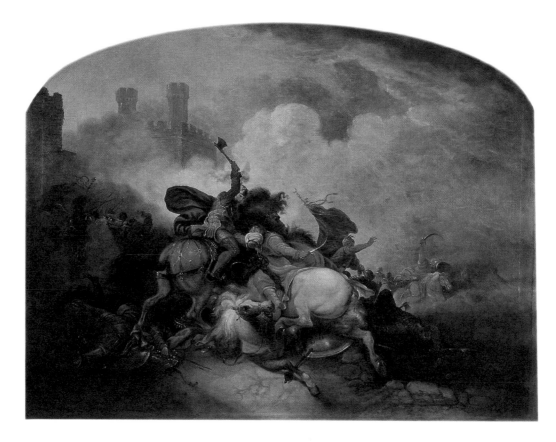

Plate 2. BATTLE SCENE

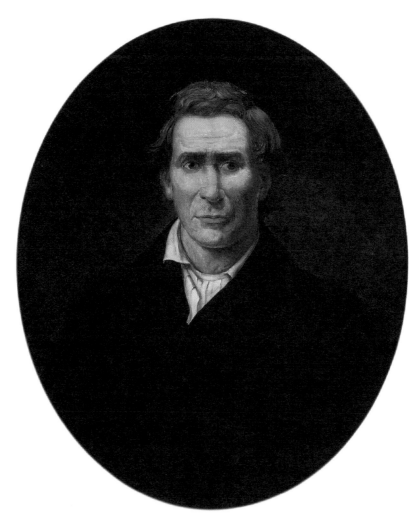

Plate 3. WILLIAM DIGBY

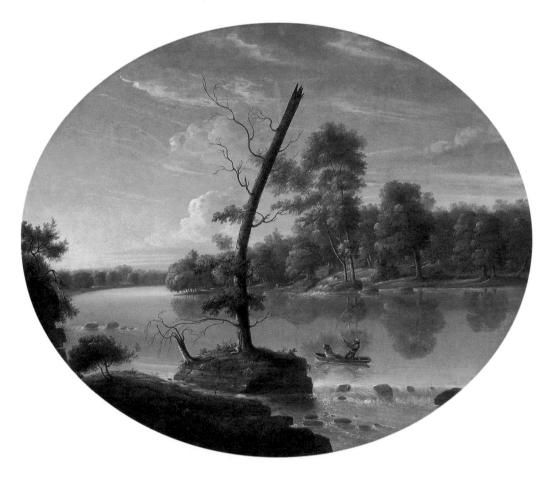

Plate 4. SCENE ON EEL RIVER

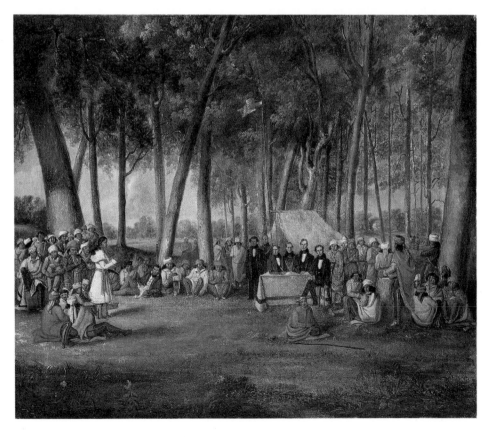

Plate 5. COUNCIL OF KEEWAUNAY

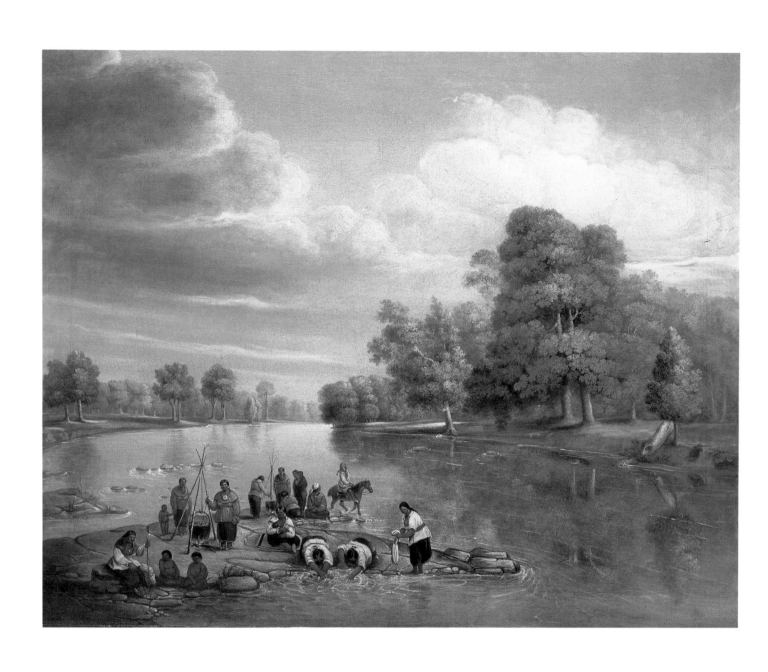

Plate 6. SCENE ON THE WABASH

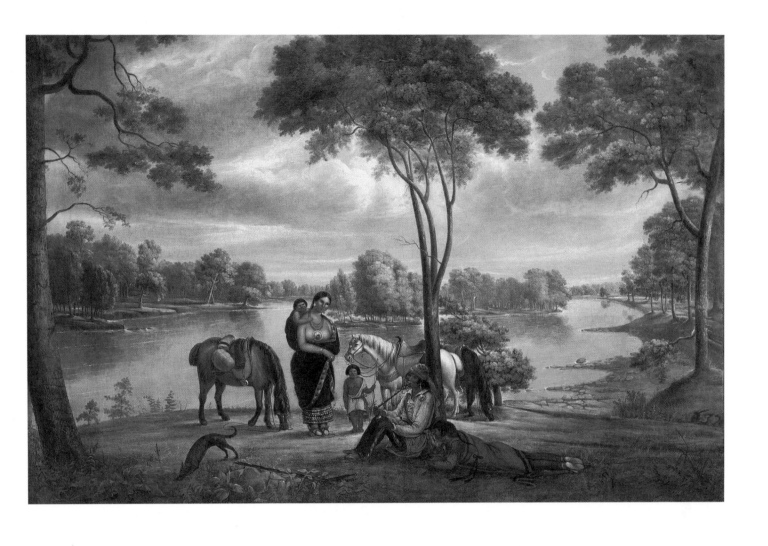

Plate 7. SCENE ALONG THE WABASH RIVER NEAR LOGANSPORT

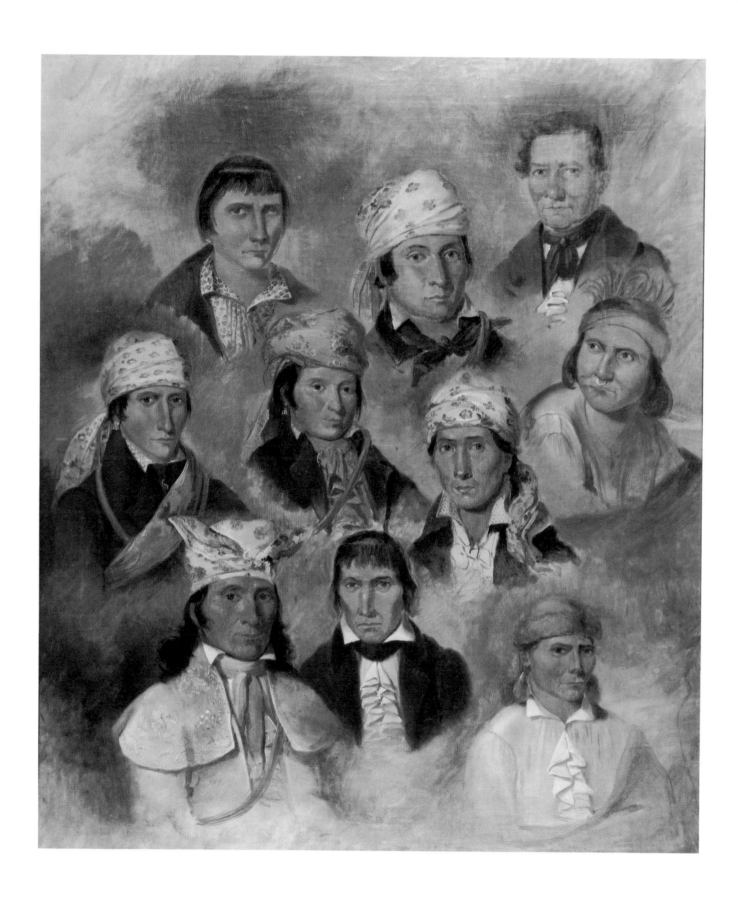

Plate 8. COMPOSITE OF POTAWATOMI CHIEFS

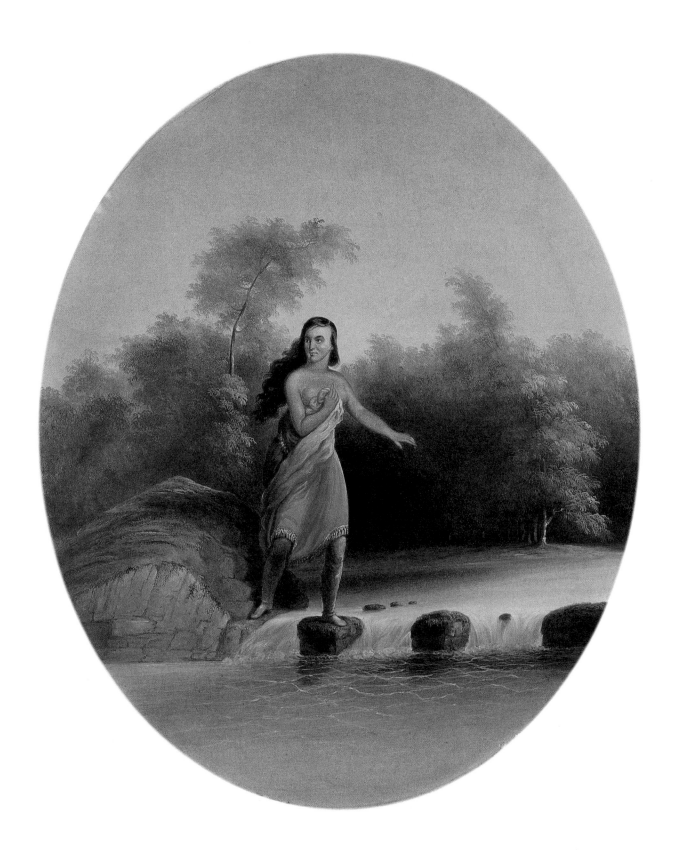

Plate 9. SPOTTED FAWN

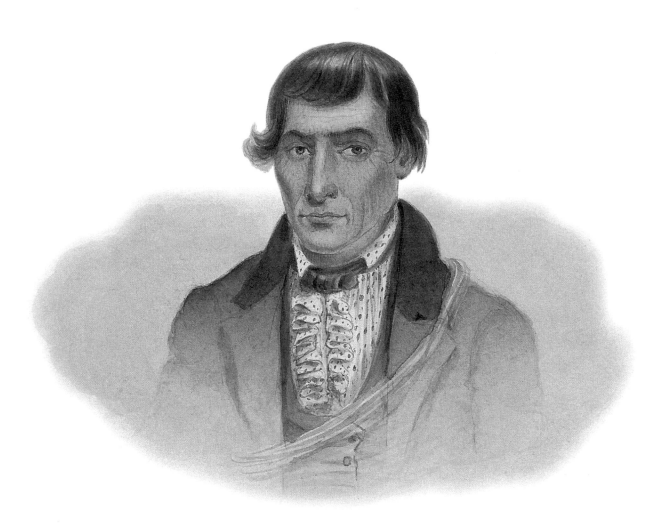

Plate 10. **SUN-GO-WAW** *(Cat. #111)*

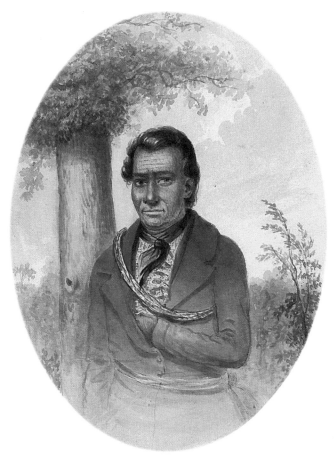

Plate 11. **BEN-ACHE** *(Cat. #47)*

Plate 12. MIAMI INDIAN GIRL *(Cat. #161)*

Plate 13. SWAW-GO *(Cat. #21)*

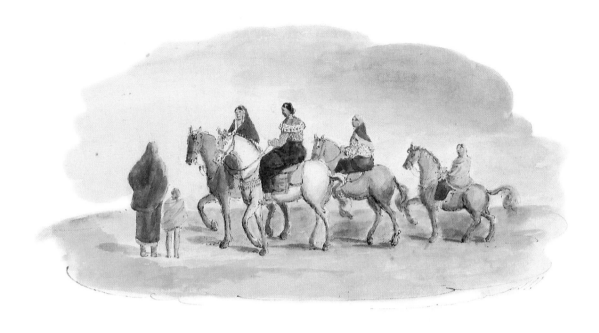

Plate 14. ABORIGINAL EQUESTRIANS POTTAWATTAMIES LOGANSPORT INA JUNE 1837 *(Cat. #6)*

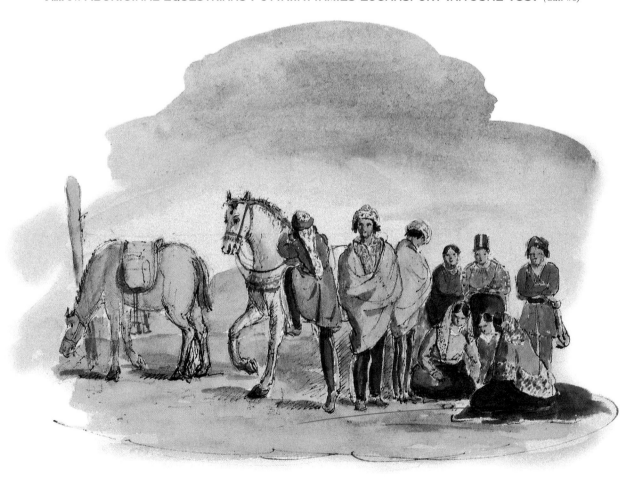

Plate 15. LOGANSPORT INDIANA JUNE 1837 *(Cat. #7)*

Plate 16. POTTAWATTAMIE INDIAN LOGANSPORT JUNE 1837 *(Cat. #11)*

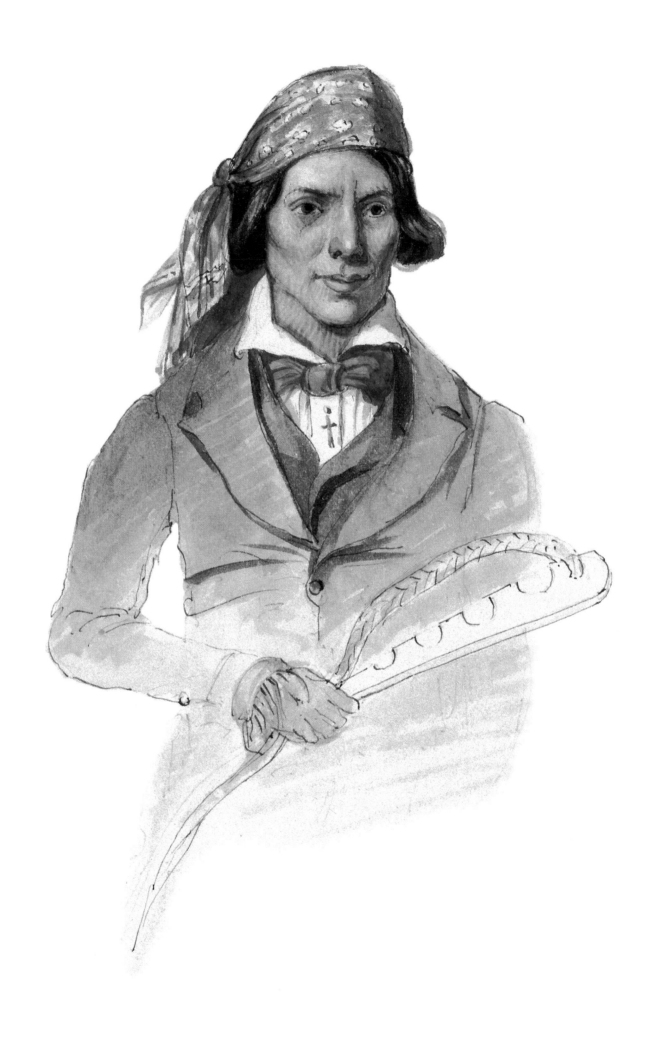

Plate 17. **PEL-WAW-ME** *(Cat. #19)*

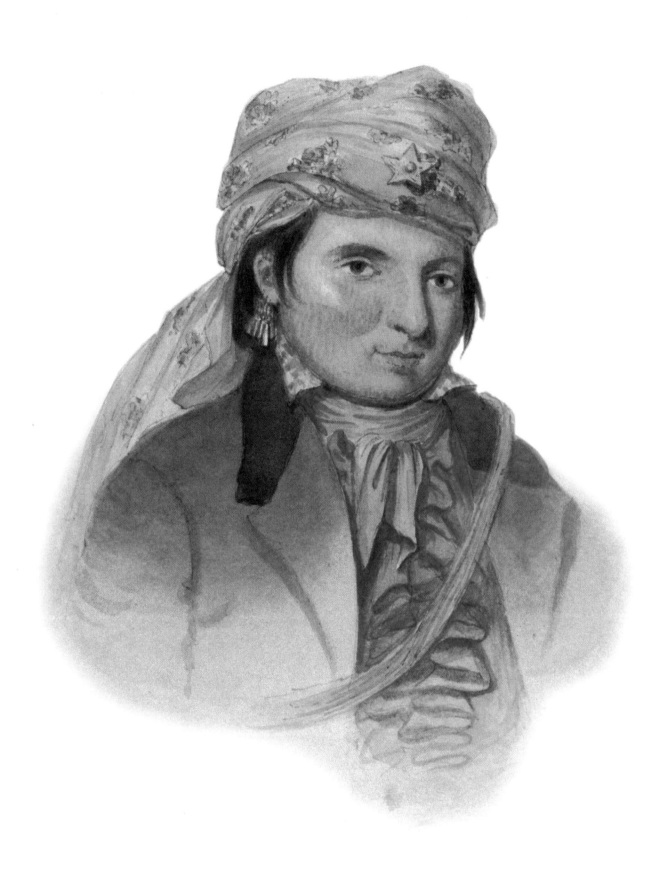

Plate 18. **POT-TA-WAT TA-MIE CHIEF. I-O-WAH** *(Cat. #26)*

Plate 19. OLD AUB-BEE-NEW BEE'S—SON LOGANSPORT—1838 [1837?] *(Cat. #28)*

Plate 20. SIN-IS-QUAW. (PEBBLE) WIFE OF TOM ROBB.
KEE-WAW-NAY VILLAGE—INDIANA JULY 20TH 1837 (Cat. #32)

Plate 21. SINISQUA (Cat. #35)

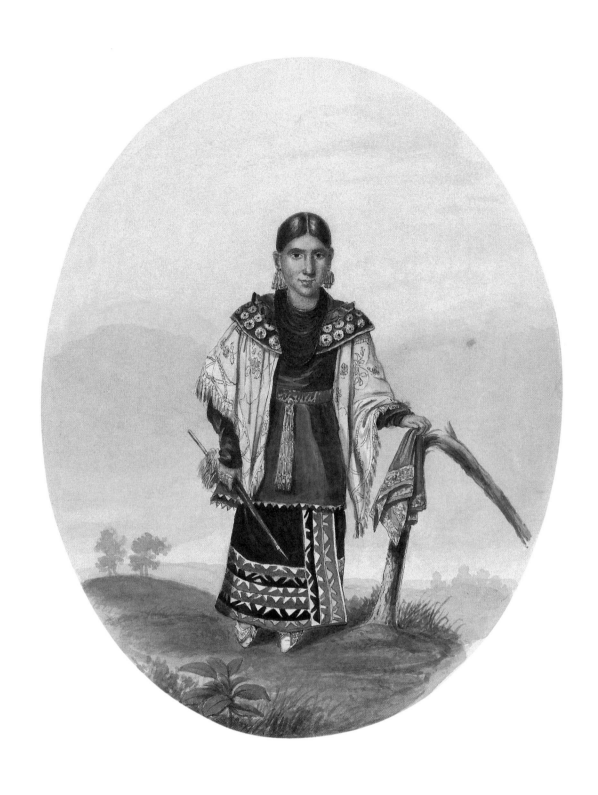

Plate 22. DAUGHTER OF MAS-SAW. MAURIE *(Cat. #36)*

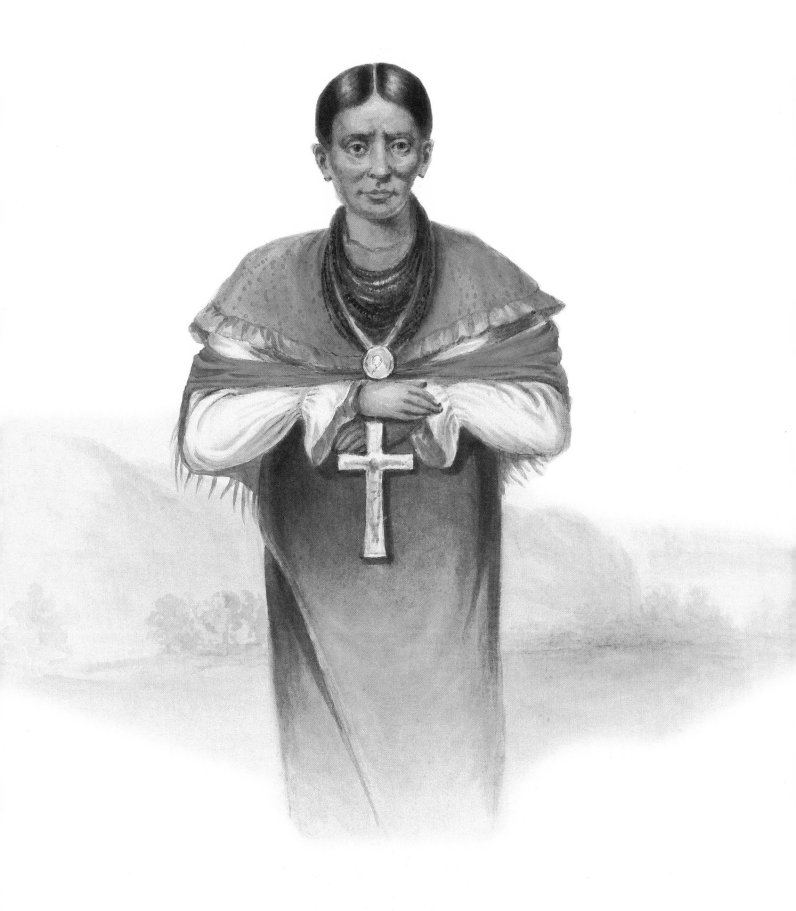

Plate 23. **MISS EN NAH GO GWAH** *(Cat. #38)*

Plate 24. QUEH-MEE SKETCHED AT KEE WAW-NAY VILLAGE 1837 *(Cat. #42)*

Plate 25. PASH-PO-HO *(Cat. #45)*

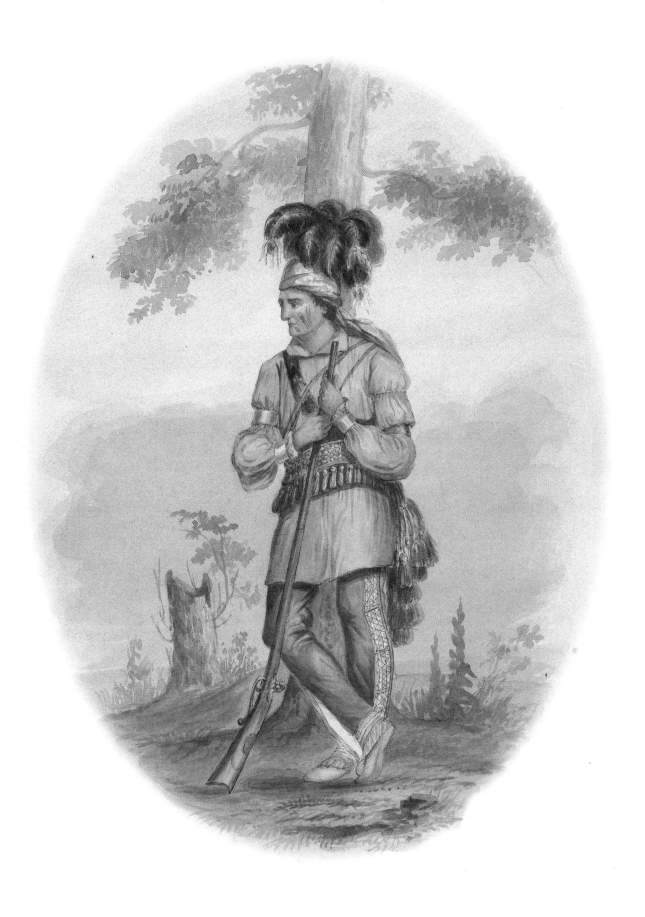

Plate 26. **YO-CA-TOP-KONE** *(Cat. #51)*

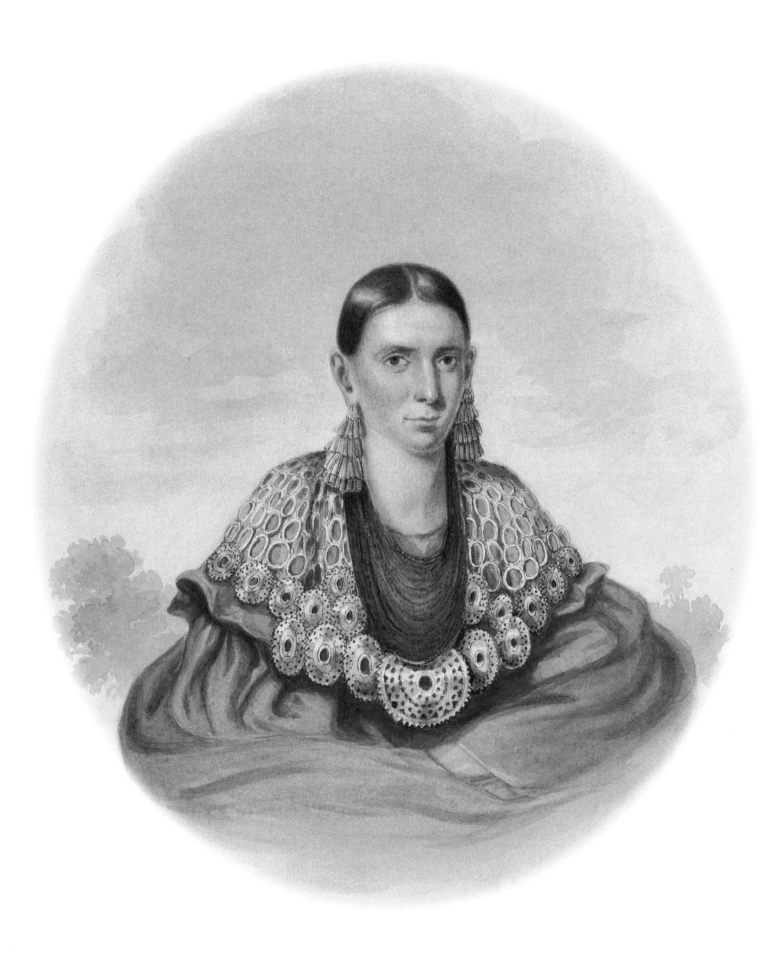

Plate 27. **D-MOUCHE-KEE-KEE-AWH** *(Cat. #57)*

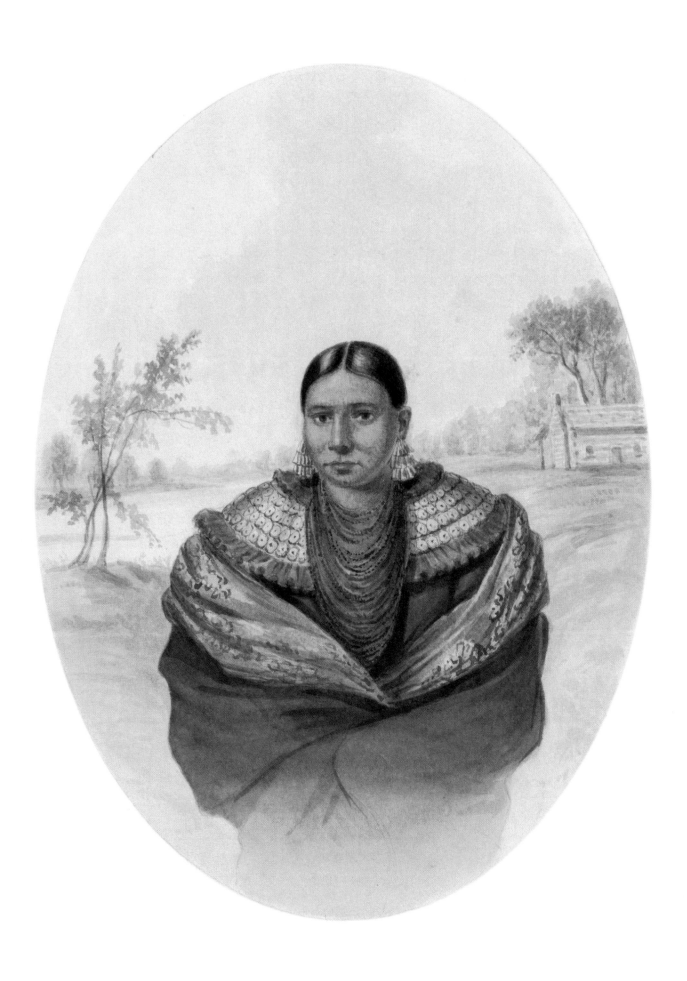

Plate 28. **MAS-SA** *(Cat. #60)*

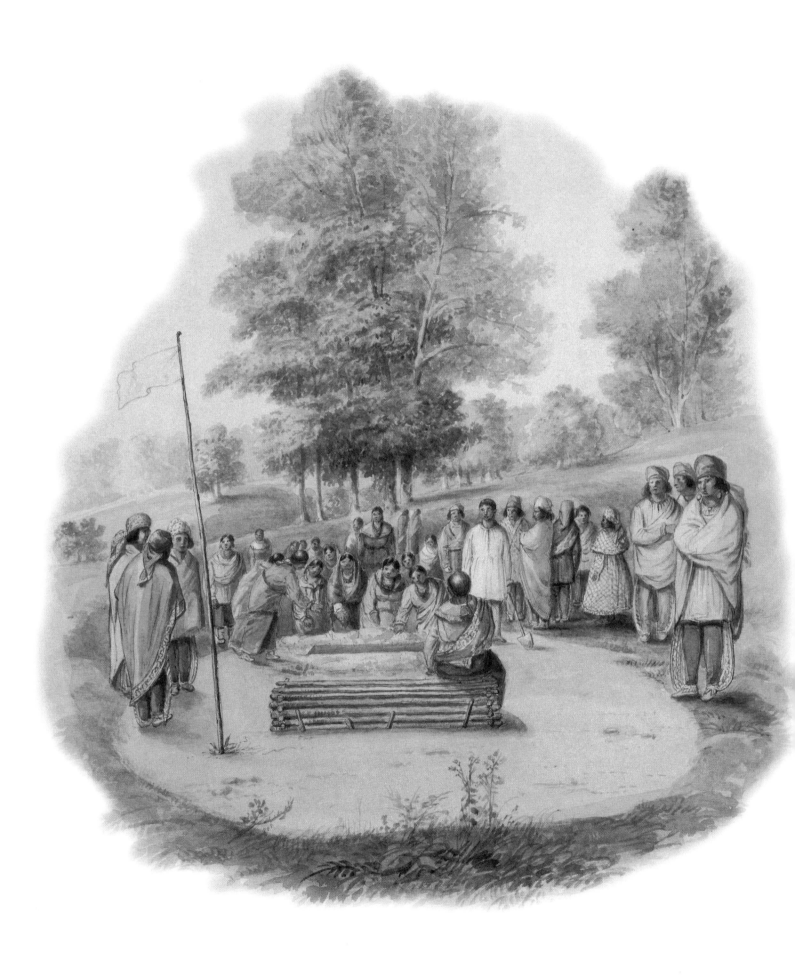

Plate 29. INDIAN BURIAL KEE-WAW-NAY VILLAGE 1837 *(Cat. #67)*

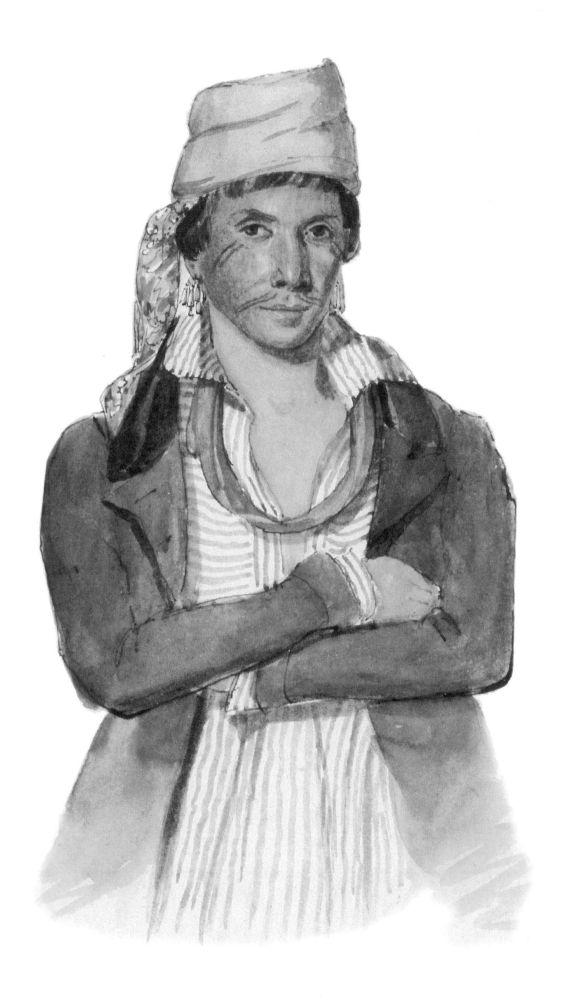

Plate 30. NO-TAW-KAH. VILLAGE OF KEE-WAW-NAY–JULY 27TH 1837 *(Cat. #75)*

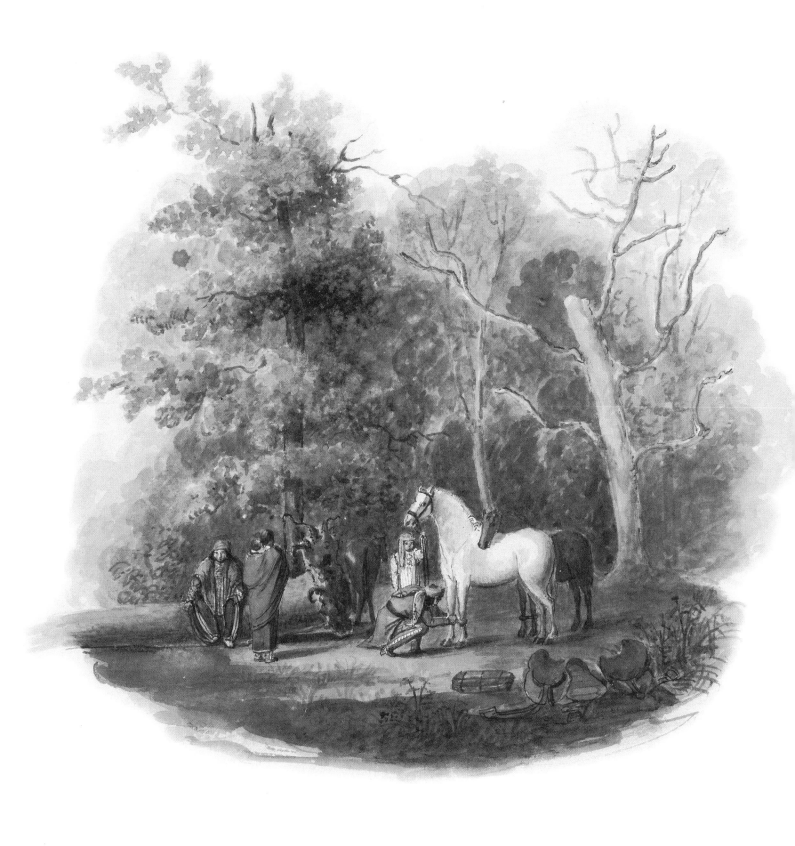

Plate 31. INDIANS RESTING NEAR LOGANSPORT AUGT 10 1837 *(Cat. #78)*

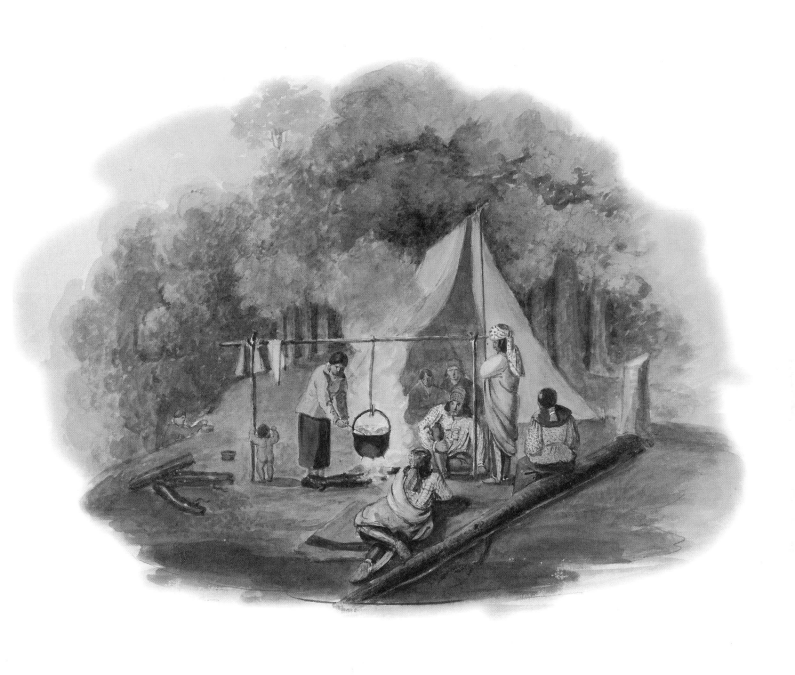

Plate 32. POTTAWATTAMIE INDIANS CROOKED CREEK INDIANA **1837** *(Cat. #81)*

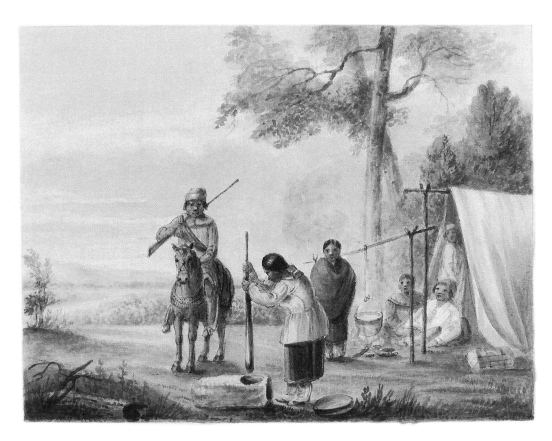

Plate 33. [CAMP SCENE WITH WOMAN POUNDING GRAIN] *(Cat. #83)*

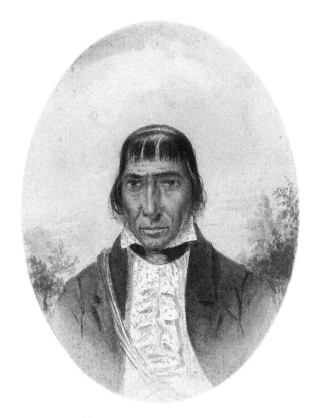

Plate 34. KE-WAW-NAY. WAR CHIEF *(Cat. #91)*

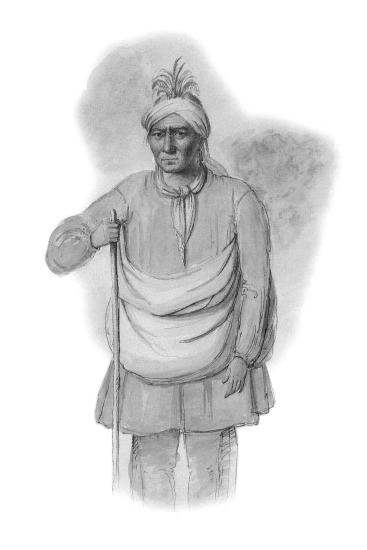

Plate 35. **KAW-KAWK-KAY** *(Cat. #97)*

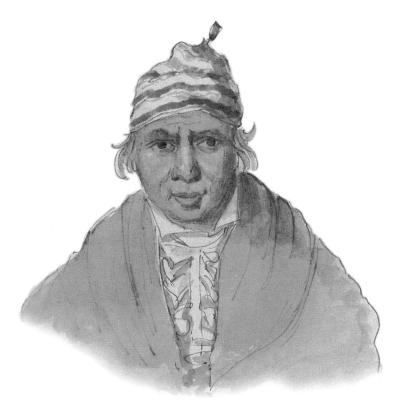

Plate 36. **MEE-SHAWK-KOOSE** *(Cat. #100)*

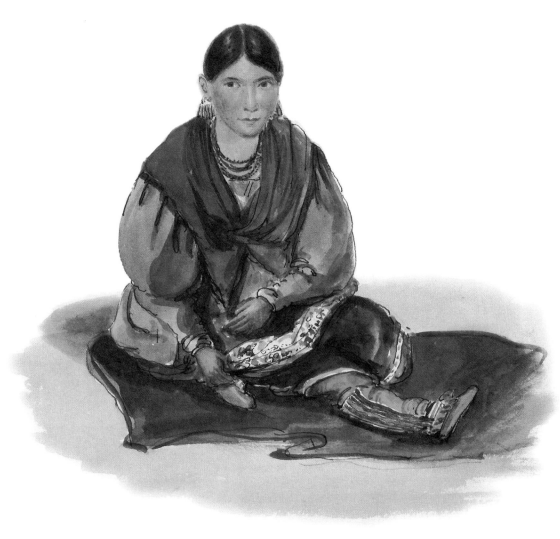

Plate 37. **PEA-WALK-O** *(Cat. #103)*

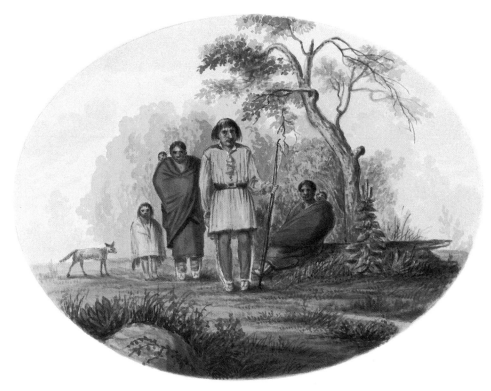

Plate 38. **MENDICANT INDIANS** *(Cat. #104)*

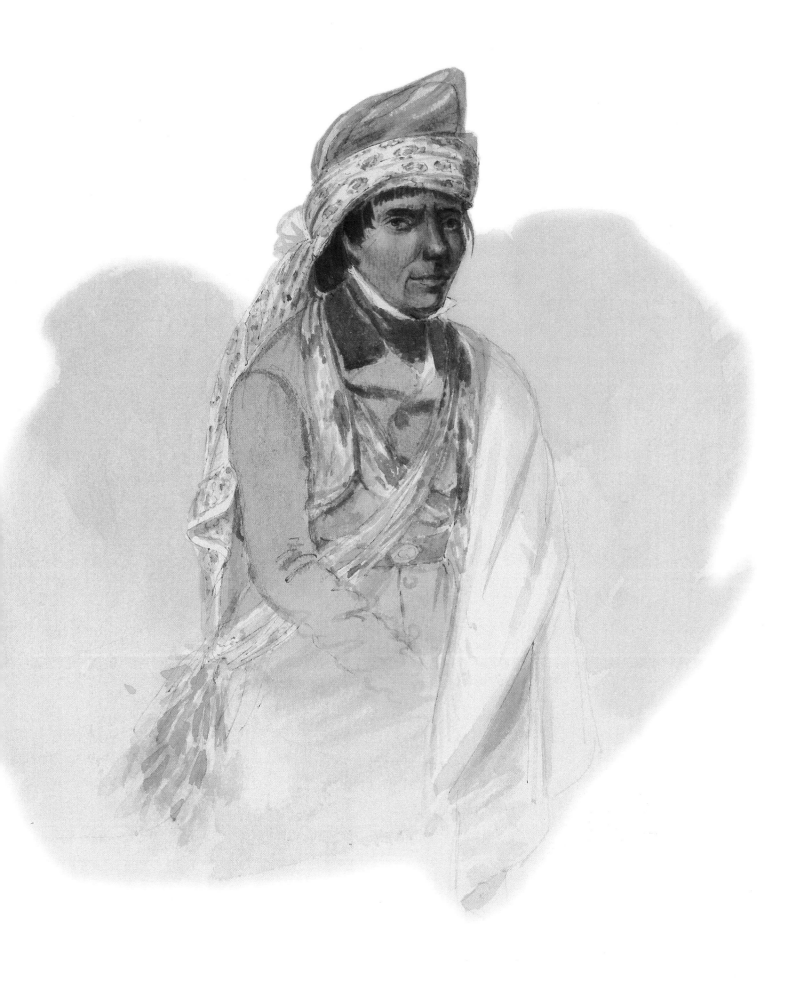

Plate 39. **WEWISSA** *(Cat. #120)*

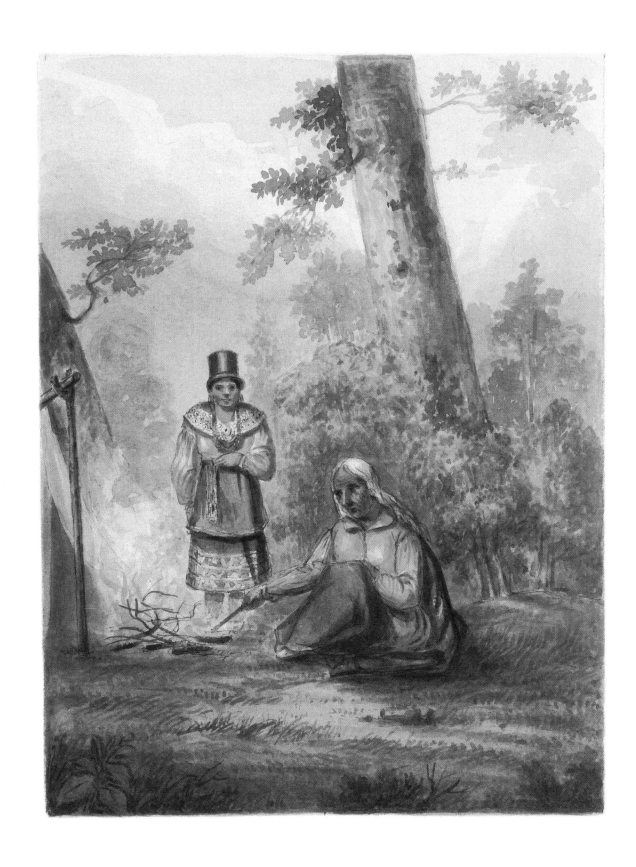

Plate 40. **THE MOTHER OF WE-WIS-SA** *(Cat. #123)*

Plate 41. **OSAGE VILLAGE 1839** *(Cat. #129)*

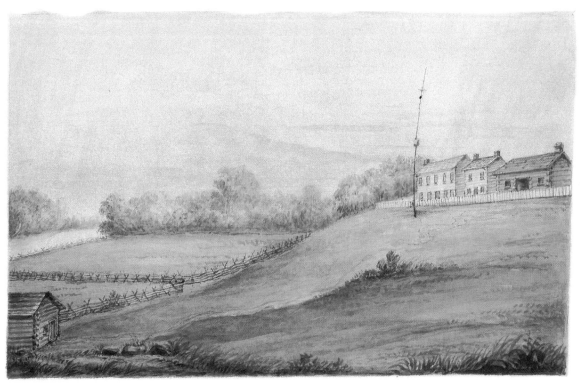

Plate 42. **NAN-MATCHES-SIN-A-WA. 1839. CHIEF GODFROY'S HOME** *(Cat. #131)*

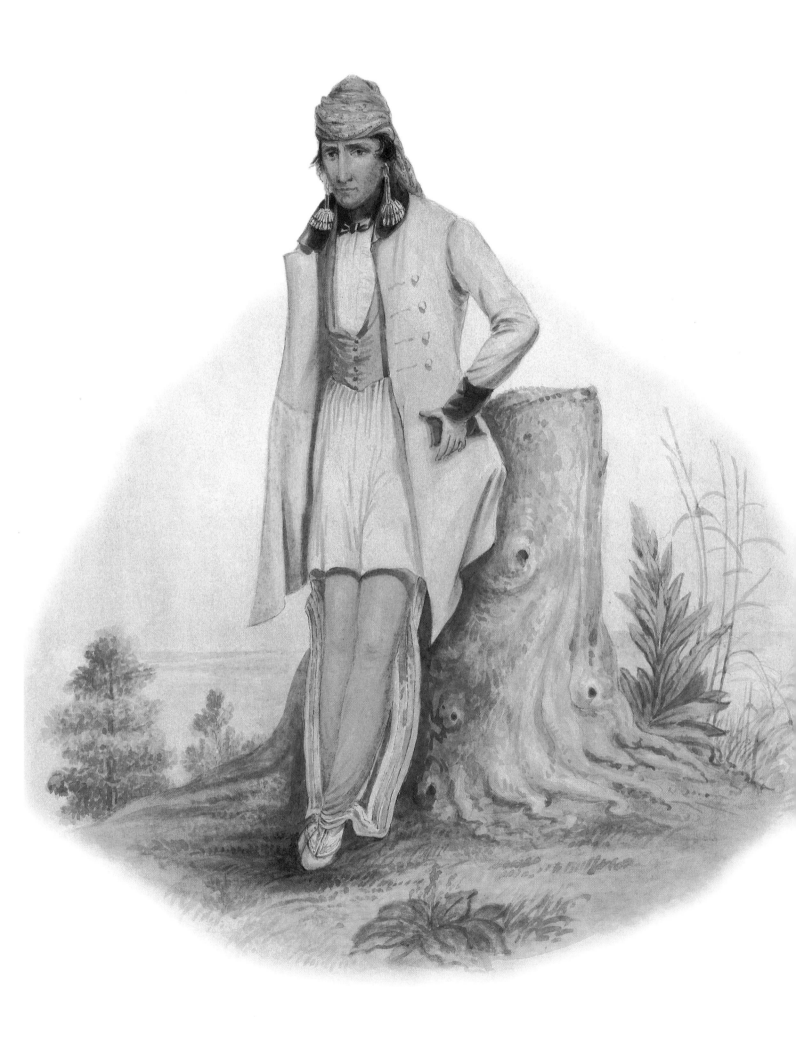

Plate 43. BOURIETTE-INDIAN INTERPRETER *(Cat. #132)*

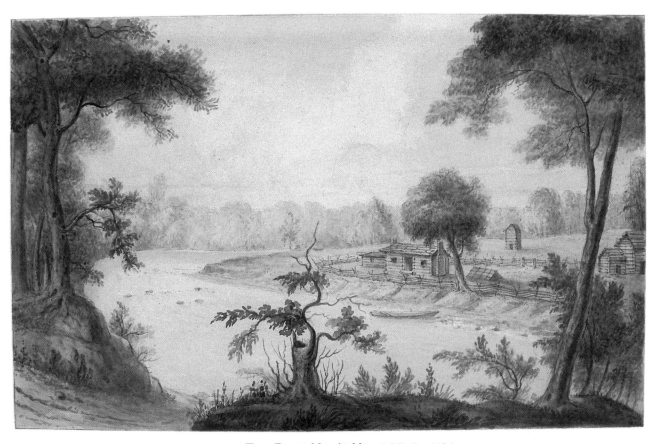

Plate 44. THE DEAF MAN'S VILLAGE *(Cat. #134)*

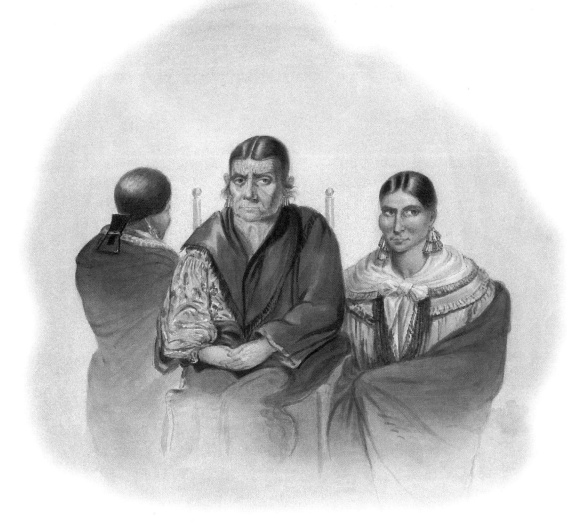

Plate 45. FRANCES SLOCUM *(Cat. #137)*

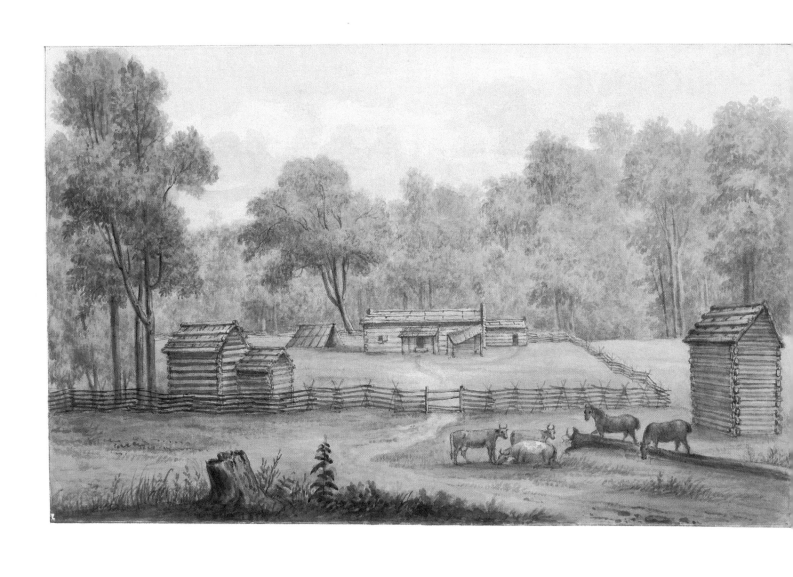

Plate 46. THE DEAF MAN'S VILLAGE *(Cat. #138)*

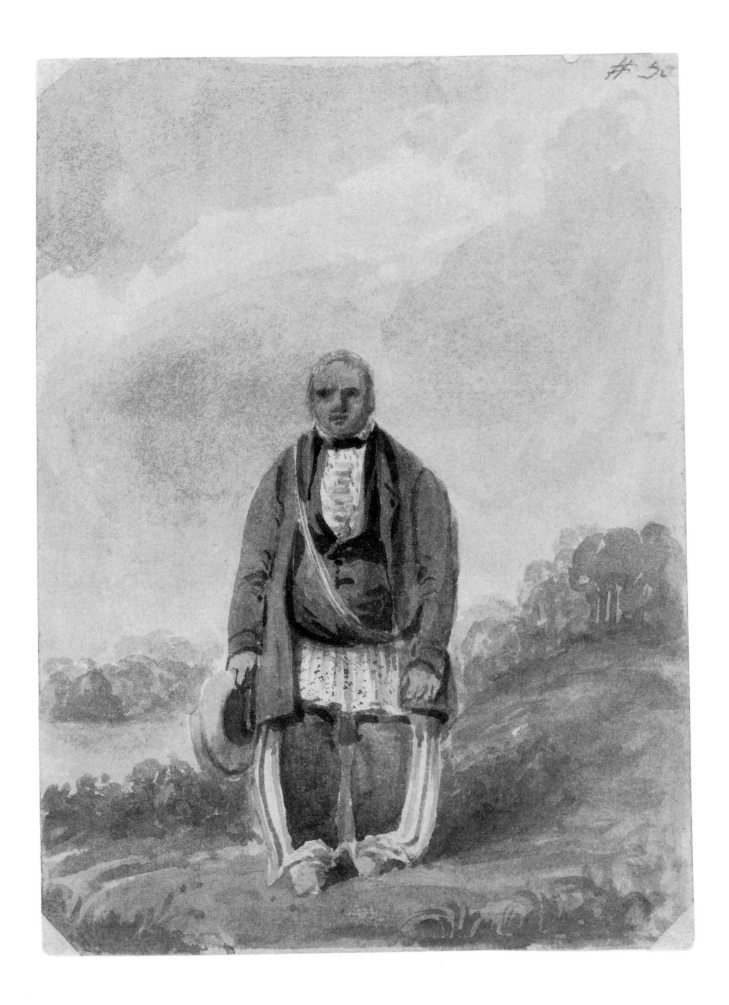

Plate 47. **FRANCIS GODFROY. WAR CHIEF** *(Cat. #147)*

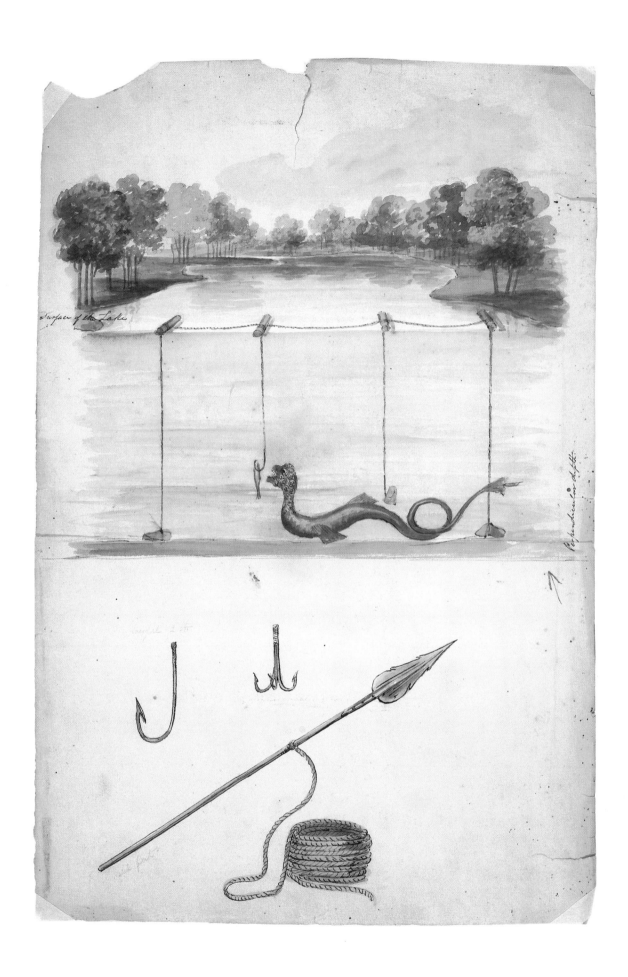

Plate 48. [DIAGRAM FOR TRAPPING LAKE MONSTER] *(Cat. #152)*

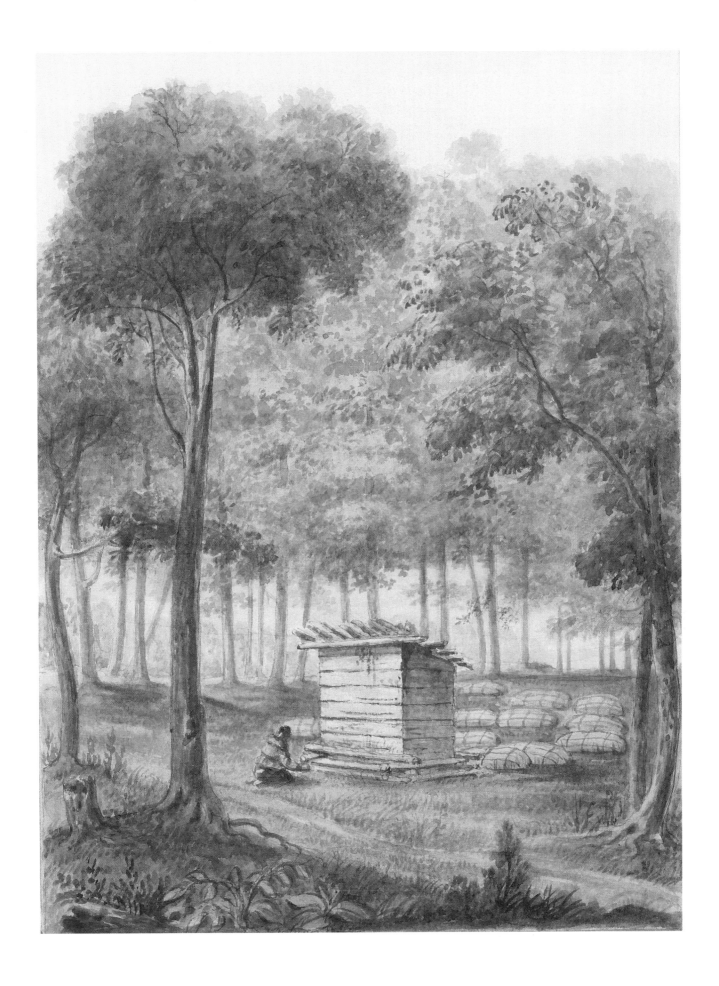

Plate 49. CAPT FLOWERS GRAVE *(Cat. #159)*

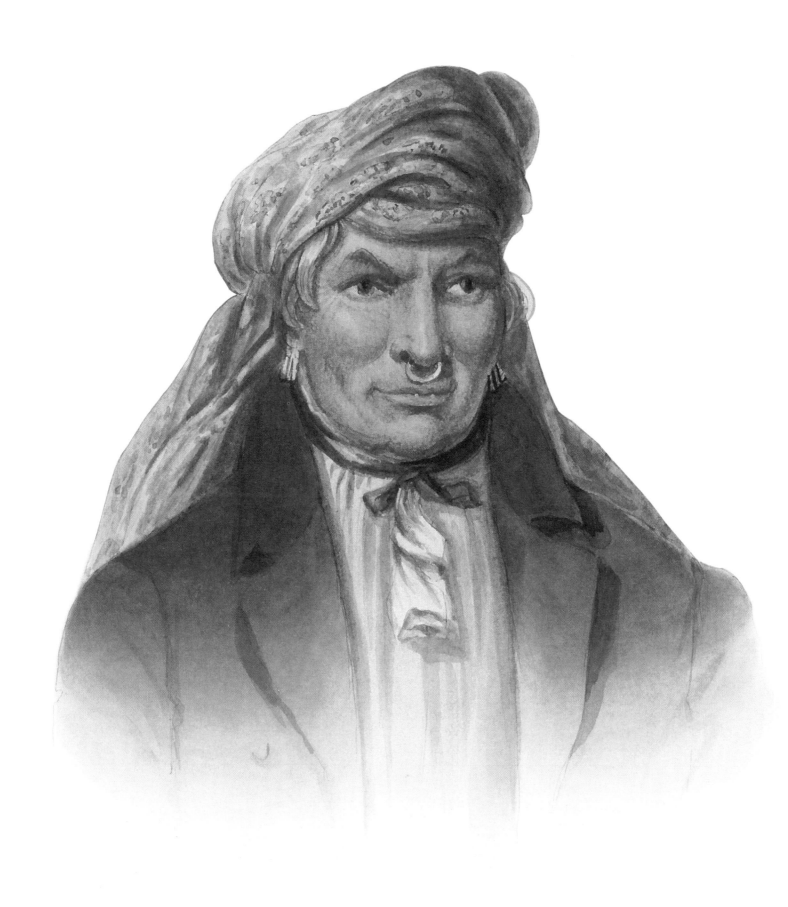

Plate 50. **PEE WAW-PAY** *(Cat. #168)*

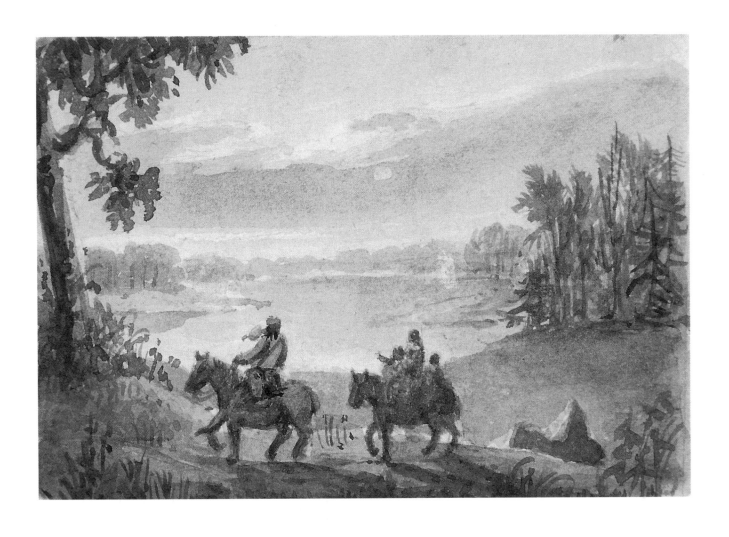

Plate 51. [FAMILY RIDING HORSES NEAR LAKE] *(Cat. #178)*

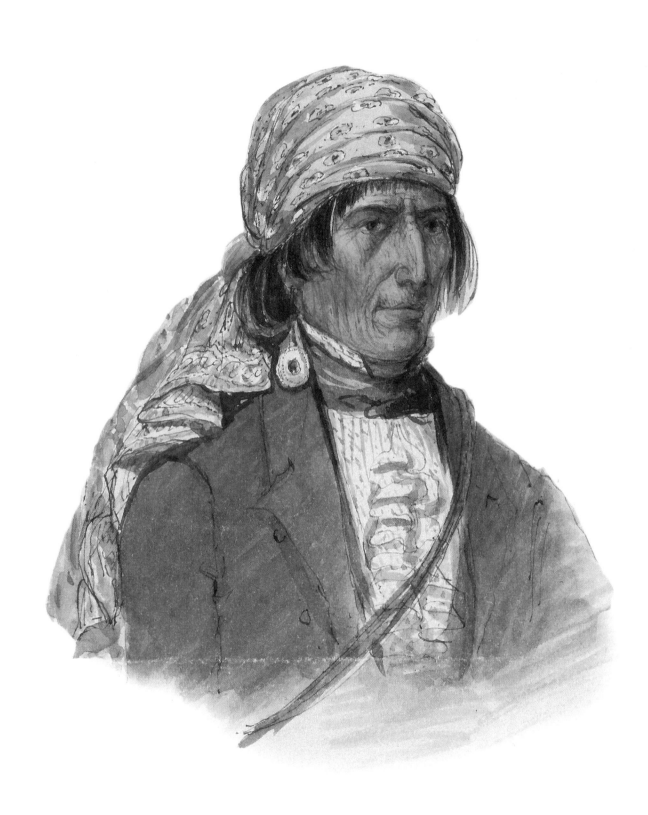

Plate 52. A MIAMI INDIAN. CALLED KEN-TUCK (Cat. #180)

Plate 53. [Purple Iris] Sketched Logansport May 27th 1846 *(Cat. #282)*

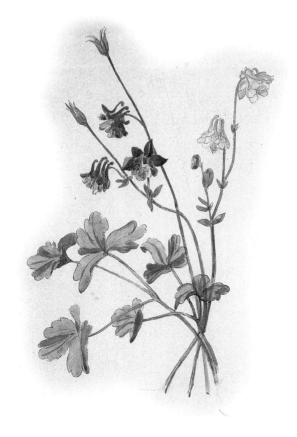

Plate 54. Columbine Sketched May 25th 1846 *(Cat. #283)*

The House Geo Winter intended to build in Logansport in 1845

Plate 55. THE HOUSE GEO WINTER INTENDED TO BUILD IN LOGANSPORT IN 1845 *(Cat. #294)*

Plate 56. [MAN AND DOG IN RURAL LANDSCAPE WITH LOG CABIN] *(Cat. #554)*

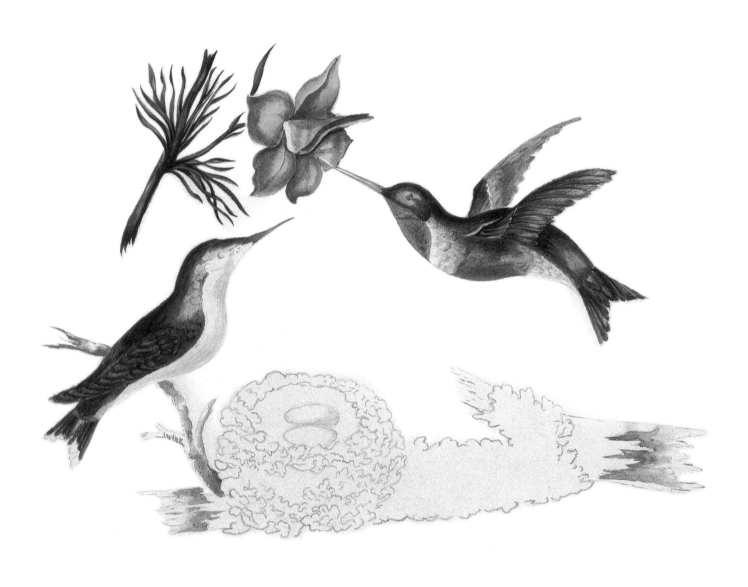

Plate 57. [TWO HUMMINGBIRDS] *(Cat. #599)*

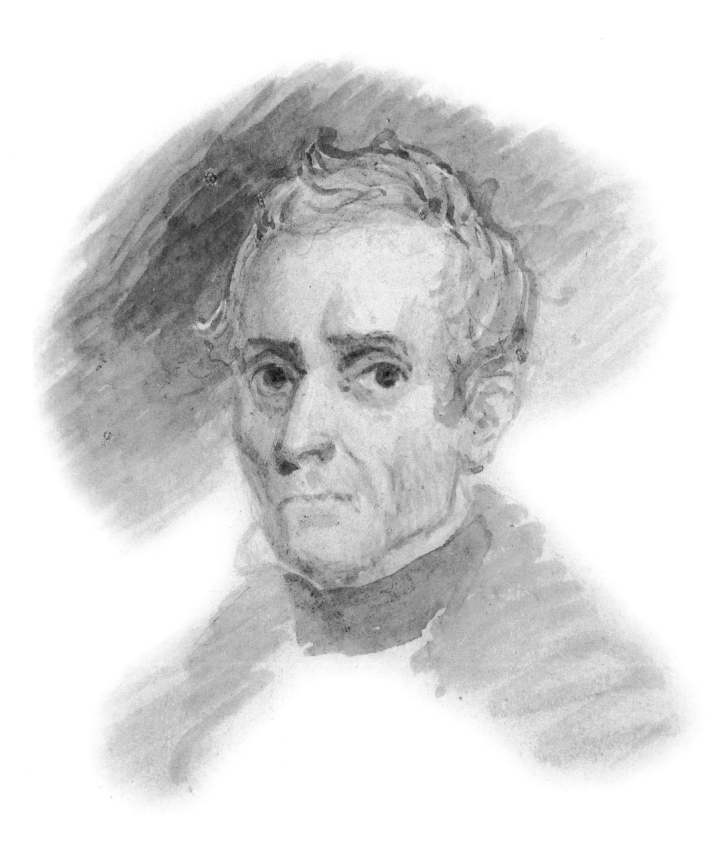

Plate 58. SKETCH OF GENL JOHN TIPTON U.S.S. THE MORNING AFTER HIS DEATH–GW *(Cat. #631)*

Plate 59. MICHAEL R BOOSE SOLDIER OF THE WAR OF 1812 1869 *(Cat. #645)*

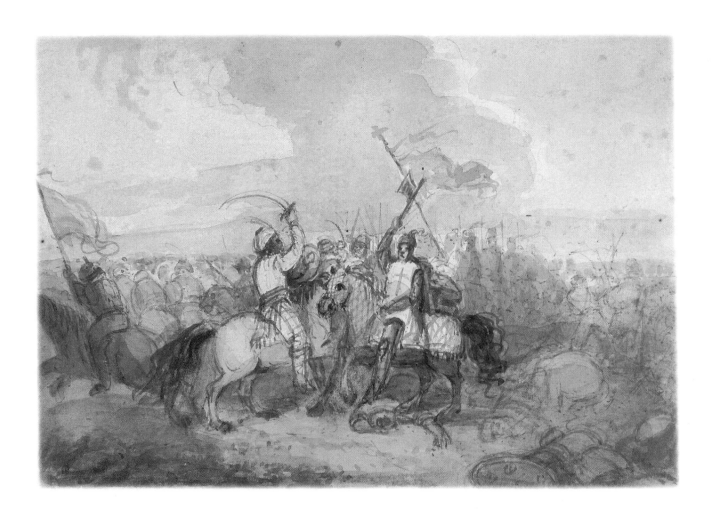

Plate 60. ORIGINAL SKETCH OF A SCENE FROM THE CRUSADES *(Cat. #697)*

Plate 61. [JOINTED PAPER DOLL] *(Cat. #760)*

135.
KICK KE SE QUA. THE DAUGHTER OF FRANCES SLOCUM THE CAPTIVE 1839

Graphite on paper
11 1/2 x 7 3/4 (29.1 x 19.7)
G-389

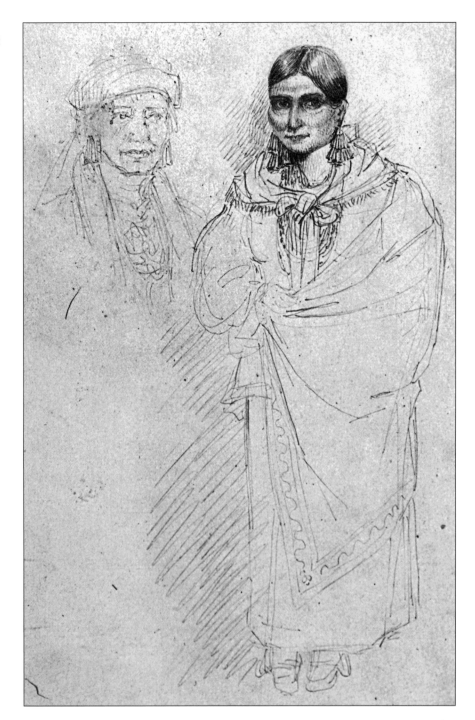

(135) "Being fatigued and needing some appeasing appliances to the inner wants, a good supper was immediately prepared for me. I did ample justice to the viands, which seemed to please Kick-ke-se-qua, who was the cook of the Cabin. . . .

The supper consisted of fried chicken, a good cup of coffee, and tolerable bread, and very good butter.

Kick-ke-se-qua, Brouillette's wife, was a fine tall and graceful woman, with an excellent face, sharp piercing eyes that indicated a capacity to penetrate below the surface of things. She was very gracious towards me; and I could but feel that they regarded me as a friend of Joseph Slocum." (GW DMV Journal)

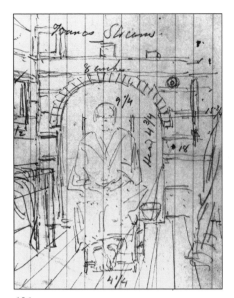

136.
FRANCES SLOCUM
Observed 1839
Graphite on lined paper
5 x 4 (12.5 x 10.2)
G-461

(136) "The evening hours had worn away now and . . . on my intimation of a desire to retire to my slumbers, I was introduced to the room where the Captive and Brouillette slept. The interior of the Cabin was of the general character of all 'double logs'. There was a large arch over the spacious fireplace, capacious enough to take in a *four foot log.* There were three *bunks,* substitutes for bedsteads, such as are commonly used by frontier people in their rude accommodations.

To the left, as you entered the room, and near the door, was the *rude boarded* structure, upon which the aged Captive slept; on the right side, were two others, one of which, Brouillette and Squaw occupied, and the one shown me for my place of rest, for the night, was near the fire place.

Matting, such as is used in temporary encampments when the canvas wigwam is brought into requisition, hung up smoothly in the space between my 'bunk' and fire place. On nails, hung several heavy rows of blue beads with numerous *watch keys,* attached with red ribbons, tied in bows. These were 'necklaces' of the aboriginal women.

Two or three pairs of 'leggins', with handsome borders, or 'wings', decorated with the primitive colored ribbons–some sewed in diamond forms, others in straight lines. Much expense is devoted to this ornamental part of the Indian's costume. A showy silk shawl hung 'here and there' upon the side of the cabin. A rifle stood in the corner.

There were no chairs in the room. The 'bunk' assigned to me had some rude studding posts, upon which were suspended some blankets. . . .

A long shelf over the arch of the fireplace revealed some bowls, jars, and a small box. The whole appearance of the room was strange–rude and aboriginal in character. . . .

On turning down the coverlet of my 'bed', I discovered a fine figured shawl of dusky colors, as a substitute for a sheet; nice clean blankets, neatly folded upon the boards of the bunk, constituted my bed. . . .

About midnight, the Captive, Captn. Brouillette, and Kick-ke-sequa entered the room, and then *'bunked'* for the night. There was no word spoken.

I slept but little, and arose and greeted 'the gentle day'." (GW DMV Journal)

137. *(see Plate 45)*
FRANCES SLOCUM
Observed 1839; executed ca. 1863–71
Watercolor on paper
16 1/4 x 11 7/8 (41.2 x 30.0)
Inscribed, l.r.: "No. 23. George Winter"
Intended for inclusion in G. W.'s Deaf Man's
Village journal
Journals and Indian Paintings, *Plate XXVIII*
OV3-51

(137) "Preparations were then made for the sitting.

An old splitbottomed chair was brought out of the ajoining room, which I placed near the little window, to obtain the best light to fall upon her.

Frances Slocum presented a very singular and picturesque appearance. Her toute en semble was unique. She was dressed in a red calico 'shirt', figured with large shewy yellow and green, folded within the upper part of a 'metta coshee', or petticoat of black cloth of excellent quality. Her nether limbs were clothed with fady-red leggings, 'winged' with green ribbons, and her feet were *moccasinless.*

'Kick-ke-se-quah', her daughter, who seemed not to be without some pride in her mother's appearing to the best advantage, placed a black silk shawl over her shoulders–pinning it in front.

I made no suggestions of any change in these arrangements, but left the toilette uninfluenced in any one particular.

Frances placed her feet across upon the lower round of the chair, and her hands fell upon her lap in good position.

Frances Slocum's face bore the marks of deep seated lines. The muscles of her cheeks were like corded rises. . . .

Her hair which was evidently of dark-brown color, was now frosted. Though bearing some resemblance to her family–yet her *cheek bones* seemed to have the Indian characteristic in that particular–face broad, nose, somewhat *bulby*, mouth indicating some degree of severity.

In her ears she wore some few 'earbobs'. . . .

She was low in stature, being about five feet in height. . . .

The above description of the personality of Frances Slocum is in harmony with the effort of my pencil. . . .

Frances Slocum was a patient sitter, and wholly abandoned herself to my professional requirements.

I relieved her as soon as possible from restraint. The pencil moved rapidly, as by an inspiration. In two hours' operation, I had transferred a successful likeness of one whose history is full of painful yet romantic incidents. The sketch was a successful result as indicated by the quick recognition of it by the many who saw it. It was among the most valued of my aboriginal sketches of the aboriginal people of the Wabash Valley. . . .

Frances looked upon her likeness with complacency. Kick-ke-se-quah eyed it approvingly, yet suspiciously–it was a mystery. The widowed daughter, O-shaw-se-quah, would not look at it, but turned away from it abruptly when I presented it to her for her inspection, as though some evil surrounded it.

I could but feel as by intuition, that my absence would be hailed as a joyous relief to the family." (GW DMV Journal, GWMSS 2-23 [13])

G. W. to G[eorge] Slocum, 14 Oct 1839

"The expense of the painting I must necessarily mention to you. Though called *from home* I shall make you no greater charge than what I have ordinarily painted for in this section of the country. I shall commence the painting tomorrow on a *canvass* measuring 29/36 inches, which will enable me to introduce the hands–for this size I have but $35 *here,* to which I must add for 5 days absence $25 and my expenses of $15–which will make $75. This I have concluded to be the *lowest* price of the painting. I would add, that through my absence I *lost* the opportunity of painting a portrait of the son of Mr. Walker, the Partner of Col. Ewing." (GWMSS 2-23 [20])

(138) "Wishing to obtain all the points of interest in the surroundings of the Captive, for I felt that I was on classic ground, I had selected in my rambles some several points of view of the village and vicinity. . . .

I took a favorable position for sketching, some fifty paces in the rear of the *double log*, and [should I] have crossed the Mississinewa, I would [have sketched] the converse view.

Such was my plan. But I had no sooner taken my stand point, and held my pencil horizontally to the eye to find a line determinedly to assist in finding the true 'point of sight', a sort of *artistic fugleism*, peculiar to a Sketcher's preliminaries, when I discovered Frances Slocum, daughters and grand paupooses, in serious consultation on the porch rear of the Cabin.

They regarded me with intense interest no doubt, in much tribulation at my seeming *conjurations* and *deviltries*. I quickly anticipated that their superstitious fears were aroused. . . .

I worked away rapidly at my sketch, securing the important points of the interesting scene before me.

At last the Captive woman advanced toward me. . . .

She addressed me in the Miami language, which was not comprehensible to me; but her manner of gesticulation was so striking and clear, that it would have been dullness of intellect, that could not have understood the desired communication of the wish.

I knew by an intuition, that there were objections to my proceeding with the sketch.

I still worked away, affecting not to comprehend her desires. At last, she said in english very emphatically, 'no good, no good'!

My portfolio I turned downwards, and appealingly gazed at her. She signified by a nod, and a pleasant smile that she was gratified.

On returning to the cabin with the Captive, all the family excepting Kick-ke-se-quah, had disappeared. She, however, exclaimed disturbedly, 'No good! No good house'!

My immediate departure was soon decided upon." (GW DMV Journal)

138. *(see Plate 46)*
THE DEAF MAN'S VILLAGE
Observed 1839; executed ca. 1863–71
Watercolor on paper
16 1/4 x 11 7/8 (41.2 x 30.1);
comp. 5 3/4 x 9 1/8 (14.4 x 23.0)
Inscribed, l.r.: "No. 13. George Winter"
Intended for inclusion in G. W.'s Deaf Man's
Village journal
OV3-53

139.
THE WIGWAM OF MA-KONE-SEEK-
QUA–KNOWN AS THE CAPTIVE,
FRANCES SLOCUM THE SCENE
IS ON THE MISSISSINAWA RIVER
INDIANA 1839
Graphite on paper
8 1/4 x 11 7/8 (20.8 x 30.1)
Similar to Cat. #138
G-459

140.

**THE CAPTIVE'S HOME ON THE
MISSISSINAWA 1839**

Ink and graphite on blue paper
4 1/2 x 5 3/8 (11.3 x 13.6)
Inscribed, u.c.: "The home of Francis Slocum 1839"
G-458

(140) "The farewell was short. I shook hands with the Captive, and her daughter, Kick-ke-se-quah. The widow, O-shaw-se-quah, and the paupooses were ambushed, and invisible. I took the canoe, which was moored below the bank immediately in front of the cabin, near the large elm tree that flung its ample shade upon the river.

I leisurely paddled across the Mississinewa. They watched my landing upon the opposite bank. This was noticeable by 'a backward gaze.'

I bowed to them farewell, and disappeared from their sight, in the dark shade of the heavy timbered forest." (GW DMV Journal)

141.

HOME OF THE CAPTIVE 1839

Graphite on paper
7 x 8 5/8 (17.6 x 21.7)
Inscribed, verso: "The Deaf Man's village.
The Home of the Captive. Frances Slocum.
On the Mississinawa River. Sketched–1839. GW"
Same view as Cat. #134
G-460

(141) "Under the advantage of my seclusion and being decidedly master of the situation, I made a sketch of the pleasant river view, including the classic village which abounded in such touching concentration of interest.

I could but linger and drink in to a fullness, the scene, so deeply impressed upon my mind. I felt enriched with 'treasures' of the highest value in historic interest, and happily retraced my way through the 'dim lit' aboriginal forest, of grandly crescented trees, rustling with the gentle breezes as they swept by from the Mississinawa." (GW DMV Journal)

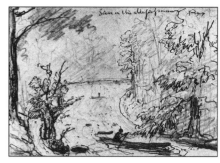

142.
SCENE ON THE MISSISSINAWA
RIVER
Ink and graphite on green paper
2 3/4 x 4 (6.8 x 10.2)
B-116

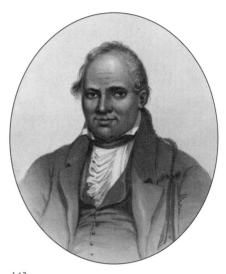

143.
FRANCIS GODFROY WAR-CHIEF
Observed 1839; executed ca. 1863–71
Watercolor and ink on paper
15 1/2 x 11 1/8 (39.4 x 28.3)
Inscribed, l.r.: "No. 4. George Winter"
Intended for inclusion in G. W.'s Deaf Man's
Village journal
Journals and Indian Paintings, *Plate XXIV*
L-50

(142) "I struck the Mississineway again and followed the trail along the banks of this cheerful stream, presenting some pleasing wild scenery which I sketched. . . .

It was but a few miles to 'Nan-matches-sin-wa', Chief Godfroy's home. No particular event occured on the route in repassing the same log cabins, inhabited by the Indians. . . .

The constant assaults of the indian dogs that complimented my passing had become familiar events. . . .

Notwithstanding the shady route to the Chief's, and the cool sweeps of cool refreshing air from the bright clear river–the day being warm–my 'tramp' through 'the pathless woods' had whetted up a keen appetite, and the inner man experienced those unmistakable sensations which herald the desire for *redress*." (GWMSS 1-23 [18], GW DMV Journal)

(143) "On my arrival at Godfroy's trading establishment, I found no one visible. . . .

My entrance to the cabin was rather unceremonious. Dinner was then being served. Chief Godfroy, his son Jim, and the white cousin constituted the company.

The Chief possessed some of his white father's french instinctive politeness.

The old squaw, who was the *cousin*, was directed to place a chair and a plate at the table for me. Some good venison soup was served up to me. . . .

. . . All present could speak english, the old squaw excepted, and a loquacious disposition was manifested. . . .

The fulfillment of a promise to sit to me, when he visited my studio in the town of Logansport, seemed *now* of doubtful accomplishment. To my solicitations under the present favorable auspices, he was evasive in manner. He indicated no wish to have his likeness painted. Upon his remarking that I would keep it myself, I replied that if he would let me sketch him, I would present him with a large portrait. . . .

Francis was a war chief and had arisen to that distinction among his tribe on his own merits. He was well known for bravery upon the battlefield. . . .

Chief Godfroy was not only a great man among his red brothers, but from his urbane manners and being of an enterprising business turn, mixed much among white men, by which he became familiar and friendly with the white settlers in the Indian country, who entertained a great respect for him.

This business enterprise was remarkable. He built a fine two story frame building for trading purposes on the *bank* between the canal and Wabash river, at the town of Peru . . . he built a substantial trading house at 'Nan-matches-sin-wa', which was well stocked with merchandise peculiarly adapted to the Indian purchaser. He possessed some several farms." (GW DMV Journal)

144.

LOUISA GODFROY ELDEST DAUGHTER OF CHIEF GODFROY OF THE MIAMIES
Observed 1839
Graphite on paper
8 3/8 x 6 (21.1 x 15.1)
G-374

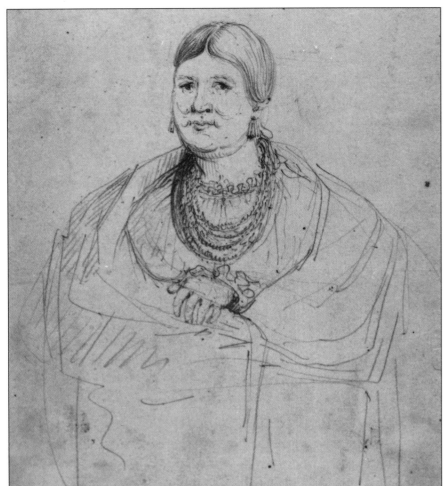

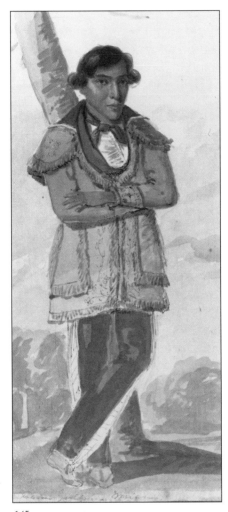

145.

JIM-GOD[F]ROY. SON OF [CHIEF] FRANCIS GODFROY–[MIAMI?]
Observed 1839
Watercolor and ink on paper
10 x 7 7/8 (25.5 x 19.9)
K-1

(144) "When at his house in the year 1839, I was anxious to secure [Chief Godfroy's] likeness, his two Squaws . . . and his numerous progeny." (GW DMV Journal)

(145) "During my stay at Godfroy's many Indians called, it being head quarters for the Miamies of the neighbouring villages, as many traded with the Chief. I was called upon by Jim Godfroy . . . to show the likeness of the Captive. The Indians generally were much pleased with it, and much animated discussion sprang up among them in regard to it. . . .

Through Jim Godfroy I proposed to sketch some of the most important Indians, but in vain. Though they were amused, and indulged in many a joke over the Captive's likeness, but were reluctant to submit to the ordeal of being transfered by my professional medium to *paper*.

Jim Godfroy . . . volunteered to let me sketch him in 'full length'; and he courageously observed, that 'if it is a *cause* of death, I am ready to die–so sketch away.'

I did so. . . . Jim prepared his toilette for the eventful occassion by putting on a handsome buckskin hunting coat, that had been bought from some of the tribes in the 'far west', beyond the Mississippi. . . .

. . . I fancied that I was winning my way with the good graces of the Miamies.

But Jim's *heroic courage* in sitting, and all his efforts to secure me sitters were abortive.

The Chief though having declined 'to sit to me'. I concluded to resort to strategy in securing his likeness." (GW DMV Journal)

146.
JIM GODFROY. SON OF
FRANCIS GODFROY
Observed 1839; executed ca. 1863–71
Watercolor on paper
14 1/4 x 11 3/8 (36.0 x 28.7)
Inscribed, l.c.: "No 34"
Similar to Cat. #145
Intended for inclusion in G. W.'s Deaf Man's
Village journal
L-48

(147) "I made a successful sketch of Godfroy after careful observation of him. So remarkable a face and person, was not a very difficult achievement to secure. . . .

Personally Chief Francis Godfroy was a very remarkable fine looking man. His tout en semble would attract the attention of the observer were he among a large congregated number of indians. He was fully six feet in heighth, remarkably portly–his avoirdupois being perhaps some 350 lbs. . . .

. . . His eye was larger than that of the general characteristic eye of the indian which is rather small, sharp and piercing. Godfroy's nose was bulby and wide-spreading and in no way characteristic of the Miami type which is more of aquiline form. His lips were large and somewhat pouting. . . . His hair was disposed to have curly tendencies.

When I knew him in the year 1838–he visited my studio in Logansport–his hair was tinged with autumnal frost which gave him a dignified and more impressive appearance.

He wore a queque, which is common among the aborigines of the Wabash, with wide black ribbon bow attached, with long ends falling over and following the curved line of his broad and massive back, which gave him a caste of the 'gentleman of the old school' character.

The day was now drawing to a close, and Peru was some several miles distant. I concluded that I would continue the recipient of the hospitalities of the Chief until the following morning." (GW DMV Journal; GWMSS 2-11 [1])

147. (see Plate 47)
FRANCIS GODFROY WAR CHIEF
Observed 1839
Watercolor on paper
4 3/8 x 3 1/4 (10.9 x 8.2)
L-21

148.
FRANCIS GODFROY. WAR-CHIEF
Observed 1839; executed ca. 1863–71
Watercolor and ink on paper
16 3/8 x 11 1/2 (41.3 x 29.3);
comp. 7 3/8 x 6 1/4 (18.5 x 15.7)
Inscribed, l.r.: "No. 3. George Winter"
Similar to Cat. #147
Intended for inclusion in G. W.'s Deaf Man's
Village journal
M-63

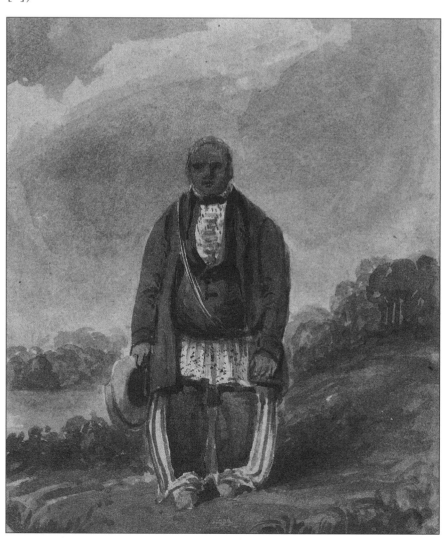

(149) "I slept well and rose with the sun, having determined to make the most of my opportunities and resolved in making a sketch of 'Nan-matches-sin-wa', the house of the Chief. . . .

I had now selected my point for sketching, and was progressing very satisfactorily. . . .

My thoughts were now directed to my return to the town of Peru . . . realizing too, with a *confident* certainty, that my presence was anything but agreeable to the Godfroy family.

I was too much 'medicine'.

. . . departed at 3 Pm. Sept 7th. for *Peru*–crossed the *Wabash* and passed through thick timbered land." (GW DMV Journal; GWMSS 1-16 [19])

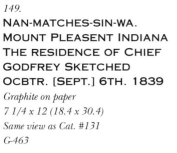

149.
NAN-MATCHES-SIN-WA.
MOUNT PLEASANT INDIANA
THE RESIDENCE OF CHIEF
GODFREY SKETCHED
OCBTR. [SEPT.] 6TH. 1839
Graphite on paper
7 1/4 x 12 (18.4 x 30.4)
Same view as Cat. #131
G-463

LAKE MAN-I-TOU, 1839

"Once more in the promising town of Peru.

Sept 9th Morning rather clouded with prospect of a fine day. Failed to find . . . horses. . . . Left afoot. . . . Crossed the Prairie in vicinity of Peru–followed road through thick timbered land. . . .

. . . *Barrens* an appropriate epithet Mud Lake–Indian encampments–Settlements . . . entered thick timbered again . . . arrival at Rochester–sun down. Lake Man-i-tou. . . .

Sept 10th Morning mistty–sun present–pleasing effect–darned my sock. Boots nearly walked off–no shoemaker. Preparation to visit the Devil's Lake." (GWMSS 1-16 [19])

G. W. to B. Lossing, 16 December 1871:

"I felt a deep interest in this inland lake as I had gathered up the facts in relation to the Indian story associated with it.

The tradition of 'Lake Man-i-tou' I published in A D 183[8] in 'Logansport Telegraph'." (GWMSS 1-23 [18])

"For the Telegraph

July 21st 1838

In the northern portion of Indiana there are many beautiful lakes which give great interest to a country somewhat open. About twenty five miles from Logansport, and in the vicinity of Rochester there is one of these lakes about two miles in length, half a mile in width, and of unknown depth. . . .

This lake is called by the Indians, 'Lake Man-i-toe', or the 'Devil's Lake'; and such is the terror in which it is held, that but few Indians would even dare to venture in a canoe upon its surface. The Indians will neither fish, nor bathe in the lake; such is the powerful conviction that 'Man-i-tou', or the Evil Spirit, dwells in its Ch[r]ystal waters. . . . When the Pottawattamie mills were erect[ed] some ten years since, at what is called the out-let of the lake, the monster was seen by men known to Genl. Milroy, under whose direction the Mills, I believe, were erected." (GWMSS 2-33 [1])

150.
PRAIRIE NEAR ROCHESTER
INDIANA
Graphite on paper
4 3/4 x 8 3/4 (12.1 x 22.2)
A-62

151.
MUD LAKE INDIANA. 1839
Blue ink on paper
7 3/4 x 9 5/8 (19.5 x 24.2)
Rough sketch of wagon on verso
A-9

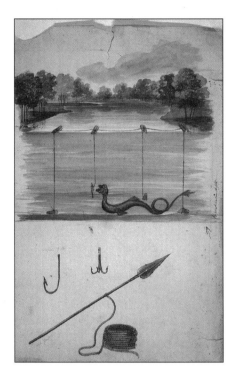

152. *(see Plate 48)*
[DIAGRAM FOR TRAPPING LAKE MONSTER]
Watercolor and ink on paper
15 3/8 x 10 3/8 (39.0 x 26.2)
M-82

(152) "Mr. Lindsey, who is well known here, was riding near the [bank?] of the lake, when he at the distance of 200 feet from him [saw] some animal raise its head, three or four feet above the surface of the water . . . and viewed the mysterious creature many minutes; when it disappeared, and reappeared three times in succession. The head he described as being about three feet across the frontal bone, and having something of the contour of a 'beef's head', but the neck tapering, and having the character of the serpent; color dingy, and with bright yellow spots. It turned its head from side to side with an easy motion, in apparent survey of the surrounding objects. Mr. L. is entitled to credibility. So convinced are many of the existance of the Monster, that some gentlemen in town have proposed an expedition to the lake, and by the aid of rafts to make an effort to capture the mysterious being which is a terror to the superstitious, but which becomes an object of interest to science, the naturalist, and philosopher. . . .

A public meeting took place in Logansport Augst 11th[?] to take into consideration and advise upon the forming an expedition to the Devil's Lake. The meeting was numerously attended. Some very appropriate speeches were made on the occassion, resolutions were passed; and a drawing of a plan for the capture of the Leviathan was presented to the meeting, and was generall[y] approved of. . . . An idea of the plan may be given in a few words. To make soundings of the Lake was the premier step–this determined, 6 or 8 buoys of logs or buoys of barrels connected by rope in a straight line and separated at regular distances of 30 or 40 feet. The two extreme or outward buoys were to have ropes descending to the bed of the lake with massive pieces of rock to moor the whole of the apparatus. From each of the central buoys a rope was to be attached and dropped at different depths; at the end of each, a piece of link chain to hold the rock, which was to be baited either with meat or a large fish. The hooks would weigh from two to five pounds. These chains of buoys were to be placed in different parts of the lake–and at the spot where the monster had been seen was to be more particularly watched." (GWMSS 2-33 [1], 2-33 [5])

153.

LAKE MAN-I-TOU

Executed ca. 1863–71

Watercolor on paper

11 3/8 x 15 7/8 (28.9 x 40.2);

comp. 5 1/2 x 10 5/8 (13.9 x 26.8)

Intended for inclusion in G. W.'s Indian journals

OV3-84

154.

LAKE MAN-I-TOU. DEVIL'S LAKE

Executed ca. 1863–71

Watercolor on paper

15 1/2 x 11 1/2 (39.4 x 29.1);

comp. 4 x 7 5/8 (10.0 x 19.3)

Inscribed, l.l.: "No 44 Geo Winter"

Similar to Cat. #153; intended for inclusion in

G. W.'s Indian journals

OV3-83a

155.

[LAKE MAN-I-TOU]

Watercolor on paper

15 1/2 x 11 1/2 (39.4 x 29.1);

comp. 2 1/4 x 3 1/8 (5.5 x 7.9)

Composition glued on same sheet as Cat. #154;

image similar to No. 153

OV3-83b

156.

**DEVIL'S LAKE NEAR ROCHESTER
IND–1839**

Graphite on paper

6 3/8 x 7 3/4 (16.2 x 19.6)

A-11

157.

**LAKE MAN I TOU NEAR
ROCHESTER INDIANA 1839**

Graphite on paper

6 3/8 x 7 3/4 (16.2 x 19.6)

A-12

158.

**LAKE MAN-I-TOU. EASTERN
EXTREMITY OR INLET. 1839**

Graphite on paper

7 3/4 x 12 3/4 (19.5 x 32.3)

Same vantage point as Cat. #153

A-13

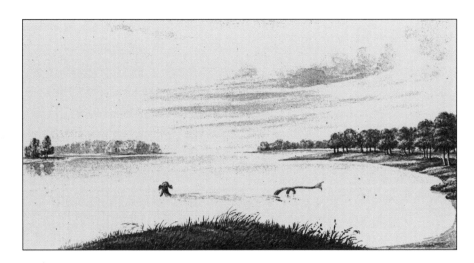

(156) "[T]he physical character of Lake *Manitou* answers not to such terrible picturesque qualities with which the *fancy or the imaginative* might *invest* it. The lake is one of pleasing quiet placidity of aspect. The banks that surround it *rise* but in slight elevations–and gentle grassy slopes run to its waters, dotted here and there by clusters of trees of rather dwarfish characteristics–not claiming to be called majestic oaks. Though here and there old burly trees with outstretching gaunt limbs–casting ample shadows from the massive cresents of foliage–Stand as watchful sentinels over the clear waters of the lake." (GWMSS 2-33 [6])

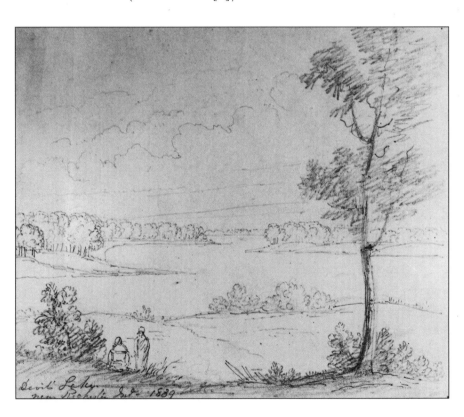

MIAMIS, EARLY 1840s

"It was not unfrequently that some of the Miamies came to Logansport to buy goods at Ewing's Trading establishment which stood diagonally to 'The Washington Hall', then kept by our old friend Capt. C. Vigus....

I never succeeded very well in making many sketches among the Miami people. They were so superstitious, that I was an object of terror among them....

My success in obtaining likenesses of the Pottawattami people lead me to much disappointment in the absence of it among the Miamies.

At Peru, at the trading houses of Chief Francis Godfroy, Berthelet & Avilines, I secured by *stealth* many sketches of the Miamies by which means only I could obtain them, as the Miami people entertained a superstitious dread of having their likenesses delineated....

While the Miamies set up some superior claims over the Pottawattamis, which perhaps was more from the arrogant pretentions of possessing more wealth in lands–they being a better sort of a *well to do* people–they yet retaining a large reservation of lands, known as the 'Miami Reservation'–yet in point of *intellectual* elevation, it was of a baseless foundation."
(GWMSS 2-9 [1], 1-17 [38c], 2-39 [1], 2-5 [10])

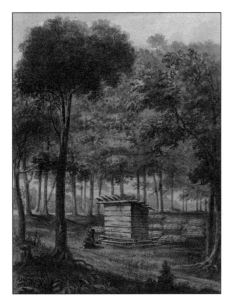

159. (see Plate 49)
CAPT FLOWERS GRAVE
Observed 1837; executed ca. 1863–71
Watercolor on paper
12 1/8 x 10 1/4 (30.7 x 25.8);
comp. 7 5/8 x 5 3/4 (19.1 x 14.1)
Inscribed, l.c.: "No 12"
Intended for inclusion in G. W.'s Indian journals
M-75

160.
CAPTAIN FLOWERS' GRAVE 1837
Graphite on paper
5 3/4 x 4 1/2 (14.4 x 11.2)
Similar to Cat. #159
G-455

161. (see Plate 12)
MIAMI INDIAN GIRL
Observed 1839; executed ca. 1863–71
Watercolor on paper
14 3/4 x 11 5/8 (37.3 x 29.5)
Inscribed, l.c.: "No 26"
Possibly intended for inclusion in G. W.'s Indian journals
M-79

162.
INDIANA. SEPTR 1839
Ink and graphite on paper
9 7/8 x 7 7/8 (24.8 x 19.8)
Seated girl with horse; similar to Cat. #161
G-388

163.
WABASH RIVER–NEAR TIPTONS HOUSE. 184[1?]
Graphite on paper
5 7/8 x 8 5/8 (14.8 x 21.8)
Three figures on wooded riverbank
G-390

(159) "The Miamis were frequently visitors to the vicinity of Logansport, for the purpose of paying a reverential tribute to the memory of the dead as there was, but a few rods distance from the south section of the bridge, which immediately lead to '*The National Reservation*', an extensive indian burial ground, which was an attraction to the curious traveller, as he was passing through this new and undeveloped country.

No doubt but what this repository of the aboriginal dead was mostly confined to the indians who died at the village of Ke-na-pa-cum-a-qua, which stood on the north bank of the Eel River, some six miles above the confluence with the Wabash. . . .

The Miami burial ground near Logansport contained the remains of the renowned chief and warrior No-ka-me-nah, or as he was more familiarly called, Capt. Flowers. The graves were generally covered with bark. The Chief's [grave] loomed up above all others of greater consequence. It was rudely constructed of logs, within which was placed a pine box, or che-pe-em-kak, protecting the remains. The Chief's rifle, tin cup, powder horn and other relics were deposited so that the Spirit might carry along with it, in its flight, the chosen earthly objects, to the beautiful world of the future hunting ground. . . .

It was a painful fact, on which no doubt rested, that the grave of No-ka-me-nah did not rest long after burial in a peaceful repose. It was a good rifle that was consigned to the grave with the chief, but the enterprising *Christian* man had soon possession of it; and many a deer has fallen since, at its sharp crack–and the venison sold for fifty cents pr Saddle, proving satisfactorily that the violation of a redman's grave, was a pecuniary gain.

But why should we *underrate* moral acts? Stealing from an indian grave is after all but a Whiteman's 'smart' trick of trade!" (GWMSS 2-9 [1])

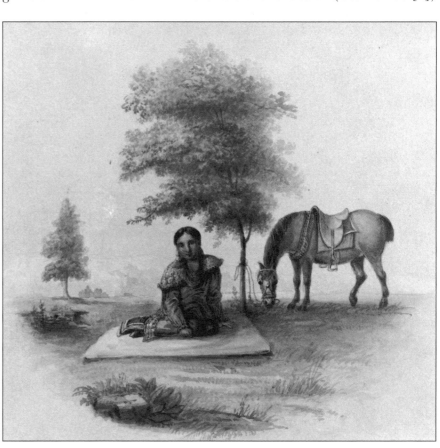

164.
Miami squaws–Peru
May 1843
Graphite on paper
9 1/2 x 6 (24.2 x 15.3)
G-395

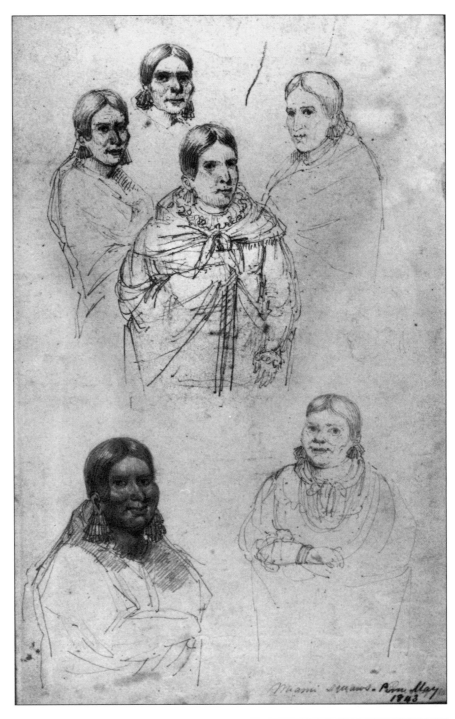

165.
A Miami woman
Graphite on paper
9 5/8 x 5 7/8 (24.4 x 14.9)
OV-395a

166.
A Miami Indian
Graphite on paper
8 x 6 (20.2 x 15.0)
G-375

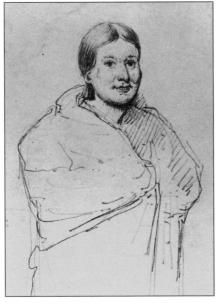

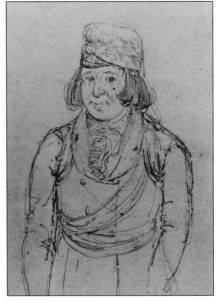

167.

SKETCHED AT PERU INDA. 1843

Graphite on paper

8 3/8 x 7 (21.2 x 17.6)

Inscribed, center left: "Sack-hum. a Miami."

center right: "Capt. Squirrel."

l.r.: "Pee-waw-pay–a Miami."

G-399

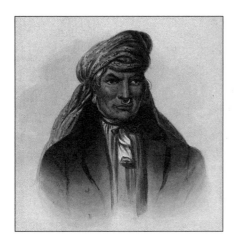

168. (see Plate 50)

PEE WAW-PAY

Executed ca. 1863–71

Watercolor and ink on paper

12 5/8 x 11 1/2 (31.9 x 29.1)

Inscribed, l.c.: "Looks like Capt Squirrel No 9"

Possibly intended for inclusion in G. W.'s

Indian journals

M-56

169.

[MAN WITH NOSE RING]

Graphite on paper, lined on verso

4 5/8 x 3 5/8 (11.5 x 9.3)

Similar to Cat. #168

G-429

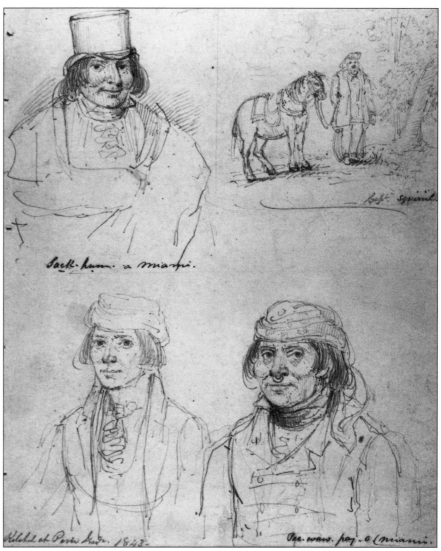

170.
POTTAWATTAMIS MIAMI WOMEN. PERU. 1843

Graphite on paper
9 1/8 x 5 3/4 (23.1 x 14.3)
Inscribed, center: "Saw-ney."
l.r.: "Charley's Widow"
G-398

171.
PERU MAY 27TH 1843

Graphite and ink on paper
8 1/2 x 6 7/8 (21.6 x 17.6)
G-392

172.
PERU MAY 29TH 1843

Graphite on paper
4 1/4 x 7 (10.7 x 17.7)
G-393

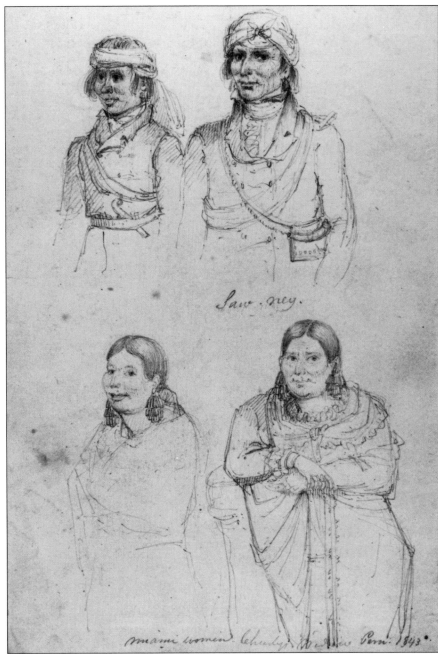

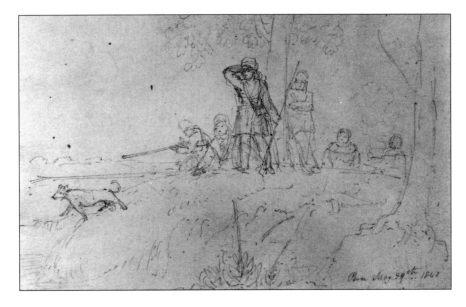

173.
PERU MAY 30TH 1843
Graphite on paper
4 3/8 x 7 (10.9 x 17.7)
G-394

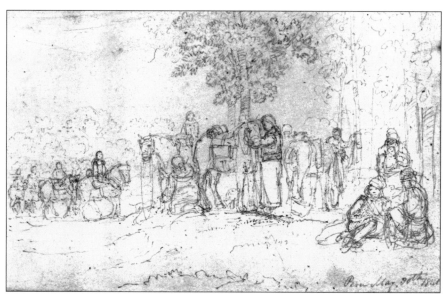

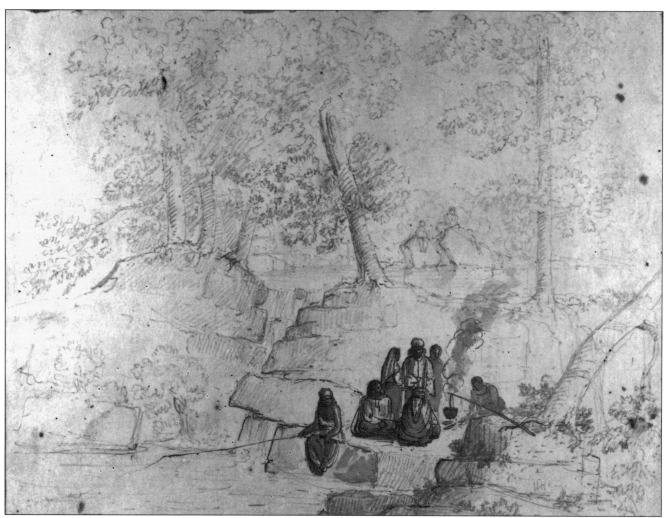

174.
MIAMI INDIANS. SEPTR 1843
Graphite, ink, and wash on paper
6 7/8 x 8 1/2 (17.5 x 21.4)
G-397

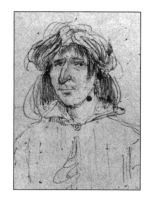

175.
WASH-SHING. A MIAMI
Graphite on paper
4 1/8 x 2 5/8 (10.3 x 6.7)
G-415

176.
[TWO FIGURES WITH HORSES]
Graphite on paper
11 3/8 x 9 1/8 (29.0 x 23.1)
Man riding horse resembles "Wash-shing" in
Cat. #175
G-416

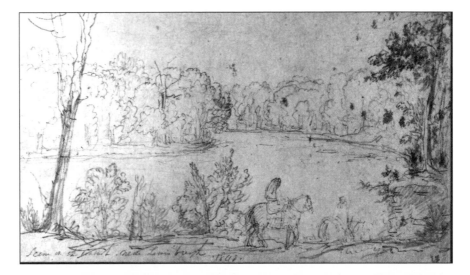

177.
SCENE ON THE WABASH–
NEAR LEWISBURGH 1848
Graphite on paper
4 7/8 x 8 1/8 (12.4 x 20.4)
G-413

178. *(see Plate 51)*
[FAMILY RIDING HORSES NEAR
LAKE]
Watercolor on paper
2 1/4 x 3 1/4 (5.7 x 8.2)
L-37

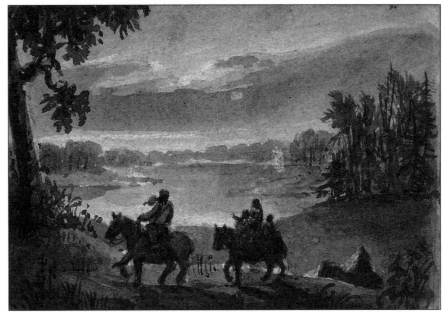

179.
[COUPLE RIDING HORSES NEAR
LAKE]
Executed ca. 1863–71
Watercolor on paper
6 7/8 x 11 1/4 (17.3 x 28.5);
comp. 5 1/2 x 10 (13.9 x 25.3)
Similar to Cat. #178
Possibly intended for inclusion in G. W.'s
Indian journals
L-47

180. *(see Plate 52)*
A MIAMI INDIAN.
CALLED KEN-TUCK
Watercolor and ink on paper
10 1/2 x 7 5/8 (26.8 x 19.3)
Inscribed, l.c.: "Said to be a white man by birth,
and taken Captive when a child"
l.l.: "No 43 Geo Winter"
L-40

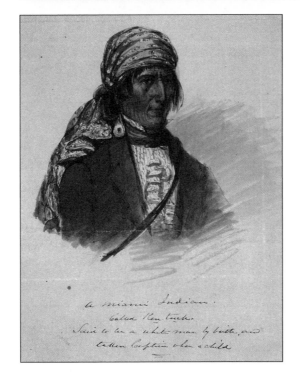

COMPOSITIONAL SKETCHES WITH INDIAN FIGURES

"I need not say that so engaging a subject of aboriginal life, to the artist's mind, my pencil has been much directed to; I have had my mind filled with plans for illustrating it in various ways. But like many of the schemes of life, which we are all apt to dwell upon, yet do not always find the *facilities* to embody them forth and have had to forgo them for the present. Yet, I often feel gratified in knowing, that I have recorded upon canvas, many a face, form, and idea, that but for my fortuitous position, would have had no palpable existance. I have also collected some facts, and traditions, and little histories of the events I have had opportunities to observe and sometimes indulge in the idea of expanding the thoughts at some leisure time, as a pleasing, and rational recreation." (GWMSS 1-15 [15])

181.
[MAN WITH HORSE]
Graphite on paper
4 1/2 x 6 1/2 (11.2 x 16.3)
G-404

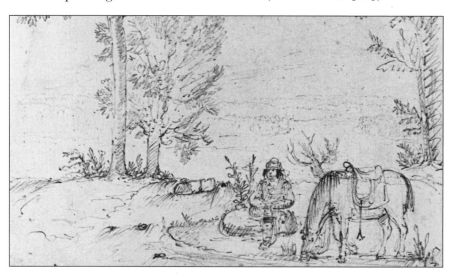

182.
[GROUP RESTING]
Graphite on paper
4 1/2 x 6 1/2 (11.2 x 16.4)
G-402

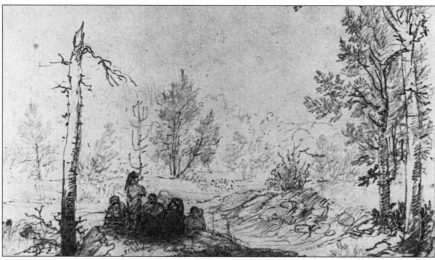

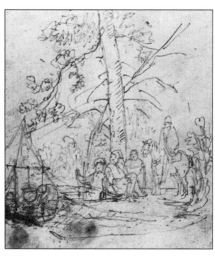

183.
[CAMP SCENE]
Graphite on paper
3 7/8 x 3 1/2 (9.8 x 8.9)
G-435

(183) Notice of Winter's distribution of paintings, Lafayette, 11 November 1852:

"'Indian Encampment.' This painting is characterized by its mellowness and delicacy of touch. An Indian Encampment gives interest to the scene. An elm tree in the centre shades the group–a bright light advances to the rugged foreground."

184.
[CAMP SCENE]
Graphite on paper
4 3/8 x 6 1/2 (11.1 x 16.3)
G-403

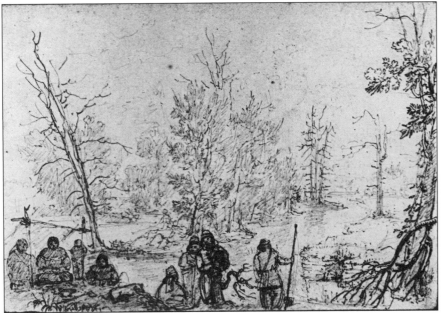

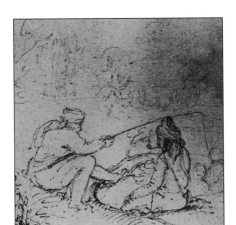

185.
[MEN FISHING]
Graphite on paper
4 1/2 x 3 1/4 (11.2 x 8.3)
G-410

(187) Notice of Winter's distribution of paintings, Lafayette, 12 March 1859:

"'The Leafy Season.' A large painting–an original design, conveying a pleasing sense of an undulating country. In the distance a soft sunny effect is observable,–contrasted with the middle land of heavy timber in sombre shade. Cascades descend the hill sides into the reservoir or head water, which sweep divergingly into channels. An Indian sits upon a rock–near him a squaw is in the act of dipping a gourd into the rushing water. In the foreground stand noble oaks, upon a broken wall of masonry."

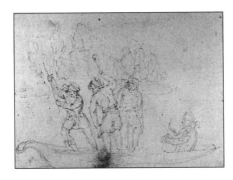

186.
[FOUR MEN IN BOAT]
Graphite on paper
3 1/4 x 4 1/2 (8.2 x 11.3)
G-409

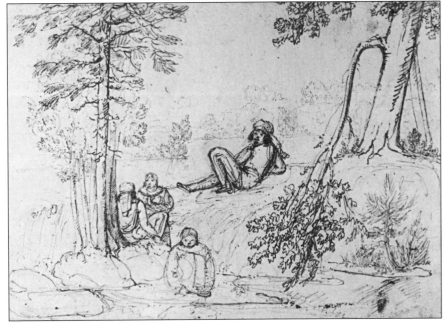

187.
[GROUP ON ROCKY BANK]
Graphite on paper
6 5/8 x 8 7/8 (16.6 x 22.5)
G-412

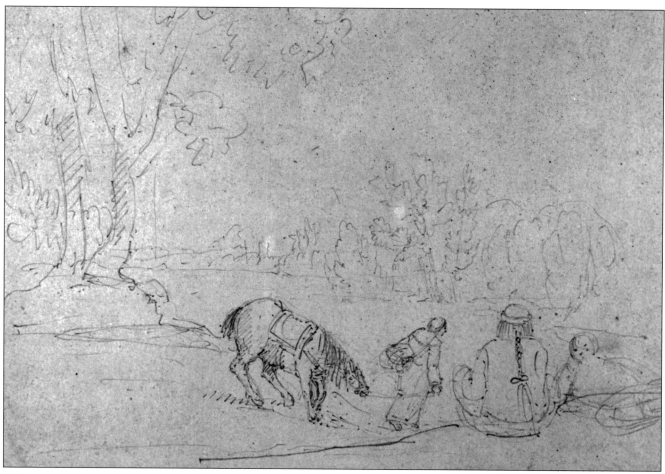

188.
[WOMAN LEADING HORSE]
Graphite on paper
6 5/8 x 8 7/8 (16.6 x 22.5)
On verso of Cat. #187
G-412v

189.
[CAMP SCENE ON RIVERBANK]
Graphite on laid paper;
watermark "PARSONS CO. HOLYOKE"
4 1/8 x 7 7/8 (10.3 x 19.9)
Outline drawing of object on verso
(possibly cross section of picture frame)
G-423

190.
[CAMP SCENE AND EQUESTRIANS NEAR LAKE]
Graphite on paper
3 1/8 x 5 1/8 (7.7 x 13.0)
F-285

SMALL CAMP SCENES

Notice of Winter's distribution of paintings, Lafayette, 16 March 1854:

"'Indian Wigwam.' An aboriginal group camped upon the banks of the Upper Wabash–giving a faithful delineation of the Indian character. The tints of Autumn give a variety of color to this painting;–pleasing perspective view. Foreground enriched by fallen timber and profusion of tangled weed."

191.
[CAMP SCENE WITH HORSES NEAR LAKE]
Graphite on paper
3 7/8 x 9 7/8 (9.7 x 24.9)
G-426

192.
[CAMP SCENE WITH WOMEN PLAYING CARDS, BOAT ON WATER, AND EQUESTRIANS]
Graphite on paper
8 5/8 x 11 7/8 (21.8 x 29.9)
Contains figures and elements similar to Cat. #69, 177, and 198
G-353

193.
[CAMP SCENE]
Ink and graphite on paper
7 3/4 x 5 (19.6 x 12.6)
Diagram for trousers leg on lower half of sheet
G-436

OTHER SMALL SCENES

194.
[CAMP SCENE]
Graphite on paper
5 7/8 x 9 5/8 (14.7 x 24.2)
G-425

195.
[CAMP SCENE]
Graphite on paper
9 5/8 x 11 5/8 (24.4 x 29.6)
G-424

196.
[CAMP SCENE]
Graphite and ink on paper
1 5/8 x 2 5/8 (4.0 x 6.6)
Sheet cut in two; on verso of Cat. #218 and 219
L-22v, L-23v

197.
[THREE FIGURES SEATED AROUND TREE]
Graphite on paper
4 1/2 x 3 1/4 (11.2 x 8.1)
Similar to seated group in Cat. #183
G-408

198.
[SEATED GROUP WITH BOAT ON WATER]
Graphite on paper
3 1/4 x 4 3/8 (8.2 x 11.1)
G-407

199.
[FIGURES ON ROCK, BOAT ON WATER]
Graphite on paper
3 1/2 x 4 1/4 (8.7 x 10.8)
Rough landscape on verso
A-25

200.
[FAMILY CROSSING STREAM ON FALLEN LOG]
Graphite on paper
3 3/8 x 4 3/8 (8.3 x 11.2)
G-411

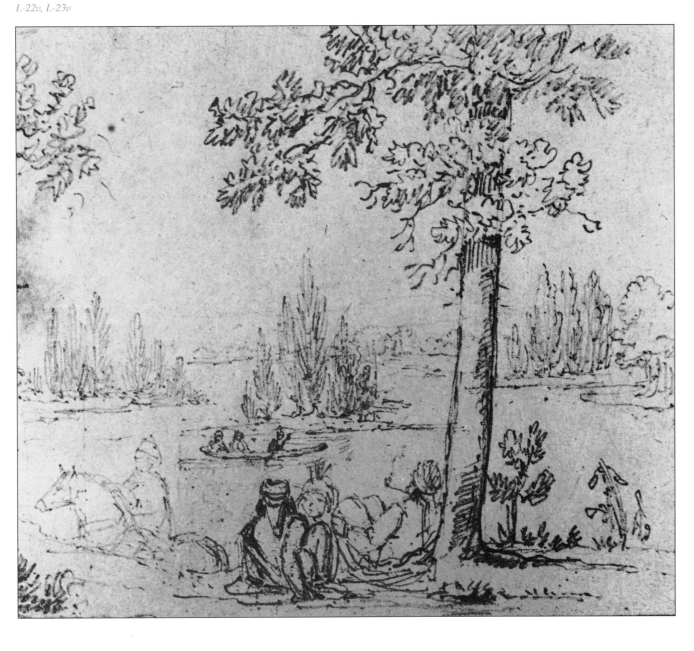





201.

[WOMAN CARRYING BABY, CROSS-
ING STREAM ON FALLEN LOG]

Graphite on paper

5 1/8 x 6 5/8 (13.0 x 16.8)

H-543

202.

[THREE FIGURES]

Graphite on lined blue paper

2 3/4 x 3 7/8 (6.7 x 9.7)

G-442

203.

[THREE FIGURES]

Graphite and ink on paper

1 3/4 x 3 3/4 (4.4 x 9.5)

Inscribed, verso: list of women's surnames

G-440

204.

[TWO SEATED FIGURES]

Graphite on lined blue paper

2 1/4 x 5 3/8 (5.6 x 13.6)

G-430

205.

SQUAW AND PONY

Graphite on lined paper

4 1/8 x 3 (10.3 x 7.6)

G-446

206.

[WOMEN WITH HORSES]

Graphite on paper

4 1/2 x 3 3/8 (11.2 x 8.3)

G-445

207.

[GROUP WITH HORSES]

Graphite on paper

8 1/2 x 7 (21.5 x 17.6)

G-396

208.

[GROUP WITH HORSES]

Graphite on paper

2 7/8 x 2 3/4 (7.2 x 6.7)

G-441

209.

[GROUP WITH HORSES]

Graphite on paper

2 x 2 3/8 (4.9 x 6.0)

G-439

210.

[MOUNTED FIGURE]

Graphite on blue paper, lined on verso

2 1/2 x 4 (6.3 x 10.0)

G-421

(205) Notice of Winter's distribution of paintings, Lafayette, 7 January 1860:

"'Squaw and Pony.' An aboriginal woman leading her pony down a declivity. A broken bank with overhanging trees."

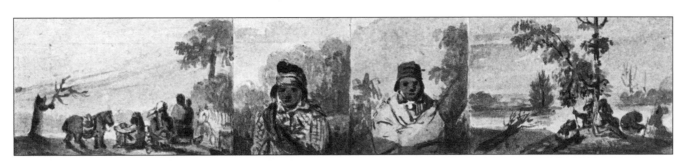

211.
[MULTIPLE COMPOSITION WITH FIGURES]
Watercolor on paper
1 3/8 x 6 1/8 (3.2 x 15.3)
L-36

(211) Notice for Winter's distribution of paintings, Lafayette, 7 January 1860:

"'Indian Group.' An Indian lounges carelessly upon a log–Squaw and papoose sit beside him; two ponies near with an appropriate back ground."

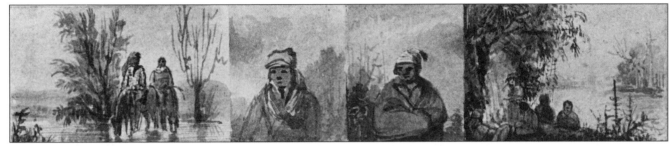

212.
[MULTIPLE COMPOSITION WITH FIGURES]
Watercolor on paper
1 1/4 x 6 (3.2 x 15.1)
L-27

213.
[MULTIPLE COMPOSITION WITH FIGURES]
Watercolor on paper
2 1/8 x 3 1/4 (5.2 x 8.0)
L-25

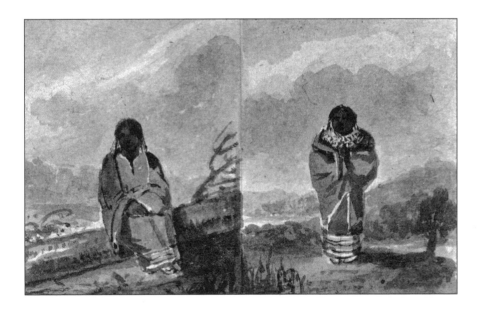

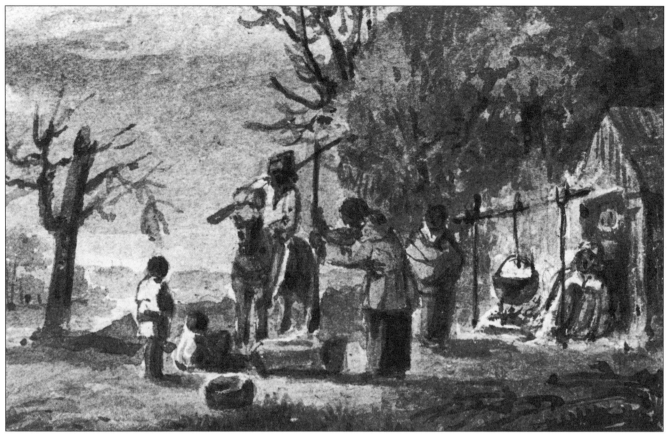

214.
[CAMP SCENE WITH WOMAN POUNDING GRAIN]
Watercolor on paper
2 x 3 1/4 (5.1 x 8.2)
Similar to Cat. #83 and 84
L-35

215.
[MAN WITH STAFF AND ROACH]
Watercolor on paper
1 1/2 x 1 3/8 (3.8 x 3.3)
Similar to Cat. #97 (Kaw-kawk-kay)
L-32

216.
[MAN WITH ROACH]
Watercolor on paper
1 5/8 x 1 3/8 (4.0 x 3.3)
L-28

217.
[MAN WITH TURBAN]
Watercolor on paper
1 5/8 x 1 3/8 (4.1 x 3.4)
Similar to Cat. #26 (I-o-wah)
L-30

218.
[MAN WITH RED TURBAN]
Watercolor on paper
1 5/8 x 1 3/8 (4.0 x 3.3)
Similar to Cat. #75 (No-taw-kah);
portion of camp scene (Cat. #196) on verso
L-22

219.
[MAN WITH PATTERNED TURBAN AND RED SASH]
Watercolor on paper
1 5/8 x 1 3/8 (4.0 x 3.3)
Portion of camp scene (Cat. #196) on verso
L-23

220.
[MAN WITH CAPED COAT]
Watercolor on paper
1 5/8 x 1 3/8 (4.0 x 3.4)
Similar to Cat. #62 (O-ga-maus)
L-29

221.
[WOMAN WEARING CAPE WITH
BROOCHES]
Watercolor on paper
1 5/8 x 1 3/8 (3.9 x 3.2)
Similar to Cat. #57 (D-mouche-kee-kee-awh)
L-31

222.
[LANDSCAPE WITH TWO MOUNTED
FIGURES]
Watercolor on paper
1 7/8 x 2 5/8 (4.5 x 6.4)
L-26

223.
[LANDSCAPE WITH THREE
MOUNTED FIGURES]
Watercolor on paper
1 1/8 x 1 3/8 (2.6 x 3.3)
L-34

224.
[LANDSCAPE WITH FOUR
MOUNTED FIGURES]
Watercolor on paper
1 1/8 x 1 3/8 (2.6 x 3.4)
L-33

225.
[GROUP WITH HORSES]
Watercolor on paper
2 1/4 x 3 1/4 (5.7 x 8.2)
L-24

226.
INDIAN CHIEF–EXPLAINING TO HIS
SONS THE PECULIARITY–OF THE
COMPASS PLANT
Ink on grey paper
8 x 10 1/8 (20.3 x 25.6)
G-451

227.
[MAN CARRYING BUNDLE ON
BACK]
Graphite on paper;
embossed seal showing steamship with rigging
9 7/8 x 7 7/8 (24.8 x 19.8)
Inscribed, l.c.: "In the silence of the midnight I
journey with the dead in the darkness of the forest
boughs, –Slowly doth I tread."
G-427

228.
[MAN WEARING BLANKET]
Graphite on paper
10 1/2 x 6 3/8 (26.5 x 16.1)
Several unrelated inscriptions on sheet
G-450

229.
[MOUNTED FIGURE, DEER]
Ink and graphite on lined paper
1 7/8 x 3 7/8 (4.8 x 9.8)
Rough studies of deer, horse, landscape on verso
G-447

230.
[BATTLE SCENE WITH FOUR
INDIANS]
Ink on lined paper;
embossed seal "Southworth Co. Superfine"
9 3/4 x 7 3/4 (24.7 x 19.7)
G-449

231.
[TWO MEN PLAYING LACROSSE]
Ink on cardstock
2 3/4 x 1 1/2 (6.9 x 3.7)
G-448

232.
[MAN WITH ARM RAISED]
Ink and graphite on card with gilt border
4 1/8 x 2 1/2 (10.4 x 6.2)
Printed inscription on verso reads: "Wm. Everden,
Photographer, No. 89 Main Street, Lafayette, Ind."
G-414

IDENTIFIED
LANDSCAPES

"The magnificence of natures varied works invites the lover of the beauties of creation to contemplate the glory, wisdom, and power of that hand which has stamped divinity upon everything; and as we wander amidst the splendour of the scenes that inspire our admiration, our love and gratitude to our Creator are deeply awakened and felt. The simplest of created objects are worthy our attention–thus we love to cull a flower by the road side, or mount the rocky cliffs–to seek their fossil riches which have been embedded by the mysterious operations of nature for centuries.

. . . I love to quit the public road and gain the summit of some friendly eminence and take a retrospective view of the outspreading scene that we have travelled over. . . .

. . . Thanks to the Almighty for giving me capacity to enjoy such a scene. Why do not every body cultivate a taste for the sublimates of God's works? I believe there is *more religious feeling experienced* where the heart is gladdened by the inspiring influences which the magnificent scenes of nature exert, than under the excitement of *long* and *ranting* prayers."
(GWMSS 1-1 [7], 2-29 [1])

SCENES NEAR LOGANSPORT, INDIANA, 1837–1849

"In the year 1837, Logansport did not contain a population exceeding 1,000 inhabitants. Its locality possessed very many natural beauties; the river views were picturesquely charming, being dotted with many thrifty islands. There was one that existed close to the confluence of Eel River with the Wabash—that, and some four others within a mile, *extending eastward* up to *Genl. Tipton's old homestead*—have totally disappeared through the influence of greater volumes of water passing through the channel of the river, being the result of the cleaning up of the country around, and the removal of the obstructions of the creeks and runs, that are tributary to the Wabash.

There were not then any bridges spanning either the river Eel, or Wabash. In this year the abutments were built, and the framing of the bridge accross the Wabash. . . . The Canal was yet incomplete to this point.

The town though unpretentious, and *frontieresque* in character, had many good stores—and certainly many very pleasant homes. Being situated between the two rivers, whose banks were fringed by the forest timber, we could but feel a secret charm in the *rudimental* condition of the future city. . . .

. . . 'The National Reservation', on the south side of the Wabash, was then an unbroken forest. It was the great Reserve of the *Miamies*. The northern side of the river, embraced lands through which the Michigan Road continued to the lake. It was nothing more than an avenue cut through the forest—barren, and prairie lands, showing but limited cultivation of the soil." (GWMSS 1-2)

WABASH AND EEL RIVER SCENES, BIDDLE'S ISLAND

Winter prepared three collections of his works in the form of "journals," which combined written narratives illustrated with watercolor paintings. These included the account of his visit to Deaf Man's Village, his "Indian Journals," and a volume entitled "Views of Biddle's Island, by George Winter." The latter, which is in the possession of the Cass County Historical Society, Logansport, Indiana, was commissioned by Winter's friend Judge Horace P. Biddle, who lived on this Wabash River island near Logansport. Although Biddle commissioned the volume in 1872, the watercolor illustrations were based on pencil drawings from 1837, included in the following series.

"At the time that these accompanying drawings of Biddle's Island were first sketched, the residence of the present occupant–The Honbl. H. P. Biddle–was the early home in the Wabash valley of the late venerable Dr. John Gitle. It was afterwards occupied by Spear S. Tipton, the son of Genl. John Tipton, and subsequently a short time preceeding the purchase of the Island by Judge Biddle, it was the residence of the younger son of Ge[n]l Tipton–George Tipton, Esqr." (GWMSS 2-5 [9])

Horace P. Biddle, Island Home [Logansport, Indiana], to G. W., 4 March and 25 March 1872:

"I give you hereby a commission to get me up a series of drawings in water colors, of the Island, to be left to your own taste and judgement as to number style &c &c, only limiting the whole work to one hundred dollars. Let the description of the points dates &c &c be full and clear, and leave some three or six blank pages in the beginning of the book for the history of the Island. . . . I suppose the work ought to have a tittle page–something like this–'Pen and Pencil Sketches of Biddle's Island, By George–&c'." (GWMSS 1-24 [3], 1-24 [6])

233.
**DISTANT VIEW OF LOGANSPORT
SEPT 14TH 1841**

Graphite on paper
7 x 8 5/8 (17.6 x 21.7)
Foliage studies on verso
A-21

(233) "At the confluence of the rivers, there was the foundation of a mill–and large hewed massive timber there were betrothed to corroding time–to waste away and *rot.* On turning from this dark mass of unused timbers, and following along the banks of the Wabash, and thence a few rods westward upon the travelled road–you would arrive in close vicinity to the old log cabin of the famous and venerable Indian Interpreter Joseph Barron.

Then by a military manouver of 'right about', the scene depicted in the accompanying drawing would greet the vision.

You would be within the shadows of noble and giant elms with outspreading branches in their richly laden foliage bending to the stream. Biddle's island from this point forms the centre of the scene. The northern and southern banks of the river run in converging lines in the point of distance. The small island observable, is just above where the Eel river sweeps along into the Wabash. . . .

From our present point of view, we discover the incipient condition of the northern section of the Wabash bridge–and it will be observed, that there is no abutment yet indicated on the southern *channel.*

The completion of *that* section was the rendering of the connecting link of the thoroughfare of the well known 'Michigan Road', north of Logansport, and south of it leading to Indianapolis the Capital of the State of Indiana. . . .

On the southern bank, which is to the right in the drawing, is the northwest boundary line of the 'Great National Miami Reservation'." (GWMSS 2-5 [1]) [This manuscript was written to accompany a view of this scene as it appeared in 1837, an image not extant in the TCHA collection.]

234.
**WABASH RIVER NEAR
LOGANSPORT 1837**

Graphite on paper
8 7/8 x 13 (22.3 x 33.0)
A-8

(234) "On following up the road to Tipton's and passing the scene of [image number 240] . . . the Wabash continues to reveal her many charms. The water is low and translucent, and images the wooded banks, giving a mirrored life to the scenes. . . .

This scene was among the many that became inviting to the pencil. We rest here at 'Echo Point'–so named by the artist from the circumstance that at [the] point where the closely chipped stump is depicted was the spot where we have often saluted the forest accross the river–which sometimes *echoed* back to the ear more than was enunciated by the questioning voice.

The eye is now turned from the east making the backward gaze towards Logansport. Biddle's Island is the most distant one–with the remote northern bank continuously running from our stand point to the remotest distance curving gracefully–apparently around the Island. . . . The Island that rests in the centre of the Wabash is striking for its eliptical conformation and its thrifty young sycamore trees that cluster so luxuriantly.

The *jutting point* to the left in the scene, in a line with this island, is a partial visible portion of another small island eastward–it is apparently cut off by the oak tree that stands upon the foreground in this scene. This little island is the fifth one above the confluence of the Eel River with the Wabash. They dot the river and diversify it–and in the fruition of the leafy season when the stream is low, and free from sedimentary disturbance, the glassy surface, with the reflected surroundings, gives a fairy like landscape, where sprites may love to dwell.

Here before us, is a scene where no evidence of civilization appears, save in the prostrate trunk in the foreground–the work of the axe. The red people–the Miamis–(1837) still occupy the great National Reservation accross the river." (GWMSS 2-5 [6])

235.
ON THE WABASH–NEAR LOGANSPORT SEPTR 4TH 1837

Graphite on paper
6 3/4 x 10 5/8 (17.2 x 26.9)
A-5

236.
SCENE ON THE WABASH NEAR LOGANSPORT INDIA. 1837

Graphite on paper
7 x 8 1/2 (17.8 x 21.5)
Vantage point similar to Cat. #233
A-7

(235) "The outsweeping river as viewed from this extreme point of Biddie's island includes the *'old ford'*–commonly found by emigrants to the valley of the 'Upper Wabash'. It was also [the] common *water road* used by the early settlers of the town of Logansport before the bridges were built.

The remote distance in this scene extends beyond the stately elms that cluster upon the bank near Barron's Log–The same point from which the sketch [image number 233] was made . . . which indicated the incipient condition of the northern section of the bridge.

The group Fording as depicted in this drawing represents the white 'bow topped' wagon of the pioneer, followed by a train of cattle, forms one of these picturesque scenes that are ever attractive to the artist's eye.

The cluster of partially submerged branches and tree drift, rests upon the bed of the river and laved by the shallow water–and the few fragments of rock rising above the surface make gentle ripples, indicative of the current of the stream. . . .

The Island and the wooded banks of the Wabash were now in their primeval condition–no visible inroad of civilized hand of industry comes within the scope of vision from this part of Biddle's Island." (GWMSS 2-5 [2])

237.

**VIEW OF THE WABASH BRIDGE
LOGANSPORT INDIANA 1837**

Graphite on paper
6 x 7 3/4 (15.2 x 19.7)
A-6

238.

**SCENE ON THE WABASH NEAR
LOGANSPORT. INDIANA–1839**

Graphite on paper
8 3/4 x 13 (22.1 x 32.8)
*Vantage point similar to Cat. #233, looking slightly
more toward the northern channel of the Wabash*
A-15

(237) "This sketch was made in the autumn of the year 1837.... The bridge now presents in this pleasant view, its full completion.

To obtain the position necessary to this view of the Wabash, we must seek *'The Point'*–so beautifully wooded with forest trees–at the confluence of the sprightly Eel with the Wabash.

What magnificent trees stood there.... Time has wrought its changes–the clay bank has yielded to the constant washings–the noble trees have been *undermined*, and have disappeared–barrenness and desolation now meet the eye where once they stood in their pride.

The river is represented as clear, translucent, gently flowing–and in a low state. The rocky bed is exposed to the gaze. By passing the beaten slope at the Point, the position was easily obtained–the rocky surface extends as observable in the drawing, to the centre of what might be properly designated the north channel....

The 'Biddle Island', as shown in this drawing is but partially portrayed–the north western side and *point* only coming within the range of vision.

Logansport is located on the opposite side of the Wabash. The bridge was yet but a passage way from the Island to the town–the *southern section* being yet incomplete.

The 'old ford' was yet the great thoroughfare used by the Pioneer settler whose white topped bowed wagon, with his cattle in slow line of march following in procession, might be daily seen crossing this lovely river, yet in its pride and 'untamed existance'." (GWMSS 2-5 [3])

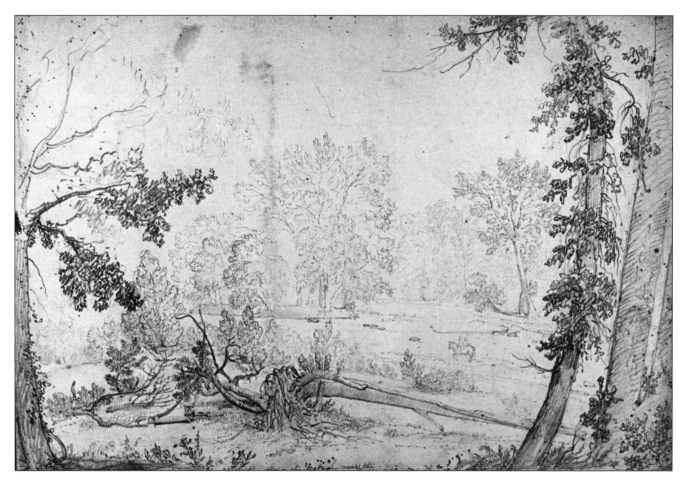

239.

**SCENE ON THE WABASH NEAR
THE INDIAN NATIONAL RESERVE**

Graphite on paper
8 1/8 x 12 1/8 (20.7 x 30.8)
A-36

(239) G. W., "Sketches of Logansport, No. 1.," *Logansport Telegraph,*
2 October 1841:

"The sprightly Wabash was low (July) and its rocky bed was occa-
sionally visible, yet it flowed wildly on. The river is a clear and rushing
stream, dotted by small islands–which threw their images upon the glassy
surface. It was a mixed scene that presented itself to the eye, combining the
wild with the partial markings of civilization: on the southern side of the
Wabash is the great Miami Reservation, known for its unsurpassed excel-
lence of soil and valuable timber. It is a noble but *Fated* forest, and the sound
of the axe has already reverberated in its shady recesses." (GWMSS 1-7 [6])

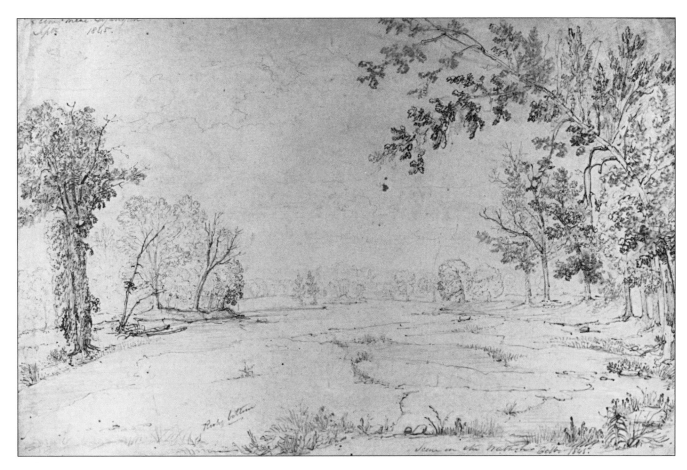

240.
SCENE ON THE WABASH
OCTR–1845
Graphite on paper
8 1/8 x 12 1/2 (20.4 x 31.7)
Inscribed, l.l.: "Rocky bottom"
u.l.: "Scene near Logansport Septr 1845."
A-32

241.
SCENE ON THE WABASH
Graphite on paper
8 1/4 x 12 1/8 (20.9 x 30.8)
A-37

(240) "A short distance above the bridge that spans the northern Channel this view of the Wabash was obtained.

On looking directly up the road way, to the left in the scene, pleasant and shady with noble forest trees, the eye gazes in the direction of the locality of the well known fishing traps in close vicinity to Tipton's. . . .

The tone of the foliage of the wooded banks indicates in the accompanying drawing, that the *full strength* of the summer season had passed, and the *fall* was coming quickly along. . . .

The rocky bed of the river . . . was the stand-point from which the sketch was made. . . .

Biddle's Island in *this scene* forms the right bank of the Wabash, though but the eastern portion of it is seen. The sycamore inclining over the low receding bank, and the noble *twin elms* standing on the gentle rising of the eastern slope, existed for many years. . . .

In the middle distance the island above Biddle's juts out to the centre of the scene, and blends with the timber of the south side and impresses you with the idea of the Wabash from this point, has but one channel of water. But from the Eel River up to, and beyond Tipton's there are many picturesque Islands dividing and diversifying the river.

There is at this point of Biddle's Island some breakers, and a strong current dashes around and between the two islands to the south channel that is bounded by the Great Miami National reservation." (GWMSS 2-5 [8])

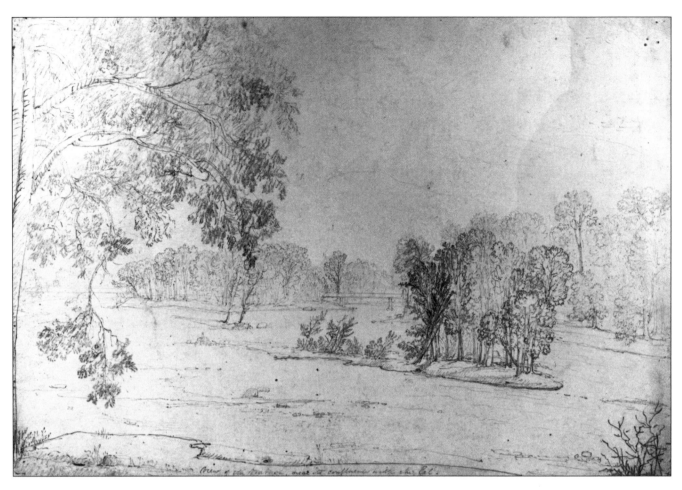

242.

**VIEW OF THE WABASH, NEAR ITS
CONFLUENCE WITH THE EEL**

Graphite on paper
8 3/8 x 12 1/8 (21.0 x 30.7)
Vantage point similar to Cat. #233
A-38

(242) G. W., "Sketches of Logansport, No. 1.," *Logansport Telegraph,*
2 October 1841:

"The bridge is formed of two spans of about 60 ft. each, neither of
which until recently had a central pier as an auxiliary support. An abut-
ment of each span rests upon either side of the island which nearly equally
divides the river. This, therefore, may be considered as a connecting link to
the great central avenue of the state–the Michigan road. The bridge was
built by Messrs. Town & Peck, it cost $25,000. The design is well known as
Town's–the sides of the bridge being made of cross pieces of plank bolted
together forming, as it has been graphically remarked, Xes. . . .

The view of the river eastwardly has a picturesque charm. Three
islands prettily wooded just developed their outlines through the haize that
hung upon the tree tops." (GWMSS 1-7 [6])

243.

**SCENE ON THE WABASH–NEAR
LOGANSPORT–OCTR 1845**

Graphite on paper
8 1/4 x 12 1/8 (20.8 x 30.7)
View similar to Cat. #242, from vantage point
closer to south (center right) bridge
A-35

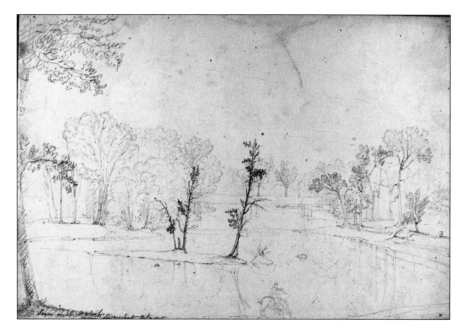

(243) "The Biddle Island in this scene is portrayed from a stand point on the Logansport side–not far from the Ford, and but a few rods distance from Col J. B. Durett's residence.

A few years have changed the picturesque aspect of the Wabash. Now A.D. 1845 we witness in this scene the effects of the partial clearing up the country, and the agricultural advancements since the Pottawattamies emigrated west of the Mississippi 1838. The clearing up of the country has had a striking effect upon the affluents of the Wabash–the beautiful Islands, once so thrifty are beginning to wash away under the influence of the greater volume of water that fills the banks and increased rapidity of the current of the river.

'Biddle's Island', in this scene, is represented nearer to the eye than it is in some of the other accompanying views. In the view [image number 233] . . . , sketched A.D. 1837, the southern section of the bridge had then no foundation laid. In this view the eye looks upon the southern channel of the river which is now spanned by the bridge which forms a picturesque part of this scene. The Wabash now has lost the partial adornment of the little island [to the west of Biddle's]. . . . Of that thrifty island, but a sand bar is left to indicate its original locality. The few slender shafts of sycamore trees stand up in barrenness–and with the few struggling branches retain, notwithstanding in the artistic sense, an important *auxilliary* to the effect of this pleasant scene." (GWMSS 2-5 [7])

244.
[RIVER SCENE WITH MILL]
Graphite on paper
8 5/8 x 15 (21.9 x 38.0)
Inscribed, u.l.: "looks like some mill at Logansport"
B-79

(244) G. W., "Sketches of Logansport, No. 2.," *Logansport Telegraph,* 9 October 1841:

"[T]he eye, in glancing up the river, discovers a good solid bridge built by Willis at the expense of the state; consequently no toll in crossing it is exacted. Above that, is a good substantial acqueduct, which is a connecting link of the Wabash and Erie canal, which is a great outlet for the exportation of the produce of the country to the eastern and southern markets, and which will prove the means of incalculable wealth to this important point. A short distance above the acqueduct, is another free bridge, erected at the expense of some liberal and enterprising citizens. These convenient and necessary superstructures have been thrown across the Eel, within the last three years. On the northern side of the river is the embryo town, known as West Logan, which will doubtless become a thriving place. Preparations have already been made for the erection of a large mill–the race has been completed some time. It runs parallel with one dug at the expense of Gen. John Tipton on the Logansport side of the river. The dam by which these races will receive their streams has been built on a line nearly with bridge st. Lumber may be seen now piled up in large masses, subject to the action of the elements and certain decay. This was 'got out' for the erection of a mill in proximity with the delightful Point." (GWMSS 1-7 [7])

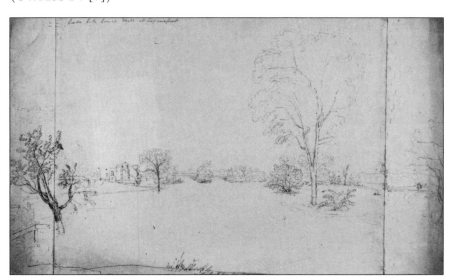

245.

SCENE ON THE WABASH NEAR THE INDIAN NATIONAL RESERVE OCTBR 3RD 1845

Graphite on paper

8 1/8 x 12 1/8 (20.5 x 30.8)

A-33

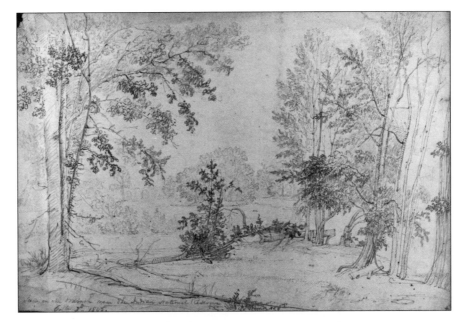

246.

WABASH RIVER NEAR TIPTON'S ISLAND 1846

Graphite on paper

8 1/8 x 12 1/8 (20.5 x 30.7)

A-39

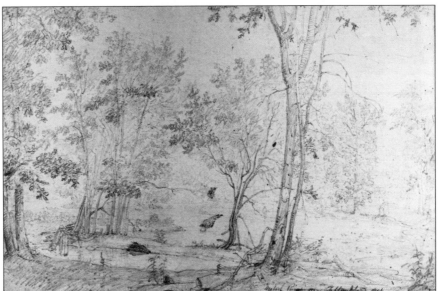

(246) "The completion of the Logansport bridges which cross Biddle's Island was soon found of great public convenience. . . .

On passing from the road which runs accross the Island from bridge to bridge, over the abutment of the southern section of the bridge–a path could be traced around the Island under beautiful groves of soft maples and noble elms. While following around to the south eastern point from which this drawing was made–The oaks and walnuts and Elms upon the Reserve side of the river were found in the highest perfection of vernal growth.

In this drawing, the eye is looking the eastward direction, and the road leading to Tipton's is traceable in the distance–between the bank of the national Reservation and the small island immediately above the point of Biddle's Island.

The Indian Reservation along the river bank appears yet intact."

(GWMSS 2-5 [5])

247.

**VIEW ON THE BANKS OF
THE WABASH RIVER NEAR
SENATOR TIPTON'S RESIDENCE.
JUNE 1ST 1847**

Graphite on paper
8 3/4 x 12 7/8 (22.2 x 32.6)
A-40

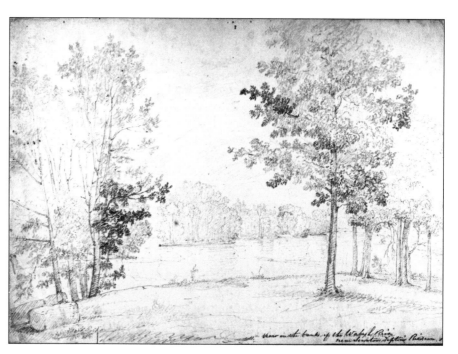

248.

**SPENCER SQUARE LOGANSPORT.
ABOUT 1841**

Graphite on paper
7 x 8 1/2 (17.7 x 21.6)
Inscribed, l.c.: "Cadet Bell's monument."
A-22

249.

[WOODED LANDSCAPE]

Graphite on paper
7 x 8 1/2 (17.7 x 21.6)
Rough sketch; on verso of Cat. #248
A-22v

250.

[BURIAL MONUMENT]

Graphite on paper
8 5/8 x 7 (21.7 x 17.6)
*Inscribed: "west side To Cadet James W. S. BELL
of Indiana He died at Logansport Ia on the
5th Augt 1837 in the 20th year of his age."
Additional notations recording monument
inscriptions*
A-23

(248) "The love of trees was a marked peculiarity of General Tipton's. This was shown in his care for the preservation of the old forest oaks that stood around the road side near his residence on the Wabash and in the deer park, which he preserved. His donation of *'Spencer Square'*–Logansport to the city was a gift that did not stand the *strong* test of the Law. It fell back to his heirs. 'Spencer Square' was a reservation of a beautiful grove of forest trees; it was an ornamental spot–rural in its aspect and inviting to the ramblers who sought the shade in the heat of summer. . . .

In *the center* of 'Spencer Square' . . . *General John Tipton* was buried–it was *his chosen* spot for his final earthly rest. (I remember the funeral well–being present–1839.) Two years previous to his death and burial in the grove, Young Bell, son of the venerable Major Bell, now living (1873)–a cadet of West Point–came home on a visit . . . 1837 and died suddenly. The Cadets of West Point did honor to his memory by erecting a monument over his grave. It was placed on the West Side of the Square." (GWMSS 2-25 [3])

251.
VIEW OF THE WABASH RIVER-FROM THE GRAVE YARD LOGANSPORT JUNE 11TH 1847
Graphite on paper
8 7/8 x 13 (22.3 x 32.8)
A-44

252.
THE GRAVE YARD–LOGANSPORT INDIA
Graphite on paper
8 1/4 x 12 1/8 (20.9 x 30.7)
A-34

(251) "Separated from [Spencer] Square by the distance of a few rods was the *old grave* yard–a donation of Genl. Tipton to the city of Logansport. Many marks of the natural beauty of this sacred spot were preserved in the many groups of forest trees–spared by the axe under direction of the generous donor." (GWMSS 2-25 [3])

253.

VIEW FROM THE EASTERN END OF TIPTON'S ISLAND–ON THE WABASH JUNE 15TH 1847

Graphite on paper
8 1/8 x 12 1/8 (20.5 x 30.5)
Vantage point similar to Cat. #246
A-42

(253) "The Island from its natural charms, being located in the centre of the Wabash, was a place of constant resort. It was cool retreat in the oppressive days of summer–and it was particularly attractive to the young, who often found there rich rewards in their rambles and for those particularly who loved the wild flowers. . . .

There were many views of attractive interest on this southern channel of the Wabash and though they were confined within limitation and gave no great outspreading distance, yet a pleasing variety of scenes changed upon your view by making only a few paces in different stand points.

This point of the Island *now* is protected in some degree by the picturesque but small island above–but some change in the volume and flow of the river is indicated to the observant eye. The sand washes are more marked–drift wood has settled more densely upon this point–But the soft maples that stand so picturesquely as represented in the drawing, though slender in shaft, are full in foliage and seem to survive the more rapid flow–but alas! they are fated to pass away like many a grand oak and elm that once stood in the beautiful grouping, in the great masses of the densely timbered forest." (GWMSS 2-5 [5])

254.

SCENE UPON THE UPPER WABASH JUNE 15TH 1847

Graphite on paper
8 1/8 x 12 1/8 (20.7 x 30.6)
A-41

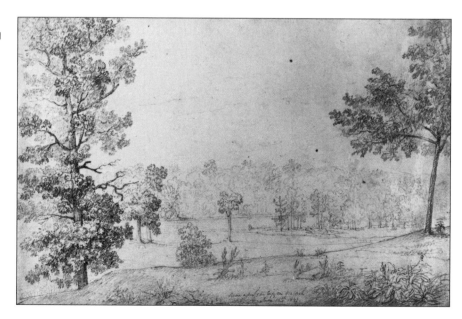

255.
AUGST 12TH 1847
Graphite on paper
8 3/8 x 12 3/8 (21.0 x 31.4)
A-43

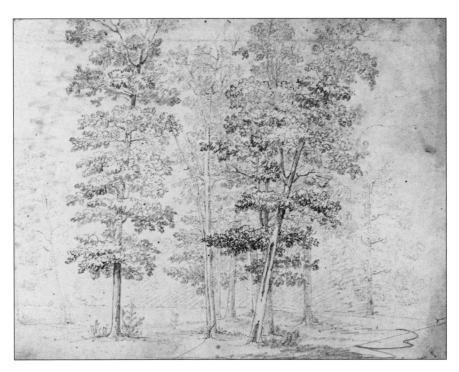

256.
VIEW OF THE WABASH
LOGANSPORT JULY 18TH 1848
Graphite on paper
8 3/4 x 12 5/8 (22.1 x 32.1)
A-50

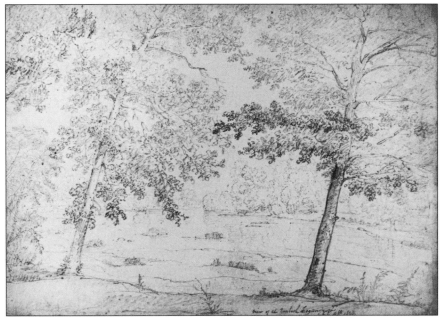

257.
SCENE UPON THE WABASH NEAR
TIPTON'S HOUSE JULY 20TH 1848
Graphite on paper
8 3/4 x 12 5/8 (22.1 x 32.0)
A-51

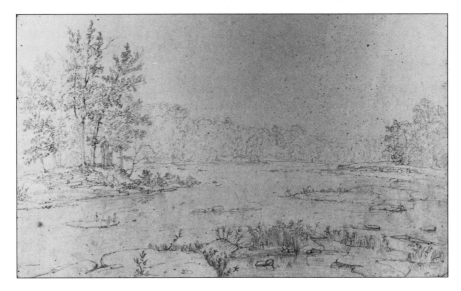

258.

**CRANE ISLAND–SCENE IN THE
WABASH JULY 22ND 1848**

Graphite on paper
8 3/4 x 12 3/4 (22.2 x 32.3)
A-52

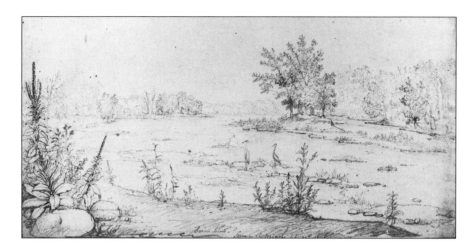

259.

**SCENE UPON THE WABASH
JULY 26TH 1848**

Graphite on paper
8 3/4 x 12 5/8 (22.2 x 32.0)
A-53

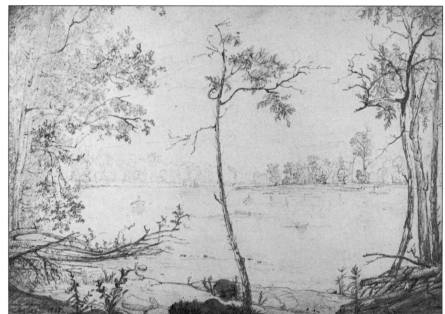

260.

**SCENE ON THE WABASH
INDIA–JULY 27TH 1848**

Graphite on paper
8 3/4 x 12 5/8 (22.2 x 32.0)
A-56

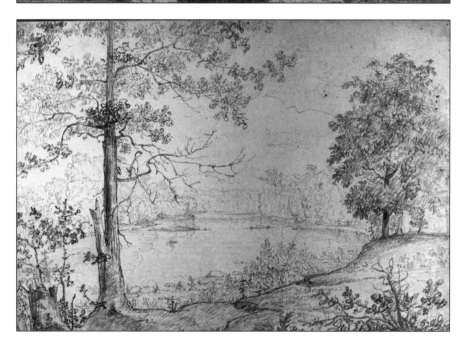

261.
SCENE ON EEL RIVER. INDIA OCTR-13TH-[18]48
Graphite on paper
8 3/4 x 13 (22.3 x 32.8)
B-71

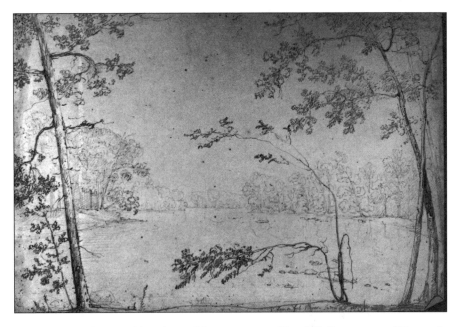

(261) G. W., "Sketches of Logansport, No. 2.," *Logansport Telegraph,* 9 October 1841:

"Eel river is a mad but clear stream, that laves the many islands that tower from its bed. It is not navigable, though rafts of wood are sometimes floated from above the dam, thence received by the Wabash, through whose waters are sent to the southern market, the treasures of the great Wabash Valley." (GWMSS 1-7 [7])

262.
SCENE ON EEL RIVER-INDIA 1848-ABOVE TABER'S FARM
Graphite on paper
8 3/4 x 13 (22.2 x 33.0)
B-72

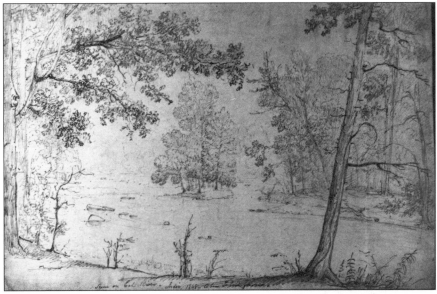

263.
THE WABASH NEAR MIAMI NATIONAL RESERVE. 1848
Graphite and brown ink on paper
8 3/4 x 12 3/4 (22.1 x 32.1)
B-73

264.
WABASH RIVER
Graphite on paper
3 1/2 x 6 1/8 (8.8 x 15.6)
G.W.'s signature repeated several times, on verso
B-114

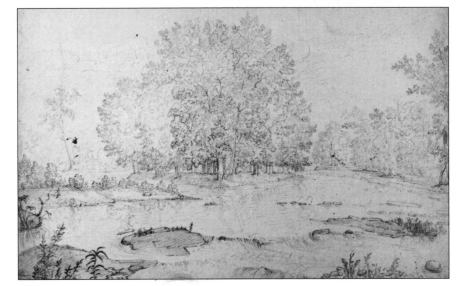

265.
BIG SNAKE CREEK NEAR LOGANSPORT

Graphite and brown wash on paper
9 x 14 1/2 (22.7 x 36.7)
B-96

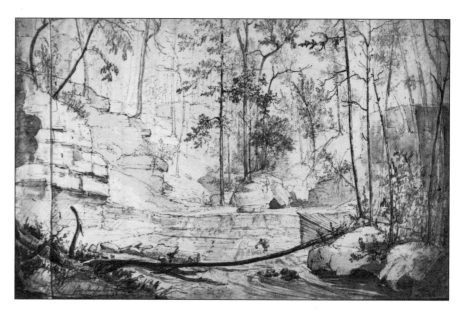

(265) G. W. to Rev. B. F. Tefft, Cincinnati, Ohio, 18 October 1849:

"The Scene Chepalapec'–or to call it by the indian name Kche-man-i-tou se-pe-wah [Big Snake Creek] . . . I sketched upon the land belonging to Mr. Wm. Brown, a merchant of this place. It is on a farm embracing some several hundred acres of land about 3 miles west of Logansport–and is a part of the well known tract of land originally belonging to Mr. *Barron*, an Indian Interpreter–a Canadian frenchman by birth. This tract was a grant made by the indians to Mr Barron. . . .

This *ravine* and creek of which my painting represents a portion is a natural curiosity and wonder; and were it located in vicinity of a large city it would doubtless become a 'Lion'. The sides of the ravine is composed of high and perpendicular walls of limestone rock. This rocky solitude is entered by the 'Wabash and Erie' canal, which glides but a few yards from its base; and the Wabash river too flows parallel to it, at but a few hundred paces from it. Broken masses of rock, that have fallen from the cliffs, or washed in from the creek above have accumulated with broken branches of trees, and drift wood, offer partial obstruction to the explorer. On looking upward as you enter–you discover in the wall on the west side large fissures in horizontal lines; and huge masses of the rock seem to threaten a seperation from the greater bulk. Upon the large group of rock, around the base of which the water flows, walnut trees have grown struggling for the light above. At a casual glance the mind would be impressed with the idea that these huge masses of rock have been displaced from the summit of the walls, by some shock of nature; but upon an investigation they are found not to be of the limestone formation, but of a calcareous substance, pourous, and spongey looking, and rounded evidently by aquaeous action, and have been formed where they now are, or have been placed there by those causes which have made the various changes in the physical condition of the earth. Near this group of rocks which is a potent auxillary to the picturesque effect–is a platform of solid limestone . . . rising some 8 feet from its base. It assumes the semblance of successive steps, as the stratification of the rock gives that indication. There is a subteraneous spring that gushes forth profusely in large volumes, near which a spring house has been erected by Mr. B. . . . Following up these furrowed and rugged cliffs a short distance, among inumerable fragments of rocks fallen trees–with limbs enterwoven and entangled–the lines of the walls gradually converge, when another platform of rock raises itself some several feet with all the regularity of steps–over which falls a beautiful cascade. The summit level of the creek arrived at–it becomes a very insignificant channel, which in the dry season scarcely any water flows from it down the precipitous ravine.

The whole of this strange gap is overhung with forest trees–giving it a secluded and cooling aspect." (GWMSS 1-12 [13])

266.
[WOODED LANDSCAPE WITH LOW LOG STRUCTURE]
Graphite on paper
8 3/4 x 12 3/4 (22.1 x 32.3)
A-54

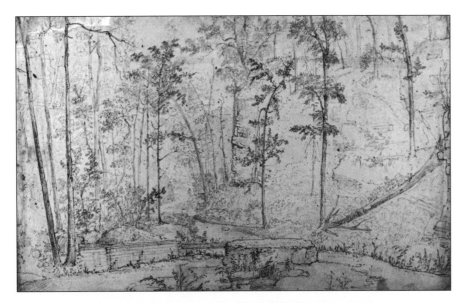

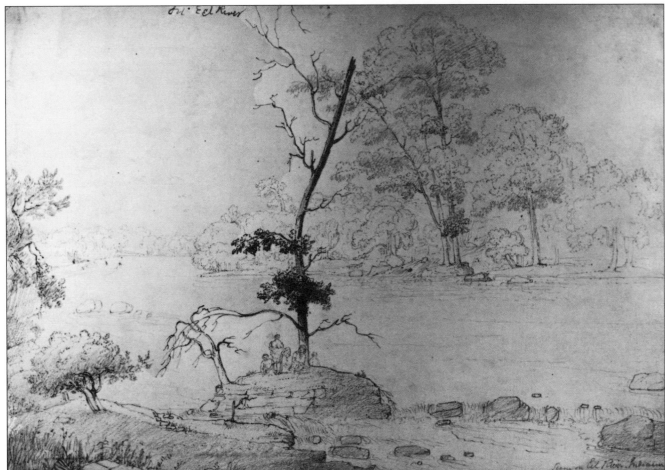

267.
SCENE ON EEL RIVER. INDIANA
Graphite on paper
8 7/8 x 12 5/8 (22.4 x 32.1)
Compare to oil version in Plate 4.
A-20

(267) Notice of Winter's distribution of paintings, Lafayette, 31 December 1857:

"'Sho-a-maque.' This is the Indian name for Eel River. The autumn season is depicted in this painting. The river expands into a bay-like appearance. A warm glow of the setting sun lights the scene. A belt of timber stretches out in the middle distance, which is pleasingly reflected in the limpid water." (GWMSS 2-1 [23])

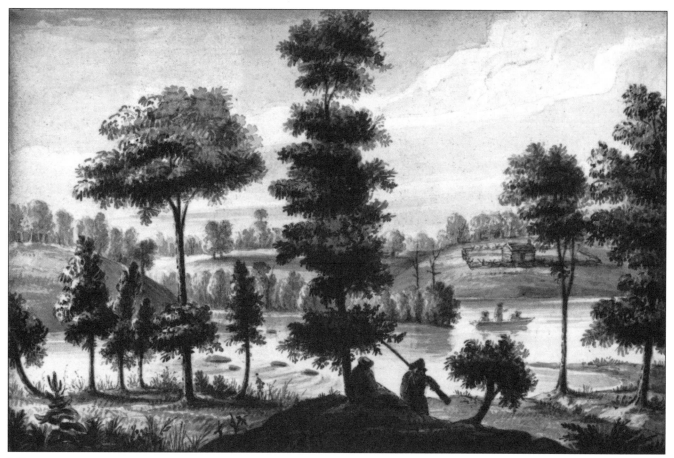

268.
SCENE ON EEL RIVER NEAR THE CONFLUENCE OF WABASH

Ink and wash on paper
8 1/4 x 10 7/8 (20.8 x 27.3);
comp. 4 7/8 x 7 3/8 (12.2 x 18.8)
Inscribed, l.c.: "Original–Geo Winter"
OV-250a

269.
LEWISBURGH, ON THE WABASH RIVER, AND WABASH AND ERIE CANAL SEPT 24TH 1849

Graphite on paper
5 1/4 x 8 1/2 (13.2 x 21.5)
B-75

270.
ON THE WABASH. INDIA. VICINITY OF LEWISBURGH SEPTR 24TH 1849

Graphite on paper
6 1/2 x 8 3/4 (16.3 x 22.2)
B-74

(268) Notice of Winter's distribution of paintings, Burlington, Iowa, 31 December 1856:

"'Under the Tree.' A Cabinet Painting. An Autumnal effect is portrayed. A warm sky–with a sloping hill–mellows in the distance–a sheet of water with timber banks–a log cabin to the right. In the centre of the Painting an old leafy Oak." (GWMSS 2-1 [20a])

271.
GEORGE TOWN LAKE–INDIANA.
JUNE 8 1867. [1847?]
Graphite on paper
9 1/8 x 13 (23.1 x 33.0)
Georgetown is located in western Cass County,
near Logansport
B-103

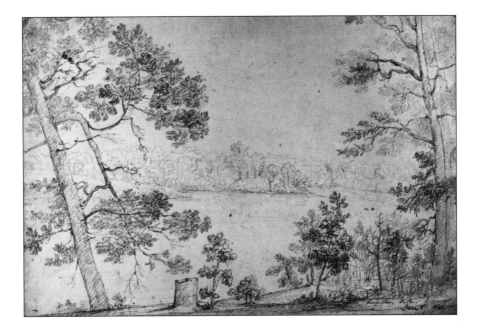

TREE AND FLORAL STUDIES

272.
NEAR LOGANSPORT INDIANA.
OCBR 6TH 1837
Graphite on paper
12 5/8 x 7 7/8 (31.9 x 20.0)
Study of tree
F-304

273.
NEAR LOGANSPORT INDIANA
OCBR 6TH 1837
Graphite on paper
12 5/8 x 7 7/8 (32.0 x 20.0)
Study of trees
F-303

274.
ELM AND SYCAMORE TREE ON
WABASH. IN.
Graphite on paper
13 1/8 x 8 7/8 (33.1 x 22.4)
F-307

275.

BANKS OF THE WABASH RIVER
INDIANA 1845

Graphite on paper
13 x 8 1/4 (32.9 x 21.0)
Study of tree
F-313

276.

SYCAMORE TREES AT THE
CONFLUENCE OF THE RIVERS,
MIAMI

Graphite on paper
8 7/8 x 12 7/8 (22.3 x 32.6)
F-319

277.

BUCK-EYE LOGANSPORT
JUNE 29TH 1848

Graphite on paper
12 3/8 x 7 3/4 (31.4 x 19.5)
F-321

278.

[STUDY OF TREES]

Graphite on paper
12 x 9 (30.3 x 22.7)
F-330

279.

[STUDY OF TREES]

Graphite on brown paper
13 1/4 x 8 7/8 (33.4 x 22.4)
F-329

280.

[STUDY OF TREE]

Graphite on paper
6 3/4 x 8 1/2 (17.2 x 21.5)
F-311

281.

[STUDIES OF TREE BRANCHES]

Graphite on paper
7 7/8 x 12 5/8 (19.9 x 31.9)
F-305

282. (see Plate 53)

[PURPLE IRIS]
SKETCHED LOGANSPORT
MAY 27TH 1846

Watercolor and ink on paper
15 x 10 (38.0 x 25.4)
M-94

283. (see Plate 54)

COLUMBINE SKETCHED
MAY 25TH 1846

Watercolor, ink, and graphite on paper
15 3/4 x 10 (39.8 x 25.4)
M-93

284.
[LILAC SPRAY]
Watercolor and ink on paper
10 x 8 (25.4 x 20.1)
M-92

285.
[WILDFLOWERS]
Watercolor, ink, and graphite on paper
6 7/8 x 10 1/2 (17.2 x 26.7)
Inscribed, u.l.: "3 184[1?]"
Faint sketch of man with turban, on verso
M-90

286.
LOGANSPORT, INDIANA.
AUGST. 20TH 1846
Graphite on paper
8 7/8 x 12 7/8 (22.4 x 32.5)
Inscribed, u.r.: "verveine Heartsease smartweed"
F-314

287.
IRON WEED
Graphite on paper
8 7/8 x 12 7/8 (22.4 x 32.6)
F-315

probably the pitcher plant

288.
PROBABLY THE PITCHER PLANT
Graphite and brown ink on paper
5 1/2 x 8 3/4 (13.8 x 22.2)
F-334

289.
[STUDIES OF VEGETATION]
Graphite on paper
9 x 12 5/8 (22.8 x 32.0)
F-332

290.
[STUDY OF VEGETATION]
Graphite on paper
5 3/8 x 8 5/8 (13.7 x 21.9)
F-335

291.
[LADYSLIPPER]
Graphite on lined paper
12 x 7 5/8 (30.3 x 19.2)
Bird's head and profile of man in hat, on verso
F-331

292.
[CARNATION]
Graphite and wash on paper
2 1/2 x 2 3/4 (6.2 x 6.9)
F-338

293.
[CARNATION]
Graphite on paper
4 1/8 x 3 7/8 (10.5 x 9.9)
F-337

LOGANSPORT ARCHITECTURAL RENDERINGS

294. *(see Plate 55)*
**THE HOUSE GEO WINTER
INTENDED TO BUILD IN
LOGANSPORT IN 1845**
Watercolor, ink, and graphite on paper
9 1/8 x 11 3/8 (23.0 x 28.7)
M-95

295.
**[FRONT VIEW OF A ONE-STORY
BUILDING]**
Graphite on paper
5 7/8 x 9 3/8 (14.8 x 23.7)
I-628

296.

[TWO VIEWS OF A ONE-STORY
HOUSE WITH VINE-COVERED
VERANDA]

Graphite on paper

5 7/8 x 9 3/8 (14.8 x 23.7)

On verso of Cat. #295

I-628v

297.

**PROFILE VIEW OF THE HOUSE
FACING BROWN'S–EXHIBITING
WEST WING.**

Ink and graphite on paper

7 7/8 x 9 3/4 (19.9 x 24.7)

*Inscribed, l.c.: "The Chimnies marked 1 & 2 are to
rest on joices–adapted for stoves." Dimensions are
given on the drawing.*

I-627

298.

[FRONT VIEW OF ONE-STORY
HOUSE]

Ink and wash on paper

9 x 11 3/8 (22.9 x 28.9)

I-629

299.

[FRONT VIEW OF TWO-STORY HOUSE]

Ink and graphite on paper
11 3/8 x 9 1/8 (29.0 x 23.1)
On verso of Cat. #176; similar to Cat. #294
G-416v

300.

JUDGE BIDDLE'S RESIDENCE LOGANSPORT, INDA.–SKETCHED JUNE 1864.

Graphite on paper
8 1/2 x 13 (21.5 x 33.0)
Inscribed, u.r.: "The space between shelter and Pillar–twice width of shelter"
Other notes and details around sheet perimeter
I-626

(300) "The building now the residence of Judge Biddle though not pretentious in its exterior appearance is picturesque and attractive–and blessed with the rural surroundings–and invites the notice of the traveller as he passes over the rail Road bridge that crossed the Island; and gets a passing glance at the home of one of marked character and wide reputation. The distinguished Judge–the Poet–musician–scientist–and literary man." (GWMSS 2-5 [9])

SCENES IN THE LAFAYETTE, INDIANA, AREA
BATTLE GROUND, INDIANA, 1840

In 1840, Winter visited the historic sites of the Battle of Tippecanoe and Prophet's Town, located several miles north of Lafayette, Indiana. In his sketches and oil paintings, he attempted to convey the details of this "classic ground" as he viewed it in 1840 and in subsequent visits in 1869 and 1873.

John B. Dillon, Indiana State Librarian, to G. W., 19 January 1849:

"I am authorised by an act of the Legislature to purchase your Tippecanoe Painting at a price not exceeding one hundred dollars. It is a small sum for the work; but if you are willing to let the State have it at that price please advise me of the fact; and give me directions as to the manner of forwarding the amount to you. I wish you could make it convenient to visit Indianapolis, that I might receive some instructions as to the proper light, frame, &c. for the Painting." (GWMSS 1-12 [4])

Notice of Winter's distribution of paintings, Burlington, Iowa, 31 December 1856:

"'Tippecanoe Battle Ground.' This is classic ground, being a graphic representation of the scene as it appeared in 1840–it being from the same sketch as the Painting from my pencil, now in the State House at Indianapolis and bought by the Legislature of Indiana. The front line of the fence marks the position occupied by Captain Spencer." (GWMSS 2-1 [20a])

G. W. to J. P. Luse, Louisville, Kentucky, September 1873:

"What shall become of my accumulated sketches, I often ask myself, as no one else could embody them upon canvas. How many years of patient waiting have I not experienced–shall I not say?–Yes! long has the artist been looking for sympathetic, and comprehensive minds, that could *encourage* the perpetuation, by an expansion upon canvas, these *historic points* of the Battle Grounds of Tippecanoe–and *the many* other historical localities too." (GWMSS 1-25 [11])

301.
THE TIPPECANOE BATTLE GROUND
Observed 1840
Graphite on paper
10 1/8 x 15 1/4 (25.8 x 38.6)
Inscribed, l.l.: "Taken near the spot where
Col [Spencer's] Company were stationed"
u.c.: "Sketched in 1840 taken near the spot where
Col Spencer's Company was stationed CGB"
OV-16

(301) "Tippecanoe Battle Ground Octr 6th 1840.

Arrived here at 4 o'clock. A beautiful and clear atmosphere. The country around under the influence of the autumnal tinge. The foliage still full and retaining its graceful forms; and inviting to the exercise of the pencil. It's mostly oak timber–and the trees within the enclosure of the Battle Ground are extremely fine. I never saw finer studies for the Painter.

The battle ground retains nearly all its original appearance–but few trees have been cut down since the army encamped on it. The timber is not thick–but open and like that country known as the Barrens. On approaching the enclosure–it assumes the appearance of a small park. . . . There is a prarie on either side–through the western side runs Burnett's creek from which the army were supplied with water–on the eastern side of the ground is a marshy prarie through which the Indians retreated. . . . A few minutes after my arrival I commenced sketching a view of the extreme point of the battle ground. I stood at about 300 feet from the sumit in the centre of the Lafayette Road." (GWMSS 2-29 [1])

302.

SCENE OF THE GRAVES WHERE
THE LIVES OF THOSE WHO FELL
IN THE BATTLE OF TIPPECANOE
WERE BURIED. SKETCHED 1840.

Graphite on paper
6 1/2 x 8 (16.5 x 20.3)
OV-19a

(302) "Stood beneath the trees where Col Owen was burried–and also where Col J. H. Daviess remains rest. Many of the trees yet bear marks of the bullets–their positions show that the Indians fired high up. Visitors have badly husked the bark to obtain the leaden balls.

The trees in the grove are now in their golden and russet glory–the leaves are changing their hues–the fall season is advancing. Today is lovely and warm. This [is] a beautiful spot–sanctified by a bloody conflict–woes–suffering and death. It is lovely for the dead to repose within so peaceful abode. . . . The delapidated enclosure around the graves must be supplied some day with a higher mark of regard for the memories of those who fell upon this field. They deserve a grateful tribute to their well won renown. . . .

Friday morning. [Oct.] 9th

Rainy–gloomy–and no hopes of immediate change in the weather. 12 o'clock–have just returned from making a sketch of the graves of the brave fellows whose bones rest in the lovely shadows of this sacred ground. My paper is wet. A miserable day. I can't return to Prophet's town to day to make a sketch of the site of the ancient village.

Commenced sketching another view of the Battle ground–took my station in *the log Cabin* erected by the Whigs for the Convention. A very tedious operation, though a pretty view." (GWMSS 2-29 [1])

303.

TIPPECANOE BATTLE GROUND 1840

Graphite on paper; watermark "G & Co"
8 1/8 x 14 1/8 (20.5 x 35.7)
Inscribed, l.r.: "Geo Winter"
A-18

(303) "7th Octr 40.

I have commenced sketching a scene, on the sumit, and near the line where Capt. Spencer's company were formed. This includes to the left the prarie through which the Indians retreated–the point where the Prophet sat during the battle. And nearly the whole surface upon which the American army were encamped.

It is extremely hot today!

I have been standing in the hot sun just 12 hours with scarcely any intermission." (GWMSS 2-29 [1])

304.

A VIEW OF PROPHETS TOWN– SHAW'S HOUSE ON THE BLUFF–1840

Graphite on paper
6 1/8 x 11 7/8 (15.5 x 30.0)
A-19

(304) "I have visited Prophet's town. . . . It is almost impossible to cross the marsh north of the enclosure. I passed down nearly at the *point*, and jumping down from the fence into the corn field which is a cultivated part of the prarie–my coat caught on the fence, and thereby tore *the back up*. The weeds grow to a great height, and render the field scarcely passable. . . .

Having crossed the prarie, I entered some fine Barren land–immediately opposite the Battle ground. . . .

I followed a foot path around the margin of the prarie until I came to a road leading to the town. A great many fine Mallard Ducks were sporting in a swamp within gun shot. Followed the road through dwarf oaks, and at last arrived at Mr. Shaw's house, which is on the bluffs near the Wabash River, where the wigwams of Tecumseh & the Prophet once stood. . . .

The Prophet's wigwam was not many feet distant westerly from that of Tecumseh's. Mr. Shaw's son has designated these localities to me. Mr. Hiram Shaw, son of J. Shaw—to facilitate my sketching—has assisted me in levelling a number of Shumac Trees that were obstructions to my greatest range of vision.

A wild Cherry tree stands at the extremity or outward eastern line of the circle upon which the wigwam of Tecumseh existed. This tree has grown up spontaneously—near the hearth stones of the wigwam—I am informed that these stones have been used in a sugar camp in the opposite woods. . . .

Found a good point to sketch Shaw's Cabin. . . . The prairie is before me shaven of the grass at some places—near base of the bluffs—weeds are prolifick and dry stocks of stubble and young trees—thrifty with foliage pleasant to gaze on. The 'bluffs' loom above. . . . At the summit line, they slope at a slight angle from the highest point at the right, where the wild cherry tree stands—as seen from my stand point conspicuously, marking the sight of Tecumseh's Wigwam visibly, down to clusters of trees to the left of Shaws Cabin—extending to the prairie bottom. . . .

. . . among the points of interest here are the remains of a black-smith's shop—visible, though no distinct relic of the building itself exists—but the charred wood and ashes are quite unmistakable and stamps the locality . . . [where an] unknown Indian vulcan plied his vocation. Mr. Shaw has presented me with a pony shoe found at this spot of singular workman-ship. A squaw hatchet, knife, and some iron—valuable relics recd from the hands of my kind host, and highly prized.

The Indian burial ground is a special object of interest—here is the telling tale of this corroding hand of time. Some mounds of earth of slight elevation—and scattering debris of decayed bark. . . .

The village of Prophet's Town originally stood upon a clearance of about forty five acres of land. This area has not been extended since Mr. Shaw entered the land and held occupancy of it.

The principal changes in the appearance of this site since the indians departed from the region, has been in the increasing growth of the tim-ber—and a dense undergrowth of young oak saplings which seem to hedge in this farm—and the pleasant oak openings, affording no longer the range of view. . . .

An earnest day's sketching of the local scenes was completed. I had looked upon scenes historically famous—my portfolio was enriched by val-ued sketches—gratitude to John Shaw and family's hospitality was felt—The last glance of Prophet's Town dimly seen as the backward gaze was made—trudged along buoyant in feelings.

. . . recrossed the swampy prairie at the north western edge. It was the hour when 'twilight dews were falling fast'. I found myself once more within the shadows of the oaks of the Tippecanoe Battle Ground."
(GWMSS 2-29 [3])

305.

**VIEW OF TIPPECANOE BATTLE
GROUND–FROM THE RATTLE
SNAKE DEN 1840**

Graphite on paper

9 3/8 x 12 1/8 (23.7 x 30.8)

*Inscribed, u.c.: "Battle Ground from Rattle Snakes
Den now called 1840 Prophets Rock"*

A-17

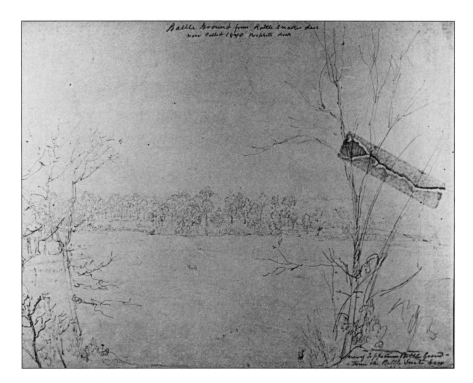

(305) "Monday–[Oct.] 12th. . . .

. . . To day–crossed over the creek on west side–prairie bottom–partially dry grass–rank–a solitary cow–munches it with a seeming relish. . . . Get to the Rattlesnakes' den–a large rock–well known to the settlers. The rock is of a calcareous kind. There are seemingly fabulous accounts of the number of rattlesnakes killed in this den. It is an ugly looking place. The rock has opened its fissures. It looks like open jaws–big holes in the recess–look like they had been scooped out.

Made a sketch upon the sumit of the rock–this point commands a bird's eye view of the Battle Ground. . . . The prairie below–Burnett's creek winds its silvery thread along the steep banks of the Battle Ground. The large willows bend to the stream. . . .

The leaves were falling around me as I sketched. I could not but some times imagine the snakes were spraying the rattles in the den beneath me. I could fancy as the leaves fell that some snake was near me. I secured my sketch." (GWMSS 2-29 [1])

BATTLE GROUND, INDIANA, 1869

During Winter's 1869 visit to the Battle Ground, he reflected upon and recorded the changes that had occurred in the intervening twenty-nine years.

"Visited the Tippecanoe Battle Ground and Prophet's Town–July 24th 1869.

The changes in the physical characteristics of the country–since my first visit to these classic spots in the year 1840. . . .

The farm of Soloman Shaw–the old homestead of his father John Shaw–now *deceased*–is situated on the Wabash River. It is now *easily* reached by a good road running directly from the Battle Ground rail road station–or more immediately from the Tippecanoe Battle Ground at a point near where the oak trees stood . . . where Col J. Daviess fell when he charged the indians. . . .

. . . The path from *the ground* commences near the spot where the trees stood where Col *Daviess* fell in the battle. The trees were chopped down when the Rail Road was made.

My *sketch* of these trees–preserved. . . .

. . . There is a gravel path now accross the swampy prairie that leads to Hiram Shaw's house–and thence following through the 'ancient wood'– by a blind old road you can reach the old sight of Prophet's Town. . . .

No fence now surrounds the reserved portion of the Battle Ground. In 1840–there was a post and rail fence–with two large gateways at either end of the enclosure. The secure enclosure has since disappeared–it was partly destroyed by fire occasioned by the fire wafted by the passing Engine of a train. . . .

. . . we gazed upon this scene accross the 'impassable' prairie–in a direct line south easterly to the classic locality of Prophet's Town in the year 1840–a year ever to be remembered as one of great political excitement . . . and now in a summer day of 1869, we gaze upon the scene from the same identical spot–how singular and interesting the change. The swampy prairie has now changed into rich fields of varied tints of green and lovely lawn appearances.

No longer the swamp and prairie grass shoot up from the moist and mucky bed in broad coarse and rank blades. But finer thready blades, affording amplitude of sustenance (appreciable to the husbandman) to the well conditioned herd that are fed by its nutricous qualities.

The plough too runs deep furrows upon the gentle and undulating rise of rich soil–and the fields of wheat and corn respond to the hand of industry. The landscape though now domestically tame, is all aglow with the golden ears of the grain." (GWMSS 2-29 [8], 2-29 [7])

306.
BURNETT'S CREEK–NEAR
TIPPECANOE BATTLE GROUND–
SEP 8TH–1869

Graphite on paper
6 x 10 (15.0 x 25.4)
B-107

307.
BURNETT'S CREEK–NEAR
TIPPECANOE BATTLE GROUND.
SEPT. 8TH 1869

Graphite on paper
6 1/8 x 10 (15.3 x 25.3)
B-108

308.
BURNETT'S CREEK TIPPECANOE
B. G.–SEPT 8TH 1869

Graphite on paper
6 1/8 x 10 (15.4 x 25.3)
B-106

309.
THIS STONE–WHERE DAVIESS
WAS PLACED AFTER KILLED
SEPT. 8TH 1869

Graphite on paper
6 1/8 x 10 (15.4 x 25.2)
Inscribed, l.r.: "Sketched on Tippecanoe Battle Grd.
near where Col. Daviess–fell–1811."
B-109

(308) Notice of Winter's distribution of paintings, Lafayette, 16 March 1854:

"'Vicinity of Tippecanoe Battle Ground.' . . . Road running up to the point where the out-sentinel was killed by the Indians–Burnett's Creek is seen flowing from the bluff side of the Battle Ground." (GWMSS 2-1 [12a])

310.

CABIN OF SLOCK-EN-OH. DAVIS FERRY. WABASH RIVER OCBR 14TH–1873

Graphite on paper

5 3/4 x 9 7/8 (14.5 x 25.1)

Inscribed, verso: "Accompanied today Ocbr. 14th 1873 on a trip to Tippecanoe Battle Ground– by Dr. Martin Stephens (Oberlin Ohio) T. Harding–builder of Fence of the B. G."

G-464

(310) "We made a visit to the Tippecanoe Battle Ground . . . yesterday with Mr. Harding who is constructing the new iron fence. The enclosure will be a running line of fence composed of 470 panels–eight feet to a panel–about 90 have yet to be put up.

The line of fence will be 3760 feet–with two entrance gates. . . .

The fence is substantial and is composed of 80 tons of iron. It is well coated with tar–and will be impervious to atmospheric action for many years. It is strongly anchored–being placed upon a solid foundation, thirty inches below the surface, and will not be affected by the winter frosts. We crossed the Ferry accross the Wabash–known as Davises' Ferry. The old ferry by the bye was a few rods above the present point. The old two story cabin of the *famous* Shock-en-osh is still standing though in a very dilapidated condition. . . .

. . . Nancy Daviss–Her Indian name Stock-en-osh–remembered many years at her cabin at the Ferry. . . . Her father–Indian Chief of prominence. Built a mill (grist) on Burnets' creek–enters the Wabash where she resided. . . .

. . . Stock en-osh cabin was head quarters–a large number of Indians were always seen around her cabin. . . .

. . . It would appear from the surroundings [of the cabin] that the cultivation of the soil has not been extended beyond the limits that it was at the time when Sock-en-osh–or Nancy Davis owned the ferry years ago– where as an old settler well remembers an Indian was the ferryman–and who was distinguished particularly and who wore a ring in his nose. The scenery on the Wabash–as viewed from this cabin–is very placid and attractive and has a picturesque appearance; and the distant view of the cabin from the eastern side of the river is rather an interesting subject, having much traditionary association. It stands upon a high bank–below some good springs are discernable near the water line–a few trees that stand contribute to make the whole a point of interest." (GWMSS 2-29 [19a], 2-36 [9])

OTHER LAFAYETTE AREA SCENES

(311) Notice of Winter's distribution of paintings, Lafayette, 29 December 1852:

"'View near Lafayette.' A pleasing effect of light in the distance–a shady bank to the left–to the right a group of soft maple trees–the foreground promiscuously entangled." (GWMSS 2-1 [8])

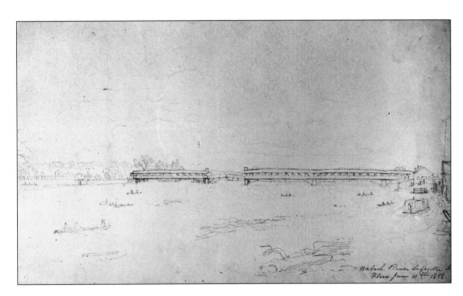

(313) "The Great Flood of June 11, 1858.

The entire Spring had been wet and the water courses high. . . . [T]he Wabash rose at the rate of 4 inches per hour, during all of the 11th, and at midnight stood at its highest, at which time the river and canal, foot of Main st., were on a perfect level. The entire piers of the Wabash bridge, except six tiers of stone, were covered. Mr. Winter, an able artist of Lafayette, has perpetuated the scene from nature in a painting of unspeakable value, as a faithful representation of an object of great interest in the history of Lafayette." (*Lafayette City Directory*, 1858-59. Lafayette, Indiana: Luse & Wilson.)

316.
WILD CAT OCTR 29TH 1860
Graphite on paper
8 1/8 x 12 (20.6 x 30.4)
B-100

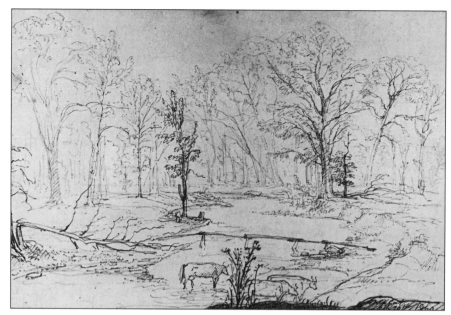

317.
THE WILDCAT NEAR ROBESON'S
FACTORY. OCTR 29TH 1860
Graphite on paper
8 1/4 x 12 (20.9 x 30.4)
B-99

318.
JULY 30TH 1865
Graphite on paper
8 3/8 x 12 1/4 (21.2 x 31.1)
F-322

319.
WABASH RIVER. LAFAYETTE–
OCTR. 15TH 1866
Graphite on paper
8 1/2 x 13 (21.5 x 32.9)
B-101

320.
VIEW FROM INDIAN HILL
OCBR–1867
Graphite on paper
9 7/8 x 15 1/2 (24.9 x 39.3)
Possibly preliminary study for oil "Wea Plains–
From Indian Hill," advertised in distribution of
30 December 1868 (GWMSS 2-1 [37])
OV-104

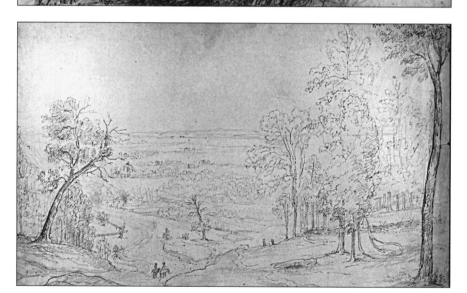

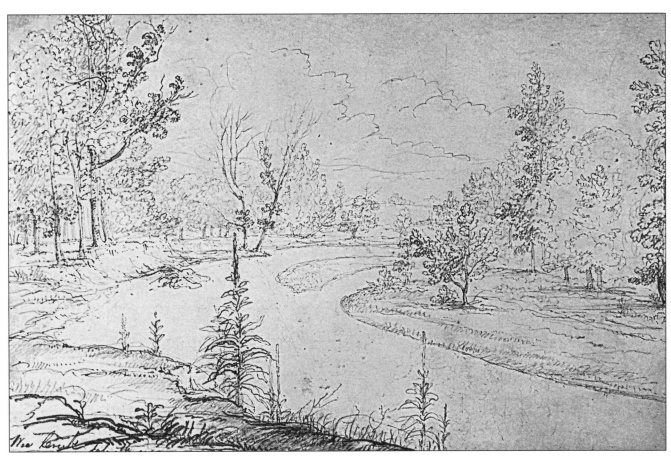

321.
WEA CREEK JULY 7TH 1871
Graphite on paper
7 3/4 x 11 5/8 (19.5 x 29.5)
Possibly preliminary study for oil "Wea Creek,"
advertised in distribution of 30 December 1871
(GWMSS 2-1 [45])
B-110

322.
FAIR GROUNDS–TIPPECANOE
CO–INDIANA AUGT. 22D–1871
Graphite on paper
12 7/8 x 8 3/8 (32.6 x 21.0)
B-111

323.
[STUDY OF VEGETATION WITH TREE STUMP]
Graphite on paper
8 1/2 x 13 (21.5 x 33.0)
Similar to tree stump in Cat. #3
F-323

324.
OCBR 20TH 1871
Graphite on paper
9 1/2 x 5 7/8 (24.0 x 14.9)
Study of leafless tree
F-325

325.
[BUILDING SCREENED BY TREES]
Graphite on paper
8 1/4 x 6 1/4 (20.8 x 15.8)
F-327

326.
[STUDY OF TREE]
Graphite on paper
8 1/4 x 6 1/4 (20.8 x 15.8)
Inscribed, l.l.: "1871"
On verso of Cat. #325
F-327v

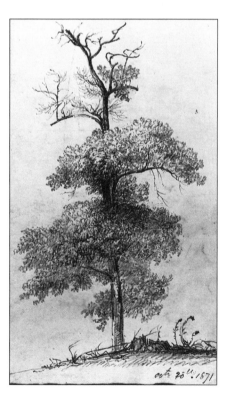

327.
OCTR 20TH 1871
Graphite on paper
9 1/2 x 5 7/8 (23.9 x 14.8)
F-326

328.

SUGAR TREE. JULY 1ST 1872

Graphite on paper
9 3/8 x 7 1/8 (23.7 x 18.0)
Portion of landscape (Cat. #330) on verso
F-328

329.

DISTANT VIEW OF THE WEA
PLAINS JULY 1ST 1872

Graphite on paper
7 1/4 x 9 3/8 (18.3 x 23.7)
Portion of landscape (Cat. #330) on verso
B-112

330.

[SKETCH OF LANDSCAPE WITH
BUILDINGS]

Graphite on paper
9 3/8 x 14 1/4 (23.7 x 36.2)
Sheet cut in two; on verso of Cat. #328 and 329
F-328v, B-112v

331.

[PERSPECTIVE DRAWING OF
MONUMENTS IN IRON FENCE
ENCLOSURE]

Graphite on paper
8 5/8 x 11 1/4 (21.9 x 28.4)
One monument in graveyard is inscribed:
"Archibald Hatcher"
B-119

332.

TIPPECANOE RIVER HORSE SHOE
BE[ND] NEAR MONTICE[LLO]

Graphite on paper
9 3/4 x 15 1/2 (24.8 x 39.4)
Inscribed, l.r.: "Aug 15"
OV-45

333.

SWAMPY PRAIRIE–NEAR
TIPPECANOE RIVER

Graphite on paper
4 3/4 x 8 3/4 (12.0 x 22.1)
A-66

MISCELLANEOUS EARLY SCENES

334.

**NEWPORT MANUFACTORY ON THE
OHIO RIVER–APRIL 29TH 1836**

Graphite on paper; watermark of sailing ship
5 1/4 x 8 1/2 (13.3 x 21.4)
A-1

335.

[BUILDINGS ALONG RIVER]

Graphite on paper
8 x 9 7/8 (20.3 x 25.0)
B-120

336.

[BUILDINGS ALONG RIVER]

Graphite on paper
8 x 9 7/8 (20.3 x 25.0)
On verso of Cat. #335
B-120v

337.

[SKETCH OF TOWN SKYLINE]

Graphite on paper
8 7/8 x 13 1/8 (22.4 x 33.1)
B-121

338.

**DISTANT VIEW OF CARPENTER'S
GROVE AND THE IRIQUOIS RIVER**

Ink and graphite on paper
3 3/4 x 9 7/8 (9.3 x 25.1)
Landscape with cranes at river's edge
B-113

339.

SHAWNEE CREEK

Graphite on paper
3 1/2 x 3 7/8 (8.7 x 9.9)
B-115

340.

SCENE OF GRAND PRAIRAIE

Graphite and ink on blue laid paper; embossed seal;
watermark showing man on half globe, holding
flag, over script "L"
7 3/4 x 9 3/4 (19.5 x 24.6)
B-118

CEDAR LAKE AND LINDSAY'S CABIN, 1844

"Cedar Lake is one of those charming inland lakes that contribute so much to the picturesque effects of the northern part of Indiana which is diversified with Prairie, Barren and Thick timbered forest groves. This lake is perhaps some seven miles in length, and as it appeared in the fall, as we approached it as the sun was setting in golden folds of rich and massive clouds, some three miles . . . distance to the opposite shore, which rounded from the eyes, with its banks studded with *dwarfish* oak trees.

Cedar point was not a long distance from *True Axe's* Cabin at the head of the lake.

Near this Point–on the eastern shore–were two log cabins built by some pioneer and deserted–it was the temporary property of any of those pleasure seeking people who were hunting or fishing. Near these cabins were the remains of some aboriginal work–These being some six circular pits with large quantities of broken rock of a character similar to that which is used in mecadamized roads.

These pits were called by the settlers–Potato pits–where the indians used to cook their Indian potatoes, by filling the pit partially full–then placing the broken rocks upon them. Afterwards fires were built–which operating upon the rocks, generated sufficient heat to cook the potatoes beneath. In 1844 *with G[eorge] A[dams]*, I camped at the head of the lake–fished and hunted–and gathered cranberries on Cedar Point where the berry grew spontaneously and luxuriantly. . . .

. . . Camp upon a gentle slope–fine view of the lake. Light over camp fire–by a huge prostrate tree. Grand effect of the light. The wind ripples the lake–music of its waves. The voice of the Loon. The situation–fruitful of imaginative scope. . . . We had been seeking the romance of the woods. We were realizing it." (GWMSS 2-22 [3], 1-8 [18])

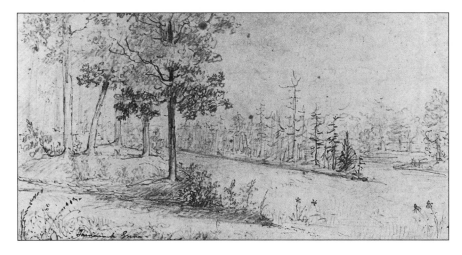

(346) "Rise early. Sun shines brightly. Breakfast. Sip our coffee–a good smoke. Prepared for White Horse Lake–six miles distant. . . . Pleasant scenery–oak openings. Glances at various small prairies–Tamarack groves. Fine Cedar groves. The sun increases in warmth. The warm tints of the oak foliage. The blue mist softly blends in with the scene." (GWMSS 1-8 [18])

347.

NEAR LINDSEY'S CABIN 1844

Graphite on paper

7 x 8 3/8 (17.7 x 21.3)

Inscribed, u.c.: "White Horse Lake Indiana"

A-26

(347) "The character of the land now changed, and we soon found ourselves upon the 'barrens'–or white oak openings, and immediately below us was a small translucent lake, whose glassy expanse imaged with fidelity its marginal beauties.

We found Lindsay, located here. Wap-kaw-neh-a-tosk-shah. Ke-chik-o-mink was six miles from Cedar Lake.

The sun was peering through the lower stratta of clouds–and the mists hung like a veil upon the lake and more distant scenery–sweeping along as if reluctant to lift itself to reveal the beauties of the scenery around. . . .

This . . . lake is but a few *hundred* yards accross its greatest breadth, and probably not exceeding three quarters of a mile in length. The surroundings of it assume no uniform appearance, yet [are] somewhat eliptical. The point upon which we stood was of a mixed sandy and muxy character–near Lindsay house it formed a graded descent towards the lake. The opposite side from Lindsay's the banks were somewhat elevated and rolling, and a deep depression intervened between this fronting and the continuous land beyond it, as if some other lake had once existed upon a higher elevation than the waters of 'Wap-kaw-neh-a-tek-shah. Ke-chik-o-mink'." (GWMSS 2-35 [4])

(348) "We ramble around the lake. Make a sketch–near by point–Wild flowers. Prepare to leave Lindsay." (GWMSS 1-8 [18])

DAYTON, OHIO, 1844

The family of Mary Squier Winter, George's wife, lived in the vicinity of Dayton, Ohio. The couple stayed with Mary's family from early January 1844 (when their daughter Annette was born) through spring of 1845, although Winter took occasional trips elsewhere during that time. He was apparently in financial difficulties throughout this period, and letters indicate that he attempted to borrow money and to sell some of his possessions in Logansport through local contacts. It is possible that the family's return to Logansport was delayed by a shortage of funds needed to finance the journey.

353.
SCENE ON THE BIG MIAMI NEAR DAYTON–OCTR [] 1844
Graphite on paper
8 3/4 x 12 7/8 (22.2 x 32.6)
A-30

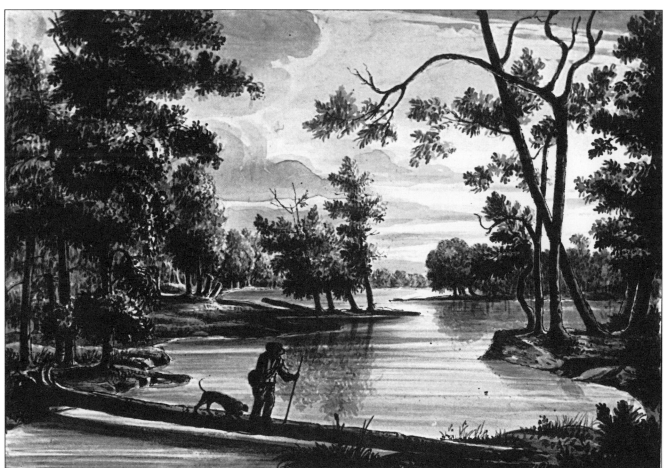

354.
CROSSING A BAYOU MIAMI RIVER IN THE DISTANCE VICINITY OF DAYTON OHIO.
Wash on paper
9 x 14 1/2 (22.7 x 36.8);
comp. 5 1/4 x 7 1/2 (13.1 x 19.1)
Inscribed, l.c.: "Original–Geo. Winter."
Vantage point similar to Cat. #353.
OV-250b

(354) Notice of Winter's distribution of paintings, Evansville, Indiana, 24 December 1853:

"'The Big Miami.'–The setting sun with shafts of light shooting up is an attractive part of this painting–the reflection giving brilliancy to the near objects. A Bayou runs up to the foreground. A hunter and dog crossing a fallen log give a picturesque effect to the scene." (GWMSS 2-1 [12])

355.
SCENE ON THE MIAMI RIVER NEAR
DAYTON OHIO
Graphite on paper
4 3/8 x 6 1/2 (11.1 x 16.3)
Sketch of two arms, one holding lyre, on verso
A-31

356.
SYCAMORE MIAMI RIVER DAYTON
OCTR 4TH '44
Graphite on paper
8 1/2 x 7 (21.5 x 17.6)
F-310

357.
NEAR DAYTON OCTBR 25TH 1844
Graphite on paper
7 7/8 x 12 7/8 (19.9 x 32.6)
A-28

358.
NEAR DAYTON OCTR 25TH 1844
Graphite on paper
8 7/8 x 13 (22.4 x 33.0)
A-29

359.
**NEAR DAYTON OHIO
NOV. 8TH 1844**
Graphite on paper
8 7/8 x 11 1/2 (22.4 x 29.1)
F-312

360.
NEAR DAYTON 1844
Graphite on paper
8 3/4 x 12 7/8 (22.3 x 32.6)
Study of two trees
F-309

363.
**THE RIVERS–ST. MARY &
ST. JOSEPH FORT WAYNE
JUNE 17TH 1848**
Graphite on paper
9 1/8 x 12 5/8 (23.0 x 32.0)
Inscribed, l.l.: "This is sketched from the sight of old
Fort Wayne by Geo Winter"
A-47

(359) " 'To a decaying trunk'

Venerable, leafless, and decaying old trunk! Thou hast withstood the lightening's flash, and the wanton storm. Thou standest proud monarch of the forest still, erect, and in various hues relieved by the young green, and tender progeny around thee. Time has been with thee, and thy days are numbered. Old tree! thy vernal honors have disappeared. Thy rugged bark unshaded by thy once fibrous expansions–still protects the fast *ebbing* sap that scarcely supports thee. By thy base, lie thy prostrate kindred in wild confusion and in rotten dissi[p]ation. Thou has stood in favour with the elements! . . .

Noble tree of the forest! Like man thou hast had thy *infancy*, childhood, youth, and age; but more than man thou hast experienced thy seasons, each in due succession. . . .

Emblem of human greatness! thou standed brave and erect, 'till the last. A thousand storms have ye defied." (GWMSS 1-4 [6])

361.
[FOLIAGE STUDIES]
Graphite on paper
12 1/4 x 7 7/8 (31.1 x 19.8)
Indistinct buildings in background
F-333

362.
[STUDY OF TREE]
Graphite on paper
9 x 8 1/2 (22.8 x 21.5)
F-324

FORT WAYNE, INDIANA, AND ST. MARYS RIVER, 1848

(363) "The travelled route at this early period to the Wabash from Hamilton was via of Dayton, Piqua, Richmond–thence the 'Old Quaker Trace' to St Mary's, and directly to Ft. Wayne, which stood high upon the banks of the river commanding a pleasant view embracing the junction of the St Joseph & St Mary's, making the head waters of the Maumee (Omi), which flows in its north easterly course onward to Lake Eirie." (GWMSS 2-39 [15])

Notice of Winter's distribution of paintings, Lafayette, 29 December 1852:

" 'St. Mary's River,' A pleasing perspective view of the river–dashing cascade runs into the flowing stream–on the left bank a clump of trees–bolders in the foreground." (GWMSS 2-1 [8])

364.

A PART OF "FORT WAYNE"– JUNE 19TH 1848

Graphite on paper

8 7/8 x 12 1/2 (22.4 x 31.5)

Inscribed, l.c.: "16"

A-48

365.

SKETCH OF THE APPLE TREE NOTED FOR BEING OVER 100 YEARS OLD AND THE REPUTED BIRTH PLACE OF CHIEF RICHARDVILLE. ST. JOSEPH RIVER JUNE 19TH 1848

Graphite on paper

7 1/2 x 9 1/8 (18.8 x 22.9)

Inscribed, l.l.: "Omi–(village)"

F-320

366.

ST. MARY'S RIVER NEAR FORT WAYNE JUNE 19TH 1848

Graphite on paper

7 3/4 x 8 1/8 (19.6 x 20.4)

A-49

(365) "It was opposite to Ft Wayne, and on the east bank of the St Joseph river stood the old Miami village *Ke-ki-ong-gay*. It was at this village and under the very large apple tree that Pee-jee-wa–or Richardville principal Chief of the Miamies was born. I made a sketch of this historical tree some 18 years ago." (GWMSS 2-39 [15])

WINAMAC, INDIANA, AND LAKE MAXINKUCKEE, 1848

367.
NEAR WINAMACK SCENE UPON THE BARRENS–WINAMACK ROAD 1848
Graphite on paper
4 7/8 x 8 3/4 (12.2 x 22.2)
A-67

368.
FROM WINNEMACK TOWARDS MUX-IN KUCK-KEY
Graphite on paper
4 7/8 x 8 7/8 (12.2 x 22.5)
A-65

369.
LAKE–MUX IN-KUCK-KEY–INDIA. SEPTR 8TH 1848
Graphite on paper
9 1/8 x 12 5/8 (23.0 x 32.0)
Inscribed, u.c.: "I have several views of this from different points"
A-68

(367) Notice of Winter's distribution of paintings, Lafayette, 7 January 1860:

"'Scene on the Barrens.' This is a representation of a primeval scene. . . . The timber is sparse, having a park like appearance . . . a little prairie bordered by a strip of timber." (GWMSS 2-1 [32])

370.
LAKE MUX-IN KUCK-KEY–
SEPTR 8TH 1848
Graphite on paper
8 3/4 x 12 3/4 (22.2 x 32.1)
A-69

371.
SOUTH VIEW OF
LAKE–MUX-IN KUCK-KEY
SEPTR 8TH 1848
Graphite on paper
8 5/8 x 12 3/4 (21.9 x 32.4)
A-70

372.
LAKE–MUX IN KUCK-KEY. 1848
Graphite on paper
4 7/8 x 8 3/4 (12.1 x 22.2)
A-61

373.
EAST VIEW OF LAKE
MUX IN-KUCK-KEY. 1848
Graphite on paper
4 3/4 x 8 7/8 (11.8 x 22.3)
A-63

374.
LAKE–MUX-IN-KUCK-KEY 1848
Graphite on paper
4 7/8 x 8 7/8 (12.3 x 22.3)
A-64

MAUMEE RIVER, OHIO, 1854

375.
**VICINITY OF MARINGO–
MAUMEE RIVER–MAY 31. 1854**
Graphite on paper
8 5/8 x 11 1/4 (21.9 x 28.4)
B-78

376.
VICINITY MARINGO
Graphite on paper
5 5/8 x 8 5/8 (14.3 x 22.0)
B-86

377.
**VIEW FROM MAUMEE CITY
JUNE 2ND 1854**
Graphite on paper
8 1/4 x 13 1/8 (20.9 x 33.2)
Inscribed, l.l.: "Fort Miami in the Distance"
B-82

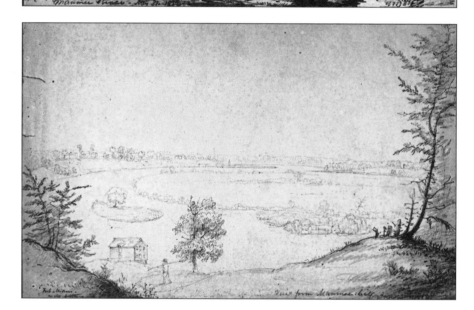

(377) Notice of Winter's distribution of paintings, Lafayette, 12 March 1859:

"'Fort Miami.' A view on the Maumee,–in the middle distance is seen the old British Fort. This view is famous for its connection with Anthony Wayne's exploits. The river here is peculiar in its character forming a bay, centered with a large Island." (GWMSS 2-1 [31])

378.

MAUMEE RIVER–FORT MIAMI

Graphite on paper

8 5/8 x 11 1/4 (21.9 x 28.3)

B-83

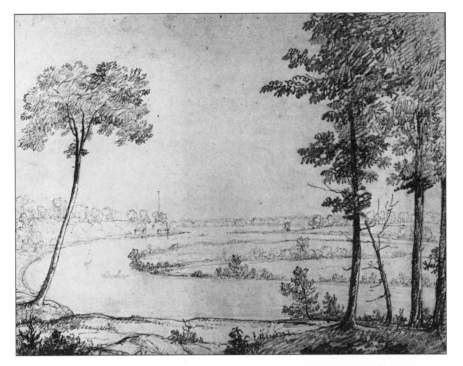

379.

**ROCHE DE BOUT MAUMEE RIVER
1854**

Graphite on paper

8 3/4 x 11 1/4 (22.0 x 28.3)

B-85

380.

**VIEW FROM MAUMEE CITY–
JUNE 3RD 1854**

Graphite on paper

8 5/8 x 11 1/4 (21.9 x 28.4)

B-84

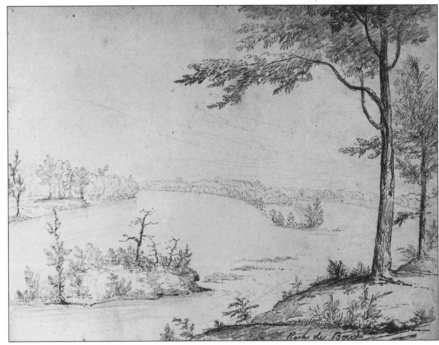

(*379*) Notice of Winter's distribution of paintings, Lafayette, 31 December 1857:

"'Roch de Bout.' This is an interesting point on the Maumee. The river widens, and assumes a lake-like appearance. Here the Missionary Island makes a graceful curve. A large mass of rock stands isolated in the river, adding much to the picturesque effect of the scene. It was at this point that Wayne encamped his soldiers before the battle of Presquile." (GWMSS 2-1 [21])

381.

**MISSIONARY ISLAND.
MAUMEE RIVER. OHIO. 1854**

Graphite on paper
8 3/4 x 11 1/4 (22.0 x 28.3)
B-80

382.

**DELAWARE FLATS–MAUMEE RIVER
OHIO**

Graphite on paper
8 5/8 x 15 1/8 (21.9 x 38.3)
B-81

BERLIN, WISCONSIN, 1856

383.

**FLINT ROCKS. VICINITY OF
BERLIN WISCONSIN
JULY 19TH 1856**

Graphite on paper
8 7/8 x 11 1/2 (22.6 x 29.2)
B-90

(383) Notice of Winter's distribution of paintings, Lafayette,
12 March 1859:

"'Flint Rocks.' A scene in Wisconsin near Berlin. This is a broken
and romantic scene composed of irregular masses of rock upheaved upon
the summit of a hill. Oak trees of rich foliage stand in their midst. The set-
ting sun is shrouded in richly tinted clouds. Shafts of light shoot up giving
splendor to the scene." (GWMSS 2-1 [31])

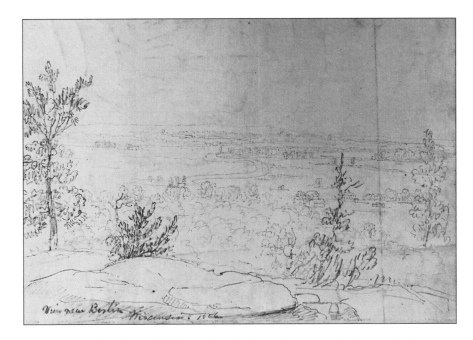

384.
VIEW NEAR BERLIN WISCONSIN.
1856

Graphite on paper
9 x 11 1/8 (22.7 x 28.2)
B-87

385.
FOX RIVER BERLIN WISCONSIN
JULY 19TH 1856

Graphite on paper
8 7/8 x 11 5/8 (22.5 x 29.3)
Similar view to Cat. #384
B-88

(384) Notice of Winter's distribution of paintings, Lafayette, 31 December 1857:

"'View near Berlin, Wis.' The sun is setting, throwing a warm tinge upon the country, extending to a distant horizon. In the prairie which extends through the middle distance, the Fox river curves gracefully, and is lost in the heavy timber below the mass of flint rocks which rests upon the elevated table land. The foreground is full with rich wild weeds." (GWMSS 2-1 [21])

386.
OMRO. FOX RIVER. WISCONSIN
JULY 20TH 1856

Graphite on paper
8 7/8 x 11 1/2 (22.5 x 29.2)
B-91

387.
[RIVER SCENE WITH BOATS]

Graphite on paper
4 7/8 x 11 7/8 (12.3 x 30.0)
Rough landscape with figure, on verso
I-624

388.
**SCENE NEAR BUTTE DES MOIRS
WISCONSIN–JULY–1856**
Graphite and brown ink on paper
8 7/8 x 11 1/2 (22.4 x 29.3)
B-89

389.
[STUDY OF STEAMBOATS]
Graphite on laid paper; embossed seal with
"Laflin Bro's," crown and scroll
8 x 5 (20.1 x 12.5)
I-620

390.
[STUDY OF STEAMBOATS]
Graphite on laid paper; embossed seal with
"Laflin Bro's," crown and scroll
8 x 5 (20.1 x 12.5)
Inscribed, l. margin: "Lafayette Feb 19th 1857."
On verso of Cat. #389
I-620v

391.
**BLACK HAWK ROCK NEAR
BURLINGTON IOWA
SEPTR. 17TH 1856.**
Graphite on paper
9 3/8 x 14 1/8 (23.7 x 35.8)
B-97

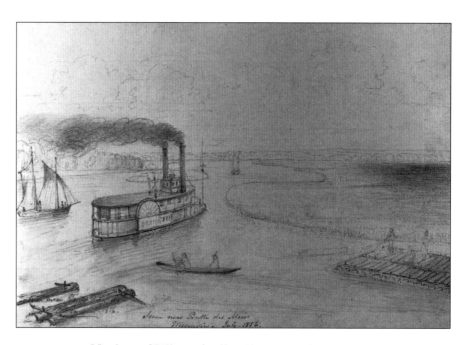

(388) Notice of Winter's distribution of paintings, Lafayette, 12 March 1859:

"'Lake Buttes des Moirs.' A small steamer is seen entering the Lake of the Bones of the Dead, from the Fox River. Other craft floating, giving interest to the scene." (GWMSS 2-1 [31])

BURLINGTON, IOWA, SEPTEMBER 1856

(391) Notice of Winter's distribution of paintings, Burlington, Iowa, 31 December 1856:

"'Black Hawk Rock.' A Painting of peculiar interest from its supposed or real associations with the Indian Warrior, whose memory will live when the red race will be no more. The physical character of the scene is striking, being sudden slopes or hills, making a broken amphitheatrical appearance. A lively Spring gushes from the base of the right-hand hill; on the left a large bolder is seen, where Black Hawk is supposed to have often sat amidst his warriors. Reclining trees from the hill side make a cool refreshing shade. The Mississippi is seen in the distance." (GWMSS 2-1 [20a])

392.

SCENE ON THE MISSISSIPPI NEAR BURLINGTON–IOWA

Observed 1856

Graphite on paper

9 3/8 x 14 1/8 (23.6 x 35.7)

B-93

393.

BANKS OF THE MISSISSIPPI– NEAR BURLINGTON. IOWA.

Observed 1856

Graphite on paper

9 1/2 x 14 1/8 (24.0 x 35.7)

B-94

394.

IRVING'S CASCADES NEAR BURLINGTON IOWA

Observed 1856

Graphite on paper

11 7/8 x 14 1/8 (30.0 x 35.8)

OV-95

(*392*) Notice of Winter's distribution of paintings, Lafayette, 31 December 1857:

"'Scene on the Mississippi.' The scenery around Burlington, Iowa, possesses many interesting characteristics. This is one of the many pleasing scenes viewed, looking northward. The Mississippi here is diversified by many small islands. The belt of timber to the right is the boundary of Illinois. The forest to the west extends beneath the eye until it mellows into the horizon." (GWMSS 2-1 [21])

(*394*) Notice of Winter's distribution of paintings, Burlington, Iowa, 31 December 1856:

"'The Cascade.' A broken and romantic scene near the Mississippi, and in the vicinity of the Irving farm. From a broken and abrupt crescent of rock that fronts the eye looking upward, a dashing cascade descends; overhanging vines and trees towering above the eye and at the base, make a charming scene." (GWMSS 2-1 [20a])

WESTERN SCENES, 1874–75

In June 1874, upon the death of George's older brother Charles, a resident of Oakland, California, George traveled to California to serve as executor of the estate. Winter's initial six-week visit was followed later that year by another trip to Oakland, this time in the company of his wife Mary. The couple remained in California for over a year, residing in the house that had been left to them by Charles, and making frequent excursions to points of interest in the environs of Oakland. Both visits to the West are documented with landscape sketches and in letters written by Winter to his family in Lafayette.

G. W., Elk, Nevada, to Mary Winter, 7 June 1874, and G. W., East Oakland, California, to Nette Ball (George and Mary's daughter), 11 June 1874:

"[W]e have witnessed some *grand* and *remarkable* scenes–mountain Rock–and level. . . . It was a huddled group that crowded the [train] platform to get each one of us the best view of the *remarkable* scenes, which passed by, alas! so quickly. . . . The Watsach mountains impressed me with a strange feeling of wonder. This range was capped with snow. The blue tint that prevailed over them and the silver shining snow, upon their points made a beautiful scene. The barren scenes that we had passed upon the Rocky mountains, gave us a higher enjoyment of the great variety of beautiful scenes that have come in such quick succession before us. . . . Night closed upon us as we entered the great American Desert. The moonlight at 3 o'clock in the morning gave a soft light upon the desert scene, the distant mountains looked solemn in their . . . hazy appearance. I was up by sun and enjoyed the peculiar scenes of the Desert. . . .

The distant mountains were peculiarly interesting. The snow capped points were matters of speculation. The Sierra Nevada mountains, seen so far off blended with the bright clouds, so that it became a question among us whether they were bright clouds or not. We however could trace the delicate lines of the mountains–which assured us of their true character. When we entered the 'Laramie Plains'–The mountains were very grand. . . . But I *wanted* the grand trees of Indiana. The country all along seemed so barren of trees. The Rocky mountains were so peculiar, in their character–without verdure–and so strange in their *singular formation*. High peaks and embankments and long ridges–broken rocks tumultuously scattered along, like decayed fortifications. They were umber colored–but in the distant views the blue atmosphere gave them great beauty of color. . . . Pools of water would be seen–and little streams catch the eye–but the *green* verdure was *scarce*. There was beauty even in the desolation of the scenes however. . . .

The moon effect in crossing the desert was solemn. I laid in my berth and saw through the window the distant mountains while all were sound asleep. I was up *early* and *late* and drank in all that was to be seen. I did not have a night's sleep during the trip–I however rested, and at the end of my journey I was fresh and in no way fatigued." (GWMSS 1-26 [9], 1-26 [11])

G. W., East Oakland, California, to Mary Winter, 27 and 21 June 1874:

"Alameda County in which East Oakland is, I think is the most fertile in appearance–indeed the country has quite a reputation for its remarkable productiveness. I found some very pleasant communicative people on the train–and I did not fall backward from making acquaintances. I ask at all times for information wherever I have been. . . .

. . . I want to see everything in nature–and the general aspect of things. I am in a new world, and I wish to learn to adapt myself to the *newness* of things. . . .

. . . It seems strange, and looking around upon the new circumstances of life–you can hardly realize that it is America.

I like the freedom of the people. There is less conformity to recieved customs than at home. *All are independant.*" (GWMSS 1-26 [17], 1-26 [15])

395.

BEAR RIVER–UTAH JULY 1874

Graphite on paper
5 7/8 x 9 7/8 (14.8 x 25.1)
View of mountain valley with two figures,
possibly Indians, in foreground.
B-124

396.

SCENE ON STANISLAUS
RIVER–CALIFORNIA
SKETCHED JULY 2ND-1874.

Graphite on paper
8 3/4 x 11 (22.3 x 28.0)
B-122

397.

WEBER CANON OCTR 1874

Graphite on paper
4 3/8 x 5 5/8 (11.0 x 14.3)
Inscribed, verso, l.c.: "Weber Canon–Utah–
Octr–15th 1874."
Mountainous landscape with railroad tracks
in valley
B-123

398.

TOANO MOUNTAINS
OCTR-1874–NEVADA

Graphite on paper
6 1/2 x 10 7/8 (16.4 x 27.6)
View of mountain valley with two figures,
possibly Indians, in foreground
B-126

399.

TOANO RANGE–NEVADA–1874

Graphite on paper
4 3/8 x 11 (11.0 x 27.9)
Landscape with mountains in background;
indistinct camp scene in foreground
B-127

400.

HUMBOLT RANGE OF MOUNTAINS
NEVADA 1874

Graphite on paper
8 3/4 x 11 (22.2 x 27.7);
comp. 6 1/2 x 11 (16.3 x 27.7)
Landscape with mountains in distance
B-125

401.

[3425?] ELEVATION-1874

Graphite on paper
5 1/8 x 9 3/4 (12.8 x 24.6)
Mountainous landscape
B-128

402.

MINK LAKE ALAMEDA CO.
CALIFORNIA DEC 1874

Graphite on paper
9 7/8 x 19 3/8 (24.8 x 49.2)
Landscape with lake; buildings and scrubby
vegetation dotting hills on far shore
OV-129

(397) G. W., Elk, Nevada, to Mary Winter, 7 June 1874:

"I was delighted with Weber Canyon. It was overpowering to behold those *Towering red rocks*–words fail to impress other minds of what we feel in contemplating these wonders of creation." (GWMSS 1-26 [9])

(400) G. W., Elk, Nevada, to Mary Winter, 7 June 1874:

"We have been running along the Humbolt river, with a series of views of mountain scenery. The meadows as they border on this peculiar river–The day has lost its highest warmth–and the sun getting towards the horizon and the coloring of the mountains is most charming in tint.

We have passed some hot springs at the base of a hill. The vapours are rising–But we still miss the 'trees'–there are no trees of any character." (GWMSS 1-26 [9])

403.
PABLO RANGE CALIFORNIA 1875
Graphite on paper
6 3/8 x 10 1/2 (16.1 x 26.7)
B-132

404.
PABLO RANGE–CALIFORNIA 1875
Graphite on paper
6 3/8 x 10 1/2 (16.1 x 26.7)
Hilly scene, similar to Cat. #403; figure in foreground
B-131

405.
MOUNTAIN ROAD LEADING TO CASTRO VALLEY–CALIFORNIA 1875
Graphite on paper
2 3/4 x 3 1/8 (6.9 x 7.7)
Landscape with mountainside road
B-133

(403) G. W., East Oakland, California, to Nette Ball, 19 July 1874:

"The morning was very hazy and much resembling scotch mist. The Pablo range of hills were *invisible* and accross the inlet of the bay of San Francisco the coast range of mountains were not dicernable.

Before however we returned home, the sun peered forth, and the landscape was all aglow with beauty. The blue tints of the atmosphere gave a most charming life to the natural beauties of the numerous scenes we witnessed. The hills and distant mountains partook of *violacous* tints, and though treeless, yet presented a diversified appearance from their surfaces being so irregular–deep depressions that seemed filled with intense *bluishness*–there an elevation would recieve a soft light. There is such a beautiful veil of gauzey blue that hangs over the mountain scenery generally, that it seems like enchanted land, where substantial earthly bodies could not walk." (GWMSS 1-26 [25])

(405) G. W., "The Golden State." Letter to the *Lafayette Journal*, 17 June 1875:

"[We] ascended a road running around the side of the mountains. Our increasing elevation increased our expanse of view. Our road was so narrow that it would have been impossible for a descending team to have passed us. This made it a little sensational. The slopes on the one side ran down into considerable deepness, until it met the base of another mountain, looming up to unreasonable elevation. One mountain's hight we passed must have commanded a vast range of vision. These mountains have no forestry. They are bald. Occasionally some scrubby dwarfed evergreen oaks grow upon the sides that round into the depressions of this peculiar range." (GWMSS 1-27 [8a])

406.

CASTRO VALLEY
CALIFORNIA–1875

Graphite on paper
7 1/4 x 11 1/4 (18.4 x 28.6)
View of valley surrounded by mountains
B-134

407.

PICNIC-MOUND-ROAD-LEADING TO
CASTRO VALLEY–CALIFORNIA
1875

Graphite on paper
2 3/4 x 3 1/8 (6.7 x 7.8)
Mountain with road in foreground
B-135

(406) G. W., "The Golden State." Letter to the *Lafayette Journal,*
17 June 1875:

"As we approached the beautiful valley of Castro, we all became
enraptured with the view before us. In the remote distance lay a mountain
boundary; the slopes showed the yellow harvested wheat; the upper lines of
their surroundings were bathed in purple tints, and the hollows and deep
depressions partook of that color which helped to define the *inner* rolling
lines–giving their true physical conformation. As we reached the valley
which was aglow with yellowish color of the vast wheatfields, here and there
were dottings of green trees, and to our more direct nearness, was a larger
grove of the Australian gum or Eculytus tree." (GWMSS 1-27 [8a])

408.

LONE MOUNTAIN CALIFORNIA
SEPT. 8TH 1875

Graphite on paper
10 x 13 1/4 (25.4 x 33.6)
B-136

(408) Mary Winter, East Oakland, California, to Nette Ball, 9 Sep-
tember 1875:

"Yesterday your father & I went over to 'Lone Mountain', to make
some *sketches*–when we left home, the *fog*, was so *dense*, we feared, it was
going to be a bad day–yet hoped for its disappearance about *noon*–we did
not get out there, until near *twelve* oclock, the fog & *wind possessing* every
thing. We *rested* for a time–then ventured in to the *Cemetery,* & wandered
about, for a *very* long time, at *last,* the sun did show his *face,* & the 'fog
clouds', turned from the mountain leaving the *points* most *desirable,* to
sketch, standing out *boldly* to view–with just *enough delicate mist* behind
them, for a *pretty effect.*" (GWMSS 1-28 [3])

409.

**LONE MOUNTAIN–CALIFORNIA–
VICINITY OF SAN FRANCISCO
SEPT 8TH 1875.**

Graphite on paper
8 7/8 x 11 1/8 (22.3 x 28.1)
B-137

410.

**NEAR C. [NEWTON'S?] RESIDENCE
& MERRITT LAKE CALIFORNIA–
SEPT 10TH 1875.**

Graphite on paper
10 1/8 x 13 1/4 (25.5 x 33.6)
Study of large tree
B-138

**VIEW OF MOUNTAIN RANGE–
OVERLOOKING FRUIT VALE–
ALAMEDA COUNTY–CALIFORNIA–
1875**

Graphite and purple ink on paper
3 3/8 x 5 7/8 (8.6 x 14.7)
B-143

(411) G. W., "Winter in California–Moraga Valley." Letter to the *Lafayette Journal*, 6 November 1875:

"The long expected visit to [Moraga Valley] has been realized. . . .

After a two mile drive our scene was diversified in character. . . . To our right . . . Fruit Vale was distinctly seen, with the green tops of eucletylus and other trees yet retaining their greenness amidst the parched-up surface of the earth, unknown to rain for many months. This scene, though not so broken or grand as many found in the Moraga valley, yet tempted my pencil for a hurried sketch." (GWMSS 1-29 [3a])

412.

MOUNT TEMALPAIS–ON THE BAY OF SAN FRANCISCO FROM THE ROAD LEADING TO THE MORROCCO VALLEY– OCT. 23-1875–CALIFORNIA

Graphite and purple ink on paper
3 1/2 x 5 3/4 (8.8 x 14.5)
B-142

(412) G. W., "Winter in California–Moraga Valley." Letter to the *Lafayette Journal*, 6 November 1875:

"We constantly took the backward gaze, and many charming scenes presented their striking peculiar characteristics. There was a point that I could not resist sketching. It was an opening in the mountains, giving a view of a portion of San Francisco Bay. Nature here was very kind in arranging so complete a picture. It was an opening that was bounded by a rugged cliff with overhanging trees ready to fall from their root-holding, and on the other side a wooded slope running to a creek some thousands of feet. In the middle distance was a massive rounded head of a bold hill, furrowed with deep depressions; beyond was the bay. Mount Temalpais towering up in the distance, its peak, piercing the sky, having a faint indication of a seeming pathway, it being the marked curving line of a remarkable land slide of recent date. This famous mount was suffused in a dreary blue haze. . . .

After traveling some seven miles in the mountains we gained the 'summit'. Here we paused and rested our horses. . . . Here the pencil was again brought into requisition." (GWMSS 1-29 [3a])

413.

APPROACH TO RED WOOD CANON CALIFORNIA OCT. 1875

Graphite and purple ink on paper
2 3/4 x 4 3/8 (6.9 x 11.0)
B-145

(413) G. W., "Winter in California–Moraga Valley." Letter to the *Lafayette Journal*, 6 November 1875:

"Mr. Colby and I rode down to the entrance to the Red Wood Canon, and the ladies 'footed' it down the mountain road. Our down ride was yet precarious, but necessity impelled the risk. . . . We sped our way for some miles through the canon, which was wooded on the south side with pine, spruce and young red wood, and trees which were new and unfamiliar to me." (GWMSS 1-29 [3a])

414.
SCENE IN MORAGA VALLEY
CALIFORNIA–OCT. 1875
Graphite on paper
2 3/4 x 4 3/8 (6.7 x 11.0)
B-144

415.
MORAGA VALLEY
CALIFORNIA–1875
Graphite on paper
7 3/8 x 11 3/8 (18.7 x 28.5)
B-140

416.
MORROCO VALLEY. CALIFORNIA
Observed 1875
Purple ink and graphite on lined paper
9 7/8 x 8 1/8 (25.0 x 20.5);
comp. 5 x 8 1/8 (12.5 x 20.5)
Mountain valley with figure on path
B-130

417.
MOUNT DIABLO ROAD LEADING
TO THE MORROCO VALLEY–
CALIFORNIA–OCTBR. 23 1875
Graphite on paper
7 1/8 x 9 7/8 (17.9 x 25.0)
B-141

418.
SAN FRANCISCO BAY–LONG
WHARF AND GOAT ISLAND
MOUNT DIABLO ROAD–
CALIFORNIA OCT 23 /75
Graphite and purple ink on paper
4 1/2 x 9 7/8 (11.3 x 25.1)
B-139

(414) G. W., "Winter in California–Moraga Valley." Letter to the *Lafayette Journal*, 6 November 1875:

"The Moraga Valley is a fine valley, very rich in soil, and producing good wheat crops. Its scenery too, is very remarkable. The formation of the hill sides reminded me of some of the peculiarities of the Rocky Mountains. This valley is perhaps not known much to travellers, nor to many who live within ten miles know much of it." (GWMSS 1-29 [3a])

(417) G. W., "Winter in California–Moraga Valley." Letter to the *Lafayette Journal*, 6 November 1875:

"We struck the Diablo road after a seven hours drive. . . .

From this point we made an ascent of some three miles. . . . At one point we caught a glimpse of Mount Diablo. The blue peak stood in complimentary color to the brown hills. It was a curious scene." (GWMSS 1-29 [3a])

(418) G. W., "Winter in California–Moraga Valley." Letter to the *Lafayette Journal*, 6 November 1875:

"The last mile of our descent [from Mount Diablo] gave us a view of the bay, giving a curved line of the shore. Goat Island was visible and 'Long wharf' looked clumpy at the end of the threaded trestle-work, projecting from the Oakland Point. The blue hills that bounded the bay were mellowed in the hazy distance, being the extreme boundary, with the shipping looming up like phantoms skimming the broad waters. The sun was then setting in a golden glory." (GWMSS 1-29 [3a])

419.
**CALIFORNIA–NOV. 10TH 1875
CONTRA COSTA–RANGE**

Graphite on paper
6 3/8 x 10 (16.0 x 25.4)
B-146

(419) G. W., East Oakland, California, to Nette Ball, 12 December 1875:

"The crimson rays of sunset were reflected back upon the mountains, and they presented a bright crimson color, and the hollows were in purple shadows. I never saw a more charming effect of color of this range, now having had our constant study for fifteen consecutive months. The fog clouds too, to day, were very interesting. They would just lap over the upper line of the upper points–and moved along–seemingly plowing their way along–varying in color, and density. Some times there was thin crawling gauzey vapour coming in between the dividing ridges. The clouds or banks of fog sailed along northwardly. Your mother and I devoted a goodly time in watching the fluctuations of light upon the scene." (GWMSS 1-29 [22])

Mary Winter, East Oakland, California, to Nette Ball, 18 November 1875:

"I wish you . . . could see the 'foot hills' now, they are cloathed with *green*–look like *velvit*–Pa has made, some *beautiful sketches* of *them*, beside other *mountain* views." (GWMSS 1-29 [8])

420.
**ROUTE TO PIEDMONT
LAKE MERRITT CALIFORNIA
NOV. [12TH?] 1875**

Graphite on paper
6 1/2 x 10 7/8 (16.4 x 27.4)
B-147

421.

LAKE MERRITT. CONVENT OF THE SACRED HEART– CALIFORNIA–1875

Graphite on paper
6 3/8 x 10 7/8 (16.3 x 27.4)
B-148

422.

[MOUNTAINOUS LANDSCAPE]

Ink and graphite on lined paper
2 7/8 x 7 3/4 (7.1 x 19.7)
B-150

423.

[MOUNTAINOUS LANDSCAPE WITH FIGURE]

Graphite on paper
5 x 9 1/8 (12.7 x 23.0)
B-149

424.

[MOUNTAINOUS LANDSCAPE]

Graphite on paper
2 3/4 x 4 3/8 (6.9 x 11.0)
Inscribed, verso: "Mary Winter"
B-151

425.

[MOUNTAINOUS LANDSCAPE]

Graphite on paper
3 3/8 x 5 7/8 (8.4 x 14.8)
Inscribed, verso: "Mary Winter"
Sketches of coniferous trees on verso
B-152

(421) G. W., East Oakland, California, to Nette Ball, 5 December 1875:

"Yesterday I went down to [our friend] Bangle's and made a sketch from their bedroom–It is a pleasant scene. It embraces a distant view of the Convent of the Sacred Heart." (GWMSS 1-29 [16])

(425) G. W., East Oakland, California, to Nette Ball, 22 December 1875:

"Our disappointment in not getting home for Christmas was great, as yours, no doubt. Then we rallied and believed we would make the 'home stretch' by 'new years'. But alas! that is beyond our control. . . .

We thought that we had rented our present abode. . . . The new house is not rented yet. . . . These houses I wish to see occupied before we leave–The buggy is not yet sold. . . . It would be foolish for us to leave without things being fully completed. . . .

I have no doubt but what I should have found something to do at home during Dec–had I not unfortunately been detained here. Expenses go on–but rents will come at last, I trust to help the larder. But it is very vexatious–and perturbing–to be kept in such a precarious position. It requires some philosophy to brace up under these circumstances. Virtuous patience will soon be exhausted." (GWMSS 1-29 [25])

G. W., Lafayette, Indiana, to George Winter, Jr., 26 January 1876:

"We arrived safely home this morning–at 1-15 o'clock a.m." (GWMSS 1-29 [38])

Six days later, on 1 February 1876, George Winter died unexpectedly while attending a meeting at the Opera House in Lafayette.

UNIDENTIFIED
LANDSCAPES

Winter's production of landscape paintings was prodigious. A number of these landscapes may not have been representations of specific sites; rather, they were probably composed of various interchangeable elements that captured Winter's artistic fancy. Such recurring natural features included rocky terrain, trees, waterfalls, lakes, and streams. The compositions were often made more appealing with the addition of human and animal figures. The sketches in this series are preliminary studies that include one or more of these components. Commissioned landscapes frequently included versions of these subjects, sometimes guided by suggestions from his patrons.

The works in this series are executed in graphite on paper unless otherwise noted.

William Hubbell, Evansville, Indiana, to G. W., 16 March 1859:

"Howe is not disappointed. He expected to get a picture [in your distribution]–felt sure of it. Upon asking him what he would have, he replied, he would leave it entirely with you. A landscape with woods, rocks, land & water such as you know how to make far better than he could tell you. It should not be oval, as he will frame it here & hang it up for a time in Healys store to show his success." (GWMSS 1-15 [19])

Clark Lane, Hamilton, Ohio, to G. W., 11 January and 10 February 1868:

"For my Painting you are to be the *workman*–the *responsible party*. I have nothing to offer on Frames–only, that I am no admirer of . . . show. Plain neatness would suit. As to real merits of a Painting I know *just nothing* at all, though I occasionally see Pictures that suit me."

"'View on the Merced' to hand about one week ago.

At first sight (though seen at a disadvantage, being *dusk* of *evening*) did'nt like it–only, however thought the *perpendicular granite wall*–too light and high colored. I still think it rather much so. But as I look upon and study the *scene*–must say that I am *well pleased with it as a whole*.–Dont understand me as not suited as you would infer from the first expression. But having had the advantage of you in *seeing the reality*, I am satisfied that a darker granite like appearance on the *perpendicular* would have been truer to Nature, though to persons knowing not, it as I do, and this *Rock appearance* as it really is, would no doubt admire, and regard the picture as much the finer as you have it. . . .

. . . Please accept my criticisms as friendly–and as from one knowing but little at best of Paintings." (GWMSS 1-20 [3], 1-20 [8])

ROCKY LANDSCAPES
RECTANGULAR COMPOSITIONS

These studies may have been preliminary works for finished oils such as the following, described in the notice for Winter's distribution of paintings, Lafayette, 29 December 1852:

"'Wabash Scene,' An expansive view of the river–the banks on either side jutting out–massive clouds in the sky–foreground broken with rocks– the water has a limped and transparent effect." (GWMSS 2-1 [8])

426.
ARCH ROCK 4.4
3 1/4 x 4 1/4 (8.2 x 10.7)
D-214

427.
3 7/8 x 4 3/4 (9.8 x 11.9)
E-272

428.
Graphite on paper, lined on verso
4 3/8 x 5 1/4 (10.9 x 13.2)
F-299

429.
2 7/8 x 3 3/4 (7.2 x 9.3)
D-218

430.
3 7/8 x 5 (9.7 x 12.5)
E-270

431.
4 1/4 x 3 3/8 (10.7 x 8.4)
D-200

432.
Graphite on cardstock
4 x 2 5/8 (10.0 x 6.4)
F-293

433.
2 7/8 x 4 3/4 (7.3 x 11.8)
D-199

434.
3 1/4 x 4 3/4 (8.1 x 11.9)
Bust of elderly man on verso
D-196

435.
4 1/4 x 3 1/4 (10.7 x 8.2)
D-211

436.
4 x 3 1/4 (10.2 x 8.2)
F-292

OVAL COMPOSITIONS

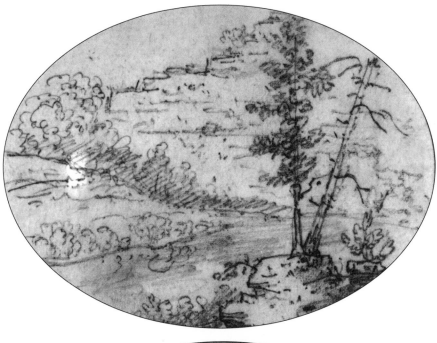

437.
Graphite on onionskin paper
3 7/8 x 4 7/8 (9.8 x 12.2);
comp. 2 5/8 x 3 1/2 (6.5 x 8.8)
C-184

438.
Graphite on onionskin paper
4 1/8 x 5 (10.3 x 12.7);
comp. 2 5/8 x 3 1/2 (6.5 x 8.8)
C-185

439.
4 x 5 (10.2 x 12.8);
comp. 3 1/2 x 4 1/2 (8.7 x 11.4)
D-227

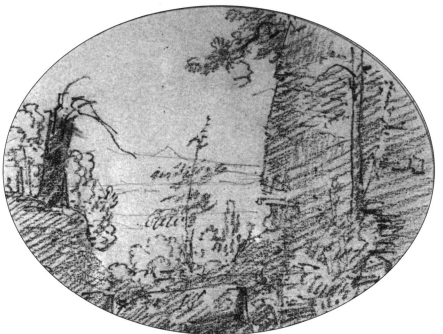

440.
4 x 7 3/8 (10.2 x 18.7);
comp. 3 1/2 x 4 1/2 (8.7 x 11.4)
D-237

441.
5 1/8 x 3 3/4 (12.8 x 9.4);
comp. 4 1/2 x 3 3/8 (11.4 x 8.5)
D-217

442.
Graphite on onionskin paper
4 3/4 x 4 (11.8 x 10.0);
comp. 3 1/2 x 2 1/2 (8.8 x 6.4)
C-182

443.
3 1/4 x 4 3/8 (8.3 x 10.8);
comp. 3 1/4 x 4 3/8 (8.0 x 10.8)
D-212

444.
5 1/4 x 4 (13.3 x 10.1);
comp. 4 1/2 x 3 3/8 (11.4 x 8.5)
D-229

445.
3 3/8 x 4 3/8 (8.3 x 10.8);
comp. 3 3/8 x 4 3/8 (8.3 x 10.8)
D-201

446.
5 x 4 1/4 (12.7 x 10.8);
comp. 4 1/2 x 3 1/2 (11.4 x 8.7)
D-216

447.
5 5/8 x 4 (14.2 x 10.2);
comp. 4 1/2 x 3 3/8 (11.5 x 8.6)
D-233

448.
7 7/8 x 4 (19.8 x 10.1);
comp. 4 1/2 x 3 1/2 (11.4 x 8.6)
D-235

449.
Graphite on laid paper;
watermark "PARS[ONS] HOL[YOKE]"
4 x 5 5/8 (9.9 x 14.2);
comp. 3 1/2 x 5 1/4 (8.7 x 13.2)
C-169

450.
Oil on paper, glued to cardboard
9 1/2 x 11 3/8 (24.0 x 28.7);
comp. 9 1/2 x 11 3/8 (24.0 x 28.7)
N-5

WITH WATERFALLS;
RECTANGULAR COMPOSITIONS

These studies may have been preliminary works for finished oils such as the following, described in the notices for Winter's distributions of paintings, Lafayette, 3 April 1852, and 12 March 1859:

"'Landscape View'–Scene on the Wabash, showing a bend of the river; a promontory jutting into it; a high bank to the right, with a spring dashing over." (GWMSS 2-1 [7])

"'The Cascade'. . . . A crescent of rock confronts the eye in looking upward–being a singular work of natural masonry of the limestone formation, over which a cascade dashes down, giving a pleasing effect. Tall, slender trees tower up to light from the depths of the rocky enclosure." (GWMSS 2-1 [31])

451.
BIFILO LAKE–14X17
Graphite on lined paper
4 7/8 x 4 (12.2 x 10.0)
B-117

452.
MOONLIGHT–14X11
3 1/4 x 4 1/4 (8.2 x 10.6)
D-215

453.
Graphite on cardstock
4 1/8 x 2 1/2 (10.3 x 6.2)
Printed inscription on verso: "Wm. Everden, Photographer, No. 89 Main Street, Lafayette, Ind."
C-176

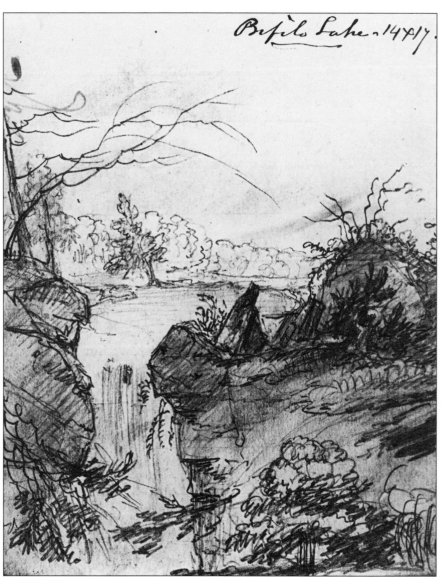

454.
3 7/8 x 5 3/8 (9.7 x 13.5)
F-294

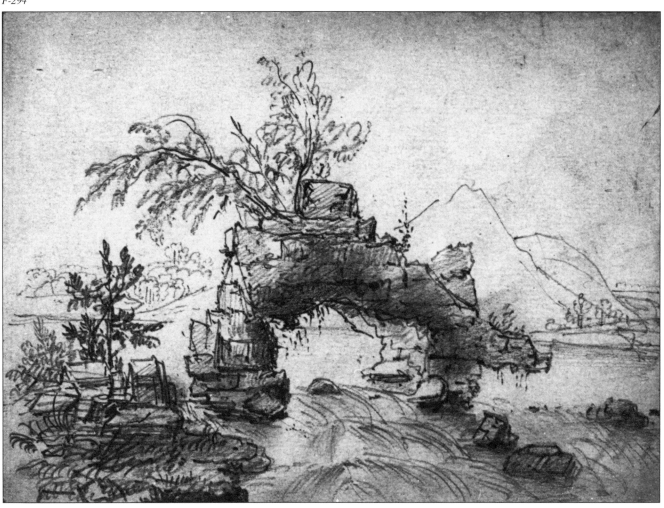

455.
Ink, wash, and graphite on paper, lined on verso
4 x 5 1/4 (10.0 x 13.4);
comp. 3 3/8 x 5 1/4 (8.6 x 13.4)
C-163

456.
4 1/4 x 3 5/8 (10.8 x 9.0)
D-220

457.
Graphite on cardstock
4 1/8 x 2 1/2 (10.3 x 6.2)
Printed inscription on verso: "Wm. Everden,
Photographer, No. 89 Main Street, Lafayette, Ind."
C-175

458.
Graphite on section of envelope
3 x 2 3/4 (7.6 x 6.9)
F-290

459.
4 1/4 x 3 1/4 (10.7 x 8.2)
D-205

460.
4 1/4 x 3 3/8 (10.8 x 8.4)
D-203

461.
Graphite on cardstock
3 5/8 x 2 3/8 (9.2 x 5.8)
D-193

462.
Graphite on cardstock
3 5/8 x 2 3/8 (9.2 x 5.8)
D-191

463.
Graphite on laid paper; section of watermark
5 x 3 7/8 (12.6 x 9.7)
C-165

464.
Graphite on lined paper
4 7/8 x 3 7/8 (12.4 x 9.9)
F-297

465.
4 3/8 x 3 1/2 (10.9 x 8.8)
D-219

466.
4 1/4 x 3 1/4 (10.8 x 8.2)
D-206

467.
Graphite on laid paper with embossed seal showing
columned building, "Congress Parsons. Co.;"
watermark "PARSON"
5 x 4 (12.6 x 10.1)
C-166

468.
4 1/4 x 3 3/8 (10.7 x 8.6)
F-296

WITH WATERFALLS; OVAL COMPOSITIONS

469.
ARCH FALLS–8 1/2 x 6 1/4
4 3/8 x 3 1/2 (11.1 x 8.9);
comp. 2 5/8 x 1 5/8 (6.6 x 4.0)
E-259

470.
4 7/8 x 4 1/8 (12.1 x 10.2);
comp. 4 1/2 x 3 3/4 (11.2 x 9.4)
C-186

471.
4 1/8 x 3 3/4 (10.4 x 9.3);
comp. 3 1/2 x 2 5/8 (8.6 x 6.5)
D-224

472.
4 x 3 1/2 (10.2 x 8.7);
comp. 3 3/8 x 2 5/8 (8.6 x 6.5)
D-223

473.
5 5/8 x 4 1/4 (14.3 x 10.7);
comp. 4 5/8 x 3 1/2 (11.5 x 8.7)
F-298

474.
4 1/4 x 3 1/4 (10.8 x 8.2);
comp. 4 1/4 x 3 1/8 (10.8 x 7.8)
D-207

475.
4 1/4 x 3 1/4 (10.7 x 8.2);
comp. 4 1/8 x 3 1/4 (10.5 x 8.0)
D-208

WITH FIGURES; RECTANGULAR COMPOSITIONS

These studies may have been preliminary sketches for finished oils such as the following, from Winter's distribution of paintings, Burlington, Iowa, 31 December 1856:

"'North Hill.' . . . A long stretch of the River extends before the gaze, dotted with many Islands. The east side of the River is bounded by a belt of timber that makes a converging line, contributing to the perspective effect. The foreground stands high above the River.–Two hunters in the foreground have a telling effect." (GWMSS 2-1 [20a])

476.
Watercolor on paper
3 x 3 7/8 (7.7 x 9.7)
M-96

477.
Graphite on lined paper
3 7/8 x 4 7/8 (9.6 x 12.3)
F-291

478.
3 x 4 3/4 (7.3 x 11.8)
D-198

479.
Ink on paper
4 1/4 x 3 1/4 (10.6 x 8.3)
D-209

480.
Graphite on cardstock
2 1/2 x 4 1/8 (6.2 x 10.2)
Printed inscription on verso: "Wm. Everden,
Photographer, No. 89 Main Street, Lafayette, Ind."
C-178

481.
2 1/2 x 3 7/8 (6.2 x 9.7)
F-288

482.
4 3/8 x 3 1/8 (11.1 x 8.0)
D-197

483.
4 x 5 1/8 (10.0 x 12.8)
C-187

484.
3 1/4 x 4 1/4 (8.2 x 10.7)
D-204

485.
Graphite on paper, lined on verso
5 1/4 x 3 3/4 (13.1 x 9.5)
C-162

486.
Graphite on cardstock
2 1/4 x 3 5/8 (5.7 x 9.2)
D-189

487.
Graphite on laid paper;
watermark "G & Co. [HOLY]OKE"
4 x 5 5/8 (9.9 x 14.2)
C-167

488.
Ink and graphite on paper
2 3/8 x 3 7/8 (6.0 x 9.8)
C-159

489.
Ink and graphite on paper
3 x 2 3/8 (7.5 x 5.8)
E-284

490.
4 3/8 x 5 3/8 (10.9 x 13.4)
F-300

491.
Graphite on cardstock
3 5/8 x 2 1/4 (9.2 x 5.7)
Inscribed, verso: calculations of prices for paintings
D-192

492.
3 x 2 3/4 (7.7 x 6.9)
E-273

493.
Graphite on laid paper
4 x 5 1/8 (10.1 x 12.8)
C-164

WITH FIGURES; OVAL COMPOSITIONS

494.
Oil on paper, glued on heavy cardboard
10 1/2 x 14 (octagonal) (26.6 x 35.4);
comp. 10 1/2 x 13 5/8 (26.4 x 34.5)
N-8

495.
4 x 5 5/8 (10.1 x 14.2);
comp. 3 3/8 x 4 1/2 (8.6 x 11.4)
D-234

496.
5 3/8 x 8 3/4 (13.6 x 22.1);
comp. 4 7/8 x 7 (12.4 x 17.6)
F-301

497.
4 7/8 x 3 3/4 (12.2 x 9.5);
comp. 4 1/2 x 3 1/2 (11.4 x 9.0)
F-295

498.
5 1/4 x 4 1/8 (13.2 x 10.2);
comp. 4 1/2 x 3 3/8 (11.4 x 8.6)
D-228

499.
5 5/8 x 4 1/4 (14.0 x 10.7);
comp. 4 5/8 x 3 1/2 (11.5 x 8.7)
E-269

500.
4 x 4 1/8 (10.1 x 10.2);
comp. 3 1/2 x 2 5/8 (8.7 x 6.5)
D-221

501.
4 1/8 x 4 7/8 (10.3 x 12.4);
comp. 3 1/2 x 4 1/2 (8.7 x 11.4)
D-230

502.
3 3/4 x 4 1/8 (9.5 x 10.3);
comp. 2 5/8 x 3 3/8 (6.5 x 8.6)
D-222

503.
Graphite on onionskin paper
3 7/8 x 5 1/8 (9.9 x 13.1);
comp. 2 5/8 x 3 1/2 (6.4 x 8.8)
C-183

504.
6 3/8 x 5 3/4 (16 x 14.4);
comp. 6 3/8 x 5 3/4 (16 x 14.4)
C-188

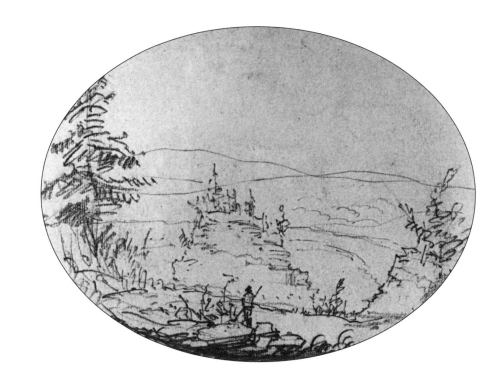

WITH FIGURES CROSSING BRIDGES;
RECTANGULAR COMPOSITIONS

505.
Ink and graphite on cardstock
3 x 2 1/2 (7.5 x 6.2)
Printed inscription on verso: "Wm. Everden,
Photographer, No. 89 Main Street, Lafayette, Ind."
C-180

506.
4 x 5 (9.9 x 12.7)
E-261

507.
4 x 5 1/8 (10.2 x 12.8)
E-262

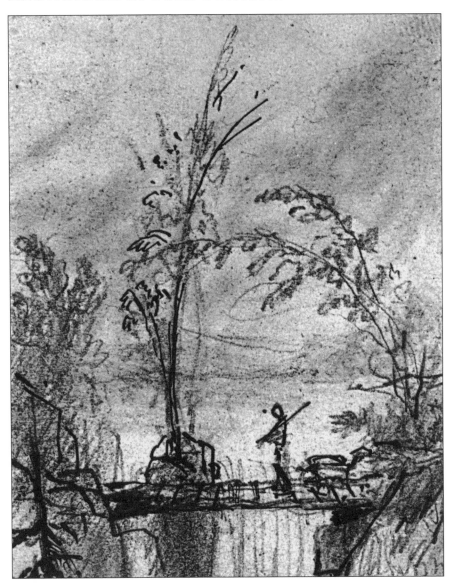

WITH FIGURES CROSSING BRIDGES;
OVAL COMPOSITIONS

508.
Ink and graphite on paper
6 5/8 x 5 3/8 (16.7 x 13.6)
Equestrian on wooden bridge over stream;
on verso of Cat. #562
E-258v

509.
5 5/8 x 8 5/8 (14.2 x 21.8);
comp. 5 x 7 (12.6 x 17.6)
E-263

510.
8 1/8 x 4 (20.4 x 10.1);
comp. 4 1/2 x 3 3/8 (11.4 x 8.6)
D-238

511.
4 1/2 x 3 1/2 (oval) (11.5 x 8.7);
comp. 4 1/2 x 3 1/2 (11.5 x 8.7)
D-226

512.
Graphite on brown envelope
3 5/8 x 4 5/8 (9.2 x 11.7);
comp. 3 5/8 x 4 1/4 (9.2 x 10.8)
E-281

WOODED LANDSCAPES
RECTANGULAR COMPOSITIONS

These studies may have been preliminary sketches for finished oils such as the following, described in several of Winter's painting distribution notices:

"'The Upper Bend'–Scene on the Wabash near Logansport; decline of day; a wide bay-like appearance characterizes the view; foliage tinged with autumnal tints." (Distribution, Lafayette, 3 April 1852; GWMSS 2-1 [7])

"'The Upper Wabash,' An island in the middle distance. In the foreground fragments of rock fringed with tall grass and weeds–Autumnal season–sky lurid and mellow–a warm glow suffused throughout the painting." (Distribution, Lafayette, 29 December 1852; GWMSS 2-1 [8])

"'Moonlight Scene.' A view on the Wabash, near Tipton's residence. The river is expansive and diversified by an island, and large bolders. A reclining tree in the foreground opposes its dark foliage to the sky. The moon is rising and throws her light upon the rippling water, giving it a brilliant effect." (Distribution, Lafayette, 31 December 1857; GWMSS 2-1 [21])

"'Wabash River.' This is a cabinet painting of a peculiar mellow tone of color. This view is taken near the confluence with the Red River. Heavy timber on either side of the Wabash and two islands add much to the picturesque effect." (Distribution, Lafayette, 31 December 1857; GWMSS 2-1 [21])

513.
Graphite on yellow envelope
3 1/4 x 5 1/2 (8.1 x 14.0)
Computations on verso
E-274

514.
3 1/4 x 4 1/2 (8 x 11.2)
C-153

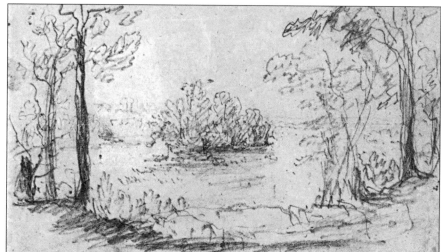

515.
1 7/8 x 2 3/8 (4.7 x 5.9)
E-267

516.
Graphite on cardstock
4 1/8 x 2 1/2 (10.3 x 6.2)
Printed inscription on verso: "Wm. Everden,
Photographer, No. 89 Main Street, Lafayette, Ind."
C-177

517.
Graphite on cardstock
2 x 3 1/8 (5.0 x 7.8)
D-195

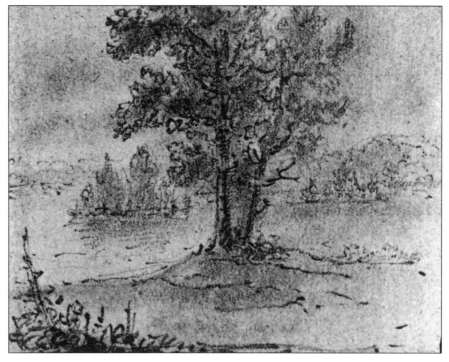

518.
3 1/4 x 4 3/8 (8.1 x 11.2)
C-154

519.
3 1/4 x 4 3/8 (8.1 x 11.0)
C-155

520.
Graphite on cardstock
2 x 3 (5.0 x 7.5)
D-194

521.
Graphite on cardstock
4 1/8 x 2 1/2 (10.3 x 6.2)
Printed inscription on verso: "Wm. Everden,
Photographer, No. 89 Main Street, Lafayette, Ind."
C-179

522.
2 5/8 x 4 (6.4 x 10.0)
E-271

523.
Graphite on blue laid paper, lined on verso
3 1/2 x 7 7/8 (8.7 x 20.0)
Computations on verso
E-278

524.
Graphite on paper, lined on verso
2 x 3 (5.0 x 7.6)
C-160

525.
3 x 4 3/8 (7.4 x 11.1)
E-266

526.
2 3/8 x 3 1/4 (5.8 x 8.3)
C-173

527.
2 1/4 x 3 1/4 (5.8 x 8.2)
C-174

528.
8 3/4 x 6 1/2 (22.2 x 16.5)
Inscribed, verso: computations regarding costs and
charges for artistic commission
E-279

529.
Graphite on cardstock
3 x 5 1/4 (7.3 x 13.1)
Printed notice for distribution of paintings,
30 December 1869, on verso
E-268

OVAL COMPOSITIONS

WITH FIGURES

These studies may have been preliminary sketches for finished oils such as the following, described in Winter's painting distribution notices:

"'Upper Wabash.'–A beautiful bend of the Wabash in vicinity of Lafayette. The sun is setting, and the red clouds of evening float upon the warm sky. Water clear, imaging the woody banks–figure and dog in middle distance–foreground rich in color and variety of tangled weed, and logs of decaying timber." (Distribution, Evansville, Indiana, 24 December 1853; GWMSS 2-1 [12])

"'Twilight.'–Scene on the Wabash, representing a bend of the river–a clump of trees on the bank throws the distance in good perspective. Two figures stand in the centre of the scene–foreground broken and varied. Subdued coloring in accordance with the sentiment conveyed." (Distribution, Lafayette, 16 March 1854; GWMSS 2-1 [12a])

"'Eel River.'–The sun is setting–shafts of light shoot up, giving a pleasing effect. Red cloudlets float above the horizon–Autumnal tints enrich the forest trees–the river gracefully winds its way beneath the bluff. Boy and dog in the foreground." (Distribution, Lafayette, 16 March 1854; GWMSS 2-1 [12a])

534.
3 7/8 x 5 1/2 (9.6 x 13.8)
F-289

535.
Ink wash and graphite on paper
2 3/4 x 4 1/4 (6.8 x 10.5)
C-170

536.
3 1/4 x 4 1/4 (8.3 x 10.6)
D-213

537.
[TWO FIGURES ON RISE OVERLOOKING PLAIN]
4 1/4 x 12 1/4 (10.6 x 30.9)
E-243

538.
[TWO FIGURES ON HILL OVERLOOKING PLAIN]
3 1/2 x 8 3/8 (8.9 x 21.1)
E-245

539.
[FOUR FIGURES ON HILL]
Graphite on grey paper
3 1/8 x 7 1/4 (7.8 x 18.4)
E-240

540.
[FOUR FIGURES ON HILL]
3 1/4 x 7 3/8 (8.1 x 18.7)
Similar to Cat. #539
E-239

541.
[FOUR FIGURES ON HILL]
1 5/8 x 3 5/8 (4.0 x 9.0)
Similar to Cat. #539
Computations on verso
E-242

542.
[FOUR FIGURES ON HILL]
1 5/8 x 3 1/2 (4.0 x 8.9)
Similar to Cat. #539
E-241

543.
[HUNTER WITH RIFLE]
11 1/4 x 9 1/4 (28.6 x 23.5)
Inscribed, l.r.: "Sketched India 1850."
Similar figure appears in Cat. #537 and 539
E-244

544.
[GROUP ON HILL OVERLOOKING PLAIN]
Ink on grey paper
2 1/8 x 7 1/4 (5.3 x 18.4)
E-247

545.
[HUNTERS ON HILL OVERLOOKING
PLAIN]
Brown ink, wash, and graphite on lined paper
4 1/4 x 9 7/8 (10.5 x 25.1)
E-246

546.
2 5/8 x 3 7/8 (6.4 x 9.9)
E-275

547.
8 1/2 x 13 (21.5 x 33.0)
Inscribed, verso, l.r.: "About 1866"
Includes suggestion of building in wooded landscape
B-102

548.
2 1/4 x 3 1/2 (5.7 x 8.8)
Includes suggestion of structure and balloon
F-287

549.
3 1/4 x 4 1/4 (8.3 x 10.7)
Equestrian figure
D-210

550.
Graphite on lined paper
2 x 2 7/8 (5.0 x 7.3)
C-158

551.
2 x 2 3/8 (5.0 x 5.9)
C-161

552.
Graphite on lined paper
2 5/8 x 4 3/4 (6.5 x 12.0)
Suggestion of tent near group of figures
C-157

553.
Graphite on lined paper
2 3/4 x 3 1/2 (7.1 x 9.0)
Suggestion of two equestrians on lakeshore
C-156

554. (see Plate 56)
[MAN AND DOG IN RURAL
LANDSCAPE WITH LOG CABIN]
Watercolor on paper; in gilt frame
14 x 16 7/8 (oval) (35.4 x 42.7);
comp. 11 x 13 7/8 (oval) (28.0 x 35.3)
Frame: 22 7/8 x 20 (58.1 x 51.0)
2692.1

555.
4 1/8 x 4 7/8 (10.4 x 12.3);
comp. 3 1/2 x 4 1/2 (oval) (8.7 x 11.4)
D-231

(554) Notice of Winter's distribution of paintings, Lafayette, 16 March 1854:

"'Moonlight.'–A view representing a bayou running from the Big Miami, in vicinity of Dayton, Ohio. The moon just rising upon the horizon–the cumulous clouds receive the silvery light–the sparkling brilliancy of the water is striking in its effect. The light seen in the cabin in the middle distance cheers the old hunter, followed by his faithful dog, crossing a fallen tree, giving hopes for a comfortable rest for the night." (GWMSS 2-1 [12a])

WITH FIGURES IN BOATS

These studies may have been preliminary sketches for finished oils such as the following, described in the notice for Winter's distribution of paintings, Evansville, Indiana, 24 December 1853:

"'Eel River,' representing a fine scene. The view is taken above its confluence with the Wabash. The Indian summer haze rests upon it. The foliage indicates the autumn season. A flat boat in the distance—foreground rich in variety of weed and shrub." (GWMSS 2-1 [12])

556.
4 x 5 (9.9 x 12.6)
E-265

557.
Graphite on laid paper;
watermark "[PARS]ONS Co. [HOL]YOKE"
3 7/8 x 5 5/8 (9.8 x 14.3)
Two studies of man in broadbrim hat,
holding rifle, on verso
C-168

558.
Graphite on lined blue paper
2 1/2 x 4 (6.4 x 10.0)
E-264

559.
3 3/8 x 4 1/4 (8.4 x 10.7)
D-202

560.
10 1/8 x 14 3/4 (25.5 x 37.4)
Rough sketch includes pole barge,
log house on riverbank, covered wagon;
sheet is blocked into squares
OV-302

561.
Graphite and ink on cardstock
2 1/2 x 4 1/8 (6.2 x 10.4);
comp. 2 1/8 x 1 7/8 (oval) (5.3 x 4.7)
Printed inscription on verso reads "Wm. Everden,
Photographer, No. 89 Main Street, Lafayette, Ind."
C-181

LANDSCAPES WITH CARTS AND WAGONS

These studies may have been preliminary sketches for finished oils such as the following, as described in the notice for Winter's distribution of paintings, Lafayette, 7 January 1860:

"'Market Cart.' After Gainsborough, a very pleasing scene representing the dawn of day, a patch of woods in shade, by which a brook is running. The old gray horse and cart fording. Two figures and the good supply of vegetables in the rude vehicle give interest to this effort." (GWMSS 2-1 [32])

562.
"FORDING THE BROOK"
Ink and graphite on paper
5 3/8 x 6 5/8 (13.6 x 16.7)
E-258

563.
THE OLD OX CART
Graphite and ink on paper
5 3/8 x 8 3/4 (13.6 x 22.1)
E-248

(563) Notice of Winter's distribution of paintings, Lafayette, 7 January 1860:

"'The Old Ox Cart.' The team moves slowly along near a run. A boy sits leisurely in the old cart." (GWMSS 2-1 [32])

564.
[BOY IN CART ON PLANK BRIDGE]
Ink on paper
8 x 10 1/8 (20.3 x 25.6)
On verso of Cat. #615
I-623

565.
[SCENE WITH CAMPSITE, COVERED WAGON]
Graphite on paper
3 1/2 x 5 1/8 (8.7 x 12.9)
Rough sketch of dead fowl on verso
F-286

566.
THE [EMIGRANTS]
Ink on cardstock
1 3/4 x 2 (4.3 x 5.0)
Measurements, perhaps for paintings, on verso
E-283

567.
[SCENE WITH MAN DRIVING CART]
Graphite on paper
1 7/8 x 3 1/2 (4.8 x 8.9)
E-282

568.
[SCENE WITH MAN DRIVING CART]
Graphite on green paper
2 7/8 x 5 (7.2 x 12.6)
C-172

569.
[OXCART FORDING RIVER]
Graphite on paper
4 3/4 x 3 3/4 (12.0 x 9.2);
comp. 4 5/8 x 3 1/2 (oval) (11.5 x 8.7)
Portion of printed notice for distribution of
paintings, 28 December 1867, on verso
E-249

(566) Notice for Winter's distribution of paintings, Lafayette, 7 January 1860:

"'The Emigrants.' This is a very pleasing painting representing movers crossing the creek. The ox team, and the white covered wagon are familiar westward. The foliage is rich and full." (GWMSS 2-1 [32])

LANDSCAPES WITH ANIMALS

These studies may have been preliminary sketches for finished oils such as the following, described in notices for Winter's painting distributions:

"'Cows Reposing.' A Cabinet Painting, representing Cows in the shade of soft maple trees, relieved by a placid stream." (Distribution, Burlington, Iowa, 25 August 1856; GWMSS 2-1 [19])

"'Cows Fording.' A river scene, with Island in the middle distance– boulders and rock exposed, fringed with weeds–Cows fording the river." (Distribution, Burlington, Iowa, 25 August 1856; GWMSS 2-1 [19])

"'Returning Home.' An Original Composition. This painting glows with the warm tints of Autumn. In the distance high broken bluffs loom up above the timber, fringing a water course–a cascade dashes down into the creek which winds gracefully to the foreground. A group of cows crossing the creek, returning home, give a pleasing effect to the scene." (Distribution, Burlington, Iowa, 31 December 1856; GWMSS 2-1 [20a])

"'Cattle Group.' A river view with Cows in the foreground. The banks well wooded–a graceful bend of the river extends to the middle distance, forming a lake-like appearance. The cattle in the foreground rest in the partial shade of trees." (Distribution, Lafayette, 7 January 1860; GWMSS 2-1 [32])

570.
[WOODED LANDSCAPE WITH FOUR COWS]
Ink and graphite on lined paper
4 1/8 x 6 3/8 (10.3 x 16.1)
Section of a manuscript (in G. W.'s hand)
describing a cascading waterfall on verso
E-251

571.

**[CATTLE AND LOG CABIN ON
RIVERBANK]**

Ink and wash on paper
8 7/8 x 10 7/8 (22.5 x 27.6);
comp. 5 1/2 x 7 5/8 (13.9 x 19.2)
Inscribed, l.r.: "Original–Geo Winter"
E-250

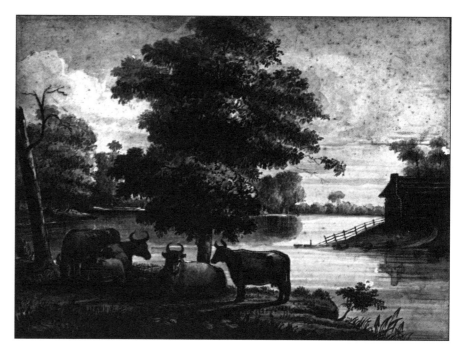

(571) Notice of Winter's distribution of paintings, Lafayette,
29 December 1852:

"'Log Cabin and Cattle.' A group of cows form the principal interest
of the scene. A shady and sylvan retreat–relieved by warm setting sun."
(GWMSS 2-1 [8])

572.

[LANDSCAPE WITH FIVE HORSES]

Brown wash and graphite on paper
8 3/4 x 12 3/4 (22.1 x 32.3)
Inscribed, l.r.: "May 1848"
A-46

573.

**[SCENE WITH CATTLE AND LOG
CABIN]**

Ink and graphite on paper
3 1/4 x 4 1/4 (8.1 x 10.8)
Suggestion of log structure on verso
E-254

574.

[CATTLE IN GROVE OF TREES]

Graphite on paper
8 3/4 x 10 3/4 (22.0 x 27.3)
E-252

575.

[CATTLE ON RIVERBANK]

Graphite on cardstock
1 7/8 x 3 1/8 (4.5 x 7.9)
Computations on verso
D-190

576.

**[WOODED LANDSCAPE WITH
CATTLE ON RIVERBANK]**

Graphite on green paper
2 3/8 x 5 (5.9 x 12.7)
C-171

577.

[HERD OF DEER ON LAKESHORE]

Graphite on paper
4 3/4 x 7 (12.0 x 17.7)
Suggestion of landscape on verso
E-255

578.

**[WOODED LANDSCAPE WITH
CRANE ON RIVERBANK]**

Graphite on paper
3 1/2 x 4 1/4 (8.8 x 10.6)
A-24

579.

**[WOODED LANDSCAPE WITH
CATTLE]**

Graphite on blue paper
8 x 9 1/8 (20.3 x 23.0);
comp. 5 5/8 x 8 5/8 (oval) (14.0 x 21.9)
E-253

580.

**[WOODED LANDSCAPE WITH
CATTLE ON LAKESHORE]**

Graphite on paper
8 5/8 x 11 1/4 (21.9 x 28.3);
comp. 7 7/8 x 9 3/4 (oval) (19.8 x 24.7)
E-280

A N I M A L & S P O R T I N G
S T U D I E S

ANIMALS AND BIRDS

581.
[GROUP OF SHORTHORN CATTLE]
Graphite on paper
7 7/8 x 11 1/4 (19.8 x 28.6)
I-576

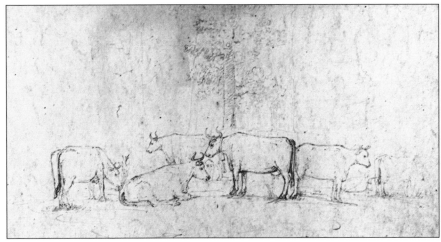

582.
[GROUP OF SHORTHORN CATTLE]
Graphite on paper
8 7/8 x 13 (22.3 x 33.0)
I-575

583.
[SHORTHORN COW]
Graphite on paper
4 x 5 3/8 (9.9 x 13.6)
I-573

584.
[SHORTHORN COW]
Graphite on paper
4 7/8 x 11 (12.3 x 27.7)
I-577

585.
[PAIR OF YOKED OXEN]
Graphite and ink on yellow tissue paper
3 3/8 x 6 (8.6 x 15.1)
I-574

(581) Notice of Winter's distribution of paintings, Evansville, Indiana, 24 December 1853:

"'Cattle Scene.'–The principal interest of this scene is a group of Cows reposing beneath the shade of a majestic leafy oak–a warm mellow sky forms the background, agreeably relieving the foreground group." (GWMSS 2-1 [12])

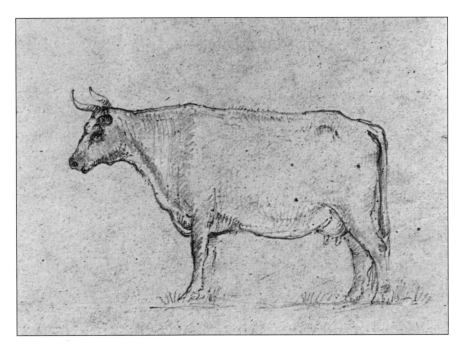

586.
[DOG IN THREE POSITIONS]
Graphite on paper
8 3/8 x 12 1/8 (21.2 x 30.6)
Inscribed, l.r.: "Sketched from life–Lafayette,
Indiana Nov. 17th 1850."
I-567

587.
[DOG IN FIVE POSITIONS]
Graphite and ink on paper
11 7/8 x 8 7/8 (30.2 x 22.4);
comp. 6 x 8 7/8 (irreg) (15.2 x 22.4)
On same sheet as Cat. #607
I-568

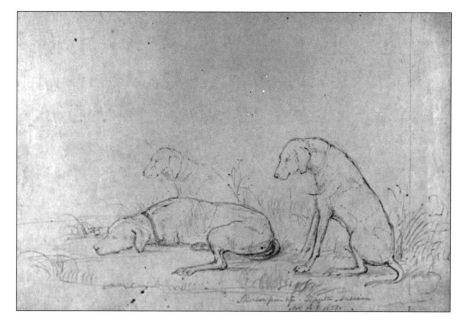

588.
[DOG WEARING COLLAR]
Ink and graphite on paper
5 5/8 x 4 5/8 (14.1 x 11.6)
I-564

589.
[DOG WEARING COLLAR]
Graphite and ink on yellow tissue paper
6 7/8 x 5 1/4 (17.5 x 13.3)
Similar to Cat. #588
I-565

590.
[SLEEPING DOG]
Graphite on paper
8 5/8 x 11 1/4 (21.9 x 28.4)
I-566

591.
[MAN LEANING AGAINST SADDLED HORSE]
Graphite on paper
7 3/4 x 10 3/4 (19.6 x 27.1)
I-572

592.
[TETHERED HORSE WITH SADDLE]
Graphite on lined paper
6 x 7 3/4 (15.2 x 19.6)
I-569

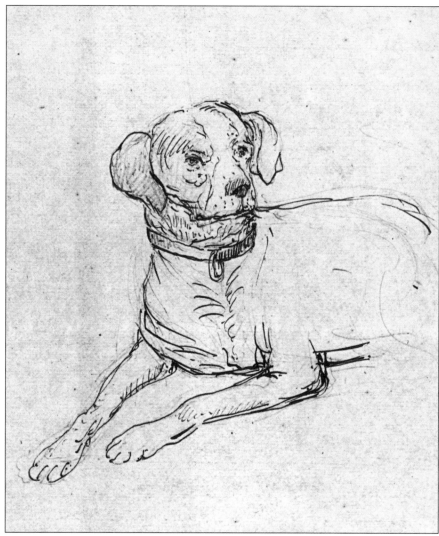

593.
[HORSE WITH CROPPED TAIL]
Graphite on paper
5 1/2 x 8 3/4 (13.8 x 21.9)
I-570

594.
[HORSE WITH CROPPED TAIL]
Graphite on paper
8 7/8 x 10 3/4 (22.3 x 27.3)
I-571

595.
[TWO STUDIES OF STAGS]
Graphite on blue paper, lined on verso;
graphite and ink on laid paper with embossed seal;
both glued to heavy paper
7 1/2 x 10 (19.1 x 25.2) (sheet size)
comp. A: 2 1/2 x 4 (6.3 x 10.1)
comp. B: 3 5/8 x 3 5/8 (9.0 x 9.1)
I-580

596.
[DEER HEADS WITH ANTLERS]
Graphite and ink on paper
2 5/8 x 4 1/2 (6.7 x 11.1)
Inscribed, l.l.: "George Winter"
On verso: faint sketch of emblem with the following
motto, in block letters, surrounding a sculpture
fountain: "Lafayette Section. Instituted 1849.
Truth, Virtue, & Deliverance."
I-579

597.
[STUDY OF DEAD DEER]
Graphite on blue paper, lined on verso
1 7/8 x 3 7/8 (4.6 x 9.7)
I-578

598.
[STUDY OF CRANES]
Graphite on paper
10 1/2 x 8 7/8 (26.6 x 22.5)
I-581

599. (see Plate 57)
[TWO HUMMINGBIRDS]
Watercolor and graphite on paper
6 5/8 x 8 3/8 (16.8 x 21.1)
M-91

600.
[TWO SWANS]
Graphite on paper
2 x 4 1/4 (4.9 x 10.6)
I-583

601.
[OWL WITH WINGS IN TWO POSITIONS]
Ink on paper, lined on verso
3 x 3 1/8 (7.4 x 7.9)
I-582

602.
[STUDY OF BIRD'S HEAD]
Ink on blue paper, lined on verso
1 3/4 x 7 5/8 (4.3 x 19.1)
I-584

HUNTERS, FISHERMEN, BOATERS

603.
[HUNTER WITH RIFLE]
Graphite on paper
11 1/4 x 9 1/4 (28.5 x 23.5)
I-610

604.
[TWO HUNTERS]
Graphite on paper
4 1/4 x 5 1/2 (10.5 x 13.7)
Inscribed, l.l.: "Blue shirt–Back of vest red.–
Brown wamus–blue pants."
I-611

605.
[SEATED MAN WITH DOG]
Graphite on paper
3 5/8 x 4 1/4 (9.0 x 10.8)
I-612

606.
[STUDY OF RIFLE]
Graphite on paper
6 1/8 x 1 7/8 (15.5 x 4.6)
I-608

607.
[FLINTLOCK RIFLE ON ROCK]
Watercolor and ink on paper
11 7/8 x 8 7/8 (29.0 x 22.8);
comp. 2 1/2 x 8 7/8 (irreg.) (6.5 x 22.4)
On same sheet as Cat. # 587
I-568

(605) Notice of Winter's distribution of paintings, Lafayette, 12 March 1859:

"'The Days Success.' A hunter is represented with his dog reposing in the shade of friendly trees. The sportsman sits with his dog, carelessly holding his gun, and the faithful companion slumbers after the day's success. The trophies of the sport lay before the Sportsman, giving interest to the subject." (GWMSS 2-1 [31])

608.
[FIVE MEN WITH FISHING GEAR]
Ink and graphite on paper
3 3/8 x 5 1/8 (8.5 x 12.8)
Portion of printed notice for distribution of
paintings, Lafayette, 4 April 1852, on verso
I-613

609.
[THREE MEN WITH FISHING GEAR]
Ink and graphite on lined blue paper
2 1/2 x 4 (6.4 x 10.1)
Outline drawing of man with pail on verso
I-616

610.
[MAN WITH FISHING POLE]
Ink and graphite on lined blue paper
4 x 2 1/2 (10.0 x 6.2)
Rough sketch of man on plank bridge on verso
I-617

611.
[THREE FIGURES WITH FISHING
GEAR]
Graphite on paper
3 3/8 x 4 (8.6 x 10.2)
Computations on verso
I-618

612.
**[STUDY OF POLE BARGES AND
ROWBOATS]**
Graphite on paper
5 3/4 x 9 1/2 (14.6 x 23.9)
I-614

613.
[TWO MEN IN ROWBOAT]
Graphite on paper
7 x 8 5/8 (17.6 x 21.9)
I-615

614.
[MAN POLING BOAT]
Graphite on paper
11 1/4 x 8 5/8 (28.3 x 21.9)
I-619

615.
**[POLE BARGE AND CANOES WITH
FIGURES]**
Ink on paper
8 x 10 1/8 (20.3 x 25.6)
On front of Cat. #564
I-623

PORTRAITS

Winter was a prolific painter of oil portraits (which included overpainted photographs), often as a result of commissions. Correspondence from his patrons reveals their interest in specifying details of the desired likeness. Occasionally a patron expressed dissatisfaction with the results of a commissioned work.

J. H. Dewey, [Delphi, Indiana], to G. W., [1863]:

"Enclosed please find my 'old Mam's' Likeness–taken some 8 years ago. . . . Please paint the 'old Gal' & make her a 'thing of life'. . . . Make her Beads show vividly, for they are the oldest relic, in the 'Dewey tribe'–they are pure Gold. . . .

Make frame–say 1/2 or 2/3d the size of mine & oval!–take good care of this likeness & return it with the pictur!–I am 'lectioneering for several similar Jobs here for you–and when they see mine & Mam's–I think they'll bite!" (GWMSS 1-17 [10])

J. H. Dewey, Delphi, Indiana, to G. W., 20 March [1863]:

"Well what I wish to 'spread' to you, now is–the *Kuller*, of *my family*–1st place–old Mam!–She has a beautiful *light Blue* Eye–*Har*–the color–that 60 years makes–mixture of Grey & Auburn–My Wife–Hair–*very light Brown*–Eyes–light Blue–Allie–Hair light Brown–Eyes–light Blue. . . .

Allie–is the gal that I wanted you to change the Dress on bosom–Nellie–I think, is a little too much stooped, in the picture, I took down–she ought to have sit up more like Allie–dont know as you can change the position any. . . .

Now George I want you to do your 'dirty best', on my tribe, for, I want to beat some pictures in town here–& aside from that, I, of course want the Job done Bully! Please get the Eyes & Hair of my tribe up according to directions–& make the oldest girls dresses plain, & dark, as you spoke of last night." (GWMSS 1-17 [27])

Harriet A. Groat, Troy, [New York], to G. W., 9 October 1848:

"Mr G is highly pleased with [the paintings] & Fathers Portrait he thinks excellent & said as soon as I opened it well there is the old Col. & every one is of the opinion that he is a fine looking old Gent. Our Portraits I cannot say much for. & as you say you, I know laboured under disadvantage in painting them so far away no one has recognised mine atall & we do not think it a good one. LG is a little like him but no one thinks it a good one & he says he does not feel as though he ought to pay for them until they can be altered. which no one else shall do but your self. I am sorry for my part that they have been done or that we could have waited until you could have had us nearer to you. if you are not pleased at this you must write Mr Groat as he will have the money to pay, but he does not feel as though he ought to pay for the Portraits." (GWMSS 1-11 [10])

Winter's paintings sometimes inspired unexpectedly positive reactions from viewers.

G. W., Lafayette, Indiana, to Nette Ball, 3 January 1870:

"'The Cottage Children–' 'The Gleaner'–'Girl and Dog–', and 'Girl Feeding the Pigs'–are paintings that you would have liked. People were surprised at them. They did not know that I could paint figures so well." (GWMSS 1-22 [2])

Winter's early training as a miniaturist led to commissions in this genre, as well.

Horace P. Biddle, Logansport, Indiana, to G. W., 2 April 1843:

"I intend to have you take me off in miniature, and I wish to procure a case. There is none in Indianapolis, which will make it necessary to send to Cincinatti.

Please say if you have the ivory to take it upon, and what size shall the case be? Tell me also the different prices for good cases–so that I may know what to order." (GWMSS 1-7 [17])

Posthumous portraits were also part of Winter's commissioned work.

W. Z. Stuart to G. W., 20 July 1846:

"You will please attend at my house immediately & take a sketch of my beloved wife now cold in death & oblige" [GWMSS 1-9 [10]]

The majority of his finished portraits were executed in oil; the images presented here were probably preliminary studies for these works.

MALE PORTRAITS

The following (Cat. #616 through 639) are bust portraits of male subjects.

616.
Graphite on paper, mounted on cardstock
3 x 2 3/8 (7.5 x 6.0)
H-482

617.
Graphite on paper, mounted on cardstock
3 x 2 3/8 (7.5 x 5.9)
H-484

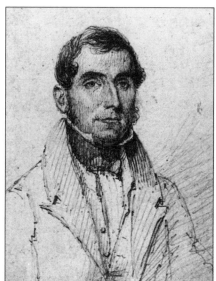

618.
Graphite on paper, mounted on cardstock
2 5/8 x 2 3/8 (6.5 x 5.9)
H-483

619.
Graphite on cardstock
2 1/2 x 2 1/8 (6.3 x 5.3)
Inscribed, verso: "1/2 paid on Monday"
"M. U. [Bird?]"
H-486

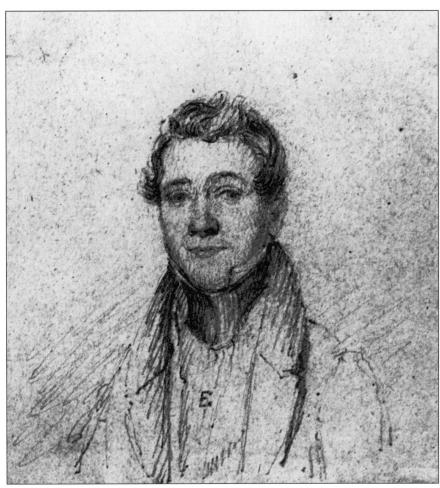

620.
Graphite on paper
3 x 2 (7.4 x 4.9);
comp. 2 1/8 x 1 3/4 (oval) (5.2 x 4.2)
H-471

621.
Graphite on paper
2 3/4 x 2 (6.8 x 5.0);
comp. 2 1/8 x 1 3/4 (oval) (5.4 x 4.4)
H-472

622.
Graphite on paper
2 1/4 x 2 1/4 (5.7 x 5.6)
H-473

623.
Graphite on cardstock
2 1/2 x 2 1/8 (6.3 x 5.2)
Inscribed, verso, u.c.: "GHopkins"
H-485

624.
Graphite on paper
2 3/8 x 2 3/8 (5.9 x 6.1);
comp. 1 7/8 x 1 5/8 (oval) (4.7 x 3.9)
H-494

625.
Graphite on paper
1 7/8 x 1 3/4 (oval) (4.8 x 4.3)
H-493

626.
Graphite on paper
3 3/4 x 2 7/8 (9.4 x 7.2)
H-495

627.
SAMBO.
Graphite on paper
3 x 2 7/8 (7.6 x 7.1);
comp. 2 1/8 x 2 1/4 (5.3 x 5.6)
H-536

628.
Graphite on paper
2 1/8 x 2 5/8 (irreg.) (5.2 x 6.7);
comp. 1 3/4 x 1 3/8 (oval) (4.3 x 3.5)
H-491

629.
Graphite on paper
7 1/8 x 4 (18.1 x 10.2)
G-418

630.
Graphite on paper
10 3/4 x 7 3/4 (27.1 x 19.5)
H-498

631. (see Plate 58)

**SKETCH OF GENL JOHN TIPTON
U.S.S. THE MORNING AFTER HIS
DEATH–GW**

Observed 1839

Watercolor on cardstock

6 3/8 x 4 3/8 (15.9 x 11.0)

*Inscribed, verso, u.c.: "Genl John Tipton Who gave
the Battle Ground to the State of"*

M-85

632.

**[PORTRAIT OF GENERAL JOHN
TIPTON]**

Watercolor on cardstock

3 3/8 x 2 3/4 (8.3 x 7.0)

M-86

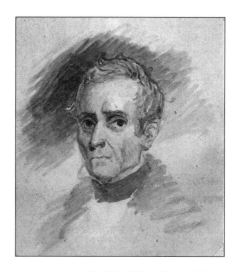

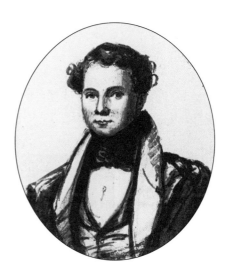

633.

Wash on cardstock

2 3/4 x 2 1/2 (7.0 x 6.3);

comp. 2 3/4 x 2 (oval) (6.8 x 5.1)

H-477

634.

Wash on cardstock

2 1/2 x 2 1/4 (6.3 x 5.7)

H-476

(631) G. W., "Sketches of Logansport, No. 2.," *Logansport Telegraph,* 9 October 1841:

"Whatever might be the differences in political opinion with John Tipton, none can withhold assent to his being a good citizen–a brave soldier, and a statesman. His death was a severe blow to the immediate interests of Logansport. He had just returned from the U. S. Senate, of which he was no mean member, to the bosom of his family, from which an active public career had necessarily severed him. John Tipton had come home to guard over the interests of his family, and to carry into effect the well devised and considered plans, which would give an impetus to his own fortune, which was identified with the advancement of this important section of the great Wabash valley. Had he lived–for he had influence abroad, and wealth at his command, the immediate great changes that would have been wrought cannot be easily specified." (GWMSS 1-7 [7])

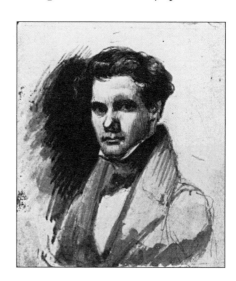

635.
Wash on paper, mounted on cardstock
2 1/2 x 2 1/4 (6.1 x 5.7)
H-479

636.
Wash on paper, mounted on cardstock
2 1/2 x 2 3/8 (6.4 x 5.9)
H-480

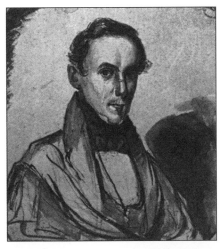

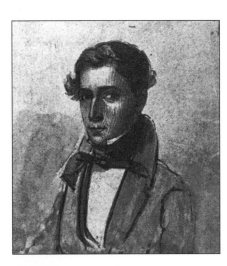

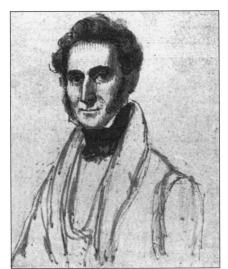

637.
Wash on paper, mounted on cardstock
2 3/8 x 2 1/4 (6.0 x 5.8)
H-481

638.
Wash, ink, and graphite on cardstock
3 3/4 x 3 (9.3 x 7.4)
H-478

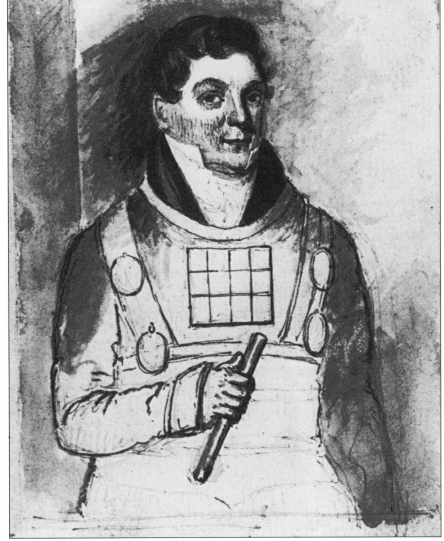

639.
[PORTRAIT OF A YOUNG BOY]
Watercolor on paper; mounted on cardstock
7 3/8 x 5 3/8 (oval) (18.7 x 13.4)
M-87

640.
[PORTRAIT OF A BABY]
Watercolor and graphite on paper
6 1/4 x 4 7/8 (15.6 x 12.3)
Rough landscape on verso
H-465

641.
[PORTRAIT OF HENRY GEORGE WAGSTAFF]
Oil on paper, glued on board; in gilt frame
11 5/8 x 9 5/8 (oval) (29.3 x 24.5)
Frame: 17 3/8 x 15 3/8 (oval) (43.9 x 39.0)
Attributed by donor to George Winter, ca. 1862
4494

The following (Cat. #642 through 645) are torso and full-length portraits of male subjects.

642.
[MAN ON HORSEBACK]
Graphite on paper
10 1/2 x 7 5/8 (26.5 x 19.3)
H-497

643.
[MAN HOLDING HAT]
Graphite on paper
8 5/8 x 5 5/8 (21.9 x 14.2)
Faint sketch of man poling barge on verso
H-468

644.
[MAN WEARING HAT, HOLDING CANE]
Ink and graphite on blue laid paper with embossed seal
9 1/4 x 7 1/4 (23.4 x 18.4);
comp. 6 1/2 x 4 3/8 (16.4 x 11.0)
H-496

645. (see Plate 59)
MICHAEL R BOOSE SOLDIER OF THE WAR OF 1812 1869
Watercolor on paper
15 5/8 x 12 (39.4 x 30.4)
OV3-88

(645) "Reminiscence of *Michael R. Boos.–*

This venerable old man was introduced to me by Col E. Robinson. To-day [12 October 1869]–called at my studio–has been an invalid for some time–afflicted with Rheumatism of the spine–unable to walk erect–uses two staves, for supports. In ascending the stairway to my studio he had to crawl up upon his hand and knees–like a helpless child.

His mind is bright–memory excellent and much fluency of speech. . . .

. . . I understand Sir–addressing me on the introduction to M. R. Boos. I understand sir, that you are anxious to take my 'portrite' 'on oil cloth'.

M. R. Boos claims to have experienced many varied scenes in this world of struggles.

1820–Since this *date*–he has descended the Ohio–and Mississippi–23 times to New Orleans on flat boats. 19 times he piloted the boats himself. He graphically narrates among the many exploits of labors of . . . having dug–in the counties of Daviess, Vermillion, Clinton and Tippecanoe–*200 hundred* wells!!

He was a soldier in the war of 1812–and under Genls Hull–Harrison–and Brouce–was at Detroit in the surrender of Hull–was then a volunteer. . . .

Lived a bachelor life–up to *61* years of age. He remarked–*must tell* you a *joke*–though I was such an old bachelor–my wife in due time gave birth to *twins*.

The old man full of vivacity could relate many things of himself that might appear vain–and boastful–don't want to touch upon that. Have of course been in battle–and in skirmishes among the indians–some of them might be called battles." (GWMSS 2-8 [14])

FEMALE PORTRAITS

646.
Graphite on paper; mounted on cardstock
2 1/2 x 2 1/8 (6.4 x 5.2)
H-474

647.
Graphite on paper
3 5/8 x 3 1/8 (9.1 x 7.8)
H-470

 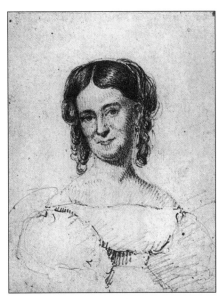

648.
Graphite on paper
3 1/2 x 3 1/8 (8.9 x 7.7)
Inscribed, u. c.: "colours Mrs. Middleton"
H-469

649.
Graphite on paper
3 1/8 x 3 1/8 (7.8 x 7.8);
comp. 2 3/8 x 2 1/8 (oval) (6.0 x 5.4)
H-473a

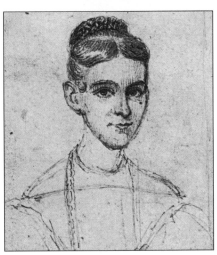

650.
Graphite on paper
7 x 4 3/4 (17.7 x 12.0)
H-490a

651.
Graphite on paper
5 3/4 x 4 1/8 (14.6 x 10.2)
H-467

652.
Graphite on paper
3 x 2 1/2 (7.4 x 6.4)
Inscribed, verso: "Mrs. Macomb Tuesday after
2 o'clock"
H-490

653.
Graphite on paper
6 1/8 x 4 1/2 (15.3 x 11.2)
H-466

654.
Graphite on envelope with embossed seal
5 5/8 x 3 1/8 (14.1 x 7.9)
H-487

655.
Graphite, ink, and watercolor on paper;
mounted on cardstock
2 3/4 x 2 1/4 (6.9 x 5.7);
comp. 2 3/8 x 2 (oval) (6.1 x 4.9)
H-475

656.
Watercolor on cardstock
5 5/8 x 4 1/2 (14.3 x 11.5)
M-89

657.
Watercolor on cardstock
6 1/4 x 4 7/8 (15.6 x 12.2)
H-488

658.
Graphite and ink on cardstock
2 3/8 x 2 1/4 (oval) (6.0 x 5.5)
H-492

659.
Brown wash and graphite on paper
3 1/4 x 2 1/2 (8.2 x 6.2)
H-489

660.
[PORTRAIT OF MRS. HENRY C.
WAGSTAFF]
Oil on paper, glued on board; in gilt frame
11 1/2 x 10 (oval) (29.2 x 25.2)
Frame: 17 3/8 x 15 1/4 (oval) (44.0 x 38.8)
Attributed by donor to George Winter, ca. 1862
4493

661.

JOSEPHINE QUEEN OF SWEDEN & NORWAY

Pink wash and graphite on paper
2 7/8 x 2 3/4 (7.3 x 6.9)
H-532

PORTRAITS OF HISTORICAL SUBJECTS

Winter produced and sold versions of portraits of historical figures, as indicated in this notice for his distribution of paintings, Lafayette, 31 December 1857:

"'Portraits.' This series of portraits of eminent men, whose fame belong to the world at large, have a peculiar interest, as they necessarily awaken in the mind the reminiscences of the history of the day in which they lived, or direct an inquiry of the facts which affect them, as men of genius, and lead to their distinction. The paintings are elaborately finished, and placed in handsome 'bead frames.' There are nine in number.

COLUMBUS.	BACON.	RALEIGH.
CROMWELL.	LOCKE.	PATRICK HENRY.
WOLSEY.	NEWTON.	A. HAMILTON."

(GWMSS 2-1 [21])

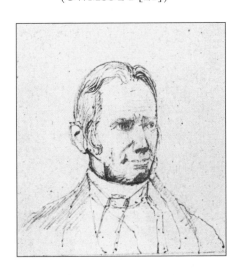

662.

H CLAY

Graphite on paper
3 1/8 x 2 3/4 (7.7 x 6.9);
comp. 2 x 2 (5.1 x 5.1)
H-535

663.

[MAN WEARING TURBAN]

Graphite on cardstock
2 3/4 x 2 1/2 (7.0 x 6.4)
G. W.'s signature repeated several times on verso
H-539

664.
[MAN IN ELIZABETHAN ATTIRE]
Graphite on paper
3 1/4 x 3 1/2 (8.1 x 8.7)
H-534

665.
COLUMBUS
Pink wash and graphite on paper
3 x 4 (7.6 x 10.1)
H-537

666.
[MAN WEARING PLUMED HAT]
Wash and graphite on paper
2 1/2 x 3 7/8 (6.4 x 9.7)
H-538

Historical, Romantic, & Whimsical
STUDIES

HISTORICAL BUILDINGS

667.
RUINS OF THE BISHOP'S PALACE, AT ST DAVIDS
Graphite on paper
3 x 3 1/8 (7.6 x 7.7);
comp. 2 1/8 x 2 3/8 (5.2 x 6.0)
Inscribed, u.c.: "Drawn in Dayton Monday De[c]"
[23rd 1844]
(remainder of inscription appears on Cat. #668)
Originally formed one sheet with Cat. #668
H-499

668.
PORCH OF THE CATHEDRAL OF RATISBON ON THE DANUBE
Graphite on paper
3 x 2 7/8 (7.5 x 7.2);
comp. 2 1/8 x 2 (5.1 x 5.1)
Inscribed, u.l.: "[Dec] 23d 1844"
(remainder of inscription appears on Cat. #667)
Originally formed one sheet with Cat. #667
H-500

669.
DUNBARTON CASTLE. SCOTLAND
Graphite on paper
2 3/8 x 2 5/8 (6.1 x 6.5);
comp. 2 1/8 x 2 (5.2 x 5.1)
H-502

670.

LOCH LEVEN CASTLE, IN WHICH THE UNFORTUNATE MARY QUEEN OF SCOTS WAS RETAINED PRISONER

Blue wash on paper
3 3/8 x 4 5/8 (8.3 x 11.6);
comp. 2 3/4 x 3 (7.0 x 7.5)
Inscribed, l. margin: "Loch Leven"
H-514

671.

[LOCH LEVEN CASTLE]

Green and black wash and ink on cardstock
2 3/8 x 2 3/4 (5.9 x 6.8);
comp. 2 1/8 x 2 1/4 (5.2 x 5.8)
Computations on verso
Similar to Cat. #670
H-513

672.

CHEPSTOW CASTLE ON THE WYE. SOUTH WALES

Graphite and pink wash on paper
3 1/4 x 3 1/8 (8.1 x 8.0);
comp. 2 7/8 x 3 (7.2 x 7.6)
H-505

673.

GOODRICH CASTLE. SOUTH WALES

Red wash and graphite on paper
3 1/4 x 3 1/4 (8.1 x 8.1);
comp. 2 7/8 x 2 7/8 (7.2 x 7.1)
H-506

674.
GREAT HALL. KENILWORTH
Red wash and graphite on paper
3 1/4 x 3 1/4 (8.1 x 8.1);
comp. 2 7/8 x 3 1/8 (7.3 x 7.8)
H-507

675.
BAYEN THURM–COLOGNE
Brown wash and graphite on paper
3 x 4 1/2 (7.5 x 11.5); 2 7/8 x 2 7/8 (7.1 x 7.2)
Inscribed, r. margin: "Logansport Indiana
May 6th 1846"
H-503

676.
BAYEN THURM
Brown wash and graphite on paper
3 x 4 1/2 (7.6 x 11.3);
comp. 2 7/8 x 2 7/8 (7.2 x 7.2)
Similar to Cat. #675
H-504

677.
BISMARKARIAN HALL
Graphite on paper
4 3/4 x 5 (11.9 x 12.6)
On verso: section of printed document regarding
an examination of the Rev. Loren W. Russ,
Rector of St. John's Church, Lafayette, by an
ecclesiastical tribunal
E-257

678.

[STUDY OF ROMANESQUE RUINS]

Graphite on paper
3 x 3 (7.5 x 7.5);
comp. 2 1/8 x 2 1/4 (5.3 x 5.6)
H-501

679.

[BRIDGE OR AQUEDUCT OVER MOUNTAIN STREAM]

Graphite on paper
2 1/4 x 2 5/8 (5.7 x 6.4);
comp. 2 1/4 x 2 1/4 (5.5 x 5.6)
Possibly preliminary study for "The Acquaduct,"
mentioned in Winter's distribution of paintings,
Lafayette, 30 December 1865 (GWMSS 2-1 [34])
H-508a

680.

[HOUSE WITH STONE BRIDGE IN BACKGROUND]

Graphite on paper
2 7/8 x 3 (7.3 x 7.5)
H-518

681.

[GOTHIC STRUCTURE OVERLOOKING WATERFALL]

Graphite on paper
2 5/8 x 3 1/2 (6.5 x 8.7);
comp. 2 5/8 x 2 7/8 (6.5 x 7.2)
Inscribed, verso, u.c.: "Retribution"
Sketch of crowned head on verso
H-508b

682.

[FORTRESS]

Graphite on paper
2 3/4 x 2 5/8 (6.9 x 6.6);
comp. 2 1/8 x 2 1/4 (5.4 x 5.6)
H-509

683.

[GORGE WITH ARCHED BRIDGE AND TOWER]

Graphite on paper
2 1/4 x 3 1/8 (5.5 x 7.8);
comp. 2 1/4 x 2 1/4 (5.5 x 5.7)
"James Winter," other notations and sketches
on verso
E-260

(678) Notice of Winter's distribution of paintings, Lafayette, 7 January 1860:

"'The Old Abbey.' A copy; a mystic effect of an old abbey dilapidated roof, and arches. The effect of light upon the broken structure gives a sombre, and picturesque impression." (GWMSS 2-1 [32])

(681) Notice of Winter's distribution of paintings, Lafayette, 29 December 1852:

"'Dungeon Gill,' An English scene–massive walls of rock loom up majestically–dashing cascades, and fragments of rock in the foreground, give majesty to the view." (GWMSS 2-1 [8])

(683) Notice of Winter's distribution of paintings, Lafayette, 7 January 1860:

"'Ruined Tower.' Original Composition; moonlight effect; a castle stands upon a rocky eminence from behind which the moon unseen, sends out her silvery rays. A Bridge connects the opposite hilly side with the stronghold." (GWMSS 2-1 [32])

684.
[ARCH WITH GOTHIC BUILDING]
Graphite on paper
2 x 2 (5.1 x 5.1)
H-519

685.
[WATERFALL WITH DOMED
ROTUNDA IN BACKGROUND]
Graphite on paper; embossed seal
4 1/2 x 4 (11.3 x 10.0);
comp. 2 3/4 x 2 3/4 (7.0 x 7.0)
H-520

686.
[FORTRESS ON ROCKY HEIGHT]
Graphite on paper
3 7/8 x 3 5/8 (9.9 x 9.0);
comp. 2 1/2 x 2 (oval) (6.4 x 5.0)
D-225

687.
[WINDMILL]
Graphite on paper
3 1/4 x 4 3/4 (8.2 x 12.1);
comp. 2 3/8 x 2 3/8 (circular) (5.9 x 5.9)
H-517

688.
[WINDMILL]
Graphite on laid paper
2 5/8 x 2 5/8 (circular) (6.4 x 6.4)
Sketch of sailing ships on verso
H-516

689.
CHAPEL AT KALENBERG. FROM
PRINCE ALBERT'S DRAWING.
Red wash on paper
3 1/4 x 4 1/4 (8.2 x 10.7);
comp. 3 x 2 7/8 (7.3 x 7.1)
H-508

690.

[GOTHIC INTERIOR]

Graphite on cardstock
2 1/8 x 2 1/8 (5.3 x 5.3)
H-512

691.

[GOTHIC INTERIOR]

Graphite on cardstock
2 7/8 x 3 (7.2 x 7.5)
Similar to Cat. #690
H-511

692.

[ROMANESQUE INTERIOR]

Ink and graphite on cardstock
2 7/8 x 2 7/8 (7.2 x 7.1)
Sketch of boy jumping rope, computations on verso
H-510

693.

[GALLERY OF ARCHED COLUMNS
WITH FIGURES]

Graphite on paper
2 1/4 x 3 1/2 (5.7 x 8.8);
comp. 2 1/8 x 2 1/8 (5.1 x 5.2)
H-515

694.

[GOTHIC ARCHITECTURAL DETAIL]

Graphite on paper
9 1/2 x 5 5/8 (24.1 x 14.1);
comp. 9 1/2 x 4 1/8 (24.1 x 10.4)
Inscribed, u.r.: "Logan[sport]"
Other semi-legible notations in right margin
Section of Gothic architectural detail on verso
H-521

695.

[DIAGRAMS OF CARDING AND
SPINNING MACHINE]

Graphite and ink on paper
11 1/8 x 7 7/8 (28.0 x 20.0)
Inscribed, u.r.: "Smaller Improvements–Two [] []"
l.r.: computations
I-625

HISTORICAL AND ROMANTIC SCENES

696.

[INTERIOR WITH GROUP IN RENAISSANCE ATTIRE]

Ink and graphite on blue paper
2 5/8 x 3 1/2 (6.5 x 8.8)
List of items of clothing, with prices, on verso
H-525

697. (see Plate 60)

ORIGINAL SKETCH OF A SCENE FROM THE CRUSADES

Watercolor on paper
4 5/8 x 6 1/8 (11.6 x 15.3);
comp. 3 7/8 x 5 3/4 (9.9 x 14.4)
M-97

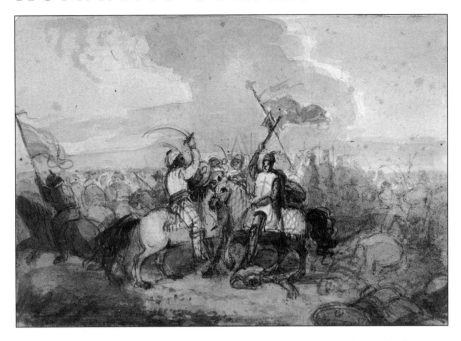

(697) Notice of Winter's distribution of paintings, Lafayette, 31 December 1857:

"'Battle Scene.' A scene from the Crusades, after the celebrated painting by Lutherburgh. Richard, the lion-hearted, wields with vigorous arm his effective battle-axe. He stands conspicuous in the majestic foreground group. This painting has been admired for the grandeur of the composition. Coloring rich and mellow." (GWMSS 2-1 [23])

698.

[MEDIEVAL BATTLE SCENE WITH DETAILS OF WEAPONS]

Ink and graphite on paper
4 3/8 x 7 5/8 (10.9 x 19.4)
Inscribed, u.l.: "An unexhaustible Winter"
H-528

699.

**SALADIN PRESENTS RICHARD
A HORSE AS TESTIMONY OF
RESPECT FOR HIS CHARACTER-
AFTER RICHARDS VICTORY AT
JAFFA**

Ink and graphite on lined blue paper
7 x 9 5/8 (17.7 x 24.2)
H-527

(699) Notice of Winter's distribution of paintings, Lafayette, 29 December 1852:

"'The Battle of Azorf,' The Saracens dispute Richard's progress–a deadly conflict. The Infidels are discomfitted. This painting exhibits the costume of that period." (GWMSS 2-1 [8])

700.

**[BATTLE SCENE WITH CLASSICAL
SOLDIERS]**

Graphite on laid paper;
watermark showing globe and armed man
3 7/8 x 6 1/4 (9.8 x 15.9)
Illegible inscriptions and small sketch of head
on verso
H-526

701.

**[MAN ASSISTING PROSTRATE
FIGURE]**

Ink on paper
6 5/8 x 7 5/8 (16.7 x 19.5)
Inscribed, u.c.: "Looks like the good Samaritan"
H-529

702.

**[MONK PRAYING BEFORE
CRUCIFIX]**

Graphite on paper
2 3/8 x 2 3/8 (5.9 x 5.8)
Faint sketch of kneeling monk on verso
H-545

703.

**[ROBED FEMALE FIGURE ON
CLOUD]**

Graphite on paper; watermark "[H]ALL 7"
2 7/8 x 3 (7.2 x 7.6)
H-546

704.

**[FEMALE FIGURE ON SHELL
DRAWN BY SWANS]**

Graphite and brown wash on paper
4 1/4 x 5 3/4 (10.8 x 14.6)
H-531

705.

**[FEMALE FIGURE IN DIAPHANOUS
ROBE, STANDING ON SHELL]**

Graphite and pink wash on cardstock
4 1/4 x 3 (10.6 x 7.6)
H-530

706.

**[BUST OF WOMAN SURROUNDED
BY GARLAND]**

Pink wash, ink, and graphite on paper
4 1/8 x 4 5/8 (10.3 x 11.6)
H-533

707.

**[COAT OF ARMS FLANKED BY LION
AND UNICORN]**

Red wash and graphite on blue paper, lined on verso
4 1/8 x 4 1/2 (10.5 x 11.4)
H-560

708.
[FLORAL SPRAY]
Pink wash and ink, graphite on paper
4 1/4 x 4 3/8 (10.6 x 11.1)
H-547

709.
[URN WITH FLOWERS]
Ink and graphite on paper
2 3/4 x 2 3/8 (6.8 x 6.0)
H-549

710.
[STILL LIFE WITH VASE]
Graphite on paper
3 3/8 x 2 3/4 (8.6 x 6.7)
H-548

711.
[EGG WITH FLOWERS]
Graphite on paper
2 x 3 7/8 (4.9 x 9.8)
H-550

712.
[CHERUB HATCHING FROM EGG]
Graphite on paper
1 3/4 x 3 7/8 (4.4 x 9.7)
H-551

713.
[CUPID IN VASE OF FLOWERS]
Ink and graphite on cardstock
2 3/8 x 3 5/8 (6.1 x 9.0)
Printed inscription on verso reads, in part,
"Ward & Co. Importers & Dealers in British and
Foreign Toys . . . 231, High Holborn."
Possibly preliminary study for "Cupid and Boquet,"
mentioned in Winter's distribution of paintings,
Lafayette, 29 December 1866 (GWMSS 2-1 [35])
H-552

714.
[SEATED CUPID HOLDING BOW]
Graphite on paper
4 3/8 x 4 3/8 (11.0 x 11.2)
H-553

715.
[CHILD ASLEEP UNDER TREE]
Ink on lined blue paper
7 7/8 x 8 (20.0 x 20.2)
H-555

716.
[GIRL IN GARDEN]
Ink on paper
3 7/8 x 4 (9.8 x 9.9)
Sketch of foliage on verso
H-556

717.
[CHILD AND WOMAN HOLDING FLAG]
Black wash, brown wash and ink, and graphite on paper
4 3/8 x 3 7/8 (11.1 x 9.8)
H-559

718.
[TWO CHILDREN WITH FLAG]
Ink and graphite on paper
2 3/8 x 2 (6.0 x 4.9)
H-557

719.
[TWO CHILDREN WITH DOG AND FLAGS]
Graphite on paper
3 7/8 x 2 5/8 (9.7 x 6.7)
H-558

720.
[GROUP IN GARDEN]
Oil on blue paper
7 7/8 x 10 (19.9 x 25.3)
N-2

721.
[GROUP IN GARDEN]
Oil on blue paper
7 7/8 x 10 (19.9 x 25.3)
N-1

722.
THE GRAVE OF THE SPOTTED
FAWN
Graphite on cardstock
4 x 2 5/8 (10.0 x 6.4)
E-256

723.
[FEMALE FIGURE BESIDE
WATERFALL]
Graphite on paper
4 1/4 x 3 3/8 (10.7 x 8.4)
H-540

724.
[WOMAN BESIDE WATERFALL]
Graphite on paper
8 1/8 x 5 (20.5 x 12.6)
Similar to Cat. #723
H-542

725.
[KNEELING WOMAN IN DRAPED
ROBE]
Ink and graphite on brown paper
3 1/8 x 2 7/8 (7.7 x 7.2)
H-541

(723) This image may have been a preliminary study for the following work, which is frequently listed in Winter's distributions:

"'The Spotted Fawn'–Or Chief's Daughter–a portrayal of a beautiful squaw standing by a running brook, draped with graceful negligence." (Winter's distribution of paintings, Lafayette, 3 April 1852; GWMSS 2-1 [7])

726.
[STUDY OF GOTHIC INTERIOR]

Watercolor and ink on paper;
related images on front and verso
10 x 7 5/8 (25.2 x 19.4)
H-523

(726) This image, with its interplay between front and verso views when held up to the light, may have been an experiment in the preparation of Winter's "dissolving views" which were exhibited in Lafayette and other Indiana towns in 1851 and 1852. The display utilized a device purchased in Cincinnati in 1851, which may have been a type of magic lantern. The effect of the technique was described in the *Lafayette Weekly Journal* of 28 November 1851:

"The 'dissolving views' was a term we did not understand till witnessing them. Nor can we describe them in such [a] way as to enable our readers to appreciate their exquisite beauty. Their views are . . . the product of Mr. W's. fertile genius.

The actual size of these paintings we do not know, but to the eye of the spectator all appear large as the natural objects. A misty, vaporous looking mass is seen, gradually dim outlines grow, and soon the scene takes shape, and appears in its fullest proportions, this gradually fades again in mist, and another takes its place. Each with its appropriate light; one is lighted up by a summer sun–another shrouded in fog–another bathed in moonlight–another half seen by the dim light of the stars, and thus the ever-varying scene brings with it another change of coloring and of light." (GWMSS 1-13 [22])

727.

[INTERIOR WITH KNEELING FIGURES AROUND STATUE]

Ink and graphite on paper

4 1/2 x 5 1/8 (11.2 x 13.1)

Faint pencil sketch of landscape with figures and buildings on verso

H-522

(727) In 1839, Winter painted scenery for the Logansport Thespian Society, an amateur theatrical troupe, in exchange for expenses. The following images (Nos. 728 through 732) may have been preliminary studies for these stage sets. In the fall of 1839, a misunderstanding arose between Winter and the Society over financial matters, which led to an exchange of letters and a severing of their association.

G. W., Logansport, Indiana, to [Logansport Thespian Society], 28 December 1839:

"I have painted you *original scenes*–I must say that I was consequently surprised when the Society commissioned you as a committee to ask me to paint 8 *additional wings* for the *sum*–I offered to paint the *9 Flats*. However we do not all view things alike–offers are not always appreciated–some are inexperienced and do not know the value thereof–I am asked in your letter if I can consistently continue my service in the Green Room–to this I must reply if your Society can show me their consistency in their conduct towards me." (GWMSS 1-4 [24])

728.

[VIEW OF INTERIOR OR STAGE SET]

Graphite on paper

6 1/8 x 7 5/8 (15.5 x 19.4)

H-524

729.

[SKETCH OF STAGE BACKDROP WITH CHERUBS]

Graphite on paper

5 1/8 x 4 3/8 (12.8 x 11.1)

H-554

730.

[INTERIOR SCENE WITH FIGURES]

Graphite on paper

7 x 8 1/2 (17.6 x 21.6)

Inscribed, l. margin: "George Winter Esqr Logansport. Ind."

H-561

731.
[INTERIOR SCENE WITH FIGURES]
Ink and graphite on laid paper
5 7/8 x 7 7/8 (14.7 x 19.8);
comp. 3 5/8 x 5 1/2 (oval) (9.1 x 13.9)
Inscribed, l.l.: "Music at night Fall From the lips
that we Love."
H-562

732.
**[INTERIOR SCENE WITH FAMILY
AND SNAKES]**
Graphite on paper
3 7/8 x 6 1/4 (9.7 x 15.8);
comp. 2 5/8 x 4 3/4 (6.7 x 12.0)
H-563

733.
[WHIMSICAL ILLUSTRATIONS]
Ink on paper
5 x 9 3/8 (12.5 x 23.7)
I-585

734.
**[WINGED CREATURE ATOP
BOTTLE]**
Graphite on paper
4 1/8 x 4 1/4 (10.4 x 10.6)
I-587

735.
[VARIOUS GROTESQUE FIGURES]
Graphite on blue laid paper; embossed seal
4 5/8 x 4 (11.8 x 10.0)
I-586

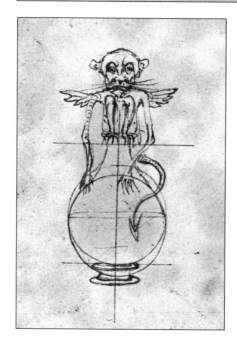

736.
[TWO FIGURES WEARING ARMOR]
Graphite on laid paper; partial watermark
2 5/8 x 3 3/8 (6.6 x 8.6)
I-591

737.
[TWO SOLDIERS]
Ink and graphite on paper
2 1/4 x 2 1/4 (5.5 x 5.6)
Computations on verso
I-609

738.
**[COMPOSITE OF IMAGES IN
TRIANGULAR OUTLINE]**
Ink on lined paper
4 1/8 x 4 7/8 (10.5 x 12.4)
I-594

741.
**[MEN OPENING KEGS; ONE MAN
BLOWN ALOFT BY EXPLODING
KEG]**
Graphite on paper
3 1/4 x 5 (8.1 x 12.6)
I-593

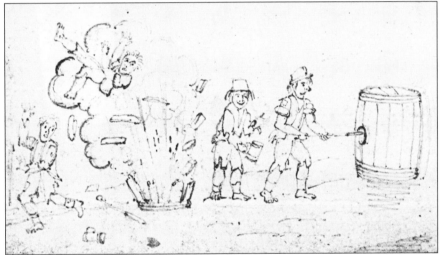

(741) This illustration may have been inspired by an episode described in a letter from G. W., East Oakland, California, to Nette Ball, 26 June 1875:

"Sis was here yesterday. She shewed me how to overcome a difficulty–in turning the faucit of a lager beer keg. In doing so–put on a force–brought out the faucit–and the *gas blew* the beer over us–completely swamping us. We ran out of the pantry at double quick time–*blind* and completely soaked. Sis had on a silk dress–spoiled I fear. I had to change my clothes–and I went over to Huffs for a change for Sis. It was a funny affair–and though we lost nearly the Keg of Beer–we were well soaked–Yet we felt it to be a jolly event to talk of." (GWMSS 1-27 [9])

742.

[MAN IN DOORWAY]

Graphite on paper
3 x 3 1/8 (7.5 x 8.0)
I-595

743.

[SAILING SHIP]

Graphite and ink on lined blue paper
3 3/8 x 4 3/8 (8.4 x 10.9)
I-622

744.

[TWO SAILING SHIPS]

Graphite on brown tissue paper
1 3/4 x 2 3/4 (4.4 x 6.8)
I-621

745.

[THUNDER GOD]

Graphite on paper
3 7/8 x 4 3/8 (9.8 x 11.1)
Image resembles figure from Benjamin West's
"Death on a Pale Horse"
H-544

746.

[SWIMMER UNDER LIGHTNING BOLTS]

Graphite on paper
3 x 4 3/8 (7.6 x 11.1)
Lightning bolts on verso
I-590

747.
[SKELETON WITH THIRD ARM HOLDING SKULL]
Graphite, ink, and wash on paper
2 3/4 x 3 1/4 (7.0 x 8.1)
I-606

748.
[STUDIES OF MAN WITH SKELETON HOLDING SCYTHE]
Graphite and ink on paper
2 7/8 x 3 3/8 (7.4 x 8.4)
Two studies of man's head on verso
I-607

749.
[UPPER HALF OF HUMAN SKELETON]
Graphite on cardstock
2 3/4 x 2 7/8 (6.8 x 7.2)
I-603

750.
[UPPER HALF OF HUMAN SKELETON]
Graphite on paper
2 1/8 x 2 1/2 (5.4 x 6.2)
I-604

751.
[STUDY OF HUMAN SKULL]
Graphite on paper
2 1/4 x 2 5/8 (5.5 x 6.5)
I-605

752.
[COBBLER WORKING AT BENCH]
Graphite on paper
4 3/8 x 6 1/8 (11.1 x 15.5)
I-600

753.
[BLACKSMITH HAMMERING METAL]
Red ink and wash, graphite on lined blue paper
4 1/8 x 3 3/8 (10.4 x 8.4)
Multiple arm positions show movement
I-599

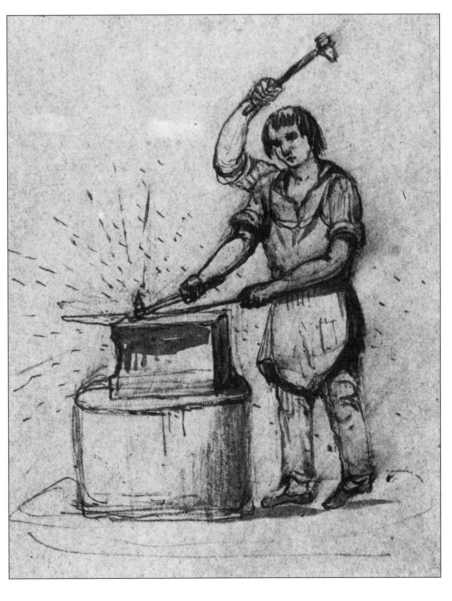

754.
[STUDY OF MAN DANCING]
Graphite on lined blue paper
4 3/8 x 3 1/8 (11.2 x 7.7)
Multiple limb positions show movement
I-596

755.
[STUDY OF MAN DANCING]
Red ink and graphite on brown tissue paper
4 1/4 x 5 1/4 (10.8 x 13.2)
I-598

756.
[STUDY OF MAN DANCING]
Graphite on paper
2 1/2 x 2 1/4 (6.2 x 5.6)
Multiple limb positions show movement
I-597

757.
[TWO JESTERS]
Graphite on paper
2 5/8 x 4 1/2 (6.7 x 11.4)
Multiple limb positions show movement
I-602

758.
[JESTER ON PEDESTAL]
Graphite on cardstock
2 3/4 x 2 5/8 (6.9 x 6.5)
Sailing ship on verso
Multiple limb positions show movement
I-601

759.
[JESTER ON PEDESTAL]
Graphite and red ink on paper
4 1/8 x 4 1/4 (10.3 x 10.6)
I-588

760. (See Plate 61)
[JOINTED PAPER DOLL]
Gouache (?) and gold leaf on cardstock.
Legs jointed at hips and knees;
joints connected with knotted string
19 1/8 (maximum height with legs extended)
x 7 1/2 (48.3 x 19.0)
OV3-99

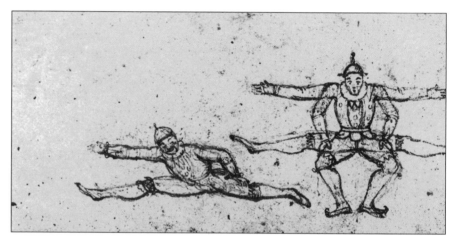

INDEX

Designer: Dean Johnson Design, Inc., Indianapolis, Indiana

Typefaces: New Baskerville (text) Copperplate (titles)

Typographer: Weimer Graphics, Indianapolis, Indiana

Paper: 70-pound Cougar Opaque Smooth, Book Weight

Printer: Shepard Poorman Communications Corporation, Indianapolis, Indiana